"Rosalinda Quintieri's exciting and timely book promises to revitalize critical analysis in visual culture through her discussion of contemporary modes of techno-scopophilia. Deploying neglected theoretical resources from the 'late Lacan' in which objects of *extimacy* become essential parts of our being, Quintieri's book engages with and develops the logic of recent photographic work deploying dolls, mannikins and marionettes that break with the Freudian paradigm of the 'uncanny'. In Quintieri's analysis the 'double' no longer simply provokes a crisis of identity and meaning but opens the way to perverse pleasures of human posterity in which the post-human follows the (an)aesthetic trajectory of the doll."

<div align="right">

– **Scott Wilson**, author of *Scott Walker and the Song of the One-All-Alone*. (Bloomsbury, 2020)

</div>

DOLLS, PHOTOGRAPHY AND THE LATE LACAN

In this fascinating new book, Rosalinda Quintieri addresses some of the key questions of visual theory concerning our unending fascination with simulacra by evaluating the recent return of the life-size doll in European and American visual culture. Through a focus on the contemporary photographic and cinematic forms of this figure and a critical mobilisation of its anthropological complexity, this book offers a new critical understanding of this classical aesthetic motif as a way to explore the relevance that doubling, fantasy and simulation hold in our contemporary culture.

Quintieri explores the figure of the inanimate human double as an "inhuman partner", reflecting on contemporary visuality as the field of a hypermodern, post-Oedipal aesthetic. Through a series of case studies that blur traditional boundaries between practices (photography, performance, sculpture, painting, documentary) and between genres (comedy, drama, fairy tale), Quintieri puts in contrast the new function of the double and its plays of simulations on the background of the capitalist injunction to enjoy.

Engaging with new theories on post-Oedipal forms of subjectivity developed within the Lacanian orientation of psychoanalysis, Quintieri offers exciting analyses of still and moving photographic work, giving body to an original aesthetic model that promises to revitalise our understanding of contemporary photography and visual culture. It will appeal to psychoanalysts and researchers from Lacanian psychoanalysis, visual studies and cultural theory, as well as readers with an academic interest in the cultural history of dolls and the theory of the uncanny.

Rosalinda Quintieri is a post-doctoral researcher based at the University of Manchester, UK. In her research and writing, photography and visual culture converge with aesthetics, psychoanalysis and an anthropology of technology. Her previous work on the poetics of the object in outsider and contemporary art has appeared in *PsicoArt* and *Prospero's*. She was awarded a President's Doctoral Scholar Award (2013–2016) to complete her PhD in Art History and Visual Studies, from which this book was born.

The Lines of the Symbolic in Psychoanalysis Series
Series Editor: Ian Parker
Manchester Psychoanalytic Matrix

Psychoanalytic clinical and theoretical work is always embedded in specific linguistic and cultural contexts and carries their traces, traces which this series attends to in its focus on multiple contradictory and antagonistic 'lines of the Symbolic'. This series takes its cue from Lacan's psychoanalytic work on three registers of human experience, the Symbolic, the Imaginary and the Real, and employs this distinctive understanding of cultural, communication and embodiment to link with other traditions of cultural, clinical and theoretical practice beyond the Lacanian symbolic universe. The Lines of the Symbolic in Psychoanalysis Series provides a reflexive reworking of theoretical and practical issues, translating psychoanalytic writing from different contexts, grounding that work in the specific histories and politics that provide the conditions of possibility for its descriptions and interventions to function. The series makes connections between different cultural and disciplinary sites in which psychoanalysis operates, questioning the idea that there could be one single correct reading and application of Lacan. Its authors trace their own path, their own line through the Symbolic, situating psychoanalysis in relation to debates which intersect with Lacanian work, explicating it, extending it and challenging it.

From the Conscious Interior to an Exterior Unconscious
Lacan, Discourse Analysis, and Social Psychology
David Pavón Cuéllar

The Constitution of the Psychoanalytic Clinic
A History of its Structure and Power
Christian Dunker

Pink Herrings
Fantasy, Object Choice, and Sexuation
Damien W. Riggs

Sexual Difference, Abjection and Liminal Spaces
A Psychoanalytic Approach to the Abhorrence of the Feminine
Bethany Morris

Dolls, Photography and the Late Lacan
Doubles Beyond the Uncanny
Rosalinda Quintieri

For more information about this series, please visit: www.routledge.com

DOLLS, PHOTOGRAPHY AND THE LATE LACAN

Doubles Beyond the Uncanny

Rosalinda Quintieri

Routledge
Taylor & Francis Group

LONDON AND NEW YORK

First published 2021
by Routledge
2 Park Square, Milton Park, Abingdon, Oxon OX14 4RN

and by Routledge
52 Vanderbilt Avenue, New York, NY 10017

Routledge is an imprint of the Taylor & Francis Group, an informa business

© 2021 Rosalinda Quintieri

The right of Rosalinda Quintieri to be identified as author of this work
has been asserted by her in accordance with sections 77 and 78 of the
Copyright, Designs and Patents Act 1988.

British Library Cataloguing-in-Publication Data
A catalogue record for this book is available from the British Library

Library of Congress Cataloging-in-Publication Data
A catalog record for this book has been requested

ISBN: 978-0-367-68200-2 (hbk)
ISBN: 978-0-367-44502-7 (pbk)
ISBN: 978-1-003-13465-7 (ebk)

Typeset in Bembo
by Apex CoVantage, LLC

CONTENTS

FIGURES

PREFACE

This book is about life-size dolls and much more. These images of enjoyment, relayed to us through art installations, open a window on the new worlds of post-Oedipal subjectivity that are unfolding a landscape that we all now inhabit, whether we like it, whether we love it, or not. Psychoanalytic subjectivity was once upon a time anchored in Oedipus, in a relation to a father figure that seemed to give consistency and order to the world. Even Freud, however, based his analysis of patients in the clinic and of cultural conditions for psychoanalysis on the fall as much as the force of the paternal imago. He opened the way for a rigorously psychoanalytic theorisation of what may now be termed "the evaporation of the father". Many theorists and practitioners have come to recognise that things are changing fast and that, in place of the standard modern arrangement of imaginary, symbolic and real, there are emerging radically innovative and singular forms of knotting, ways of stitching together these three registers of human activity. This knotting is what Jacques Lacan, in his later work, was to call the sinthome, now giving witness to uncanny conditions of doubling and simulation that Jacques-Alain Miller and others elaborate through descriptions of "ordinary psychosis".

In this uncanny book, Rosalinda Quintieri explores this new landscape of representation and subjectivity through detailed case studies of contemporary art practice in which life-size dolls loom large. She maps this hypermodern world and, with Roger Caillois, analyses the peculiar playful and symptomatic displays of mimicry, of new forms of subjectivity that operate through narcissistic supplements rather than through Oedipal symbolic warrant. Lacanian psychoanalysis, particularly in its later forms, attended to the way that we enjoy always doubles pleasure with pain, and today the *jouissance* – pleasure in pain, pain in pleasure – is structured in such a way as to replicate around and inside each individual subject what Lacan once described as the *discourse of the capitalist*. This book employs that discursive frame to provide an extraordinarily rich description of how we are enraptured

by creatively staged photographs and filmic narratives organised around the dolls. *Dolls, Photography and the Late Lacan: Doubles Beyond the Uncanny* is a book to enjoy and be alarmed by; be bewitched by the imaginary dimension, the images of the dolls, track through the way they are symbolically structured and so grasp how they provide individual creative solutions to the real.

Psychoanalytic clinical and theoretical work circulates through multiple intersecting antagonistic symbolic universes. This series opens connections between different cultural sites in which Lacanian work has developed in distinctive ways, in forms of work that question the idea that there could be a single correct reading and application. The Lines of the Symbolic in Psychoanalysis series provides a reflexive reworking of psychoanalysis that transmits Lacanian writing from around the world, steering a course between the temptations of a metalanguage and imaginary reduction, between the claim to provide a god's-eye view of psychoanalysis and the idea that psychoanalysis must everywhere be the same. The elaboration of psychoanalysis in the symbolic here grounds its theory and practice in the history and politics of the work in a variety of interventions that touch the real.

Ian Parker
Manchester Psychoanalytic Matrix

INTRODUCTION

"Quasi-subjects": the hypermodern double between flatness and affective excess

Dolls, mannequins and other inanimate human forms have made a remarkable return in European and American visual culture in the last three decades. They appear in a variety of media and registers in the work of Amber Hawk Swanson, John Miller, Isa Genzken, Rachel Harrison, Laurie Simmons, Eugenio Merino, Thomas Hirschhorn, Lynn Hershman Leeson, Cathy Wilkes, Cindy Sherman and Charles Ray, among many others.[1] With a long-standing tradition within Romanticism and the historical avant-gardes, human replicas still inspire cultural fascination and conflicting affective reactions. The complex cultural history of these figures, with their anthropological ties to child play (dolls), funerary rituals (the funerary mask, the *kolossós*), mechanical reproduction (the automaton, the robot) and capitalist seriality (the window mannequin), is at the foundation, today as in the past, of the fundamental semiotic ambiguity that makes them an invaluable rhetorical device in artistic production.[2] Through a focus on the contemporary photographic and cinematic forms of the life-size doll, this book offers a new critical understanding of this classical aesthetic motif as a way to explore the relevance that doubling, fiction and simulation hold in our Western hyper-mediated culture.[3] We will explore the ways in which the contemporary forms of the double exceed both modernist and postmodernist aesthetic and subjective paradigms, thus attempting to describe a new situation, both in relation to structures of subjectivity and forms of aesthetic engagement. In a technological and socio-cultural context in which classical distinctions between what is "real" and what is "simulated" have exhausted their explanatory efficacy, the re-emergence of the figure of the doll and its intrinsic structure of doubling offers a fertile ground for the exploration of new possible concepts for describing and understanding our current hypermodern condition.[4]

Analysing human-size mannequins and dolls and their cultural significance for the present moment will aim to engage with a precise cultural history that finds in the historical avant-gardes and the Freudian notion of the uncanny its classical

points of reference. Challenging the consideration of the contemporary photographic forms of the double as a post-Surrealist *topos* and a figure of the return of the repressed, this book will use new concepts drawn from recent developments in Lacanian psychoanalytic theory in order to capture the distinctive aesthetic qualities of the works analysed and their connection to new structures of subjectivity. The Freudian notion of the uncanny, as is well known, is grounded on the split of subjectivity and the return of the repressed, whereby anxiety points to the space between primary narcissism and castration.[5] It is a concept that impinges on a variety of psychoanalytic constructs – castration, repression, narcissism, death drive, anxiety, psychosis. "One could simply say", as Mladen Dolar has put it, "that [the uncanny] is the pivotal point around which psychoanalytic concepts revolve, the point that Lacan calls object small *a*".[6] The uncanny is the Lacanian *extimacy* of *objet a*, the "excluded interior" around which subjective life revolves, which is the paradox of a *something*, originally excluded by the action of the signifier, as a *nothing*, an empty space at the core of the symbolic order.[7] It is an encounter with the remainder of the alienation of the subject in the Other, with a presence (*objet a*) paradoxically incarnating the negative referent of the subject, her being a *lack of being*. In this sense, the uncanny is any manifestation of the fact that the unconscious – the most intimate – is an effect of exteriority, of the subject's coming into being in the realm of the Other. If this psychic constellation is at the foundation of a traditional theoretical understanding of the aesthetics of the double, this work explores the ways in which the contemporary forms of this figure and its related notions of mimicry and simulation can be seen to exceed it.

Dolls and other human doubles are still often automatically considered figures of the uncanny, but in fact one should consider how the structural foundation of the Freudian notion itself, rather than merely its content, is historically determined.[8] In her recent genealogy of the Freudian concept, cultural theorist Anneleen Masschelein, for instance, extends the operational value of the uncanny to the present culture, stating that "a recurring element of the uncanny in the [contemporary] visual arts is the importance of the (human) figure", with the traditional motif of the double "joined by new figures like the cyborg, or the technologically-enhanced human being".[9] The Freudian notion has similarly been deployed within recent art-historical accounts attempting to understand the return of the human replica in post-1989 art, often through a direct filiation from the historical avant-gardes, particularly from Surrealism. Mike Kelley's exhibition *The Uncanny* – re-edited in 2004 at Tate Liverpool after its first show in 1993 – has been the first of various critical interventions that have taken recourse to the Freudian notion to frame the return of the human figure in recent art.[10] By displaying sculptural and photographic works by Cindy Sherman, John Miller, Paul McCarthy, Duane Hanson, Tony Oursler and others, in which dolls and mannequins are perceived at human scale, Kelley's show aimed to expose the viewer's "belief in the power of the object".[11] The physical presence of these objects and images, and the uncertainty between animate and inanimate that they were seen to foreground, opened up reflections about artistic illusionism and suspension of disbelief in relation to a

mediatic context increasingly dominated by virtual-reality simulation and digital image-making technologies.

Similarly, the uncanny has been a rationale for art historian Hal Foster to understand the literalism of life-size dolls and mannequins in the arts of the 1990s, most notably in *The Return of the Real*.[12] Through the Lacanian lens of *The Four Fundamental Concepts of Psychoanalysis* (1964), here the uncanny is understood as a traumatic encounter with the Real – the beyond signification. Within a discussion on the legacy of artistic illusionism, Foster considers Cindy Sherman's *Sex Pictures* (1992), for instance, the place of emergence of the "real" as trauma, with the signifier of the mannequin standing for a subject "obliterated by the gaze".[13] The human replicas presented by Charles Ray, Mike Kelley and Robert Gober, similarly, are seen to "push illusionism to the point of the real", playing on the infantilism of a "mimesis of regression" in order to "mock the paternal law".[14] Foster considers the literalness of these works a direct filiation from Surrealism, with the surface of the simulacrum entangled with the presentation and repetition of traumatic effects as a (always failed) way to screen them.[15] Foster's notion of "traumatic illusionism" in this sense describes an image that is encrypted with trauma and, as such, is able to *puncture* the viewer in traumatic ways through technique and thematic suggestions.[16] Within this context, the use of repetition and image manipulation – by which the image is smeared, bleached, enlarged, pixelated and so on – the recourse to infantilist figures (clowns, puppets, dolls) and the appeal to the excremental and the damaged or diseased body are seen as means through which trauma is at once screened and produced, once again, for the viewer. In stark contrast with this aesthetic of trauma based on the Freudian paradigm, this book will explore a very different phenomenology of the human double, which, particularly in its most recent visual manifestations, appears disentangled both from the oppositional stance and the sense of menace of these earlier examples, in fact often foregrounding a self-conscious preoccupation with the aesthetic and the pleasure of looking.

From a broader cultural perspective, the 1990s' recourse to the return of the repressed can be seen today as the period's attempt to oppose a dominant poststructuralist notion of the simulacral, conceived as a surface devoid of referential and subjective depth, within a discussion on the conventions of post-1960 realism.[17] Foster's critical intervention sought to oppose a dominant conception of the simulacral in terms of desymbolisation of the object and negation of subjective interiority and authorial intention.[18] Fredric Jameson, notably, had characterised postmodernity as marked by an essential "waning of affect", contrasting postmodern "flatness" to high modernism as "the age of anxiety" and of an "aesthetic of expression", which presupposed "some separation within the subject, and along with that a whole metaphysics of the inside and the outside".[19] Concepts such as "anxiety and alienation", Jameson writes in *Postmodernism*, "are no longer appropriate in the world of the postmodern", with the "depthlessness" of the simulacrum transmuting structures of subjectivity and aesthetics alike.[20] Jean Baudrillard, similarly, had earlier spoken of the era of simulation as that of "a civilization without secrets", where "God himself can be simulated, that is to say reduced to the signs

which attest his existence".[21] In this sense, the 1990s' aesthetic recuperation of the figure of the double impinges on this broader cultural debate and the period's critical reappraisal of the Freudian notion can be seen as a direct reaction against what seemed to some a "postmodern apocalypse".[22]

The antagonism between affect and the simulacral is indeed a central motif of the artistic and cultural debates of the 1990s. If Foster's *traumatic realism* attempts a complication of simulacral flatness by consigning it to the "Real that lies below", a similar fissure between a model of affect and one of lack of affect in relation to illusionism can be seen in the opposition between Mike Kelley's aforementioned show and Jeffrey Deitch's *Post Human*, which one year earlier, in 1992, had proposed interpreting the return of the figure in *post-humanist* terms.[23] Displaying many of the same artworks, these exhibitions appear engaged in a critical battle for a new definition of artistic realism in its relation to reality, mediality, fiction, simulation, truth and untruth.[24] In opposition to Deitch's suggestion that the contemporary aesthetic tinkering with the human simulacrum might be read in connection with a newly emergent *post-human* personality, "drained of all emotion and affect", Kelley's proposal connected the same phenomenon precisely to a *maximum* of emotion and affect.[25] The uncanny then can be seen to emerge in this debate as a well-established construct that could be mobilised to insist on the persistence of something "old" in the newness proclaimed by Deitch, and of something "deep" in the flatness of Jameson's postmodern.[26] However, what I will argue in this book is that these oppositions – affect and flatness, depth and surface – fail to describe the contemporary aesthetic and subjective forms of the human double and, with it, our current relationship with doubling, simulation and the power of images.

Certainly, we will find that speaking about dolls and doubles is still today a means to engage with the problem of a critical definition of artistic illusionism in its relation to new forms of subjective experience and aesthetic engagement, in the context of recent changes brought about by digital technologies. *Post Human* and *The Uncanny* were animated by the same questions three decades ago, but their definition of a binary oppositional field seems untenable today. Looking at the artificial figures in the arts of the period, Deitch saw illusionist means engaged as a way to mark "the end of realism rather than its revival".[27] The "real" interrogated by Deitch was a dimension disintegrating "through an acceptance of the multiplicity of reality models and through the embrace of artificiality".[28] For the art critic, this meant the opening to a new ontological dimension that would render the Freudian subject obsolete. "The Freudian model of the 'psychological person'", he writes in the exhibition catalogue, "is dissolving into a new model that encourages individuals to dispense with the anguished analysis of how subconscious childhood experiences moulded their behaviour".[29] By contrast, Kelley, while agreeing with Deitch on the need to disrupt standard notions of reality, emphasised the dimension of split and otherness that he saw intrinsic to it, naming it through the classical Freudian structure of the return of the repressed. In the chapters that follow, I will run on the edge of this oxymoron between a conception of reality as unaccountable excess and one of simulacral flatness, interrogating the contemporary doll

as the manifestation of a new aesthetic paradigm exceeding it, one opening to a notion of the simulacrum as something simultaneously hyper-affective and flat.

Speaking about human replicas and their visual forms today also means connecting the threads between long past and more recent artistic practices interested in a reflection on aesthetic engagement through the notion of performativity.[30] As we shall see in Chapter 1, the manoeuvrability of dolls and mannequins invites interactivity and play, a dimension which in an artwork always brings into perspective the reality-producing effect of art, particularly in its relational dimension to the viewer. Kelley's exhibition can be seen as an early attempt to update a Minimalist-conceptualist focus on performativity in light of the period's broader cultural turn towards subjectivism and affect.[31] The Freudian uncanny, in this context, allowed the introduction of a performative move as a way to expose a traumatic depth in the simulacral surfaces foregrounded by the period's return to the modes of realism. To this we have to add the centrality of Minimalism as an important point of reference in this debate on the return of the human figure in art.[32] The recent insistence of dolls and mannequins in Western art can in fact be contextualised by taking into consideration how the representation of the human figure has had a very limited incidence in post-1945 European and American art – primarily in Pop Art, photorealism and some appropriation art. For the conceptualist neo-avant-gardes of the 1960s and 1970s, the figure bore multiple negative associations that made of it a retrograde form of art, resonating with the academism of monumental neoclassical statuary and its use by totalitarian regimes, as well as with the post-war neo-expressionist use of it as a site of affliction and artistic self-expression. Dolls and mannequins, in particular, only make rare appearances in this period, mostly within a post-Surrealist register, in connection with childhood and memory, or in works engaged with a critique of Pop Art and the privilege accorded therein to visuality, the stereotype and the commodity object.[33] When dolls and mannequins, with the human figure, became ubiquitous again in the 1990s, the lessons of conceptual art appear to have been internalised.

Speaking of the centrality of these figures in recent work by artists such as Rachel Harrison, Isa Genzken, John Miller and Thomas Hirschhorn, art historian Isabelle Graw underlined how these artworks seem to push objects' "flirtation with subjecthood to the extreme", with objects exposed as "quasi-subjects".[34] This effect of presence, Graw suggested, can be seen as an extremisation of Minimalist sculpture's latent anthropomorphism. As such, Graw connects the literalist presence of these artificial figures to the critical debate around modernist and postmodernist aesthetics, opened by Michael Fried's well-known critique of Minimalism in *Art and Objecthood* in 1967.[35] As is well known, in a move to despise the Minimalist object, Fried used the term "theatricality" to describe the way it called for physical and conceptual completion. Against the "disquieting" presence of the Minimalist installation, aware of its audience, Fried opposed the autonomy – elsewhere named "absorption" – of the modernist object, considered able to affirm its artistic status and overcome its condition of objecthood through a series of conventions that would exclude the beholder as a point of reference for its semiosis.[36] Between

the lines of this argument, there is a dialectics between openness and closure that will emerge at climactic points in this book, with the domain of the *image-doll* understood as one in which the theatrical and the simulacral appear hybridised in unexpected ways, rather than being mutually exclusive.

Accordingly, the visual analysis of the contemporary forms of the double also becomes a way to engage with recent discussions on pictorial and digital photography, which have recently been reviving this old debate between theatricality and absorption. For Fried, the contemporary trend of pictorial photography – its often staged, constructed, manipulated quality and attention to surface values – is a reactualisation of modernist "autonomy", whereby the artist fully bears the intention of the work, thus closed to the beholder's intervention.[37] In pictorial photography, the crafted aspect of the image would therefore affirm the intentionality that is seen to be intrinsically lacking in the index-photograph, and therefore allow the medium to become "proper" art. This view is certainly symptomatic of an antipathy for the photographic index that has traditionally run across Western culture, starting with Charles Baudelaire's famous abjure of photography in 1859 as refuge for "peintres manqués".[38] Cutting through Fried's reductionist critical determinism, it is my intention here to engage with this diagnosis of contemporary pictorial photography as characterised by an element of closure, vis à vis the openness and interaction implicated by the presence of dolls and mannequins in the works analysed in the following chapters. If the presence of the human double in the image seems to point to a post-Minimalist focus on the structural terms of the artwork, it is a matter of understanding how the contemporary image *does* something for the viewer in a different way than through its previous modernist and postmodernist strategies.

In analysing this structural hybridity in the aesthetics of the contemporary human simulacrum, I will deploy theoretical resources drawn from the late Lacan and the contemporary Lacanian orientation in psychoanalysis led by Jacques-Alain Miller. In particular, I will mobilise Lacan's theory of the discourses and his notion of the *sinthome*, which, introduced in the 1970s, have been developed in more recent interventions preoccupied with new forms of the symptom and an intention to overcome traditional binary categorisations, as a way to respond to the changes observed in the contemporary discourses.[39] This body of work has introduced a new direction which is profoundly reconceptualising the practice and its understanding of contemporary subjectivity and, as such, has the potential to revitalise our critical appreciation of contemporary visual culture. Starting with his 1972–73 seminar *Encore*, Lacan opened the path to a new stimulating direction in psychoanalysis, in which an attention to the individual subject's singular approach to treating the Real is foregrounded against traditional clinical categories.[40] With his latest teaching, Lacan inaugurated what has been called the "sixth paradigm of jouissance", which is the paradigm of the "non-rapport".[41] As Jacques-Alain Miller has underlined, the *non-rapport* is a statement on the primacy of *jouissance* and on "disjunction" – the "disjunction of signifier and signified, the disjunction of jouissance and the big Other, the disjunction of man and woman" – as an essential

condition of lived experience, which means the subject is called to create pragmatic ways to conjoin the various registers of human experience in order to inhabit her world.[42] In this paradigm, language as well as "the concepts of the big Other, the Name of the Father, and the phallic symbol are all pushed to the point of collapse into semblants", that is to say "reduced to a function of stapling together elements that are fundamentally disconnected".[43]

Thus displacing the privilege given in his earlier teaching to the symbolic dimension of human experience over its imaginary and real registers – that is, the Symbolic over the Imaginary and the Real – Lacan here introduces a fundamental disruption of the classical clinical binary between neurosis and psychosis, later formalised by Miller with the introduction in 1998 of the term "ordinary psychosis".[44] Based on recent clinical observations of a growing number of cases that are "impossible to classify" within the classical neurosis-psychosis binary, a call for a "continuist" approach has thus been emerging in the practice, based on a "generalisation from the singular psychotic effort to the clinical field as a whole".[45] Far from implying that today everyone is psychotic in a clinical sense, this formulation points to the fact that the hypermodern subject is called to find an individual, creative way to manage *jouissance* in an epoch characterised by a fundamental decline of symbolic efficiency, encapsulated in the notion that the "Other does not exist".[46] In this sense, all discourses, that is to say all forms of the social bond, can be seen as "defences against the real", as Miller put it.[47] The contemporary disbelief in the authority and power of traditional symbolic structures that used to guarantee a stable symbolic identity to the modern subject lays at the foundation of this diagnosis, as a situation urging each individual subject to find a solution to the fundamental human problem of managing *jouissance*. In the wake of Lévi-Strauss, psychoanalysis has traditionally considered the curbing of *jouissance* as the fundamental tenet of civilisation, and the repression of *jouissance* has traditionally emerged as the way the Social was constituted. *Objet a*, within this context, is the term used in Lacanian psychoanalysis to describe the remainder of the primordial Real in the Symbolic, the leftover of the necessary symbolic alienation requested to the subject. This dynamic is described in structural terms in Lacan's *discourse of the master*, with the *Name of the Father* as the master signifier through which the subject would transition from a disorganised and fragmented existence, subjected to the drive, towards the sphere of meaning and desire in the Other.[48] In this scheme of things, a portion of *jouissance* would be forbidden and become unconscious through the workings of repression.

Against this standard solution to the problem of the Real, the contemporary "decline of the Oedipus" opens to new forms of subjectivity whereby the subject is no longer "integrated into the paternal Law through symbolic castration".[49] This new organisation is already reflected in Lacan's 1972 formulation of the *discourse of the capitalist*, which postulates an unprecedented proximity between object and subject, in turn disconnected from the Law of prohibition that instead characterised the *discourse of the master*.[50] Posing enormous problems for the psychoanalytic treatment and its foundation in narrativity and symbolisation, the contemporary

clinic is a clinic of the *passage à l'acte*, "a clinic that has a direct relation with *jouis-sance* and its imperative, where the invitation to elaborate is usually rejected".[51] In this clinic, new symptoms emerge as a response to the weakness of the belief in the Other and the traditional structure of repression inherent in the *Name of the Father*. The *sinthome* defines the way the subject can curb *jouissance* through a "formal envelope", rather than through the workings of repression.[52] It opens to different modes of enjoyment not based on prohibition – on the *Name of the Father* – which becomes only one way for a subject to form a social bond. We could say that with the *sinthome* we find the issue of an *excess* to be managed through the creation of a distance, of finding the right distance from the Real as a way of speaking without recourse to the traditional ways of repression. The methodological challenge of this book is to explore the relevance of this new theoretical apparatus, emerging from clinical observations, in relation to aesthetics and the specific formal qualities of the practices engaging with dolls, doubling and simulation analysed in the following chapters. Arguing for a substantial inadequacy of the Freudian paradigm of the uncanny in reading the contemporary forms of the human and photographic double, this project explores the ways in which the model of the *sinthome* may transcend its clinical application to become an effective tool of aesthetic analysis. If *jouissance* is the central fact of contemporary experience – very far from a notion of the Real as that which "lies below", as Foster put it in 1994 – the traditional antagonism between affect and the simulacral, that we explored in this *Introduction* in relation to the figure of the double, falls apart. This means that, in art historical terms, we need a new critical rationale for describing realism. More specifically, from the point of view of psychoanalytic aesthetics, the fundamental question is to think about what consequences the contemporary decline of the Symbolic bears for aesthetic engagement and our traditional ways of describing it. If the hyper-modern Other has lost its consistency, that is to say its symbolic efficacy, how is the way we relate with images, doubling and simulation affected?

The formal hybridity of the photographic and cinematic works considered here may be in itself an invitation to experiment with the *sinthome* as a theoretical framework able to challenge established categories and traditional binary opposi-tions between signifier and *jouissance*, neurosis and psychosis. The works examined in the following chapters cross-contaminate the staged with the straight as well as photography with painting, sculpture and performance and interbreed different narrative genres. The notions of the simulacral and the affective, performativity and intentionality, explored in this introduction will circulate throughout this book, in search of a hypermodern inter-coordination and synthesis. I will start, in Chap-ter 1, with a personal synthetic account of the theoretical links at the basis of the modernist deployment of dolls and mannequins as figures of the return of the repressed, interweaving psychoanalytic aesthetic theory with a cultural history of dolls. I will take as a starting point Rosalind Krauss's Freudian reading of Hans Bellmer's dolls in *Corpus Delicti* to explore the theoretical knot that ties the mod-ern photographic forms of the human double to primary narcissism and lack.[53] The chapter will critically engage with classic literary texts on dolls as well as

with Surrealist photography, as the *locus* where the doll appears as a paradigmatic platform for the modernist interconnection between the doubling of subjectivity, mechanical reproduction and aesthetic engagement. Linking the notion of the uncanny to Lacan's theory of the *gaze*, I will finally introduce Lacan's theory of "the discourses" as a way to bring the notion of the historicity of the organisation of *jouissance* in relation to the artistic deployment of the double and to thus challenge the relevance of the Freudian uncanny for contemporary aesthetics.

In Chapter 2, I introduce the work of Olivier Rebufa (1958), a French artist-photographer who has been, since the late 1980s, producing human-scale self-portraits with Barbie dolls as a way to hybridise photography with painting, sculpture and performance. In his *Self-Portraits with Dolls: Since 1989* (1989–2016), Rebufa presents one of the earliest examples of an engagement with dolls pointing beyond a traditional Freudian register. The introduction of the Lacanian formula of the *capitalist's discourse* and recent psychoanalytic discussions on new forms of narcissism will allow us to evidence Rebufa's photographic narrative portraits as *tableaux* imbued with post-neurotic actuality. Engaging with Jameson's famous diagnosis of late capitalism as the era of a "waning of historicity", the chapter will ask if an engagement with visual and psychic flatness can produce cultural-political insight once it declares its implication with the capitalist fantasia.[54]

The hyper-realistic, life-size doll has emerged as a new, popular signifier for artists working with human simulacra since the early 2000s. In Chapter 3, I introduce this contemporary wonder of rubber technology, investigating its reception in popular culture through an analysis of Stephan Gladieu's (1969) pictorial photo-reportage *Silicone Love* (2009), documenting the everyday life of men who live with hyper-realistic *love dolls*. Coupling pictorial means with the informative mission of photojournalism, Gladieu's reportage challenges a traditional binary between aestheticisation and documentary value, interrogating the merging of ordinary reality and fantasy at the basis of a passion for these dolls. Is the erotic doll a form of adult play, a fetish, an object of perversion or something else altogether? The chapter intersects close formal analysis, psychoanalysis and play theory to reflect on what it might mean to live with a doll, interrogating Gladieu's formal choices in relation to the contemporary relationship between the simulacrum and *jouissance*.

From the documentary forms of Chapter 3, the love doll moves to the sphere of art photography and film in the subsequent two chapters. Chapter 4 is a theoretical speculation on Laurie Simmons's *Love Doll* photographic series (2009–11), which presents sumptuous pictorial images of a Japanese life-size doll, set in the elegant interiors of the artist's own house in Connecticut (US). In the chapter, I trace the artist's deployment of the human simulacrum from the miniature black-and-white works of the 1970s–80s to these recent large-scale, pictorial images of life-size dolls by drawing on the new articulation between the Symbolic and the Real described by Lacan in relation to the *capitalist's discourse* and the *sinthome*. The lavish pictorialism of Simmons's series is the ideal platform to explore the combination of openness and closure that I discussed earlier in relation to Michael Fried. How is the intrinsic performative structure of the doll integrated with the pictorial,

highly-constructed visual field of this photography? Adventuring on the uncharted ground of a post-Oedipal psychoanalytic aesthetic theory, this chapter will discuss how this articulation of opposites might be seen to challenge Lacan's traditional theory of visuality as field of the *gaze*, implicated with lack and desire.

Finally, Chapter 5 will consider *Lars and the Real Girl* (Gillespie, 2007), a dramedy film that succeeds in turning a life-size inanimate doll into a protagonist through flatness and abstraction, without the recourse to fantastic animation. The chapter will focus on the narrative structure of the film and the role of the human double therein, drawing on the generic conventions of the fairy tale in a way that challenges conventional readings of the film and traditional identificatory dynamics based on the Oedipal norm. Analysing the way in which the film uproots the figure of the doll from its historical connection with female initiation rituals and its fairy-tale associations with the maternal, the chapter explores the ways in which the film manages to make it a central signifier in a discourse on contemporary fatherhood and masculinity. Taken together, these case studies will contradict a traditional characterisation of the human double as a figure of the uncanny and of photography as a platform for its revelation. By analysing the ways in which these forms of the double hybridise the affective and the simulacral, performative openness and pictorial closure, this book aims to interrogate past and present paradigms of visuality and subjectivity. Taking as a starting point the oxymoron between *Post Human* and *The Uncanny*, this enquiry attempts to conceptualise an image-doll at once flat and affective as a counterpart to a hypermodern subject at once devoid of depth and traversed by an affective excess. Here starts an exploration of doubling beyond the uncanny.

Notes

1 See, for example, Amber Hawk Swanson, *Amber Doll Project* (2006–17); John Miller, *Mannequin Death* (2015); Isa Genzken, *Schauspieler* series (2013–15); Rachel Harrison, *Jack Lemmon* (2011); Laurie Simmons, *The Love Doll* series (2009–11); Eugenio Merino, *Stairway to Heaven* (2010); Thomas Hirschhorn, *Subjecters* series (2008–10); Lynn Hershman Leeson, *Olympia: Fictive Projections and the Myth of the Real Woman* (2007–2008); Cathy Wilkes, *Non Verbal* (2005), Cindy Sherman, *Sex Pictures* (1992); Charles Ray, *Male Mannequin* (1990).
2 Broadly speaking, in modern art, we find artificial figures standing both for values of rationality, geometricity and abstraction – as largely in Cubism and Futurism, Metafisica, Neue Sachlichkeit, Bauhaus and Constructivism – and as representatives of the realms of spontaneity, contingency, automaticity and lack of control, particularly in relation to play, childhood and the Freudian unconscious – as in Dadaism and Surrealism and, partly, in Metafisica and Neue Sachlichkeit. On the cultural and artistic history of dolls, see Kenneth Gross (ed.), *On Dolls* (London: Notting Hill Editions, 2012); Hal Foster, *Compulsive Beauty* (Cambridge, MA: MIT Press, 1995); Terry Castle, *The Female Thermometer, Eighteenth-Century Culture and the Invention of the Uncanny* (New York: Oxford University Press, 1995); Alberto Castoldi, *Clérambault: Stoffe e Manichini* (Bergamo: Moretti & Vitali, 1994); Elisabetta Silvestrini and Elisabetta Simeoni (eds.), "La Cultura della Bambola", in *La Ricerca Folklorica: Contributi allo Studio della Cultura delle Classi Popolari*, no. 16 (Brescia: Grafo, 1987); Michel Manson, "Mythe: Y a-t-il un Mythe de la Poupée?", in *Les Etats Généraux de la poupée* (Paris: C.E.R.P., 1985). Classical texts on the double

such as those by Otto Rank and Sigmund Freud are still vital references: Sigmund Freud, "The Uncanny" [1919], in James Strachey (ed.), *The Standard Edition of the Complete Psychological Works of Sigmund Freud, vol. XVII [1917–19]* (London: Hogarth Press and the Institute of Psycho-Analysis, 1959); Otto Rank, *The Double: A Psychoanalytic Study,* ed. Harry Tucker Jr. (Chapel Hill: The University of North Carolina Press, 1971 [1914]). On the double, see also Robert Rogers, *The Double in Literature* (Detroit: Wayne State University Press, 1970).

3 Among doubles of the human figure, this book focuses on inanimate, manoeuvrable replicas that allow the dimensions of play to unravel and the structures of doubling and fantasy to emerge in their most fundamental form, untouched by notions of automation, interactivity and artificial agency which become instead relevant in relation to animated human doubles, such as human-like robots and AI-enhanced machines.

4 As part of recent discussions on the obsolescence of the notion of *postmodernity* as a discursive category, there have been several attempts to define the current phase in new terms. Among the definitions introduced, "post-postmodernism" (Tom Turner), "digimodernism" (Alan Kirby), "altermodern" (Nicolas Bourriaud). "Hypermodernism", appeared for the first time in Gilles Lipovetsky's *Hypermodern Times* (Cambridge, UK: Polity, 2005), is the term I have preferred here, since the suggestion of an *excess* implied by the prefix hyper- is also topical in what I will try to describe in the following chapters in relation to contemporary subjectivity and aesthetics. I return on the issue of *excess* later in this introduction.

5 Freud describes "two classes of the uncanny", one in connection to the return of repressed beliefs and the other related to the "primitive beliefs" recapitulated in infantile complexes. See Freud, "The Uncanny", 249. I will explore this in Chapter 1.

6 Mladen Dolar, "'I Shall Be with You on Your Wedding-Night': Lacan and the Uncanny", *October,* vol. 58 (Autumn, 1991), 6.

7 Jacques Lacan, *The Seminar of Jacques Lacan: Book 7 the Ethics of Psychoanalysis [1959–1960],* ed. J.-A. Miller (London: Tavistock/Routledge, 1992), 122. See also David Pavón-Cuéllar, "Extimacy", in Thomas Teo (ed.), *Encyclopedia of Critical Psychology* (New York: Springer, 2014); Jacques-Alain Miller, "Extimity", *The Symptom,* no. 9 (Fall, 2008), available at <www.lacan.com/symptom/extimity.html>, last accessed 14.11.2017.

8 In *Marxism and Form* (Princeton, NJ: Princeton University Press, 1971), Fredric Jameson considers how the Surrealist force of an object depends on the "uneffaced mark of human labour" (104) deposited in it, thus historicising the uncanny by connecting it to early capitalism's commodity fetishism. This line of thinking can be traced back to Walter Benjamin who wrote of the Surrealists' recuperation of the *outmoded* as an instance of "revolutionary nihilism", unsettling for its ability to connect to lost pre-capitalist relations ("Surrealism: The Last Snapshot of European Intelligentsia", in *id., Selected Writings,* vol. 2 (Cambridge, MA: Harvard University Press, 1999, 210). My own argument in this book on the decline of the uncanny will instead draw on the historicity of the structure of Oedipal subjectivity, on which Freud's definition is based.

9 Anneleen Masschelein, *The Unconcept: the Freudian Uncanny in Late-Twentieth-Century Theory* (Albany: SUNY Press, 2011), 148–149.

10 See Mike Kelley (curator), *The Uncanny* (Liverpool: Tate Liverpool, 2004; *Sonsbeek 93,* Arnhem: Gemeentemuseum, 1993). Other recent thematic exhibitions featuring dolls and other artificial human figures have included *Poupées et Tabous: Le Double Jeu de l'Artiste Contemporain* (Namur: Maison de la Culture de la Province de Namur, 2016), *Silent Partners: Artist and Mannequin from Function to Fetish* (Cambridge: Fitzwilliam Museum, 2014–15), *Guys 'n' Dolls: Art, Science, Fashion and Relationships* (Brighton: Brighton Museum, 2005), *Poupées* (Paris: Halle Saint Pierre, 2004).

11 Valerie Smith, "Something I've Wanted to Do But Nobody Would Let Me: Mike Kelley's 'The Uncanny'", *Afterall,* no. 34 (Autumn/Winter, 2013), 21. See also Mike Kelley, *The Uncanny* (Arnhem/Los Angeles: Gemeentemuseum, 1993), p. 10. On Kelley's show, see also John C. Welchman, "On the Uncanny in Visual Culture", in Mike Kelley (ed.), *The Uncanny* (Liverpool: Tate Liverpool, 2004), 39–56.

12 See Hal Foster, *The Return of the Real: The Avant-Garde at the End of the Century* (Cambridge, MA: MIT Press, 1996). The 1990s saw a remarkable recuperation of the notion of the uncanny, both as an aesthetic construct and in its ethical and political implications. See, for example, Nicholas Royle, *The Uncanny* (Manchester: Manchester University Press/Routledge, 2003); *Paradoxa* (Special number "The Return of the Uncanny"), vol. 3, 1998; Anthony Vidler, *The Architectural Uncanny: Essays in the Modern Unhomely* (Cambridge, MA: MIT Press, 1996); Martin Jay, "The Uncanny Nineties", *Salmagundi*, no. 108 (Autumn, 1995). For a history of the concept, see Masschelein, *The Unconcept*.

13 *ivi*, 149. I discuss the details of this reading in Chapter 1.

14 *ivi*, 152, 159.

15 *ivi*, 144. In this direct connection between 1990s' mannequins and Surrealism, Foster is following Rosalind Krauss. See R. Krauss, "Cindy Sherman: Untitled", in *id.*, *Bachelors* (Cambridge, MA: MIT Press, 1999 [1993]).

16 *ivi*, 132.

17 In its original Platonic definition, the simulacrum, or *phantasma*, is a copy without original, as opposed to the likeness of an accurate copy. See Plato, "The Sophist", in Edith Hamilton and Huntington Cairns (eds.), *Plato: Collected Dialogues* (Princeton: Princeton University), 957–1017. In the 1960s, the notion became central within French philosophical theories on the crisis of representation, particularly in the work of Pierre Klossowski, Gilles Deleuze and Jean Baudrillard.

18 See Foster, *The Return*, 128. He refers, in particular, to Roland Barthes's "That Old Thing Art", in *The Responsibility of Forms: Critical Essays on Music, Art and Representation* (Berkeley and Los Angeles: University of California Press, 1991 [1982]).

19 Fredric Jameson, "The Cultural Logic of Late Capitalism" [1984], in *id.*, *Postmodernism: Or, the Cultural Logic of Late Capitalism* (Durham: Duke University Press, 1992), 11–12.

20 *ivi*, 14, 12.

21 Jean Baudrillard, *Simulations* (New York: Semiotext(e), 1983), 5.

22 Brian Massumi, "Realer Than Real: The Simulacrum According to Deleuze and Guattari", *Copyright*, no. 1 (1987), 90. In relation to this, John Welchman has observed how the flattening of memory, body perception and of a sense of the sacred implied by these formulations would "precipitat[e] the occlusion of the uncanny, which is dependent for many of its effects on the relations between bodies, recall and repression" (John C. Welchman, "On the Uncanny in Visual Culture", in Kelley, *The Uncanny* (2004), 49).

23 Foster, *The Return*, 144. See Jeffrey Deitch (curator), *Post Human* (Lausanne: FAE Musée d'Art Contemporain; Turin: Castello di Rivoli; Hamburg: Deichtorhallen; Athens: Deste Foundation; Jerusalem: Israel Museum, 1992). I return to Foster's *traumatic realism* in Chapter 1.

24 Works by Robert Gober, Duane Hanson, Martin Kippenberger, Jeff Koons, Paul McCarthy, John Miller, Dennis Oppenheim, Tony Oursler, Nam June Paik, Charles Ray, Cindy Sherman, Laurie Simmons, Kiki Smith and Paul Thek, for instance, were displayed in both shows.

25 Jeffrey Deitch, *Post Human* [cat. ex.] (Pully/Lausanne: FAE Musée d'Art Contemporain, c1992), n.p. In his 1993 catalogue essay, Kelley clearly posits Deitch's framework as a main point of reference for his own interpretation of the period's "trend" of figurative sculpture. See Kelley, *The Uncanny* (1993), 5.

26 See Kelley, *The Uncanny* (1993), 5, 6.

27 Deitch, *Post Human*, n.p.

28 *Ibid.*

29 *Ibid.*

30 The notion, developed in linguistic theory, points to language's reality-producing effects, as opposed to the reality-describing character of constative utterances. See John Langshaw Austin, *How to Do Things with Words: The William James Lectures Delivered at Harvard University in 1955*, ed. J. O. Urmson (Oxford: Clarendon, 1962). On performativity in art, see Dorothea Von Hantelmann, "The Experiential Turn", *Living Collections Catalogue*

(Walker Art Centre, 2014), available at <www.walkerart.org/collections/publications/performativity/>, last accessed 15/02/18.

31 In this change of direction, a pivotal role was played by the English translation of Lacan's 1964 seminar on the *gaze*, within *The Four Fundamental Concepts of Psychoanalysis* (first published in English in 1977) and of Roland Barthes's 1980 theorisation of the *punctum* in *Camera Lucida* (published in English in 1981). See Jacques Lacan, *The Four Fundamental Concepts of Psychoanalysis* (London: Penguin Books, 1994 [1973]); Roland Barthes, *Reflections on Photography* (London: Vintage Books, 2000 [1980]).

32 See, for example, Ralph Rugoff (ed.), *The Human Factor: The Figure in Contemporary Sculpture* (London: Hayward Publishing, 2014) and Isabelle Graw (ed.), *Art and Subjecthood: The Return of the Figure in Semiocapitalism* (Berlin: Sternberg Press, 2011).

33 Consider, for instance, Arman's installation *Le Village Des Damnés* (1962) and Bernand Faucon's photographic series *Summer Holidays* (1978) for the first genealogy; and, for the second lineage, Yayoi Kusama's installation *Driving Image Show* (1959–64) and Paul McCarthy's 1977 performance *Grand Pop*.

34 Isabelle Graw, "Introduction: When Objecthood Turns into Subjecthood", in *Art and Subjecthood*, 14.

35 See Michael Fried, "Art and Objecthood" [1967], in *id.*, *Art and Objecthood: Essays and Reviews* (Chicago: University of Chicago Press, 1998). The terms of this debate have recently returned to attention in relation to digital photography and the historical *querelle* of photography's artistic status in relation to painting. In his 1967 original formulation, Fried defined the effect of "presence" that the Minimalist sculpture provoked as "anthropomorphic", seen to challenge the viewer to recognise her position in front of the object, as opposed to a "true" work of art, which in its self-sufficiency would absorb the viewer in its internal elements, making her escape the fact of beholding.

36 *ivi*, 152.

37 According to this line of thought, some contemporary pictorial photography is thus able to overcome its essential non-artistic objectual existence, a status to which it would otherwise lean ontologically for its intrinsic indexical aspects. See Michael Fried, *Why Photography Matters as Art as Never Before* (New Haven: Yale University Press, 2008) and *id.*, "Without a Trace: The Art of Thomas Demand", *Artforum*, no. 43 (March, 2005), 200–201. For a detailed critical debate of these ideas, see Diarmuid Costello and Margaret Iversen (eds.), *Photography after Conceptual Art* (Chichester: Wiley-Blackwell, 2010) and D. Costello, *On Photography: A Philosophical Enquiry* (New York: Routledge, 2018).

38 Charles Baudelaire, "The Modern Public and Photography" [1859], in *id.*, *The Painter of Modern Life* (London: Penguin Books, 2010), 120.

39 See Jacques Lacan, *The Other Side of Psychoanalysis* (New York and London: W.W. Norton & Co., 2007); *id.*, "Discours à l'Université de Milan (12.05.1972)", in Giacomo G. Contri (ed.), *Lacan in Italia 1953–1978: En Italie Lacan* (Milano: La Salamandra, 1978); *id.*, *The Sinthome: The Seminar of Jacques Lacan: Book XXIII*, trans. Richard Price (Cambridge, UK and Malden, MA: Polity, 2016). In this book, I will use the Lacanian notion of discourse as a description of the way *jouissance* circulates in a given social form. In *The Other Side of Psychoanalysis*, Lacan defines the structure of discourse as a *matheme*, a formula that shows the relationship between split subject ($), knowledge ($S_2$), master signifier ($S_1$) and *jouissance* (a). Different discourses, that is, forms of the social bonds, are exposed as different ways in which *jouissance* is put in circulation in a given structure, in strict connection to – indeed as an effect of – the signifying chain. See Jacques Lacan, "Production of the Four Discourses", in *id.*, *The Other Side*, 11–28.

40 See Lacan, *Encore* (1972–73), transl. in *The Seminar of Jacques Lacan: On Feminine Sexuality, the Limits of Love and Knowledge: On Feminine Sexuality, the Limits of Love and Knowledge, Book XX* (New York: W. W. Norton & Company, 2000).

41 Jacques-Alain Miller, "Les Six Paradigmes de la Jouissance", *La Cause Freudienne*, vol. 43 (October, 1999), 7–29.

42 *ivi*, 25.

43 *Ibid.*
44 Jacques-Alain Miller, *La Convention d'Antibes: La Psychose Ordinaire* (Paris: Agalma/Seuil, 2005). This is the field of the so-called second clinic of Lacan, the Borromean clinic. *Ordinary psychosis* is "ordinary" because it contrasts with the exceptionality of the symptoms of classical psychosis, such as extraordinary delusions and elementary phenomena. A good summary of the issues at stake can be found in Alexandre Stevens, "Mono-Symptoms and Hints of Ordinary Psychosis", in *Psychoanalytical Notebooks 19: A Review of the London Society of the New Lacanian School (Ordinary Psychosis)*, no. 19 (March, 2008). See also *Psychoanalytical Notebooks 23: Our Orientation* (London: London Society of the New Lacanian School, 2011).
45 Eric Laurent, "Psychosis, or a Radical Belief in the Symptom", *Hurly-Burly: The International Lacanian Journal of Psychoanalysis*, no. 8 (2012), available at <www.amp-nls.org/page/gb/49/nls-messager/0/2012-2013/854>, last accessed 17.11.2017.
46 See Éric Laurent and J.-A. Miller, *L'Autre Qui N'Existe Pas Et Ses Comités D'Ethique, Seminar* (1996).
47 Jacques-Alain Miller, "Ironic Clinic", *Psychoanalytical Notebooks*, no. 7 (2001), 9. See also J.-A. Miller and Eric Laurent, *L'Autre Qui N'Existe Pas et Ses Comités d'Ethique (1996–1997), L'orientation lacanienne II*, unpublished.
48 See Lacan, *The Other Side*. See also Justin Clemens and Russell Grigg (eds.), *Jacques Lacan and the Other Side of Psychoanalysis: Reflections on Seminar XVII* (Durham: Duke University Press 2nd printing, 2007).
49 Slavoj Žižek, *The Ticklish Subject: The Absent Centre of Political Ontology* (London: Verso, 2000), 248.
50 See Lacan, "Discours à l'Université de Milan", 32–55. I have chosen to frame this new situation through the structure of Lacan's "fifth discourse" since here the issues of lack of distance between subject and object and the subject's self-directed formation of signifiers find an extremely clear synthetic form. These same issues, however, as pertaining to a broader notion of a capitalist subjectivity, have been contextualised elsewhere using different frameworks, principally through the lens of the *university discourse* and the *discourse of the analyst*. See, for example, Alenka Zupančič, "When Surplus Enjoyment Meets Surplus Value", in Justin Clemens and Russell Grigg (eds.), *Jacques Lacan and the Other Side of Psycho-analysis: Reflections on Seminar XVII* (Durham: Duke University Press 2nd printing, 2007); "A Fantasy" [2004], in *Lacanian Praxis: International Quarterly of Applied Psychoanalysis*, no. 1 (May, 2005), 6–17. I return to the *discourse of the capitalist* in Chapter 1.
51 Oscar Ventura, "The Symbolic Order in the 21st Century. It's Not What It Used to Be. What Consequences for the Treatment?: Without Nostalgia", in *Psychoanalytical Notebooks 23*, 93.
52 Laurent, "Psychosis, or a Radical Belief", n.p. The term is first used in Jacques Lacan, "On My Antecedents", in *id.*, *Écrits: The First Complete Edition in English*, trans. B. Fink (New York and London: W.W. Norton, 2006), 52. See also Lacan, *The Sinthome*.
53 See Rosalind Krauss, "Corpus Delicti", *October*, vol. 33 (Summer, 1985).
54 Jameson, *Postmodernism*, 21.

1

THE MODERN *DOPPELGÄNGER*

Enjoyment as subversion

I opened my introduction by taking Mike Kelley's *The Uncanny* and Hal Foster's *The Return of the Real* as two recent theoretical instances where the return of the double in contemporary visual culture has been read through the traditional Freudian-Surrealist paradigm. I have instead started to argue that the Freudian lens might be inadequate to grasp the innovative features and psychic implications of more recent forms of the double. As we have seen, Foster's Surrealist reading of mid-1990s art is based on his concept of *traumatic realism*, as a form of art "in the service of the real".[1] Lacan's *gaze* and Barthes's *punctum* are Foster's main theoretical coordinates there to theorise an image where the indexical (what is already *in* the image) and the subjective (what is *outside* the image, added to it) are confounded, where the image becomes the place of "a confusion of subject and world, inside and outside".[2] "[I]t may be this confusion that *is* traumatic", Foster concludes, which unmistakably points to the classical Surrealist *topos* of simulation as a loss of "self-possession", as famously developed by Roger Caillois in *Mimicry and Legendary Psychasthenia* (1939).[3] In drawing these connections, Foster is following a well-established critical framework, one which Rosalind Krauss had already deployed in 1985 in her ground-breaking analysis of Hans Bellmer's *Poupées* in *Corpus Delicti*. Before commenting on Foster's use of these constructs for the art of the 1990s, this chapter will take a closer look at Krauss's text and the theoretical knot it exposed and which has since dominated our critical understanding of the relationship between the human double and the photographic double.

This theoretical knot links some of the fundamental concepts of contemporary visual theory: Roger Caillois's *mimicry*, George Bataille's *informe*, Sigmund Freud's *uncanny*, Jacques Lacan's *picture* and Roland Barthes's *punctum*. This conceptual ensemble pertains to a precise theoretical constellation that cuts across the historical lineage of a certain notion of photography, from the Surrealists to Barthes's *La Chambre Claire* and beyond.[4] It is the notion of photography as an event that creates

a "wound" for the subject who looks and her illusion of mastery, as Krauss under-
lines in reading Bellmer's staging of the "construction and dismemberment" of the
Poupées as "*tableaux vivants* of the figure of castration".[5] Thus Krauss ties Bellmer's
"connection of the doll, the wound, the double, the photograph" to Barthes's
punctum, as a way to define a general condition not only of Surrealist photography
but of photography as such: "[t]he automaton, the double of life who is death, is
a figure for the wound that every photograph has the power to deliver, for each
one is also a double and a death".[6] I am immensely indebted to this essay, and
my own early fascination with dolls and photography finds here its own origins
in this entanglement of the indexical trace with that *something* beyond pleasure,
"that combination of madness and love, released by the doll and by the essence of
photography".[7] This speaks of an affection for photography as the place where the
doubling of the analogue reveals the uncanny doubling of subjectivity, the subject's
split between (ideal) image and unconscious truth. But this is a condensed way to
say it, almost in the form of a riddle, before the discussion I propose in this chapter.
Our theoretical journey here will follow Krauss's argument in *Corpus Delicti* rather
closely, for this is a text I consider to be *the* foundational reading for the traditional
association between dolls and the photographic image via the notion of doubling as
uncanny "wound". I will then move on, adding in the second part of the chapter a
few considerations that will open Krauss's reading to the possibility of its own obso-
lescence, vis à vis the contemporary visual forms of the human double explored in
the following chapters.

Dolls, mimicry and "subjective detumescence"

To unravel the theoretical associations implied in this brief preamble, it might be
helpful to introduce the original Latin and Greek words for "doll", *pūpa* and *kóre*.
These terms refer to the toy doll and, at the same time, to a young woman and to
the miniaturised image of the onlooker reflected in another's pupil in a situation of
reciprocal gaze. As philologist Maurizio Bettini underlined, by doubling the fea-
tures of a young woman, the *pūpa* is an icon but also, for its ability to denote features
like sound, mobility and a double surface – the naked and dressed body – an object
that exceeds the limits of representation to approximate the living nature of its ref-
erent, touching on the limit with personhood.[8] The doll's movable limbs stimulate
manipulability, that is to say the interaction of play, turning it into a performative
object. At the core of my interest in this book on the contemporary photographic
forms of the double lays precisely a semiotic question on the interference between
the level of representation and that of the performative and how this is articulated
in the contemporary moment. In this context, the doll becomes an object worthy
of philosophical speculation for the peculiar semiotic status that characterises it,
that of a hybrid simulacrum – as semiotician Juri Lotman already noticed, one is
invited to play with a doll, as opposed to the contemplation required by a statue.[9]
Bettini has underlined how it is the doll's structural peculiarity – whereby it can
be manoeuvred, dressed, undressed and styled – that is at the foundation of this

semiotic liminality, which turns the doll into a thing existing at the verge between object and image, between the mobility of a living person and the fixity of a simulacrum. In being performed, the doll exceeds its iconic immobility to approximate the living nature of its referent.

As an inanimate double of the human figure, the doll needs the projection of a player to be "animated" through the workings of fantasy. This points to the performative dimension of the doll, which leads to games of make-believe, of made-up worlds in which ordinary reality's usual coordinates are deconstructed and constructed anew. Speaking of dolls thus means speaking of make-believe's opening to doubling and projection, of a space *in between* self and other, a dynamic of reflection in the eyes of the other, which is already suggested in the etymology of *pūpa*-pupil. In his anthropologically oriented theory of play, Roger Caillois famously included the game of the doll within the category of *mimicry*, together with games of illusion, travesty and the broader field of the performing arts. In the case of dolls, there are no rules as such, Caillois observes, except for the will to believe in a fiction.[10] In playing with dolls, the "chief attraction" rests in "the pleasure of playing a role, of acting *as if* one were someone or something else".[11]

This opening to doubling, fantasy and make-believe, and more broadly to semiotic liminality and the performative, is a central aspect that makes of the doll a paradigmatic object attuned to our time's fascination and saturation with simulations and traditionally adopted by artists as a device to explore the boundaries between ordinary reality and fantasy. The dynamics of fantasy and play connected to the doll proved to be central for the historical avant-gardes in their attempt to dismantle naturalism in literature, theatre and the visual arts, and in the possibility of critical deconstruction of the automaton and the mannequin, icons of the mechanisation and commodification of experience at work in the period.[12] Through the doll's structure of mimicry and play, a text could be opened beyond the level of representation to imply something more than what was represented, to include the primary process, the viewer's projections and efforts of completion as well as extra-artistic spheres of image making.

In particular, the doll's implication with semiotic blurring has turned this object into an *associate* of the photographic medium, whose own semiotic *indecisiveness* has animated the discussions on the medium's relations to the fine arts since its origins. At a basic, pragmatic level, taken in their social use and materiality, photographs can be considered, like dolls, very peculiar things whereby the boundaries between image, persons and objects overlap. Even in our current ultra-digitised world, dominated by the incorporeality of cloud storage, a vernacular family photograph still inspires this affection, which is ultimately an affection for what in the photograph is *more than image*, what in it is trace. From a semiotic point of view, this is photography's implication with indexicality, its relation of continuity with the referent. On the fact that "someone has seen the referent", that something ought to be in front of the lens to be captured, Barthes famously based the *noeme* of photography as *ça a été, that has been*.[13] This principle translates the documentary value traditionally attributed to the photographic image and its fundamental

entanglement with presence and time – the mortality of "the absolute past of the pose", that which nails the subject to a death which is at once going to *be* and has already *been*.[14] As Margaret Iversen put it, with photography we are faced "with *past* presence, which is to say, the hollowed-out presence of an absence".[15]

This proximity to the referent has historically marked the medium's conceptuality, which has complicated the consideration of its artistic status within the context of a traditional definition of art as interpretation and *techne*, manual intervention. As an index, the photographic analogue presents the paradox of a "message without a code", a message for which an interpretative code is not needed since the referent is presented in its integrity, without the "transformation" involved in the other semiotic categories identified by Charles Sanders Peirce, the icon and the symbol.[16] Due to this principle of analogy, photography has historically been accused of being "unable to lie", which is to say, unable to transfigure ordinary reality, in opposition to a conception of art as an intentional cultural act, as cultivation, manipulation of ordinary reality – and of a notion of the artist as "author-God" in full control of the executional *mise en forme*. Since Charles Baudelaire's famous abjuration of photography at the 1859 *Salon*, accusations of "excessive realism" and lack of authorial intervention have been the crux of photography in its attempt to achieve artistic status. In the 1930s, Walter Benjamin, speaking of the existence of a hard, residual kernel intrinsic to the photographic image, further delineated the idea that what "in the effigy is still real" might limit the author's control and her attempt to give form.[17] However, it would be precisely photography's mechanical nature to be valorised by the historical avant-gardes as an opening to the realm of chance and contingency, and thus as a means to oppose historical Pictorialism's efforts to affirm photography's artistic value through a focus on iconic power.[18] Within this context, the presence of dolls and other human doubles in 1920s and 1930s avant-garde photography similarly foregrounded a notion of art as a sphere implicated with fantasy and the unconscious, with what is beyond image, what is *more than* image. Particularly within Surrealism, the photographic forms of the doll become the emblem for a kind of representation which bears its efficacy from a strict connection with life and the unconscious, with what is brought into the picture by the beholder's associations.

A foundational Surrealist text in this sense is Roger Caillois's *Mimicry and Legendary Psychasthenia*, published in *Minotaure* in 1935. Krauss's analogy in *Corpus Delicti* between the doll and photography is predicated on the theoretical alignment of Caillois's notion of *mimicry* with the Bataillan *informe* and the Freudian *uncanny*. At the foundation of her argument, Krauss charts a double analysis of Surrealist photography, following the Freudian reading of the double as connected, on one side, to primary narcissism and, on the other, to the castration complex. The first is seen to run through Surrealist photography as a practice preoccupied with blurring boundaries and showing a subject "invaded by space", while the second is seen to emerge as a photographic practice eager to puncture the viewer with anxiety, through the image of "what one fears".[19] Raoul Ubac's *Mannequin d'André Masson*, a photograph of the head of the mannequin presented by André Masson

at the 1938 *Exposition Internationale du Surréalisme*, and Bellmer's *Poupées* appear in Krauss's text as instances of the first and the second type of the Freudian uncanny respectively. In *Mannequin*, the Surrealist theme of the woman-mantis is signified through the cage, a cautionary measure that suggests female voracity, evidenced by the directness of the figure's look, which Ubac emphasises in its penetrating capacity by fixing it centrally in the camera. For Krauss, this is the image of a subject that "possesses" while being "simultaneously possessed by the mesh of space", connecting this double bind to the sense Caillois gives to animal mimetism as an organism's "assimilation to the surroundings", a psychotic-like "temptation by space", namely, a pathological "disturbance in the perception of space", whereby the subject–insect "no longer knows where to place itself".[20] In Caillois's formulation, simulation becomes a version of *legendary psychasthenia*, that psychiatrist Pierre Janet theorised in the terms of a disturbance of the relationship between personality and space. In late nineteenth-century psychiatric theory, psychasthenia defined "a drop in the level of psychic energy, a kind of subjective detumescence, a loss of ego substance", of self-possession in relation to the environment.[21] Reworking this concept, Caillois defined mimicry as "depersonalisation by assimilation to space", expression of a "decline in the feeling of personality and life", in which "life takes a step backwards", which is observable in both the animal kingdom and in human psychology.[22] For Caillois, "there remains in the 'primitive'" – with which he means the insects – "an overwhelming tendency to imitate, combined with a belief in the efficacy of this imitation, a tendency still quite strong in 'civilised' man".[23] These are terms which we cannot fail to recognise in their proximity to Freud's later theory of the regressive tendency of the drives. In his 1920 *Beyond the Pleasure Principle*, Freud had described the *death drive* as the ultimate instinct of life, one headed to the restoration of "an earlier state of things, which the living entity has been obliged to abandon under the pressure of external disturbing forces", and "to which it is striving to return".[24] These are fundamental theoretical points of reference for the main argument in this book since what the following case studies will show is how the contemporary double and its plays of simulation can in fact be found very far from this classical framework and its traditional binary opposition between psychosis and neurosis. Through its association with psychosis, twentieth-century mimicry points to a collapse of the distinction between subject and its surroundings: the subject is assimilated to the environment as its double. Mimicry is here a matter of fusion between subject and space, a failure of separation, a melting of boundaries.[25] In this sense, Caillois's mimicry resonates with the Bataillan notion of the *informe*, a "device" whose task is "to undo formal categories, to deny that each thing has its 'proper' form, to imagine meaning as gone shapeless".[26] For Krauss, Ubac's association between the mannequin, feminine sexuality and photography around the issue of the inscription of space on the body is a primary example of photography of the *informe*, with doubling as a version of a "disarticulation of the self", and the image as the sphere of such dispossession.[27] In Ubac's analogue, the subject is mirrored and invaded by space, while the viewer is also *viewed* by the penetrating look of the woman-doll-mantis as in an infinite play of mirrors.

Caillois's connection of mimicry to the field of representation, which Lacan would develop in his 1964 seminar on the *gaze*, is the fundamental tenet sustaining Krauss's theoretical construction of Surrealist photography as *informe* and uncanny. Caillois underlines that "it is with represented space that the drama becomes clear: for the living being, the organism, is no longer the origin of the coordinates, but is one point among others; it is dispossessed of its privilege and, in the strongest sense of the term, no longer knows where to put itself".[28] We can see how these terms then recur and are developed in Lacan's theory of the *gaze*, described as "a point of annihilation" for the subject in the field of vision, the "field of the reduction of the subject", set against "the privileges of the consciousness", that is, the Ego.[29] The *gaze* is the point where the Freudian concept of the uncanny impinges on the Lacanian field, and as such is a central tenet of psychoanalytic aesthetics. While in *Corpus Delicti* we only find the imaginary and symbolic implications of the *gaze*, the Lacanian notion is fundamentally also connected to the Real of *objet a*, to lack.[30] While Krauss turns to Freud's uncanny to describe photography as the experience of a "shock mixed with the sudden appearance of fate", one could simply point to the *gaze* as an instance of the Real, of "lack expressed in the phenomenon of castration", as Lacan put it.[31]

Besides referring to the battery of images and representations ordered within discourse (Imaginary), and to the properly symbolic stance of "the presence of others as such" (Symbolic), the *gaze* also refers to a *hole* in the picture (Real).[32] In the Lacanian diagram, the subject is, firstly, the point from which the representation is mastered, as in the classical scheme of Albertian perspective, and then a picture herself, "photographed" from the "point of light" of the gaze (*Figure 1.1*).[33] If this *point of light* describes the field of the symbolic Other from which the subject is seen, it also indicates, as in the third figure in the diagram, the field of *objet a*. The entire Lacanian project, and of psychoanalysis as a whole, could

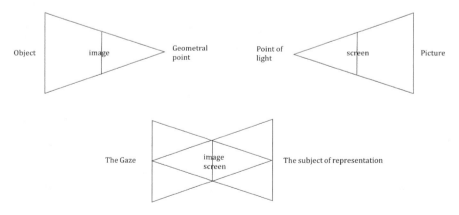

FIGURE 1.1 Lacan's diagram of the *gaze*, adapted from *Seminar XI*, "What is a Picture?" (1964).

be read in this diagram, around the position of *objet a* as a turning point for the articulation of the different orders of psychic experience. In this structure, which Lacan will later correspond to the *discourse of the master*, *objet a* is the leftover of symbolic alienation. The signifier's coming into play in symbolic alienation implies the imposition of a "distance between jouissance and the body", the restriction of "absolute jouissance", meaning a loss for the subject but one that simultaneously creates the possibility of her access to the "inverse scale of the Law of desire", to the *plus-de-jouir (surplus jouissance)* of *objet a*.[34] The subject is thus socialised through the lack instituted by desire, for she will be directed towards the Other of social relationships to search for that missing *x* forever haunting her. On the human misery of lack, fantasy is instituted as an impossible *mise en scène* of the recollection of the object, of a possible sense of wholeness for the split subject. It follows that visuality in the Lacanian sense is in a fundamental relationship with this dimension of *objet a* as lack. The relation of the subject to the *image-screen* in the final dihedron of the diagram is thus also explicative of the dynamics that Lacan had earlier described through the model of the mirror. From the 1930s to the 1950s, the model of the mirror explained a process whereby the subject is seen to be constituted in their identity through an external, precedent image, made available and ratified by the (gaze of the) Other.[35] Here, we can clearly hear the echo of Caillois's notion of an essential "tendency to imitate". What Lacan makes clear is that, ultimately, the image, albeit illusive and alienating – cause of *méconnaissance* – has a prophylactic value, for it affords the subject a sense of stability against (Real) inadequacy. As such, the image is essential for the subject to be able to take a place in the world. We similarly can see in the diagram of the *gaze* the *image-screen* imbued with a *bullet-proof* quality, as it were. It is an instance of the battery of signifiers available to the subject for her Other-directed *masquerade*, which is functioning as a mediatory layer between the *gaze* and the subject, enabling the latter to be in the world without being totally caught and dissolved in the Real.[36] In brief, we may say that the *image-screen* is in a necessary relation to the Real and at the same time a screen from it.

From a Lacanian point of view, images define their status precisely in their relationship to this dimension. A *picture* is for Lacan "a trap for the gaze", where in contrast to the field of representation "there is something whose absence can always be observed", a "central field" that "cannot but be absent and replaced by a hole".[37] In the picture, the subject can take interest in her own split, an interest in "some self-mutilation", that is to say in *objet a*, which is another way to say the annihilation of the subject in an experience of death that Freud describes in relation to the uncanny.[38] The Freudian uncanny is the Lacanian *extime*, what "join[s] the intimate to the radical exteriority", what the early Lacan would call "the Thing", at once "the primordial real which suffers the signifier" – the "mythical mother's body" – and "the signifier" itself in its fundamental "emptiness".[39] The uncanny is the emergence of *objet a* into the field of vision.

In *Corpus Delicti*, however, Krauss leaves the theory of the *gaze* to turn to Freud's notion of the uncanny the moment she aims to describe Ubac's use of mimicry and

its blurring of boundaries between figure and space, image and viewer. Mimicry is seen here as uncanny for its ability to point to a realm in which things, images and persons are not distinguished, to that "earlier states of being" that Freud ascribes to primary narcissism:

> The collapse of the distinction between imagination and reality – an effect devoutly wished by surrealism, but one which Freud analyzes as the primitive belief in magic – animism, narcissistic omnipotence, all are potential triggers of that metaphysical shudder which is the uncanny. For they represent the breakthrough into consciousness of earlier states of being, and in this break-through, itself the evidence of a compulsion to repeat, the subject is stabbed, wounded by the experience of death.[40]

Surrealism's *convulsive beauty* is a form of the uncanny return of surpassed narcissistic beliefs, and as such an "experience of death", a disruption of the subject's self-possession. Within this framework, the doll and the photographic image are aligned with the uncanny for their shared ability to impinge on this narcissistic dimension. As founded on doubling, they both concur in Surrealism towards the creation of a world in which boundaries between the animate and the inanimate, imagination and reality, self and other, subject and object are blurred. As is well known, Freud tied the uncanny to the emergence of "remnants" of an archaic "phase" of the human subject, "when the Ego had not yet marked itself off sharply from the external world and from other people".[41] The Surrealist use of dolls and mannequins in photography, as Krauss points out, was aimed at conjuring the manifestation of the double in this ghostly capacity, as "harbinger of death",[42] that is to say the death of the subject of consciousness as an effect of the emergence of a "primitive" "animistic conception" that Freud saw to be characterising the ontogenetic and phylogenetic origins of the human subject.[43] Following Otto Rank, Freud considered the projection of "spirits of human beings" over the environment, perceived as incomprehensible and hostile, as a way to guarantee to the "primitive man" and the child a control over it.[44] "[E]verything which now strikes us as 'uncanny'", Freud wrote, "fulfils the condition of stirring those vestiges of animistic mental activity within us and bringing them to expression".[45] Once a *prosthesis* of the I, the double returns for the adult – the "castrated" and "civilised" man described by Freud – as an *unheimlich* menace.

If Ubac's image of the mannequin conjures mimicry as an uncanny loss of *Ego substance* for its connection to primary narcissism, Krauss describes Bellmer's dolls, with their foregrounding of dismemberment and duplication, as an instance of the uncanny *qua* effect of castration anxiety. For Krauss, Bellmer's obsessive staging and repetition of the same, the opacity of the image and the phallic character of the doll are all elements that conjure the experience of the primary processes of dream and fantasy and their strategy of doubling, as a paradoxical defence against castration through the multiplication of symbols of castration. Dolls and doubles here are not only concerned with narcissistic liminality – the *informe* as dismissal

of categories – but closely saturated with loss. This is where the photographic uncanny is aligned to Barthes's *punctum*: the image becomes a wound in its staging, repeating and advancing the experience of a loss.[46] Between the two poles presented by Ubac and Bellmer, the Surrealist doll appears then to sit *on*, *before* and *beyond* a moment of loss, inherent to the presence and absence of the object, between primary narcissism and castration. Fundamentally, the doll in this tradition stands as the impossible presence of the object before its loss, as a fetish erected against the inexorability of loss and as a substitute for the lost object.

Loss is indeed central in the modern phenomenology of the doll and its plays of doubling. It is that which is lost that returns to haunt the subject, as Freud underlined in his definition of the uncanny as "something which is familiar and old established in the mind and which has become alienated from it only through the process of repression".[47] This is a fundamental point in the theory, and he insisted on it later, stating how "repression . . . is necessary if the primitive is to return as something uncanny".[48] In his analysis of E.T.A. Hoffmann's *Der Sandmann*, Freud sees the female automaton Olympia as an instance of castration in presenting an image of dismemberment – the doll being dismembered and Nathaniel himself being assembled and disassembled like a doll – as a "castration equivalent", analogous to the fear of being stripped of the eyes.[49] Commenting on Nathaniel's relationship with Olympia, Freud connects the anxiety related to a lack of physical integration – the loss of the eyes, the body in pieces – to a male fixation to the castration complex, a lack of resolution of the Oedipus complex. The doll in this account is considered "a dissociated complex of Nathaniel's which confronts him as a person", a figure of the male subject's fixation to the father that renders him "incapable of loving a woman".[50] The doll therefore becomes a *trait d'union* in the association between narcissism, psychosis and homosexuality that Otto Rank had already proposed in his study on the double, and to which Freud referred, speaking of the double as a "rival in sexual love", a figure of "narcissistic self-love".[51]

The Freudian association of the dismembered doll to castration is based on the relevance of an image of *pieces* being *cut out* from the body, as imaginary translation of that foundational moment of subjectivisation based on the concept of an originary loss, demanded from the subject in order to enter discourse. As we have seen, this becomes a symbolic *coupure* in the Lacanian account, which similarly develops in both sexes. It can then be said that to speak about the uncanny, of surpassed and repressed beliefs around the issue of symbolic alienation, is ultimately to speak about *jouissance* and the loss that the subject is called to endure to enter the social bond. Within this framework, the love for the doll – and for other forms of the human double, more broadly – a Romantic *topos* that becomes a photographic emblem with Surrealism, embodies an attempt to evade the imperative of symbolic alienation – the object becomes present, is not lost – one that brings the subject to indifferentiation, where distinctions between human and non-human, self and other, interior and exterior, masculine and feminine, are obliterated. In Hoffmann's tale, this destiny is in proper names: in gaining Olympia – we might think of the *Olympus*, the abode of the gods – Nathaniel loses Clara, a world of

clarity, of a coherent reality, one wherein reigns castration, psychic boundaries and sexual difference. The subject is pierced by anxiety for the sudden appearance of the object – anxiety signals that "lack is lacking", as Lacan put it – an event that shutters ordinary reality and signifies death as the subject's disappearance in an all-encompassing *jouissance*.[52]

For these associations with narcissism and the question of sexual difference, the love for the doll is also a trope employed by the Surrealists in relation to the subversive articulation of non-normative desire.[53] Subversion is an essential attribute of *jouissance* in this cultural context, and the modern double embodies such a conjunction. As Foster put it, Bellmer's dolls instance "a *jouissance* that defies the phallic privilege of the paternal", for they are figures of an "incestuous transgression" with which to identify, a "disavowal of [the father's] genital monopoly and a challenge to his preemptive law".[54] For Therese Lichtenstein, similarly, the sexual androgyny of Bellmer's dolls reflects a "reversion to the preoedipal phase", a "merging with the mother" as a way to stage a struggle against the "paternal law".[55] As an instance of a "fragmentary, fluid, feminine" self, the doll in the Surrealist tradition is thus a device to contest dominant discursive constructions of gender, sexuality and citizenship and of masculinity as "fascist armour'".[56] A figure emerging now in the guise of the maternal *Thing* – of an object recaptured narcissistically – now in relation to a frightening father-*jouissance*, the doll in this tradition fundamentally appears as a cypher of *jouissance*, as what is opposed to the law of prohibition. An instance of death for the Ego, a disturbance of sexual love and of heterosexuality, dolls and doubles in modernity are objects in the presence of which the subject of consciousness is annihilated. Bellmer's famous self-portrait as a ghost beside his doll in 1934 is possibly the most eloquent incarnation of this uncanny valence – the doll, the man: an either/or relationship, with the photographic analogue as the impossible *trait d'union*.[57]

The association that Foster and Lichtenstein draw between the doll and the maternal is a fundamental aspect of nineteenth- and early twentieth-century culture, particularly relevant where the doll is evoked through the moods of nostalgia and mourning. There is a dimension of decadent morbidity in the works considered by Krauss in *Corpus Delicti* that might be further understood through some associations with the broader cultural history of dolls and to other seminal literary texts preoccupied, in the same period, with these figures. This will lead us to consider the historical discursivity of *jouissance* and its modern form, before looking at a different theoretical framework able to assist us in the analysis of the contemporary forms of the double in the following chapters.

Pūpa as *puppa*: the doll as a maternal Thing

The association of the doll with the maternal can be considered a typical Romantic *topos*, often played in the terms of a nostalgia for lost mythical origins, as in Victor Hugo's *Les Misérables* (1861). Hugo's story on the doll of Cosette is one of the first literary occurrences in modernity where the play doll is imbued with some

psychological complexity. Here the doll emerges as an ideal image of wholeness, a signifier of a loving and caring Other and a physical presence able to comfort the child. The doll appears, initially, as a chimera of plenitude and splendour behind the glass of a shop window, a vision of paradise, in contrast with the real experience of the child, Euphrasie, nicknamed Cosette, who lives in fear and neglect, exploited by her custodians with whom the mother Fantine had been forced to leave her.[58] The doll arrives in this story as a gift from the protagonist Jean Valjean, a man sent by the mother before her death. It becomes thus a sign of presence, of an Other who, at the apex of the child's absolute helplessness, appears to answer her cry and translate it into a demand – a demand for love. For toy historian Michel Manson, who has written extensively on the cultural history of dolls, Valjean's gift of the magnificent doll to Cosette is the event of the protagonist's birth as a father.[59] However, one could argue that the role of the man in the narrative development appears more attuned to that of an original Other of hospitality, which is to say, a (m)Other. The man's investiture deriving from the child's mother and his logical function in the narrative as the agency of a foundational "symbolic adoption of life" approximate the maternal Other's function of introducing a subject's "bare life" to the "sentiment of life".[60] Within this relationship, the doll signifies a promise of presence which initiates the subject to the experience of being seen, of an acquired visibility in the field of the Other. By describing, finally, the way the child cuddles and treats her doll, bringing it to bed with her, Hugo also highlights the doll's role in terms of physical affection, pointing to yet another nuance of the maternal character of the doll. As a material thing to cuddle, the doll is reminiscent of – and a substitute for – the child's union with the lost body of the (biological) mother. We can see this proximity between the doll and the maternal body exposed in the Latin etymology, whereby *pūpa* maintains a relation to *puppa* and *poppea*, derivatives of *puppus*, female breast.[61] This gives the sense of a tactile embrace, of warmth and softness afforded by the doll as a libidinal object, an aspect valorised in post-Freudian psychoanalysis, as in Donald Winnicott's theory of the *transitional object*.[62]

Hugo's text is significant within a cultural history of dolls, chiefly because this literary association of the doll with maternal origins is based on a cultural recuperation of the anthropological and historical complexity of this object. The tropes of the poor orphan girl and the gift of a doll found in Hugo connect high culture to the folk tradition, specifically to the tale of the biting doll, in turn connected to the cultural history of Classical antiquity. In the folk tradition, the doll is a magic object originating from a maternal figure able to comfort a female child, to free her from a condition of misery and to create the premise for her final marriage to a powerful man, which marks the conclusive point at which the doll, typically, disappears.[63] As underlined by Michel Manson, Hugo's story marks a fundamental turning point in nineteenth-century literature, since it connects the aesthetic use of the doll to its cultural-historical function within classical antiquity's rituals of passage, preserved in folk stories within the sphere of magic.

In the fairy tale, the doll must be inherited and finally lost in order for the young woman to realise her marriage and sexual "maturation". In this sense, the doll is

a figure of mediation – a vanishing mediator, we could say – the support of a dia-lectic progress in the subjective path of sexual development. In this dynamic, one can find the ritualistic aspect of the doll of the Classical period, that of an object of play that also pertained to the sphere of the sacred, being dedicated to the altar of Aphrodite-Venus by young maidens at the eve of their marriage.[64] In this context, the *pūpa* is at the centre of a rite of separation that dramatised the detachment of the woman-to-be from her childhood self and pastimes. The doll mediates the offer of a virgin to a virgin – from the child to the goddess – and as such is a sig-nifier of female virginity, an object found in the tombs of female children as well as adult virgins. Bettini has underlined how the doll is found in these tombs not only as an object of the virgins' in-life personal equipment but as a proper "virginal equivalent", a double of the living virgin:

> [t]hus consecrated to the goddess, the *pūpa* or *kóre* becomes the simulacrum of a time (and a person) which once existed but that has irremediably gone. . . . The *pūpa* is now the simulacrum of an absence – the virgin has disappeared, the doll is transformed into a *kolossós* . . . , the rigid equivalent of a physical and cultural age irremediably lost. . . . Now one discovers that its eyes were desperately blank and melancholic.[65]

Bettini compares the doll to the *kolossós* as a sign imbued with the impossible task of giving form to absence, to signify absence as the effect of a loss.[66] Jean-Pierre Vernant famously described the *kolossós* within the context of ancient Greek funer-ary rituals and oath-binding ceremonies, as an "idol" used to fix and evoke the *psūkhē* – the immortal soul of the dead – in a material form.[67] The *kolossós* fixes the double of the dead to one place, "relegating him forever to his underground resting place" in an attempt to defuse its persecutory power, while simultaneously manifesting the dead to the living as a "peculiar and ambiguous presence that is, at the same time, a sign of absence".[68] Giving a psychoanalytic turn to Bettini's definition, the doll, as a *virginal equivalent*, can be then considered the *kolossós* of the virgin as an object full of the past, a dimension of absence retroactively created through the mark of a loss.

Hugo's doll, however, is all comfort, care and narcissistic reassurance, untouched by any uncanny disturbance. Everything is realised on the level of a heartening, cosy maternal dimension that ultimately positions the doll, and the world of child-hood, on a mythical register – Romanticism's child as innocent, free from social conventions, closer to nature and to the world of imagination and so forth. We have to turn to Charles Baudelaire to find a more perplexing figure of the child with toy, one that loses its seraphic innocence to approximate what Freud would later describe as the "polymorphous perverse" "aptitude" of childhood.[69] Whereas Hugo's appropriation of the tale of the biting doll shows the period's recuperation of cultural and psychological complexity for the doll, in speaking more broadly about toys, in his influential 1853 essay *Morale du joujou*, Baudelaire outlined a series of links between toys and libidinal enjoyment that would be central to Surrealism's

association of the doll with a "pre-Oedipal" *jouissance*.[70] The subversive cultural potential that Surrealists – as well as Dadaists – would later attach to this figure is ultimately based on the association between art, child's play and the realm of the irrational, of freedom and loss of control, as opposed to the rationalism of the dominant *bourgeoisie*. We find precisely such a link in Baudelaire's eclectic text. The "barbaric simplicity" of the means of child's play is here a metaphor for beauty *tout court* – later described as the realm of the "naively bizarre", the "involuntary, unconscious".[71] He spoke of the child's relationship to toys to underline the "poetry" of childhood as *terminus a quo* of the "imaginative impotence" of "our blasé public": the child with a toy is a figure of a sensual and aesthetic experience, set against the sterility of the "class of ultra-reasonable and anti-poetic people", that is the *bourgeoisie*.[72] However, there is more in this text, suggested between the lines:

> [t]he facility for gratifying [*contenter*] one's imagination is evidence of the spirituality of childhood in its artistic conceptions. The toy [*joujou*] is the child's earliest initiation into art, or rather it is for him the first realisation; and when maturity intervenes, the most accomplished realisations will not give his mind the same warmth [*chaleurs*], the same enthusiasm, nor the same belief [*croyance*].[73]

Morale du joujou emerges as a disquisition on aesthetic enjoyment and a statement on enjoyment *tout court*, if we consider the abundance of terms characterised by a strong erotic charge, such as, in this passage, "contenter" and "chaleurs", the latter being highly ambiguous for its double meaning as "enthusiasm" and "sexual excitement". It is to be noted that *joujou* is ill-translated into the English "toy", for *joujou* is a diminutive, a word based on the repetition of the same syllable typical of infantile speech, of children's lallation prior to a full mastery of language. A child with his *joujou* is the figure of a satisfaction that for the adult is irretrievable but of which the toy, nevertheless, remains the sign and as such becomes the archetype of the artwork.

That the *joujou* is a libidinal object is shown in the opening of the essay, through the remarkable, supposedly personal memory of Mme Panckoucke, a lady in "velvet and fur", whose offer to take a "souvenir of her" from her sumptuous "treasure" of toys clearly appears as an encounter with *jouissance*.[74] Baudelaire described it as a moment in which "desire, deliberation and action are so to speak compacted into a single faculty", that is, a moment of disinhibition, "admirable" in children.[75] The text is punctuated with the word "desir", and it is indeed a phenomenology of desire that Baudelaire seemed to offer in this text through a varied series of children with their toys. We can read the scene with Mme Panckoucke as a veritable original fantasy, one describing the metonymy of desire, where the toy stands for the lady in velvet and fur, a reading suggested by Baudelaire himself when he referred to this event as to the "cause" of his adult "abiding affection" for colourful and bizarrely shaped toys, in which he recognises the value of a "statuaire singulière" (peculiar statuary).[76] Baudelaire's phenomenology concluded with the "mania" of

children who break toys, under the force of a "metaphysical stirring" – "they want to see the soul of their toys" – which finally ends in frustration, "stupor and melancholy" at the discovery of the toy's lack of soul.[77]

This moment of despair on which Baudelaire's text finds its end, almost abruptly, is then ideally resumed as a starting point by Rainer Maria Rilke's melancholic essay *On the Wax Dolls of Lotte Pritzel* (1913). More than in Baudelaire, the relationship with the toy is underpinned in Rilke by an experience of loss and mourning, closely bordering on the Freudian description of the death drive. Pritzel's emaciated and sensual miniature dolls, well known in the 1910s and 1920s German avant-garde circles, are seen by Rilke as images of Eros as Thanatos.[78] "[S]exless like our childhood dolls", they are an image of a "permanent sensuality, into which nothing flows and from which nothing escapes", Rilke writes, a formulation that we may see echoing Freud's definition of *nirvana* as a state of plenitude and nothingness, alien to excitation.[79] Rilke's doll inhabits a childhood marked by loneliness, between misery and affection – "silence", "border", "hollowness", "death", "abyss" are all words Rilke used to describe the world shared by the doll and the child.[80] The figure of the doll emerges here as a cypher of the attraction for an Eros bordering on self-annihilation, for its proximity is a primeval confrontation with the "border" of existence, the border between the Ego and "the amorphous world pouring into us".[81] Here we find another specification of the frustration that Baudelaire described as the disappointment of the investment in the "soul" of the toy: the doll, "would almost enrage us by its horrible dense forgetfulness", Rilke wrote, "and the hatred which must always have been an unconscious part of our connection with it would burst to the surface".[82] Hence, the doll is, on one side, able to stimulate the creation of "twofold inspirations" in the dimension of play, with the child "split" into "opposing parts", playing the self and the other, to compensate for the doll's being "devoid of imagination".[83] On the other side, the doll is guilty for not being responsive enough to the child's affective investment – "stolid" and "mute", the doll is a "monster", indifferent to the "riches" of the child's affection.[84] In this ambivalence towards the doll we can certainly read, from a psychoanalytic point of view, the ambivalence towards the primordial Other. We have seen the doll at once being a vision of "paradise" in Hugo, a figure of "abiding affection" in Baudelaire and of "horrible dense forgetfulness" and hatred in Rilke.[85] From the texts and cultural traditions that we have briefly recounted here, the doll emerges as the battleground where the first articulations of absence and presence are played out. It is the first image of a world which does not give "reassuring answers", in this sense *like* and *unlike* the m(O)ther, this Janus-faced Other, at once the Other of care and presence and the Other of absence, of the most primordial lack.[86]

This connection between narcissism, the death drive and the maternal found in the period's cultural imagery is paramount in understanding the centrality of the figure of the doll and the valence of doubling in Surrealism. A very early text by Lacan, whose proximity to the group is well known, may serve here to link this cultural history of the doll to the psychoanalytically-oriented Surrealist deployment

of it.[87] In his 1938 *The Family Complexes*, Lacan writes of the *maternal imago* as an "unconscious representation" of the weaning complex, which "fixes the feeding relationship in the psyche in the parasitic form that the needs of the human infant being demand".[88] Being "entirely dominated by cultural factors", Lacan argues, weaning is "often a psychic trauma", leaving in the psyche a "permanent trace".[89] The breast-feeding mother–child relationship is seen to be characterised by "cannibalism": with the breast, "the being who absorbs is completely absorbed" in a "cannibalistic" oral fusion, he writes, "at once active and passive".[90] This longing for fusion "still survives in games and in symbolic words and . . . in the most highly developed love recalls the desire of the larva".[91] Even once sublimated, Lacan adds, the *maternal imago* maintains a central place "in the depths of the psyche" and in culture at large: the "most abstract form in which it is found" can be defined as "a perfect assimilation of totality to being", a "nostalgia for wholeness", in which "will be recognised the nostalgias of humanity".[92] In this concept of *larval desire*, we find another possible reference to supplement the associations that we have seen at work in the Surrealist photographic instances of the doll after its alignment with *mimicry*, the *informe*, the *picture*, the *uncanny* and the *punctum*. The nostalgic *larval desire* of this Lacanian description of the breast further exposes the decadent, regressive edge of the artistic uses of the figure of the doll between the nineteenth and twentieth centuries. The question "why is it a woman who embodies most fully the paradoxical combination of pleasure and anguish that characterises transgression?" in twentieth-century avant-garde art may find an answer here.[93] It is the body of a very specific woman that is the locus of that ambivalence, that is the body of the (m)Other, whose enjoyment by the child is affected by the desire of the woman, being ultimately dependent on it for its presence or absence.[94] Where once was the mother, there is the doll: a child playing with the doll is an effect of the mother's choice to create the possibility of her own absence.

Significantly, Lacan's text on the *maternal imago* ties libidinal suppression to the figure of the maternal Other, offering a psychoanalytical rationale for the cultural tradition of the *pūpa* as a female ritualistic object signifying a foundational moment of loss. In this text, Lacan takes issue with Freud's castration complex, affirming that the "prototype of oedipal suppression" lies further back, in the loss of the breast during the weaning process.[95] For Lacan, it is the mother's "refusal of weaning" that gives to the weaning complex its critical importance, as the crisis from which a first dialectical moment is instituted in play, in which the subject "assumes the reproduction of this misery [of weaning] and in that way sublimates and overcomes it".[96] It is from the loss of the maternal object that the faculty of hallucinating what is lacking, in other words, the symbol, arises. To play is to play with the symbol, that is to say creatively treating the "unpleasurable" experience of loss, as Freud had put it upon observing his nephew Ernst's game of the *fort-da*.[97] Staging the coming and going of the mother through a game of disappearance and return, Freud saw the child as dramatising his "great cultural achievement", "the renunciation of instinctual satisfaction".[98] If one of the feminist objections to psychoanalysis is the exclusion of women from the process of symbolisation, in this early Lacanian text

we find the nucleus of the suggestion that it is the maternal function – anticipating that which Lacan would later call the *paternal metaphor* – to create the first conditions for that fundamental absence on which the child can institute her access to the Symbolic.[99] In the "refusal of weaning" we may see the fundamental role of the desire of the mother, of the woman beyond the mother, as an essential element for the installation of the subject as lack of being.

For Lacanian psychoanalysis, it is the relationship with the (m)Other and the loss of that mythical first satisfaction with the *Thing*, that creates the symbol, indeed permits the symbol, as the hallucination of satisfaction in fantasy. The psychic ambiguity of the figure of the doll is wholly dependent from this dialectic between a moment of presence of the object and one of absence, since the doll lives at the boundary that inaugurates the split of subjectivity and the access to fantasy, central to the process of creative sublimation as it has traditionally been defined. From a psychoanalytic point of view, in fantasy, as in play and art, the subject deals with a lack of object, hallucinating the possibility of inhabiting that lack. Crucially, for Lacan, the artistic object is an object raised to "the Dignity of the Thing", an object implicated with *jouissance* as lack.[100] It is precisely by inhabiting this liminal space defined by loss – as occupying the space *before*, *on* and *beyond* the fundamental loss – that the doll has traditionally found in culture its uncanny valence as well as its centrality within considerations on the artistic process.

However, as for everything in culture, there are not essences but only historically determined practices and constructs. Ultimately, the uncanny potential of the doll, and of doubling more broadly, rests on the historicity of the modern discontent of civilisation. In his Lacanian account of the notion of the uncanny, Mladen Dolar has underlined how the *unheimlich* irruption of the Real into ordinary reality depends on a precise historical intersection between object and discourse: *objet a* "is most intimately linked with and produced by the rise of modernity", not just as a leftover but as "a product of modernity, its counterpart".[101] Building on Dolar's suggestion, we should notice how, as a product of modernity, the uncanny is the effect of a discursive structure based on the restriction of *jouissance* through the alienating dynamics of the signifier – Lacan's *master's discourse*, as we saw in the introduction.[102] As recently underlined by Jacques-Alain Miller, "psychoanalysis was invented to respond to the discontent in civilization", which is the discontent of "a subject plunged into a civilization that can be stated like this: in order to give existence to the sexual relation, *jouissance* must be hampered, inhibited, repressed".[103] This is the loss of *jouissance* that we have seen to be at the foundation of the uncanny valence of the double and that has traditionally been the tenet for a psychoanalytic notion of the social bond, which, however, does not describe today's hypermodern discourse of civilisation.[104] *Objet a* has risen "to the social zenith", and from there it "prevails upon the disorientated subject", as Miller put it, "invit[ing] him to get past his inhibitions".[105] Today's discourse of civilisation is not opposite to the place of *jouissance*, like in the post-Victorian era, but coincides with it. The most basic claim of this book is that the muted aesthetic import of the contemporary figure of the double can be seen to reflect this anthropological

mutation, exposing *jouissance* as something assimilated to the dominant discourse, which thus emerges as antagonistic to lack and the uncanny.

The aesthetic qualities of the contemporary double, which will emerge from the formal analyses that follow, will expose how this is a different preoccupation from a possible "occlusion of the uncanny" due to a "generalised alienation" in the flattened surface of the simulacrum.[106] Affect is alive and well in hypermodernity, and it is precisely on an appraisal of its organised forms in the current discourse that the visual analyses in the following chapters will be based. By exploring the significance of the double in a discourse that promotes the liberation of *jouissance*, instead of its inhibition, we will face broader questions on the interconnection between subjects, images and *jouissance*, as well as an epistemological interrogation on new possible means to theorise it. For this enquiry, I will refer to the terms of the *capitalist's discourse*, which I shall develop in some detail in Chapter 2, following Lacan's indication, in the early 1970s, that this organisation may have replaced the *master's discourse*, as its contemporary variant.[107] With all the overlaps that are traditionally posited between the figures of the doll, doubling and *jouissance*, one cannot forgo the question of what happens to this association once the object of enjoyment is removed from its place of excess and subversion. An emblem of *jouissance* in its modernist form, the double can be traced back in contemporary visual culture as a figure revealing an epochal cultural shift, reflecting broader issues circling around the capitalist subject–object relationship, recent developments in photography and the role of the image in hypermodernity.

To return to the initial question posed at the beginning of the chapter in relation to Hal Foster's reading of the human replicas of the 1990s, there are few points to be considered to account for the ideas developed so far. The early 1990s marked a turning point in which old and new aesthetic and psychological paradigms collided, and it might be fruitful to briefly pause on this moment before moving on to consider our case studies in the following chapters. Following Krauss and her classical reading of Surrealist mannequins and dolls through the Freudian framework, Foster reads Cindy Sherman's 1992 disjointed mannequins in *Sex Pictures* as figures of the dissolution of the subject in the Real. Foster's whole account of post-1960s realism as *traumatic realism* can be traced back in the associations between mimicry and "subjective detumescence" that we have explored throughout this chapter. Completing that transition from the Freudian uncanny to the Lacanian theory of the *gaze* that Krauss started in 1985, Foster's *traumatic realism* is built on the Real dimension of the *gaze*. Sherman's fairy tale and disaster images of the late 1980s, with their focus on (simulated) organic waste and the blurring of figure and ground, are seen by Foster as a paradigmatic revelation of the *object-gaze*, "as if there were no scene to stage it, no frame of representation to contain it, no screen".[108] The artist's later introduction of artificial body parts and inanimate human replicas in place of her own body is then read in terms of substantial continuity with the previous work, as an effect of the erosion of the subject that, "invaded by the gaze", "only return[s] as disjunct doll".[109] This return to realism is, for Foster, a "thing of trauma", one that wants to "feed the gaze", as if it "*wanted the gaze to shine, the object to stand, the real to exist, in*

all the glory (or the horror) of its pulsatile desire, or at least to evoke this sublime condition".[110]
"To this end", Foster adds, this is an art that "moves not only to attack the image
but to tear at the screen, or to suggest that it is already torn".[111] Foster is well aware
that the Real of the *gaze* cannot be evoked as a positive presence but only as a nega-
tive magnitude of absence, as a hole in the representation, and yet his theorisation of
traumatic realism is based on a positive textualisation of the Real, on its imaginarisa-
tion in representation.[112] Playing with the imaginary of abjection will never expose
the Real as the intrinsic limit of the Symbolic. If one conceives the Real as what
"lies below", as what is repressed, as Foster maintains, then it can only be evoked in
a signifying formation, such as a work of art, as something beyond representation.[113]
Foster partly exposed the problem in relation to the question of the cultural-political
deployment of *abject art*, insinuating the doubt that the attempt to display the Real
might result in a mere voyeuristic representation of it.[114] Notwithstanding the rec-
ognition of the oxymoron, Foster does not seem to work through its consequences,
remaining bridled in what is a Surrealist critique of contemporary art, ultimately
founded on the Oedipal norm. There seems to be an essentialism at work in Foster's
argument that derives from a missed consideration of the historical discursivity of
the unconscious and the organisation of *jouissance*. On one side, Foster underlines
that the key for the appraisal of the possible subversive potential of a flaunting of
the Real lies in its relationship with the symbolic order. He notices that for there to
be a transgressive potential "the condition of image-screen and symbolic order is all
important", since if it is considered to be "intact", "the attack on the image-screen
might retain a transgressive value", otherwise, if considered "torn", "such trans-
gression might be beside the point, and this old vocation of the avant-garde might
be at an end."[115] However, this consideration is not brought to bear its theoretical
consequences and the contemporary crisis of the Symbolic is reduced to a "crisis of
the image-screen":

> [a]t one point, in *Powers of Horror*, Kristeva suggests that a cultural shift has
> occurred in recent decades. "In a world in which the Other has collapsed",
> she states enigmatically, the task of the artist is no longer to sublimate the
> abject but to plumb it – to fathom "the bottomless 'primacy' constituted by
> primal repression". . . . Kristeva implies that the paternal law that under-
> writes the social order has fallen into crisis. This suggests a crisis of the
> image-screen as well, and, as I intimated with Sherman, some artists of this
> period did attack it, while others, under the assumption that it was already
> torn, probed behind it as though to touch the real.[116]

Besides dismissing Kristeva's suggestion that the Symbolic might be suffering from
a structural inefficiency, this passage implies a rather automatic correspondence
between a crisis of the Symbolic and a crisis of the image-screen, which would
then give rise to the emergence of a "repressed" Real – an argument that is in fact
at the core of Foster's definition of *traumatic realism*, as we have seen.[117] Within this
notion, the human replicas in Sherman, Kelley and McCarthy's work are considered

expression of an art "in the service of the Real", with simulation holding the meaning it had for Caillois and the Surrealists in the 1930s: a loss of Ego boundaries as effect of the invasion of a deathly *jouissance*. The realism of the 1990s, like its Surrealist version, becomes the means for a transgressive liberation of *jouissance*, set against the strictures of paternal law. What I propose to consider, instead, starting with Olivier Rebufa's work in the following chapter, is how the return of the human double has come to be associated with very different aesthetic effects than via uncanny, abject, obscene or *informe* strategies. If there is continuity in the existence of an aesthetic and conceptual alliance between the double, photography and *jouissance*, the question will be to explore the mutated correspondences between these terms as they emerge in recent visual works and expose what these might reveal of our contemporary relationship with images, simulation and make-believe.

Notes

1 Foster, *The Return*, 152.
2 *ivi*, 134.
3 *ibidem*, emphasis in the original. See Roger Caillois, "Mimicry and Legendary Psychasthenia", trans. John Shepley, *October*, vol. 31 (Winter, 1984 [1939]), 16–32.
4 For a mobilisation of this legacy, see Margaret Iversen's most recent work, *Photography, Trace and Trauma* (Chicago: University of Chicago Press, 2017).
5 Krauss, *Bachelors*, 62.
6 Krauss, "Corpus Delicti", 72.
7 *Ibid.*
8 See Maurizio Bettini, *Il Ritratto dell'Amante* (Torino: Einaudi, 1992), 245–246, my translation from Italian.
9 See Jurj Lotman, "Le bambole nel sistema di cultura", in *Testo e contesto* (Roma-Bari: Laterza, 1980). See also Michel Manson, "La Poupée, Objet de Recherche Pluridisciplinare", *Histoire de l'Education*, no. 18 (April, 1983).
10 Roger Caillois, *Man, Play and Games* (Urbana: University of Illinois Press, 2001[1958]), 8.
11 *Ibid.*
12 See Foster, *Compulsive*, esp. "Exquisite Corpses", 125–153.
13 Barthes, *Camera*, 80.
14 *ivi*, 3.
15 Margaret Iversen, *Photography, Trace*, 6–7.
16 Roland Barthes, "Rhetoric of the Image", in *id.*, *Image, Music, Text* (New York: Hill and Wang: Noonday Press, 1988), 35.
17 Walter Benjamin, "A Short History of Photography" [1931], *Screen*, vol. 13, no. 1 (1 March 1972), 7.
18 See Rosalind Krauss, "Notes on the Index: Seventies Art in America", *October*, vol. 3 (Spring, 1977), 68–81; D. Costello, M. Iversen, and J. Snyder (eds.), "Agency and Automatism: Photography as Art since the Sixties", *Critical Enquiry*, vol. 4, no. 38 (Summer, 2012).
19 Krauss, "Corpus Delicti", 64.
20 *ivi*, 50; Caillois, "Mimicry", 27, 28.
21 Denis Hollier, "Mimesis and castration", transl. William Rodarmor, *October*, vol. 31 (Winter, 1984), p. 11.
22 Caillois, "Mimicry", 30.
23 *Ibid.*, 27.
24 Sigmund Freud, *Beyond The Pleasure Principle*, transl. J. Strachey (New York: Norton, 1959), 30, 32.

25 Caillois's essay indeed opens with a statement on the overarching problem of distinction as an essential phenomenon of ontological analysis.
26 Krauss, "Corpus Delicti", 39. See also Georges Bataille, "Informe", *Documents*, 7 (December, 1929), 382, in *Georges Bataille, Visions of Excess: Selected Writings 1927–1939*, ed. A. Stoekl (Minneapolis: University of Minnesota Press, 1985), 31.
27 Krauss, "Corpus Delicti", 55.
28 Caillois, "Mimicry", 9, also cited in Krauss, "Corpus Delicti", 50.
29 Lacan, *The Four Fundamental*, 82.
30 Accordingly, Krauss only reproduces the first two figures of the Lacanian diagram of the *gaze*. I interpret this omission as a result of Krauss's focus here on the schism of seeing-being seen implicit in the notion of the *gaze*, as suggested by a few phrases: "a mastery from without, imposed on the subject who is trapped in a cat's cradle of representation", "labyrinthine doubling", "play of reflections" and "seen from the vantage of another" (*ivi*, 53).
31 Krauss, "Corpus Delicti", 59; Lacan, *The Four Fundamental*, 84.
32 Lacan, *The Four Fundamental*, 84.
33 *ivi*, 94.
34 Lacan, *The Other Side*, 206, 91; *id.*, "The Subversion of the Subject and the Dialectic of Desire", in *id.*, *Ecrits: The First Complete Edition in English*, trans. B. Fink (New York and London: W.W. Norton, 2006), 700.
35 See Lacan, "The Mirror Stage as Formative of the I Function" [1949], in *id.*, *Ecrits*, 94 and *id.*, "Some Reflections on the Ego", *The International Journal of Psycho-Analysis*, vol. 34, no. 1 (1953), 11–17. The introduction of *objet a* in *Seminar X* (1962–63) as "object-cause of desire" marks a fundamental transition in Lacan's theory and a distance from the previous models of identification based on the mirror whose effects are visible in the diagram of the gaze. For a historic account of the theory, see Stijn Vanheule, "Lacan's Construction and Deconstruction of the Double-Mirror Device", *Frontiers of Psychology*, no. 2 (2011).
36 In *The Ethics of Psychoanalysis*, Lacan describes the screen as "the locus of mediation" (107) between the subject-as-picture and the *gaze*. The screen is "opaque" (96) and the subject has to *mould* herself in the image that it offers. As Lacan put it, "if I am anything in the picture, it is always in the form of the screen, which earlier I called the stain, the spot (97)." In these terms, here we can recognise the same knot between the Real, the Symbolic and the Imaginary that characterises the dynamics of the mirror.
37 Lacan, *The Ethics*, 89, 108.
38 *ivi*, 83.
39 Jacques Lacan, *Le Séminaire: Livre XVI: D'un autre à l'Autre* (Paris: Seuil, 2006), 248–249; *id.*, *The Ethics*, 122, 142, 82–85, 127, 144–145.
40 Krauss, "Corpus Delicti", 61.
41 Freud, "The Uncanny", 236. This can be seen as the foundation of Caillois's notion of distinction as the fundamental problem of life. Cfr. Note 24.
42 *ivi*, 235, cited in Krauss, "Corpus Delicti", 58.
43 Freud, "The Uncanny", 240–241.
44 *Ibid.* See also Rank, *The Double*, 83–84.
45 Freud, "The Uncanny", 241.
46 It must be pointed out that Barthes defined the *punctum* as an utterly subjective experience, as an "accident which pricks me (but also bruises me, is poignant to me)" and to nobody else (*id.*, *Camera Lucida*, 27). The *punctum* in this sense is opposed to the "cultural", "rational", "polite" and "general interest" on takes in photography, the *studium*, as the field of the operator's intentions (*ivi*, 26–27).
47 Freud, "The Uncanny", 241.
48 *ivi*, 149. The mechanism of repression is what Freud adds to Schelling's definition of the *unheimlich* as all "that ought to have remained . . . secret and hidden and has come to light" (*ivi*, 224). By insisting on the mechanism of repression, Freud is taking issue with Jentsch's definition of the uncanny as something pertaining to "new and the unusual"

content – from which a conflict between a "lack of orientation" and the "desire to mastery" would be derived. See Jentsch, "On the Psychology of the Uncanny" [1906], *Angelaki*, vol. 2, no. 1 (1995), 3, 16). As is well known, Freud's conceptualisation is based on the ambivalence of the German term *heimlich*, which besides its main meaning as what is "familiar", "intimate, friendly comfortable . . . , arousing a sense of agreeable restfulness and security as in one within the four walls of his house", also describes "what is concealed, kept from sight", a meaning also referred to as *unheimlich*, "weird, arousing gruesome fear", which is the opposite of the first meaning of the same word (Freud, "The Uncanny", 224–225).

49 Freud analyses Olympia's role within the tale mainly in a note, albeit at length, since his well-known central argument in the essay focuses on the figure of the Sandman. Contradicting Jentsch's earlier positing of the tale's uncanny effects in the terms of the intellectual uncertainty related to the animate or inanimate nature of Olympia, Freud sees in the motif of the Sandman the tale's most "striking instance of the uncanny", as the re-emergence of the infantile fear of the "dreaded father at whose hands castration is expected" (Freud, "The Uncanny", 232, 230). For a symptomatic reading of "The Uncanny", also in reference to the absence of Olympia in the main text, see Hélène Cixous, "Fictions and Its Phantoms: A Reading of Freud's Das Unheimliche (The 'Uncanny')", *New Literary History*, vol. 7, no. 3, Thinking in the Arts, Sciences, and Literature (Spring, 1976), 525–548+619–645.

50 *ivi*, 232, note 1.

51 Rank, *The Double*, 86. Rank lays out a relationship between doubling, paranoia, narcissism and homosexuality (74). The link between narcissism and homosexuality had been set in psychology with Havelock Ellis (in his 1898 "Autoeroticism: A Psychological Study") and then in psychoanalysis with Freud ("On Narcissism: An Introduction", 1914) for whom, however, narcissism enters a general account of subjectivity.

52 Jacques Lacan, "Seminar 3 (28.11.1962)", in *id.*, *The Seminar of Jacques Lacan: Book X: Anxiety*, trans. Cormac Gallagher from unedited French manuscripts, 28. For Lacan "anxiety is not the signal of a lack but of something that you must manage to conceive of at this redoubled level as being the absence of this support of the lack" (*ivi*, 36).

53 On the *topos* of Narcissus in relation to dissident sexuality in Surrealism, see David Lomas, *Narcissus Reflected* (Edinburgh: The Fruitmarket Gallery, 2011).

54 Foster, *Compulsive Beauty*, 118. For a reading of Bellmer's dolls as a fetishistic avowal/disavowal of castration and its subversive stance against Nazism, see also Therese Lichtenstein, *Behind Closed Doors* (Berkeley, CA and New York: University of California Press, 2001), 101–103, 127–138.

55 Lichtenstein, *Behind Closed Doors*, 72.

56 Foster, *Compulsive Beauty*, 119. There is also the dolls' connection to feminine subjectivity, the hysterical body and the social construct of the Aryan woman in Bellmer's work. See Lichtenstein, *Behind Closed Doors*, 87–96, 108–138. Women artists involved in Dada, such as Sophie Tauber, Emmy Hennings and Hannah Hoch, explored models of femininity through the interaction with marionettes, puppets and dolls of their own making. See, for example, Ruth Hemus, *Dada's Women* (New Haven and London: Yale University Press, 2009) and Hal Foster, "Philosophical Toys and Psychoanalytic Travesties: Anthropomorphic Avatars in Dada and at the Bauhaus", in Graw, *Art and Subjecthood*, 21–33.

57 See Bellmer's *Autoportrait avec la Poupée* (1934) on the online collection of the Paul Getty Museum, available at <www.getty.edu/art/collection/artists/1761/hans-bellmer-german-1902-1975/>, last accessed 11.1.2020.

58 Victor Hugo, *Les Misérables* (London: Penguin Books, 1982), 655. Hugo: "the doll was not a doll; it was a vision. It was joy, splendour, riches, happiness, which appeared in a sort of chimerical halo to that unhappy little being so profoundly engulfed in gloomy and chilly misery" (ibid.).

59 Michel Manson, "La Poupée de Cosette, de la Littérature au Mythe", in Evelyne Poirel (ed.), *Lorsque l'Enfant Paraît . . . Victor Hugo et l'Enfance* (Paris: Somogy, 2002), 68, my translation from French.

60 Massimo Recalcati, *Le Mani della Madre* (Milano: Feltrinelli, 2015), 24. The doll is bought by Valjean, but his intervention is derived from Cosette's mother, Fantine, to whom he promises to save the child. Valjean in this sense is a proxy for Cosette's mother. As Massimo Recalcati put it, while for Lacanian psychoanalysis the role of both parents is the transmission of a "desire not anonymous" (*ivi*, 75), the paternal function is structurally related to the demonstration of the possibility of desire within symbolic alienation, while the maternal function is connected to embodying desire for the irreducible particularity of the child as well as exposing desire as lack (*ivi*, 78).

61 See Michel Manson, "Diverses Approches sur l'Histoire de la Poupée à la Renaissance du XV au XVII Siècle", in Philippe Ariès and Jean-Claude Margolin (eds.), *Les Jeux à la Renaissance: Actes du 23. Colloque International d'Etudes Humanistes* (Paris: Librairie Philosophique Vrin, 1982) and Jeanne Danos, *La Poupée Mythe Vivant* (Paris: Editions Gonthier, 1966).

62 Donald Woods Winnicott, "Transitional Objects and Transitional Phenomena: A Study of the First Not-Me Possession", *International Journal of Psychoanalysis*, no. 34 (1953), 89–97. Often a simple piece of cloth, the *transitional object* is defined as an object neither internal or external, nor subjective or objective, but an object specifically "at the border" (89), pivot of a potential space on which the infant's path towards independence from maternal care is founded. For an account of the relationship between the *transitional object* and Lacan's *objet a*, see Alain Vanier, "Winnicott and Lacan: A Missed Encounter?", *The Psychoanalytic Quarterly*, vol. 81, no. 2 (2012), 279–303.

63 The tale is categorised as the type AT 571 C (Hans-Jörg Uther, *The Types of International Folktales* (Helsinki: Academia Scientiarum Fennica, 2004). One of its earlier versions is found in *Le Piacevoli Noti de Gian Francesco Straparola* (*The Nights of Straparola*, 1550) with the story of an orphan girl living in miserable conditions who, after receiving a doll from an old lady, discovers that it expels gold during the night. After a series of adventures, the king, who one day was passing by, is bitten by the doll, and when the girl manages to free him, he marries her, the two living happily ever after together. Michel Manson has pointed out how the elements of the poor, orphaned girl living in misery, the unexpected gift of a doll, the magic appearance of gold in the night and the final union of the girl with a rich and powerful man-saviour, coincident with the final disappearance of the doll, are all elements clearly identifiable in Hugo's story. See Manson "La Poupée de Cosette".

64 See Max Von Boehn, *Dolls and Puppets* (New York: Cooper Square Publishers, 1966), 107; Manson, *Les Etats Généraux de la Poupée*, 103; Bettini, *Il Ritratto*, 253.

65 Bettini, *Il Ritratto*, 254, my translation from Italian.

66 I will return to the *kolossós* in Chapter 5, in my reading of *Lars and the Real Girl*.

67 See Jean Pierre Vernant, *Myth and Thought among the Greeks* (London: Routledge, 1983), 308. *The kolossós* and the *psūkhē* are for Vernant manifestations of the *eidolon*, associated with dream-images, shadows and supernatural apparitions, phenomena related to the psychological category of the double (309).

68 *ivi*, 307.

69 Sigmund Freud, *Three Essays on the Theory of Sexuality*, trans. James Strachey (New York: Basic Books, 1962[1905]), 57.

70 Charles Baudelaire, "Morale du Joujou", in *id.*, *Oeuvres Completes I* (Paris: Gallimard, 1975), 582, my translation from French.

71 Charles Baudelaire, "Expo Universale 1855", in *id.*, *Oeuvres Completes* (Paris: Gallimard, 1953), 216.

72 Baudelaire, "Morale", 583.

73 *Ibid.*

74 *ivi*, 581.

75 *ivi*, 582.

76 *Ibid.* For a reading of this scene as a masochistic seduction scene, see Philippe Bonnefis, "Child's Play: Baudelaire's Morale du Joujou", in *id.*, *Reconceptions: Reading Modern French Poetry* (Nottingham: University of Nottingham Press, 1996), 21–36. See also Giorgio Agamben, "Mme Panckoucke; or, the Toy Fairy", in *id.*, *Stanzas: Word and Phantasm in Western Culture* (Minneapolis: University of Minnesota Press, 1993), 56–62.

77 Baudelaire, "Morale", 587.
78 The doll-maker was a point of reference for both Kokoschka and Bellmer. See Peter Webb, *Hans Bellmer* (London and New York: Quartet Books, 1985), 57. On Pritzel's dolls, see also Von Boehn, *Dolls*, 220.
79 Rainer Maria Rilke, "On the Wax Dolls of Lotte Pritzel", in Gross (ed.), *On Dolls*, 61. Borrowing the term from Buddhism and Hinduism, where it defines the extinction of desires and affect and the total annihilation after death (as opposed to reincarnation), Freud associates nirvana with the idea of a restorational tendency of the drives, which he introduced in *Beyond the Pleasure Principle* in 1920. See Freud, *Beyond*, 30.
80 Rilke, "On the Wax Dolls", 56.
81 *ivi*, 55.
82 *ivi*, 54.
83 *Ibid.*
84 *ivi*, 55–56.
85 Hugo, *Les Misérables*, 655. Baudelaire, "Morale", 13; Rilke, "On the Wax Dolls", 54.
86 Rilke, "On the Wax Dolls", 54.
87 For a detailed account of the exchange between Lacan and the Surrealists, see Margaret Iversen, *Beyond Pleasure: Freud, Lacan, Barthes* (University Park, PA: The Pennsylvania State University, 2007), particularly Chapters 3 and 4.
88 Jacques Lacan, *The Family Complexes in the Formation of the Individual*, trans. Cormac Gallagher [orig. "La Famille", in *Encyclopédie Française*, vol. 8 (Paris: A. de Monzie, 1938)], available at <www.lacaninireland.com/web/wp-content/uploads/2010/06/family-complexes-in-the-formation-of-the-individual2.pdf>, last accessed 17.11.2017, 21.
89 *ivi*, 16.
90 *ivi*, 18. This phase for Lacan precedes narcissistic auto-eroticism and narcissism, "since the ego is not yet constituted" (ibid.).
91 *Ibid.* This text may add another theoretical reference to the suggestion that the basis of the Surrealist *amour fou* is to be found in narcissism, as suggested by David Lomas in *Narcissus Reflected*.
92 Lacan, *The Family Complexes*, 23.
93 Susan Robin Suleiman, *Subversive Intent: Gender, Politics, and the Avant-Garde* (Cambridge, MA: Harvard University Press, 1990), 82–83.
94 Suleiman, *Subversive Intent: Gender, Politics, and the Avant-garde*, 85. On the role of the maternal function as a first instance of the dynamics of desire and symbolisation, see Recalcati, *Le Mani della Madre*, 52–57.
95 Lacan, *The Family Complexes*, 44.
96 *ivi*, 17, 28.
97 Freud, *Beyond*, 10.
98 *ivi*, 9. Within the phallocentric world in which Freud is embedded, it is the child who "is allowing his mother to go away without protesting", rather than her mother *allowing* the child the space to play thanks to her absence.
99 However, Lacan's attention to the maternal role in the process of suppression ("the discipline of weaning and of sphincter control"), is followed by an emphasis on the centrality of the Oedipus complex in the subject's ability to go "beyond its narcissistic form" (*id.*, *The Family Complexes*, 46). We can understand this to be the passage from a dual to a triangular structure, the installation of a *third term*, anticipated by the installation of *dissatisfaction* through the mother's refusal of weaning.
100 Lacan, *The Ethics*, 111.
101 Dolar, "I Shall Be", 7.
102 See Lacan, *The Other Side*, and *id.*, *Discours à l'Université de Milan*.
103 Jacques-Alain Miller, "A Fantasy" [2004], in *Lacanian Praxis: International Quarterly of Applied Psychoanalysis*, no. 1 (May, 2005), 11.
104 *ivi*, 6.
105 *ivi*, 11, 6.
106 Welchman, "The Uncanny", 49.

107 See Lacan, *Discours à l'Université de Milan*.
108 Foster, *The Return*, 152, 149.
109 *ivi*, 149
110 *ivi*, 146, 140, emphasis in the original.
111 *ivi*, 140.
112 Recalcati, similarly, albeit within a negative judgement, has written of abject art and Body Art as art of the Real, whereby the aesthetic field would be destroyed through a display of a "Real devoid of veil [velatura]", a Real "not sublimated but exhibited as object of pure horror". See Massimo Recalcati, *Il Miracolo della Forma: Per un'Estetica Psicoanalitica* (Milano: Mondadori, 2007), XIII.
113 Foster, *The Return*, 144. For more context on this discussion, see my introduction.
114 *ivi*, 156.
115 *ivi*, 157.
116 *ivi*, 156.
117 *ivi*, 145. In the note relative to the cited passage, Foster argues against a structural understanding of the "collapse of the Other" suggested by Kristeva. For Foster, the symbolic order is always in crisis, which reads as an assimilation of the Lacanian Symbolic to the actual material socio-political order to which it surely connects but should not be reduced (*ivi*, 270, note 56).

2

ENJOY (YOU MUST)!

Olivier Rebufa and Barbie's *dreamlife*

Olivier Rebufa worked as a fashion photographer before turning to art photography in the late 1980s, when he started to take pictures of miniature mannequins, namely, Barbie dolls. His first image of the project, which he would later title *Self-Portraits With Dolls (Since 1989)*, portrays him as Ken, standing on a *gâteau de mariage* at the side of that most famous of fashion dolls, Barbie Millicent Roberts.[1] With hindsight, considering how constant Rebufa has shown to be in this artistic formula, we may indeed say that on that day he married Barbie, the most eternal among all cultural icons in the West.[2] The late 1980s in France, like elsewhere, were starting to see the boundaries between the cultural industries and fine art becoming more porous, with commercial and art photography commencing to overlap. In photography, conceptualism and formalism, art and market, fiction and realism, began to appear in non-antagonistic terms. Hybrid figures of artist-photographers and photographer-artists started to become normalised, after the chasm between a conceptualist and a technical use of the medium that had characterised the central decades of the century.[3] Venice Biennale's international exhibition *Aperto 80*, in 1980, had been shaken by the return of the figure and of traditional forms of art making, styles and conventions of earlier periods within a post-conceptual digestion. The traditional avant-garde refusal of self-expression and pictorialism found itself overrun by a flow of figures, neo-expressionist gestures and decorativism. There was the sense that, freed from the ideological pressures of the previous decades, artists now could choose a personal *modus operandi* without feeling like reactionaries.

However, this return of the figure and of subjective authoriality needs to be considered in relation to a broader cultural shift, registered in the period's debates. In the opening of his 1981 *Simulacra and Simulation*, Jean Baudrillard had defined the simulacrum as "the truth which conceals that there is none", as a sign devoid of the depth of meaning.[4] Like for Fredric Jameson writing a few years later on

postmodernism, the simulacrum is for Baudrillard immanent in the logic of capital, inaugurated by the seriality of the copy. In his popular *The Era of Emptiness*, Gilles Lipovetsky in the same years described the emergence of a new version of individualism, founded on "hedonism, respect of differences, cult of personal expression, humour and sincerity", which he saw supplanting "abnegation" as the foundation of the Social.[5] Christopher Lasch's *Culture of Narcissism*, published in 1979, is easily found as an antecedent for Lipovetsky's own claim of a radical "anthropological mutation", whereby capitalism is seen to disconnect from its original Protestant ethics to be founded instead on "hedonism" and "permissiveness", on a narcissistic type of individualism.[6] Individualism here emerges as a dimension purged of the transcendence and inner-directedness described for the nineteenth and early twentieth-century "*homo oeconomicus*", whose action was based on individual initiative and responsibility before their own inner conscience and God, to be instead invested in the pure personal level of wellbeing, self-care and self-realisation.[7]

Hybridity, simulation, capitalism and narcissism are key themes exuding rather blatantly from Rebufa's photographic work. Rebufa combines photography with self-portraiture, performance and sculpture, to shape a phantasmagoria of the self in the guise of a reified doll inhabiting a world dominated by *all things Barbie*, the most imperishable icon of capitalist Americanness in Western culture. Specifically, his version of the self-portrait takes the form of a bi-dimensional object, integrated in a complex maquette made of toys and Barbie dolls, destroyed after the shoot.[8] The resulting image is a second-grade portrait – a photograph of a photograph. With the final black-and-white print, the viewer is presented with a strong narrative textuality, with the pleasure of reading sustained by a vast array of details and a serial organisation. I will take hybridity, simulation, capitalism and narcissism as headings for my exploration of Rebufa's work in this chapter, trying to map the interconnectedness of these concepts at the visual level and the way in which the doll is employed and connected to its rich cultural tradition.

The flatness of the capitalist fantasia

Rebufa's artistic career in the late 1980s started in Marseille, at a period in which the genre of self-representation had made a return, after modernism had devalued it for most of the century. Rebufa defines his work primarily as *autoportrait*, a term that in France is connected to a literary discussion on self-representation as associative *bricolage*, metaphoric and poetic in structure, as opposed to the linear reconstruction of the narrative of the self of the classical *autobiographie*. Topological and discontinuous rather than chronological, open-ended and intertextual instead of conclusive, the *autoportrait* is seen to translate subjectivity as something disseminated in historical and cultural codes as well as on the surface of the text.[9] Engaging with this discussion, Rebufa's self-portrait emerges as an effect of theatrical construction, with various implications, both on an aesthetic and cultural level.

In terms of genre, miniaturising his photographic self-portrait to the size of a Barbie doll, the artist reinvents self-portrait in sculptural terms. Self-portrait

emerges as constructedness, which is first and foremost the effect of a creative appetite in a world-building process, in the ideation and construction of a fictive set in which the artist is the star protagonist, moved around as a paper doll amidst an array of Barbies, tiny furniture and accessories. Rebufa's photography is theatrical, in this sense, as a tridimensional staging, a sculptural form of photography. His work can be approximated to that of other photographer-sculptors active in the 1980s, such as Patrick Raynaud's images of cut-out *tableaux* made of paper and wood, James Casabere's photographs of miniaturised spaces built from cardboard and Laurie Simmons's photographic staging of dolls and doll's houses. However, in contrast to other practitoners, Rebufa is present as a figure in his images, inhabiting his spaces and animating his narrative world.[10] More than anything else, Rebufa's theatricality points to his work's development in the 1990s towards other essential formal characteristics: narrativity, performance and flatness.

With regard to narrativity, we might see Rebufa's work as a form of storytelling by images, where a strong narrative implant, both at the level of the series and of the single frame, tends to collapse a clear separation between photographic and cinematic language, almost converting the single photograph into a still. A good example of this cinematic quality is *L'anniversaire* (*The Birthday*) from 1995, where time is spatialised by the merging of multiple moments in the image, while the richness of detail-clues offered to the viewer plays on the edge between the pleasure of reading and the blatant stereotyped nature of the story to be read. However, with Rebufa presenting the first and last act of this romantic scene, with the middle moments missing, the viewer is engaged in an interactive play of deconstructing cultural references and constructing possible meanings. There are gaps in the narrative that need filling, in an effort of animation.

As for the work's performative quality, we can see the pleasure of the maquette and the narrative implant to update the early photographic tradition of the *tableau vivant*. One of the latest additions to *Bimbeloterie* is a homage to Hippolyte Bayard's 1840 *Le Noyé*, in which the out-of-frame artist is redoubled by a Barbie photographer. With Bayard, Rebufa reminds us that at the very origins of photography we find not only the medium of scientific transcription of facts and objective reality, but a machine able to give form to the pleasures of the *mise en scène*. This tradition, pioneered between the nineteenth and the early twentieth century by figures such as Julia Margaret Cameron and Lewis Carroll, and revived starting from the 1960s by Luigi Ontani, Yasumasa Morimura and Cindy Sherman, among others, is one for which the photograph is a paradoxical document of fiction, taken between the analogue of the trace and the world of illusion. Through literary, mythological and cinematic references, the body is transfigured to reveal its phantasmatic matter. However, the fictions materialised by Rebufa do not appear to be "evasion from reality" or "dreams come true", as is often remarked in regard to this cultural form, as much as a consideration of how fiction structures ordinary reality.[11] This is because, before all else, stereotype plays an important part in Rebufa's constructed images. The artist's perfomance is in fact based on a never-ending series of stereotyped roles – Adam chased from paradise, New York *yuppie*, psychoanalyst,

analysand, porn film spectator, acrobat, toy figure, Tarzan, sculpture, centurion, film noir detective, celebrity signing autographs, cowboy, hairdresser for ladies and so on. We may see in this focus on the stereotype a first indication of flatness, namely, of psychological flatness. It seems all that is needed to embody the various roles is a change of dress, just like in a Barbie game, that is to say all that changes is the attire, with affective inflection kept to a minimum.

Evidently, however, Rebufa's image is also and especially visually flat. Works such as *L'anniversaire*, *Balade sur la Corniche* (1990) and *Panoplie* (1994) all foreground an aesthetic of flatness. *Panoplie* and *Balade*, juxtaposed, almost redouble the artist's own artmaking process, with the cut-out figures and props of the first mounted in the scene of the second. This is the 1990s' most farfetched luxury in toy version, with the Basquiat-inspired geometrical patterned shirt and the leopard-print coat giving a flavour of the decade's taste for excess. However, this is not child's play, as signalled not so much by the gun – children have plenty of miniature guns in their toy chests – but by the dildo in Barbie's accessories. We find here an excess of inappropriateness typical of parody, which on one side corrects Barbie's sexless design, and on the other makes clear that the world depicted here involves an adult version of an adult fantasy. Sexualising Barbie can be seen, primarily, as a reclamation of the history of this icon of child's play, through the recuperation of her pre-American German descent, *Bild Lilli*. Before being redesigned by Mattel and launched in 1959 as Barbie, Bild Lilli was a "pornographic caricature", a gag-gift sold in bars and tobacco shops for men, certainly not a toy for children. Bild Lilli was a miniature version of a post-war, sexually liberated and fashion-obsessed young secretary, born as a comic character for the German newspaper *BILD Zeitung*.[12] Re-sexualised, Barbie here rediscovers her own origins as an adult caricature. In this sense, Rebufa's engagement with dolls differs substantially from that of Bernand Faucon, for instance, a central reference for the aesthetics of dolls in the post-war French photographic tradition, where the world created in the photograph is suggestive of childhood and pre-adolescent fantasies. In *Summer Holidays* (1978), Faucon is engaged in an exquisitely crafted pictorial recreation of pre-adolescent ambiences, suffused with a nostalgic, elegiac mood, far from Rebufa's often sarcastic disposition. The inappropriateness of Barbie's sexualisation found in *Bimbeloterie* draws instead a connection to David Levinthal's 1972 series *Bad Barbie*, in which the doll is pictured in a series of sexual poses with boyfriend Ken and an African American G.I. Joe. Here Levinthal engages with the format of X-rated materials in a decade of newly sexually liberated culture, using cropping, viewing angle and black and white towards this aim. But while Levinthal's image attempts to achieve an erotically charged atmosphere, Rebufa's sexualisation of Barbie plays on the juxtaposition of the adult content in the child-centric format of the paper-cut game, creating a satirical effect. In this sense, the black-and-white format works in opposite directions in the two bodies of work. Black and white certainly speaks of the past, of memory, emphasising a Barthian *that has been*, which, if it animates Levinthal's image with a document effect, could not be more out of place in Rebufa's blatantly constructed world of toys. Rebufa's

use of black and white plays with the codes of authorial art photography, historically a means to distance the image from commercial, amatorial and journalistic photographic traditions. The filter that the black-and-white format creates from a full-color, sensually and emotively perceived experience, in Rebufa ultimately seems to point to detachment, a signifying gap in which an (authorial) comment and reading may take place.

The evidence of montage is another means to foreground the presence of meaning. Rebufa's aim is not the creation of a fully credible fictitious world, otherwise digital photography or a more refined and pictorial surface would have been more appropriate. Here there is the interest in maintaining visual signs of the manual construction of the set, evident in the fact that the artist leaves obvious traces of its constructedness. While *Panoplie* thematises the construction process as a cut-out game, *Balade Sur La Cornice* combines props and figures in a way that avoids the erection of a seamless, organic whole. The car is more *in front* of a bi-dimensional scene than *in* a livable space, with the projected backdrop narrowing the space, refusing perspective and repelling depth, similar to an early cinema feature. As in the films of George Méliès – to whom Rebufa has recently paid homage – here space and action emerge as a series of flat, cut-out figures and effects, more akin to a stage performance set in front of the viewer than to an immersive tri-dimensional classic cinematic space.[13]

Montage is not only declared through the deployment of a flat space but sometimes emphatically overstated, as in *L'anniversaire*, where two-dimensionality becomes fragmentation – the image barely *keeps it together*. The space is not only (dis)organised on multiple perspectives and sequential temporality but the seams of the flat backdrop used for the floor are evident. This focus on the seams of various elements and materials forces attention onto the surface of the image. The viewer is both invited to interact with and to maintain a distance from the image. In contrast to the high production values deployed by other contemporary art photographers engaging with fictions, where illusionism and credibility play an important role, Rebufa's laborious photographic process self-consciously foregrounds a simplicity effect. This can be read as an attempt to maintain a naivety of the image, which connects culturally to nineteenth-century forms of mass entertainment, such as early cinema, and, affectively, to the artist's own childhood pastimes – Rebufa's father would "pass him" silent films in 8mm and early Disney cartoons in black and white.[14] This manifest planning, building, dismantling and playing involved in Rebufa's artmaking reveals a form of affection for the sources of popular culture, an element that strongly distances this work from previous appropriation art. Sherrie Levine's *President's Collages* from 1979, for instance, which present images of women from magazines scissored out and mounted in silhouette portraits of American presidents, are customarily read as a disillusioned statement on the demise of originality and individual expression, as much as a critique of mass-media culture from which they borrow, distanced both emotionally and aesthetically. Albeit engaged in a similar analysis of the discursive structure of subjectivity, Rebufa's work does not distance itself from the sources of mass entertainment he appropriates, thus

revealing how the artwork shares *in*, rather than rejects, a broader mass-media context and its capitalist ideological condition.

This type of affective engagement with forms of popular entertainment appears indeed central in Rebufa: we find not only early cinema and Barbie among these sources, but also the modern traditions of the *bibelot* and the *images d'Epinal*. These are popular cultural sources that are both strongly ideologically charged and affectively, positively *played with* in Rebufa's work. Cultural history is mobilised through an aesthetic of flatness, opening to a whole array of contradictions, some of which we come to see: high art and mass culture, conceptualism and manual intervention, engagement and distance. However, the chief contradiction might involve the use of the simulacrum within a claim of historicity that the deployment of nineteenth-century sources seems to belie. Speaking of the fashion for the *rétro*, Jameson has famously written of the simulacrum as the end of history, whereby "the past as 'referent' finds itself gradually bracketed, and then effaced altogether, leaving us with nothing but texts".[15] If the risk of a cultural recuperation of the past is political flattening, a-historical stylisation and false historical depth, Rebufa's recuperation of the cultural history of toys in the context of a highly self-conscious practice of image building poses a question. Can affective engagement be more than style? What space is left for a critical position when the artwork declares its own flirtation with the capitalist spectacle?

With *Bimbeloterie* – whose etymology derives from the French *bibelot* – we are reminded that there is an adult and cultural history of play. In modern Europe, *bibelots* were decorative objects devoid of practical utility – trinkets, knick-knacks, curiosities – indicating an adult taste for miniature replicas, such as ingenious complexes of houses, interiors and fittings.[16] Originating in the *ancien régime*, *bibelots* lived in a golden age in the nineteenth century, when they would be typically found among the paraphernalia displayed in the *drawing room*, or the French *salon*, dedicated to social gatherings and the entertainment of guests. These miniature objects would be displayed in a case, out of the reach of children, who, however, would also play with them, testifying to the lack of clear social boundaries between adulthood and childhood typical of the period before the nineteenth century.[17] Writing in the late nineteenth century, Walter Benjamin saw *bibelots* as middle-class remnants of a previous art of the people, proceeding from the German house and the Neapolitan crib. Like the Surrealists, he found in "objects that have come to be extinct" the "symbols of the desire of the previous century", uncanny "ruins of the bourgeoisie", objects with a revolutionary potential for their ability to galvanise historic consciousness.[18] There is a historical dimension inherent in play and toys, a stratification of earlier religious, social and economic structures. Giorgio Agamben has spoken of toys as a manifestation of "the Historical at its purest", for toys "belonged – *once, now no more* – to the sacred or to the practical and economic spheres", maintaining as such something of human temporality.[19]

It is in connection to this socio-anthropological dimension of toys and to the value of play as a historically socialised practice, as a space of mediation between subject and discourse, that the use of these sources in Rebufa's work becomes

significant. The space between the individual and discourse is the space that Jameson, following Lacan, attributes to ideology, as what coordinates between individuals and the Other.[20] By miniaturising his figure to Barbie-size, Rebufa invites the viewer to delve into the sphere of a representation where the apparent naivety of baubles for children reveals a complex network of texts, rhetorics and codes as the fabric that weaves together subject and discourse. Toys have in fact always been ideological tools, miniature "mythologies".[21] Rebufa certainly recuperates this ideological and pedagogical level of toys and play, and after the *bibelot* another cultural source recaptured from the past is the *imagerie d'Epinal*, a popular form of mass entertainment in eighteenth- and nineteenth-century France. The *images d'Epinal* included printed *divertissements* – such as paper theatres, architectural forms and dolls to cut out and assemble or to animate with pull strings – but also stories for children, folk traditions, simplified accounts of political events and religious culture. They were an educational form of play, conveying themes and literary *topos* of moral, Manichean simplicity to educate children to adult mores, in line with the era's progressive conception of play as a tool for education.[22] In particular, we may approximate the richness of detail in the Rebufian *tableau* and its invitation to play to the *devinettes d'Epinal*, image enigmas where viewers were asked to find a character or an object *hidden* in the meanders of the image.

In terms of ideology, Barbie is, perhaps, among all contemporary toys, the most popular icon of the *American dream*, at the centre of all sorts of ideological commentary and criticism since its launch in 1959.[23] Barbie is the most iconic fashion doll in the West, a doll model, reproducing the details of a social type, a doll strictly connected to the realm of the ideal, what art historian Michel Manson would call a "poupée-model".[24] Like all other toys, dolls introduce a child into a particular discourse, to those conducts and beliefs whose apprenticeship guides an individual to fit in. Dolls, however, are different from all other toys since they are also a double of the human body and therefore able to support imaginary identification as a mirror image. Doll models like Barbie, in particular, express an image of success in relation to dominant socio-cultural values, displaying the most desirable attributes within a given context. As such, they offer a conciliatory model of the self, able to relieve the child from the contradictions of her lived experience. Psychologist Jeanne Danos, intervening in the cultural history of dolls with her 1967 *La Poupée Myth Vivant*, described this aspect of doll play as a "ritual of expectation", in which the child engages with the "norms of good and evil", as defined in her socio-cultural context.[25] Like in the Lacanian mirror, where the image is *in advance* of reality, the doll model affords the child a narcissistic satisfaction, a "purification", an imaginary compensation for the humiliations and failures of real life.[26]

The way Rebufa plays with his own miniaturised self-portrait, arranged in multiple guises and set-up scenarios, borrows the modality of a particular form of doll play, that is role play. This can be described as an exercise of mimicry which sets out "to imitate adult processes, while reducing them to [a child's] own scale", and that as such can be seen to promote the exploration of the discursive components of the Other.[27] However, engaging with Barbie means not only engaging with general

processes of imaginary identification, but also with those fantasies of *the good life* to which she is so typically associated, of the *dream* that we find as a compulsory epithet of all things Barbie (and often American): Barbie's *dream house, dream life, dream castle, dream camper, dream car* and so on. Rebufa's photography presents narratives deeply steeped in the stereotyped imagery of a Barbie cartoon. When Barbie emerged in the 1950s, she was an immediate success, as this feminine icon represented an independent, single and beautiful professional young woman oriented towards a leisure-led lifestyle that many women at the time could only dream of. However, Barbie ultimately represents a problematic model of subjectivity whose essentialism resides in the need of perpetual renovation through consumption.[28] Besides overtly marketing branded items, such as in the *Barbie Loves McDonald's* doll series, Barbie's narratives work as a fantasy machine built on the desirability of a highly commoditised world of incessant leisure – skiing, camping, swimming, skating, cycling, boating, dancing, shopping and so forth – from which Barbie's *dream life* appears as a time of unrelenting commodified satisfaction. Without any form of parental bond or any binding commitment – Barbie only has younger siblings (seven, to date) – Barbie's is a world where children and young adolescents, hyperbusy in a life of uninterrupted leisure, are born from themselves, "with neither history nor authority figures to restrict [their] actions".[29] We are in a fantasy world where life coincides with leisure and a fundamental freedom from authority, and where intersubjectivity emerges as horizontal homogeneity. If authority figures are absent, Barbie is nonetheless an authority in her world, she is a *celeb*, mild as a girl next door and ultimately cruel as only an idealised image can be. She gives body to an unattainable model, inspiring adoration, or resentment, at any rate centred on a purely narcissistic dimension.

Barbie reflects the American dream as representative of a conception of subjectivity as something that one can *make*. As an individual creation, subjectivity is, in this frame, the effect of a personal effort, of a movement of perpetual renovation of which one is actively in charge. Barbie's motto "I can be whatever I want to be" is the toy version of the capitalist belief that one can choose one's own destiny, *make* oneself like a mythical self-begotten being. Psychoanalysis would define such a prospect as psychotic – as Žižek put it, "the subject who thinks he can avoid this paradox and really have a free choice is a psychotic subject, one who retains a kind of distance from the symbolic order – who is not really caught in the signifying network".[30] By surrounding his own portrait with Barbie dolls and Barbie *dream* accessories, Rebufa inhabits a hyper-commercialised, super-accessorised world, revelling in the realm of the imaginary ideal. As the quintessential Barbie-type, his version of subjectivity is seductive, pleased with his own appearance and success, albeit occasionally apathetic. Barbie's world guarantees the entrance into the shallowness of a subjective and intersubjective space built on the imaginary promise of satisfaction and sustained by celebrity adoration. On the level of the signified, narcissistic satisfaction is often a theme: it takes the form of leisure (*Balade sur la Corniche*), wealth and sexual abundance (*Et Passe . . .*, 1995), sexual bravado (*Le Coffre à Jouets*, 1994), celebrity life (*Autographes*, 1994). On a par, scenes of failure

also abound: in terms of apathy, or failure to enjoy (*Amour à Marseille*, 1990), in terms of submission, or a failure to dominate (*Travaux d'Eté*, 1995), or in terms of plain defeat (*K.O.*, 1994). It is an existential world of polarised opposites.

This focus on narcissism is often read through the classical Freudian construction of dream as wish fulfilment and of the artwork as one of its equivalents but, on the contrary, the historical and the ideological implications of his cultural references point to actuality. Following the Freudian framework, art critic Paul Ardenne speaks of Rebufa's work as "cathartic", since "stepping into the world of dolls makes it possible to reconfigure one's life", "to overcome frustration and replay one's life, turning around episodes of actual failure or half-success, inventing scenes hoped for but never lived".[31] This is clearly an orthodox psychoanalytic reading, and one of psycho-biography at that, in which narcissism is an attribute of the artist himself. Even if that were true, it would not really contribute to an understanding of this particular project in its cultural and art-historical significance. The artist as immortal *hero* is a classic trope of Freudian aesthetics: art is a narcissistic exercise to transfigure reality in a dimension dominated by the pleasure principle, and as such an equally cathartic experience for the viewer.[32] However, if the Ego clearly takes centre stage in Rebufa's Lilliputian world, it is not in *dreaming* and *wishing* that this image seems to engage us but rather in a meditation on narcissism as a condition of our present historical moment, "since 1989". This date, added in brackets to the title of the self-portraits' series, hints to historical time and particularly to a moment that many have associated with the onset of global capitalism, which accelerated after the end of the Cold War and the subsequent collapse of Communism. Rather than dream, Rebufa's narrative self-portraits appear as an engagement with the very *matter* of ordinary experience, with fantasy as the very foundation of discourse. In this sense Rebufa can be seen to depart from a modernist tradition of the *tableau vivant* as escape into the realm of the irrational. The photographic *tableaux* of artists such as Margaret Cameron, Hans Bellmer and Claude Cahun exposed subversive and often uncanny scenarios of an *other* possible world, one that could disrupt the austere confines of modern patriarchal mores, which repressed the truth of the subject and her libidinal satisfaction. *Bimbeloterie*, on the contrary, seems to epitomise the most ordinary imaginary alienation at the basis of the perception of ordinary reality.

As seen in Chapter 1, fantasy can be defined as a *mise en scène* of desire, whose fundamental discursivity derives from its being an effect of symbolic alienation. Fantasy is the result of the subject's alienation in the signifier and her consequent loss of *jouissance*. The inhibition of *jouissance* has historically defined the Social, with discourse working through the offer of a series of alternative, regulated, partial forms of enjoyment, of *surplus-jouissance*, as the product of structural impossibilities that make a discourse a fundamentally "open-ended structure".[33] Inhabited by lack, discourse has traditionally been characterised as the impossibility of satisfaction, as an effect of which a never-ending attempt on the part of the subject to realise her desire follows. This intrinsic failure to enjoy is what has traditionally protected the subject from disappearing in an all-encompassing *jouissance* and

what has created the conditions for fantasy, as the hallucination of that impossible satisfaction. It is to this central question that we can link Rebufa's mobilisation of the doll and the mimicry of play, that is, to the problem of fantasy and desire in their relation to capitalism and the status of the commodity object therein. This is not a sociological problem since the value we attribute to photography and art is wholly dependent on subject–object relations and on the connections between *jouissance* and the symbolic order. Consorting with Barbie in a flat fantasia becomes a question about desire in a world of plastic, as well as a question about the role of photography in a world overflowing with *stuff* and idealised self-images.

That has never been: dea(p)th-less photography

Bimbeloterie could be retitled *Mirrors*. The mirror is a central feature of Rebufa's world, both thematically and structurally. It is a literal presence as well as a structural element, as it appears from works such as *Coiffeur Pour Dames* (1994), *Le Psy* (1995) or *De l'Autre Coté du Miroir* (1995), all of which show the realm of the visible as a mirror reflection. Overall, the mirror in these works defines the ways in which the codes of self-representation coalesce with those of photography and psychoanalysis. In *Coiffeur Pour Dames* Rebufa plays the role of the hairdresser, holding a pair of scissors over Barbie's head while Barbie sits on the chair and looks straight into the camera, at the viewer, clearly positioned on the other side of the mirror. The camera-viewer *is* the mirror in which Barbie contemplates herself, a mirror that is in fact invisible and yet the *locus* of what is seen. In *Le Psy*, the psychoanalytical setting, and the depth of photography with it, is reduced to a symmetrical fold-and-cut papercut, with the image almost perfectly folding into itself along its middle axis, like a mirrored image. This is also another example of temporal conflation, with Rebufa playing both the analysand and the analyst in the same frame, engaging with the process of image manipulation with analogue means – one cannot really know, at first glance, if this is a digital or analogue montage. The chief example in terms of mirroring is *De l'Autre Coté du Miroir*, emblematic both in presenting a doubling of the process at work in Rebufa's artmaking and in offering one of the few instances where the artist's life-size body makes an appearance. The image shows Rebufa with two attractive blonde women looking at the miniaturised figure of the artist entering a small octagonal mirror while two Barbie dolls appear to wait for him on the other side. While revealing the downsizing move at the basis of his artistic process, Rebufa here plays with the concept of the mirror psychoanalytically and photographically. The image is in fact built on the juxtaposition of two mirrors, a smaller octagonal one, posited as the door to *Barbie-land*, and a bigger one, whose frame is invisible, on which the first leans, creating the gap in which the two Barbie dolls are located. There is a politically incorrect equivalence set here between the two sexualised female figures and the Barbie dolls – are they a replica of Barbie's standards of beauty, or is Barbie a replica of them? Simulation defines the visual field: a direct index of a pre-photographic reality – the artist and the women – is already in itself

a mirror reflection. All that exists – the self, the other, the photograph – is the result of a play of mirrors.

This connection between the subjective and the photographic is made even more flagrant in *X-Rays* (*Figure 2.1*). Here we find a well-concentrated *pasticcio* whereby psychoanalysis, subjectivity, dolls and photography appear as a *conundrum*, in which a statement on one reveals something of the other, albeit in very different ways than in its traditional Surrealist variant.[34] There is a whole visual and theoretical tradition condensed in this 80x60cm construction, from Man Ray's *rayographs* and Freud's theory of analysis to Barthes's *punctum* and the 1930s fascist *Gläserne Mensch*. A miniaturised Rebufa is having an X-ray examination in what looks like a waiting room, a public space. A blonde doctor Barbie performs the radiography, with her profile doubling a printed X-ray image of a Barbie on the wall. Self-portrait, as an art historical genre of subjective introspection, is here recalled through the literalisation of its classical analogy with anatomy.[35] Self-portrait has traditionally meant self-analysis, often regarded as a practice whereby artists turn themselves into an object of knowledge, in a movement of dis-identification from their mirrored image.[36] Self-analysis, in turn, has classically been associated with an anatomical examination. Freud, for instance, remembering one of his own dreams during self-analysis, interpreted anatomic dissection as equivalent to psychoanalytical analysis, which also implies psychoanalysis as a movement from surface to depth.[37] Similarly, modern anatomy theatres and treatises, handling more literal human *interiors*, traditionally presented the inscription *Nosce Te Ipsum* (know yourself), which transfigured the spectacle of the finitude of the human body to an edifying lecture on mortality, while exposing the perfection of the internal functioning of that same body as a revelation of the divine Other.[38]

These associations impinge on this image thus exposing this radiography, primarily, as a radiography of the history of photography. Mortality in this sense hints to the theoretical attempt to isolate photography from other media by pointing at its supposedly intrinsic essence, a *noeme*, which Barthes famously identified in the *ça a été*, in time past.[39] That we may be toying with the *punctum* here is suggested by the insertion of a literal encounter with death, a skeleton holding a scythe, posited almost at the exact intersection of the image's diagonals, not immediately recognisable, confounded in the shadow cast by the artist's figure. Death is *hidden* in the image, like in a *devinette d'Epinal*, where the viewer would be challenged to find an enigmatic object. The visual enigma here might well be "where is the *punctum* in the picture?" Surely death is literally there, with all the attributes of a classical *vanitas* – the scythe, the clock, human bones – with the clock hanging over the artist's head in the form of a tiny black *spot*. However, if the skull only emerges after close inspection, maybe as a surprise, we are more likely to be amused than "annihilated", like the viewer described by Lacan before the anamorphosis of Hans Holbein's *The Ambassadors*.[40] In the same seminar on the *gaze* that we analysed in Chapter 1, just before discussing his diagram of visuality, Lacan speaks of the anamorphic moment as the subject's encounter with her own castration, an encounter with the Real as that which is irreducible to the signifying chain. I think we are

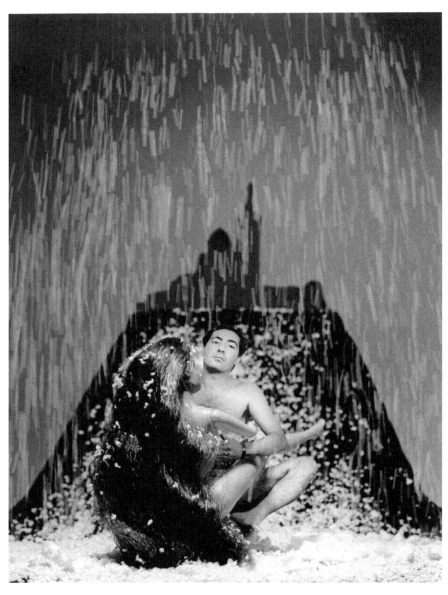

FIGURE 2.1 Olivier Rebufa, *Amour à Marseille*, *Bimbeloterie* series, 1990. Gelatin silver print, 60 × 80 cm. © Olivier Rebufa. Courtesy of the artist.

here faced more with a question than with an answer as to what the destiny of such a dimension in a universe of simulacral hall of mirrors is. There is certainly *studium* in this photography, as every aspect of the image is the meticulous result of the artist's composition. The body of the artist, the only thing *once* alive that could speak of time past and death – the artist's own body which does age along the series "since 1989" – is itself a copy, the photograph of a photograph. Rebufa's self-portraits are flat in this sense, because they have their referent in always yet another image, with the self reduced to the "dusty spectacle" of a "multitudinous photographic simulacrum".[41] But does this mean that this photography is devoid of affect and historicity?

The use of historical cultural sources and the issue of subjective introspection point to a depth, but we have started to see how this is in tension with the shallowness suggested by formal treatment and the centrality of the mirror surface. This conflation of flatness and depth in Rebufa's work seems to speculate on Jameson's diagnosis of late capitalism as the era of the simulacrum not only in terms of "waning of affect" but also in terms of "waning of historicity".[42] For Jameson the "art language of the simulacrum" flattens the representation of the past as well as that of the present, reducing it to style, to a "glossy mirage", with the effect of hindering "our lived possibility of experiencing history in some active way".[43] Glossy mirages are indeed all that we have with Rebufa, but the contradictions exposed seem to ask if we are condemned, as producers and viewers, to a "schizophrenic", "addictive" attitude towards them.[44] Certainly that particular pose recorded by Rebufa's photography *has never been* in the Barthian sense, not being extrapolated from mortal time, but is rather a pose created in fantasy and then cut and pasted onto a *maquette* before being photographed. The portrait is a recreation of a precedent fictional scene which is printed, cut out and re-photographed again within a three-dimensional *mise en scène*. What is left of the subject in this second-grade photograph? The beauty and pleasure of Rebufa's work might be closer to cinema's fictionality than to the still photograph that Barthes had in mind in *Camera Lucida*. The poignancy of the frozen still so literally embodied by the artist in the making of the initial photograph is diluted in the final image, where the viewer is *caught* by the richness of intellectual and cultural references emblazoned on it, rather than by an uncanny gaze. We are caught in a network of signifiers that travel on the surface of the image rather than pointing to psychic depth.

From being the avant-garde *topos par excellence* of the emergence of *jouissance*, the doll is here engaged with a lack of depth and *lack of death*. Instead of the axis between the subject, the *punctum* and the Real that we saw in Chapter 1 characterising the aesthetic of the doll in Surrealist photography, here the doll is taken between a bi-dimensional subject and a constructed photograph which overtly exposes its own constructedness. It is a photography whose shallowness seems to thematise the medium's myth as document of reality, through the recuperation of a long tradition of visual trickery, from Méliès to the *devinettes d'Epinal*. Particularly, this is a photographic practice whose hybridisation with sculpture, performance and cinema complicates the attempt to define the medium's specificity, the photographic.

The radiographed images of Barbie as posters hanging on the wall in *X-Rays* are a direct engagement with Man Ray's 1920s experiments with camera-less photography and, like *rayographs*, they linger undecidedly between icon and index, painting and photography.[45] These images are the miniature version of Rebufa's own photographic experimentations with X-rays in a 1996 series, *Inherences*. Like *rayographs*, these radiographs both have the appearance of an abstract representation and the essential quality of the index, of being a direct, automatic emanation from a material object. As a redoubling of the artist's choice of constructed photography, they foreground a conception of the medium that instead of fulfilling its promise of faithful reproduction leans towards a version of the visual as what is ultimately ambiguous, whose denotative meaning is elusive. The inclusion of these pictorial radiographs in *X-Rays* suggests once again the essential undecidability of this photography between icon and index, image and body.

Barbie radiographs on the wall can also be seen to point, ideologically, to a normative ideal that the Rebufian subject under X-ray might be called to match. When coupled to the ostentatious public character of this display of interiors-interiority, we may think of visibility as transparency and of its early twentieth-century model, the *Gläserne Mensch*, the transparent *Glass Man*.[46] We may this way enter a rather dystopian version of the visible and of subjectivity. The 1930s preoccupation with public health, personal hygiene and sanitation promoted the ideal of a transparent citizen devoid of any self-determination but the diligent willingness to be observed, as through X-rays, by the intrusive gaze of the State. The *Glass Man* is the totalitarian epitome of a body built on compulsory health and fitness, a body-machine to be maintained in the name of productivity, fertility and military strength. It is the model of "regimented ideals of collective individuality, stripped of corporeal or psychic anomalies and aligned with the values of science" that, *mutatis mutandis*, we may see returning in the hypermodern ideology of wellness and fitness of which Barbie, with her thinness and improbable body measurements, is the obvious toy version.[47] Barbie is an icon of willpower, of beauty as discipline of the body.[48] Adopting Barbie as a signifier surely also means thematising the contemporary worshipping of body fitness and the way the image of the self – the *selfie*, the self as brand – has become crucial in the definition of individual worth in the last few decades. The subject has become a beautiful image to be achieved, with digital enhancement alongside the more traditional self-disciplinary practices of fitness and dieting as a tool to live up to the ideals of the self as promoted by science, fashion and advertising. Social media platforms have become an *ersatz-agorà* where a relationship between images – constructed, "airbrushed" – have substituted relationships between subjects. We could evoke Barthes's remark on the photographic portrait as a "statue" of oneself, as "Total Image", or Benjamin's note on fashion as the manifestation of "the rights of the corpse" over the living to describe the deathly and coercive aspects of the ideal along the line of which we find united persons, dolls and pictures.[49] However, where the old fascist imperative of wellness and fitness of the *Glass Man* is to be seen as an emanation of the State, of "paternal authority", in Rebufa's world of Barbie dolls, the question arises as to whom is

the Other who makes the judging. For what kind of gaze is that image of the self thus exposed?

Narcissus and the echo of capital

If there is a constant in Rebufa's world, it might be the dependence of the subject on an other's look, either diegetically or extradiegetically. If the mirror is a fundamental structure in this work, it is so also as a mode of apperception of the image itself. The subject is the doubling of an image offered as a spectacle to be enjoyed. *Amour à Marseille* is exemplary in this sense since it reflects on enjoyment as something externalised. It depicts a sexual act between the *dollified* form of the artist and a brunette Barbie in the context of what resembles a snow-globe souvenir, with the profile of the most popular landmark of Marseille in the background, *Notre Dame de la Garde* (Our Lady of the Guard). If I earlier introduced this work as an instance of a failure to enjoy, it is because through a cool, apathetic look, Rebufa presents a sexual enjoyment as cold as snow and shallow as the layered montage of flat cut-out figures suggests. Like an early film, what exists is taken between the bi-dimensionality of the frame and the theatricality of a stage performance. Rebufa's somewhat demonstrative attitude finds a resonance in the phallic tower in the background, again a sign that the artist is engaging a well-read viewer in a network of shared cultural references. We are presented with the Freudian *Interpretation of Dreams'* most cliché example of displacement in the tower as symbol of phallic *grandeur*. The visual axis created between the dominating tower in the background, the artist's look and that of the beholder travels along the line of a display of enjoyment, while the prominent stance of the tower, dedicated to the Marian Guard – nicknamed by local inhabitants *La Bonne Mère* (the Good Mother) – defines the space of existence in terms of absolute visibility as well as maternal protection.

What we find here is another rich cultural pastiche. In the most improbable of all locations, a miniature city skyline snow globe, we are presented with the conflation of an exhibition of sexual enjoyment with the instance of a godly maternal protection and a tower *panopticon*.[50] After the *Glass Man*, the *panopticon* is another *topos* of permanent visibility that hints to the fact that, traditionally, the agency of control is *non-existent*, and properly functioning as such, for it is internalised. Foucault described it as the instance of an "automatic functioning of power", able to induce in the observed a state of constant auto-surveillance, "a power situation of which they are themselves the bearers".[51] That is to say the prisoners, unable to see if they are being seen at any given moment, must assume they might be and therefore behave accordingly. However, as for the *Gläserne Mensch*, the *panopticon* relates to a top-down identification model that seems ill-fitting with the horizontal, idealised world of Barbie, where no authority whatsoever is present to hinder individual satisfaction. If the mirror is central here, it seems not to be in relation to an Other of the gaze, as in the Lacanian mirror, where the *ideal Ego* is connected to the *ego Ideal*, the Imaginary to the Symbolic. In that classic dynamic of alienation, the subject would recognise herself in the mirror image thanks to

the symbolic inscription of that image in the field of the Other, in the network of discursive socio-symbolic norms and ideals. There is such a flaunting of enjoyment and defeat in Rebufa's world to suggest that its interminable procession of mirror images might not be read in the terms of a classical Oedipal identificatory dynamic.

Bimbeloterie's coupling of Ego *grandeur*, other-directed displays of enjoyment and formal shallowness can be read as a form of *conte philosophique* revising narcissism and *jouissance* for the 1990s. The subject reduced to a paper template, a cut-out model adaptable to the most variable scenarios, all reunited under the common banner of a demonstrative display of enjoyment, seems to literalise an existential thinning of subjectivity that has been recently described in relation to the socio-cultural conditions of post-industrial capitalism. What Lacan has suggestively called the "evaporation of the Father", the historic demise of authority and symbolic efficiency in Western societies, is a central turning point for the curtailing of the central impossibilities that have historically characterised the circulation of *jouissance* in the social bond.[52] As we have seen, after introducing his theory of the discourses in 1968, Lacan added a fifth discourse, the *capitalist's discourse*, as a form of social bond that he considered to be in the process of supplanting the traditional *discourse of the master*, as its contemporary "substitute".[53] In the *matheme* of the *capitalist's discourse*, we find an inversion between the subject and the master signifier (the arrow going from $ to S_1), which indicates that the subject is not submitted to the alienating action of the signifier. The direction of the arrow from the subject to the S_1 indicates that it is the former that directly manoeuvres the fabrication of signifiers, thus determining the modalities to access *jouissance* (*Figure 2.2*). At the lower level of the formula, the obliteration of the blockage between the object (*a*) and the subject ($), which is instead found in the *master's discourse*, appears as a

Discourse of the Master

$$\frac{S_1}{\$} \overset{\longrightarrow}{\times} \frac{S_2}{a}$$

Discourse of the Capitalist

$$\frac{\$}{S_1} \times \frac{S_2}{a}$$

FIGURE 2.2 Lacan's formula of the *capitalist's discourse*, adapted from *Discours à l'Université de Milan* (1972).

fundamental distortion of the formula of fantasy, where the subject would be in a contradictory relationship – attraction and repulsion – with the object.[54]

As Lacan put it, in the capitalist economy "surplus jouissance is no longer surplus jouissance but is inscribed simply as a value to be inscribed in or deducted from the totality of whatever it is that is accumulating", that is to say that *jouissance* is put at work, changing its nature, becoming an "imitation surplus jouissance".[55] What previously was an unaccountable excess – *jouissance* as waste-product – becomes in the *capitalist's discourse* a value incorporated into the system, a calculated and consumable pleasure. What we find here is the negation of lack, with the object present to the subject that, precisely for this lack of blockage, ends up being engulfed by it. This is a situation which, on one side, is antagonist to desire as the *nothing* at the core of the subject, always object-less.[56] As Žižek argued, the problem of the "'permissive' 'consumer society'", is that "with the constant flood of new consumer items and the provocation of demands", there emerges a "saturated field" where the "impossible desire can no longer be articulated".[57] On the other side, this lack of distance from the object causes a state of permanent anxiety, as an effect of a *lack of lack*.

These aspects advance a new discursive organisation of *jouissance* and of subjectivity that Lacanian psychoanalysts have been discussing, in the last decade, in relation to so-called "new symptoms" – contemporary forms of the symptom, such as eating disorders, process and substance addictions, anxiety and depression. These symptoms' "newness" is in their resistance to signify, and therefore to be treated through the traditional Freudian clinic of interpretation, where the symptom would be interrogated as a metaphor, as a signifier of the repressed. This means a failure of symbolic mediation and the inefficacy of the old binomial repression-return of the repressed configuring the traditional character of the symptom as an index of the subject's unconscious desire, substituted by new structures founded on an absence of desire.[58] Colourful neologisms such as "subject without unconscious" or "subject without gravity", developed in these contexts, attempt to address a situation where the symbolic mediation offered by the classical neurotic symptom seems to be substituted by a compulsion to enjoy unconcerned with a dialectic with the Other.[59] Massimo Recalcati speaks of an "urgent need to enjoy which bypasses any principle of symbolic mediation" and of a "narcissistic reinforcement of the ego" as the two main forms of this contemporary clinic.[60] On the one side, there is a subject who submits to a superegoic injunction to enjoy, out of a symbolic dialectic, and, on the other, a subject whose "solid identification" to the social mask emerges via a disconnection from the unconscious split of the subject.[61] This narcissistic problem of identity and its connection to the *capitalist's discourse* can shed some interesting light on Rebufa's focus on self-images and, more broadly, on the return of dolls and other human doubles in contemporary visual culture. However, this opens the theoretical challenge of finding a way to mobilise this psychoanalytical framework for the analysis of our case studies beyond a mere narrative description. One way to do that is to employ these tools to examine the visual structure emerging from these works and ascertain their value in creating new knowledge, a better understanding.

In connection to the above, the problem of the mask seems central. The mask as veil has been classically connected to hysteria and to the veiling of desire, as an instance of the subject's difficulty in subjectifying her unconscious truth, of discarding repression. In contrast to this classical description, Rebufa's structural focus on lack of depth seems to connect with a more recent reconceptualisation of the mask in non-neurotic terms. Recalcati speaks of a "clinic of the mask" to underline how a new binomial between mask and anxiety might better describe the contemporary subject's main concern to defend from a type of anxiety which is alien to the traditional problem of repressed desire.[62] Žižek, similarly, has written of "Pathological Narcissus" as a subject which gives the "unsettling impression" that 'there is nothing behind the mask'", that is, the impression of speaking to a "puppet", as if what is hiding behind the mask is something "dialectically not mediated" by it.[63] Anticipating these accounts, Helene Deutsch spoke in the 1930s of the *als-ob* (as-if) personality type, a description of a type of imaginary identification beyond the dynamics of symbolic mediation. Deutsch has written of *als-ob* subjects' "highly plastic readiness" to reflect and adapt to a given environment, coupled with the inability to derive an authentic inward transformation.[64] These discussions tie in with the notion of "ordinary psychosis" recently developed in the Lacanian orientation as a way to describe a hybrid psychic structure, "sit[ting] on the dividing line between psychosis and neurosis", where the psychotic element is "ordinary" both as a way to oppose it to the extraordinary phenomena classically associated to psychosis, such as delirium and hallucinations, and as a way to underline the frequency of these new manifestations.[65] "Ordinary" also points to the fact that these new cases of psychosis have the ability to stabilise themselves, namely through "imaginary compensation" and "substitution" through the *sinthome*, which describe two ways in which stabilisation is achieved without the aid of the *Name of the Father*.[66] While the *sinthome* is a signifying task, effectively substituting the signifier of the *Name of the Father*, as in the case of Joyce, that Lacan analyses in his 1972 seminar, imaginary compensation is a strategy based on the imaginary level of a mirror identification.

This is the sphere of the *as-if* type that Žižek described in his 1986 "'Pathological Narcissus' as a Socially Mandatory Form of Subjectivity" in relation to post-industrial capitalism, where we may find the most accurate phenomenological description for Rebufa's flattened capitalist subjective type. Published originally as an introduction to the Slovenian edition of Christopher Lasch's *The Culture of Narcissism*, this essay gives a Marxist–Lacanian spin to the connection between narcissism and post-industrial capitalism operated by Lasch. "Pathological Narcissus" refers to a subjective structure that relies on primary defence mechanisms, such as splitting, projection and denial, instead of repression through the paternal metaphor. In the slightly literal and normative terms of this early description of the phenomenon, Žižek underlines how this is a subject who "has failed to 'internalise' paternal law, which is the only path to transformation . . . of the cruel, 'anal' sadistic Superego into the pacifying 'inner law' of the ideal Ego".[67] Instead of the *Name of the Father*, *Pathological Narcissus* often displays a *big Ego*, which blends the real

Ego, the ideal Ego and the ideal object, as a supplementary imaginary formation that compensates for a missing symbolic agency. The other is thus split between an ideal other – which functions as an extension of the subject, in the guise of an idealised other that "loses all negative characteristics and appears as an omnipotent 'good other'" providing narcissistic satisfaction – and a Real other, which "takes a 'degenerate' form of the horrifying, blind, cruel, paranoid and threatening force of the Superego, as an 'evil fate' embodied in the 'enemy' into whom the subject projects her own aggression".[68] *As-if* subjects can thus conceive of an internal critical agency only in terms of a cruel, sadistic Superego, as opposed to a neurotic structure where the pre-Oedipal split of the Other (as either good or bad) would be surpassed and integrated through the interiorised symbolic agency of the *Name of the Father*. The ideal Ego is thus directly subjected to the sadistic pressures of the Superego, with the subject exposed to unbearable anxiety, perpetually crushed between the attempt to attain narcissistic satisfaction and self-humiliation in the face of failure.

If it is obvious how Rebufa's insistence on the simulacrum, and on doubling and mirroring, exposes *Bimbeloterie* as deeply engaged with the narcissistic problem of identity, it is the structural significance of flatness and the adoption of the capitalist mythology of Barbie that render this account contemporary and post-Oedipal. On the level of the signified, Rebufa's narrative of the self-as-Barbie manages to deeply conjoin capitalism with narcissism, indeed exposing capitalism *as* narcissism. His bi-dimensional man, morphing into an interminable series of types and stretching the codes of social success, seems the perfect incarnation of a consumeristic "abnormally normal" subject affected by a pathologically conventional behaviour.[69] By linking this subjective shallowness to Barbie's capitalist mythology, Rebufa seems to echo Žižek's definition of the *as-if*'s pathological narcissism as "the prevalent libidinal constitution of late bourgeois 'permissive' society".[70] Narcissus, in the context of the injunction to enjoy of the *capitalist's discourse*, is far from being revolutionary, in this sense not the same Narcissus that, from Surrealism to a classic work such as Marcuse's *Eros and Civilization*, has traditionally been seen as a figure of subversion in relation to a liberation of *jouissance*. Rebufa exposes how the double, the mirror and the doll, traditional tropes related to Narcissus as anti-authoritarian figure of cultural resistance, have become associated with conformist compliance, indeed with duty.

In Rebufa's world, enjoyment appears to be conflated not only with conspicuous consumption and narcissistic pleasure but also with a sense of enforcement and duty, as seen in *Amour à Marseille*. We find this connection between enjoyment and duty thematised in other works, such as *Tiré par les Cheveux* (1995), *J'Ai la Pigne* (1997) and *Travaux d'Eté* (1995), where Rebufa plays the role of an instrument for the enjoyment of the Other-Barbie. The social bond with an other-as-doll emerges as either narcissistic satisfaction in social success or masochistic self-humiliation. At this point, the link to the fascist *Glass Man* appears more emblematic. Thomas Elsaesser wrote of the "pleasure of fascism" of the modern petit-bourgeois subject as the pleasure of "making a public spectacle of [one's]

good behaviour and conformism" in view of the "all-seeing eye of the State".[71] To this landscape we might have connected in the past the transparency of the *Glass Man* and the absolute visibility of a tower *panopticon* like that of *Amour à Marseille*. However, far from this modernist constellation, the imaginary exhibitionism exposed by Rebufa is certainly engaging with conformism but both the good behaviour and the State as Other who might punish self-indulgence have left the place to the conformism of enjoyment and to an *Other who enjoys*. If the *as-if* subject cannot conceive of the Social but as a game, a play of puppets, Rebufa could not find a better stand-in for this Other of enjoyment than the ever-enjoying Barbie, a friendly and kind *mistress* of consumeristic *imitation jouissance* steadily and actively ensuring that everyone enjoys at all times. Barbie's iconic power as the quintessential image of the Western liberal way of life and her ideal authority over others might be seen here as a metaphor for the transfiguration of the Freudian law of libidinal repression in the contemporary return of the law in the Real – law as the necessity to enjoy which irremediably spoils any actual possibility of enjoyment. Barbie has been classically read as a cultural text based on the parental and societal demands imposed on children as the convenience of being "good".[72] Then play, in contrast to conformism, is typically associated with transgression, with the expression of a subjective "concealed inner chamber", a place of evasion from "the ascetic pretence demanded to children by the adult world".[73] However, what is transgression once the Law prescribes enjoyment? This is the question that *Bimbeloterie* asks by associating Barbie, play and a narcissistic display of enjoyment with conformism and an oppressive atmosphere of duty. In a Žižekian move, one might be tempted to read the accord between Barbie, the *Bonne Mère*'s benevolent look and the menacing *panopticon*-like aspect of the tower in *Amour à Marseille* as the embodiment of a *maternal superego*, one of several baroque formulations the philosopher has accorded over time to Superego enjoyment.[74] There is enough self-humiliation side by side with an idealised display of narcissistic success in the narrative between Rebufa's puppet-self and an imperturbably smiling Barbie to suggest this sadomasochistic constellation. Interestingly, Rebufa constructs the subject as image, exposing it as an object of the enjoyment of the Other, not only on the level of the signified. He plays the part of the puppet working hard to satisfy the Other thematically, as clearly in *Travaux d'Eté* and *J'ai la Pigne*, and structurally, on the visual relationship with the beholder. The viewer is invited to enjoy the puppet-self's display of enjoyment, thus being interpellated as a Barbie-Other who enjoys, as it were, in a jubilee of visual consumption. The gaze that this subject-image seems to call for is one which might enjoy, rather than repress, such a display of enjoyment.

On a structural level, then, the subject is image as much as the image is subject. This image must produce an affect, it seems; it must be able to produce *jouissance* for the gaze of the Other in a way that foregrounds the coincidence between the personality of the artist-as-brand and that of the artwork, both put to work in a market-oriented field of existence. Rebufa's bi-dimensional figure embodies the artist as a "corporate façade", a "casing" for a "disembodied

screen-cathected labouring brain", a wording proposed as a definition for the contemporary artist.[75] The "soul" is "at work" in contemporary capitalism, as suggested by Franco "Bifo" Berardi, echoing Lacan's view of capitalism as a system wherein "surplus pleasure" has become "calculable", "counted".[76] As Brian Massumi has pointed out, this poses fundamental, difficult questions for cultural politics:

> Capitalism starts intensifying or diversifying affect, but only in order to extract surplus-value, . . . to intensify profit potential. It literally valorises affect. The capitalist logic of surplus-value production starts to take over the relational field that is the domain of political ecology, the ethical field of resistance to identity and predictable paths. It's very troubling and confusing, because it seems to me that there's been a certain kind of convergence between the dynamics of capitalist power and the dynamics of resistance.[77]

It is this "intensification" of the modern logics of the market and individualism that defines the excessive character – the "hyper" – of the current historical moment.[78] This is another way to speak about the valorisation of *surplus jouissance* within the Lacanian *capitalist's discourse*, where *objet a* is accounted for and, as such, stripped of its unaccountable quality, its element of hindrance, that is, the death drive, the repetition of *nothing*. Everything runs smoothly in the *capitalist's discourse* – "it runs as if going on casters, it could not run better, but in fact it goes so fast that it consumes itself" – with *imitation surplus jouissance* obscuring the impossibility of *jouissance*.[79] Massumi's convergence between power and resistance points to frustration and impotence as the effects of a discourse that in its globalism is everywhere and nowhere, whose alienating effects are invisible. This also means, as Zupančič underlined, that if enjoyment is a duty, its onus lays on each individual's ability to attain it, "with the subject *deactivated* in any right to complain about the system, disabled in his antagonistic ability, if in the end he is unsatisfied".[80] This is "troubling", as Massumi puts it, because desire *feeds* into the system instead of opening the field of "resistance" to the "predictable path" of the dominant discourse. What is left of the truth of the subject once the Real is *textualised*? The skull that we encountered in *X-Rays* (*Figure 2.3*) thus not only appears as an *ersatz-punctum*, as I said earlier, but also as this fundamental imaginarisation of *objet a*, as a gap always reabsorbed in the capitalist system. Death is an image without trauma. By creating a montage between the consumeristic world of Barbie and a normative display of enjoyment – of *imitation enjoyment* – Rebufa not only thematises a general condition of subjectivity within capitalism but exposes the inefficacy of a modernist conception of art as a field alien and opposed to the machinery of the capitalist spectacle. This is the problem of individuating the role of art, of understanding what – if anything – an artwork does differently from capitalist production in a system where everything is transformed into a value.

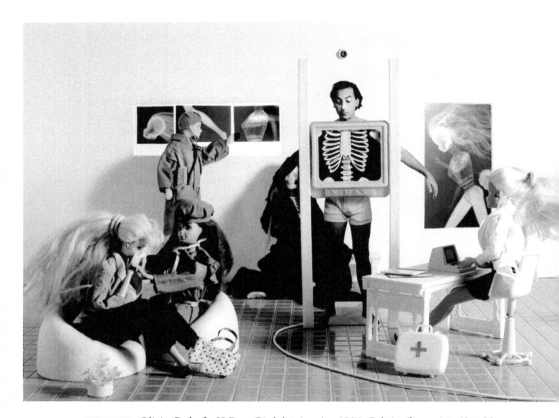

FIGURE 2.3 Olivier Rebufa, *X-Rays*, *Bimbeloterie* series, 1996. Gelatin silver print, 60 × 80 cm. © Olivier Rebufa. Courtesy of the artist.

Simulacrum interruptus: capitalist metonymy "running empty"

With his Barbie narrative of the self, Rebufa does not offer the catharsis predicated on narcissistic identification that Freud described as a dimension opposed to the reality principle – and the *capitalist's discourse* seems to provide plenty of narcissistic mirages anyway. Neither does he offer an *anamorphic* aesthetic, where the image would emerge as a limit of representation and the subject would be "punctured" by a sudden apparition of lack. Rebufa appears to have chosen the path of mimicry, of a valorisation of the image as mass *divertissement*, offering enjoyment as *ersatz jouissance*, a commercialised, spectacularised *jouissance*, plastic as the iconic Barbie: the beholder is invited to a never-ending visual banquet.[81] This image does not ask viewers to maintain the detached ironic distance so typical of earlier postmodern exercises of appropriation, as Rebufa's fascination and positive engagement with popular visual culture is tangible and inviting for the viewer. The beholder is invited to play, to be amused, entertained, to engage with the image, and we have seen how much of the historical tradition of image-games is enclosed in it. The suggestion might be that the artistic image is not different from its commercial counterpart, its pleasures not different from the edulcorated narratives of mass media and mass entertainment. At the same time, this image *is* different because it is aware of its own constructedness. With the foregrounding of the seams and gaps of montage, achieved through a sculptural contamination of photography, Rebufa's photographic image emerges as the space for the exposure of a *seamed*, rather than *seamless*, reality.

Nevertheless, this chapter has emphasised throughout how Rebufa's subjective and photographic world appears depthless. The question that seems to be raised is then whether we can have critical distance without depth, or distance with absorption, immersion in the illusion. Rebufa's aesthetic solution seems to point to the sphere of play, and the recuperation of the figure of the doll might in itself hint towards this direction: for in play, one has to be fully immersed to enjoy but at the same time to never forget that one is playing to actually enjoy it. Jameson has suggested that one possible way out from the addictive logic of the simulacrum might be "an aesthetic of cognitive mapping", through which one can map the coordinates of her world and her position within it while being immersed in it.[82] This is a cultural form that for Jameson is an expression of a "new radical cultural politics" in which we may "grasp our position as individual and collective subjects and regain a capacity to act and struggle".[83] We can see in Rebufa's work one possible description of how cognitive mapping might look, suggesting play and world-building as its equivalents. Rebufa's work is clearly not subversion, nor blind immersion, visual addiction, as much as it is reliant on a *magic circle* through play.[84] The viewer is invited to play but also to keep in mind that she is playing. There is the pleasure of playing in the activity of integrating the incongruent levels of what is represented into a meaningful whole, of finding hidden objects, of reading a story, but at the same time the exposure of the trickery, acting as a signal

"this is play".[85] There is an illusion which is at all times aware of its own devices. Miniature is traditionally regarded as a deconstructionist device, a means to make sense – Lévi-Strauss defined it as the replacement of empirical dimensions with intelligible ones, which closely approximates Jameson's effects of cognitive mapping.[86] Working in miniature implies world-building, which is a complex form of play implying mimicry of what already exists but also analysis of the connections between events and a form of synthetic knowledge through construction of novel patterns and configurations.[87]

This double edge of Rebufa's image – both illusive and aware of its illusion – seems to attempt a historicisation of "natural", seamless, ordinary reality. Each image of the series can be seen as the construction–deconstruction of the way contemporary *mythologies* are built and *naturalised*, offering a miniature Barthian-style analysis of cultural phenomena, albeit one freed from its negative critical edge. If Barthes has defined *myth* as the establishment of "a historical intention as nature, a contingency as eternity", Rebufa's foregrounding of constructedness might be seen as an attempt to expose historicity.[88] If ordinary reality and fantasy emerge as interchangeable, nevertheless their machinations are exposed. This would make Rebufa's image a paradoxical *historical simulacrum*, a simulacrum which foregrounds historicity against its flattening in a sequence of spectacles. In this sense, *Bimbeloterie* emerges as a spectacular theatricalisation of the challenge opened by Jameson for new aesthetic ways to resurrect the "retrospective dimension indispensable to any vital reorientation of our collective future" that he saw disappearing, precisely as an effect of the "multitudinous photographic simulacrum" – a homeopathic cure, as it were, with the poison as a treatment.[89]

But what exactly is historicity here? I have mentioned the cultural stratification of the sources, affectively appropriated, and the valorisation of the gaps within the image. However, any attempt to historicise must take into account the subjective structures implicated in a given discourse. Having spoken of the *capitalist's discourse* and of a narcissistic sado-masochistic visual dynamic replicated through the image, one would think that the possibility of play, of a (symbolic) creative engagement with the image, would be excluded. With the image inserted within the *capitalist's discourse* and thus implying a capitalist subject, historicisation must be actualised as hystericisation, which is simply a synonym of subjectivisation – as Žižek put it, "subjectivity as such is hysterical, in so far as it emerges through questioning the interpellating call of the Other".[90] If the capitalist subject, like an *as-if Pathological Narcissus*, is "saturated with answers without questions", being shown incessantly "what he really wants" in the form of always-new gadgets as a way to fill the lack; if the "petrified subject" is one who "lives and acts, but doesn't think about him or herself", one "who has no questions about himself", then Rebufa's pausing on the gaps can be seen as a metaphor for a question.[91] Besides, transfiguring the world into a *maquette* appears, from a psychoanalytical point of view, as an exercise of explorative analysis and reconfiguration of the coordinates of one's world, not far from a definition of a psychoanalytic experience. With psychoanalysis recurring at many levels in Rebufa's work, we may now take the *Traversée du Miroir* as an

auspice, certainly in the form of a *boutade*, of traversing the phantasm, the psycho-analytical equivalent of enlightenment: the clarification of one's personal formula, the disarticulation of the imaginary prestiges of the I.

This is the point where we should exceed the level of the single image to look at *Bimbeloterie* in its fundamental serial format, in its interminability "since 1989". It is the serialisation of Rebufa's parade of simulacra that might lead more strongly to a point of hystericisation and thus historicity. The illusions of this narcissistic Barbie world, of these capitalist mirages of a possible satisfaction of desire, ulti-mately deflate in the metonymic movement of an inconclusive narrative in which the ultimate inconsistency of desire appears as a desire for *nothing*. It is exactly this "running empty" in the serial metonymy that can be seen to create an effect of knowledge in Rebufa's work, rather than any precise imaginary content on the level of the signified.[92] The capitalist exploitation of desire and fantasy is exposed as a never-ending, sado-masochistic up and down "since 1989". Turning narration into an atemporal space in which everything changes and everything is always the same, flattening the capitalist promise of the realisation of desire in the circular-ity of the series, we play the "game of the capitalist" with a view on the point at which its machinations lie: in an ever-returning *nothing*. Temporality here seems to appear, ultimately, as the atemporality of the drive. The drive is "what remains of desire after the image of realization has been stripped away", it is "desire without the hope of obtaining the object, desire that has become indifferent to its object".[93] In this sense, Rebufa's work has "no future", as Hervé Castanet suggested, but certainly not because of an alleged inaptitude as a "Lacanian artist" in showing a precise "progressive" content, rather because it shows desire as that which has no possibility to realise itself in the future.

Olivier Rebufa re-reads this classical trope of the Freudian uncanny, the doll in photographic form, for the era of global capitalism. With it, a concept of art as an antagonistic cultural practice is put under discussion, opening to an exploration of alternative modes of cultural politics not based on an oppositional negative critique. Through the signifier of the gap and of serial interminability, the image still man-ages to work indexically, even without *punctum*, even in its simulacral forms. It offers insight through mimicry of the system of cultural mass consumption. That is why I have dubbed Rebufa's project an exercise of *simulacrum interruptus*: we enjoy, up to a point. As artists and viewers, we are not outside the observed world but in a position to see its machinations. *Bimbeloterie* can be ultimately considered a formal attempt to strike an equilibrium between the openness of indexicality and the intentionality of iconicity in the way in which photography is contaminated through pictorial values, sculpture and performance. This formal research can then be seen as an *analogon* of a wider subjective quest towards an equilibrium between the ideal and the Real, which ultimately here emerges as metonymy, series. For this reason, Rebufa's *Self-Portraits With Dolls (Since 1989)* may never be finished. Playing with the conventions of the mask and playing with the conventions of the photograph thus emerge as the two edges of a contemporary impasse pertaining the status of doubling both in rela-tion to subjectivity and photography: *what is a subject? What is a photograph?*

Notes

1 All the images cited in this chapter can be seen on the artist's website, available at <www.documentsdartistes.org/artistes/rebufa/repro8.html>, last accessed 11.1.2020.

2 M.G. Lord has called Barbie "the most potent icon of American popular culture", with the advantage over flesh-and-bones icons of never "rotting", since perpetually reinvented by her designers. Lord, *Forever Barbie: The Unauthorized Biography of a Real Doll* (New York: Morrow and Co, 1994), 7.

3 Hybridity can mean the conjunction of pictorial and conceptual values, as in Robert Mapplethorpe and Cindy Sherman's work, for instance, or the inextricability of artistic and commercial work in the case of Helmut Newton, or the cross-contamination of sculpture and photography as in the work of Sandy Skoglund.

4 Baudrillard, *Simulations*, 5.

5 Gilles Lipovetsky *L'Ere du Vide: Essais sur l'Individualisme Contémporain* (Paris: Gallimard, 1983), 9, my translation from French.

6 *ivi*, 56.

7 *Ibid*. Two classical texts on the downfall of Protestant ethics appeared earlier in the U.S.: David Riesman's *The Lonely Crowd* (1950) and William Whyte's *The Organization Man* (1956), which focused on the passage between a "self-directed" to an "other-directed" individual, in correspondence with the development between early capitalism to corporate capitalism. In *Culture of Narcissism*, Lasch, then followed by Lipovetsky, added a third stage to this process, describing a narcissistic type in correspondence of the onset of post-industrial capitalism.

8 Scenarios are first sketched on a *carnet de note*, then made in sculptural form using cardboard, dolls and miniature equipment, and lastly photographed, destroying the model (but keeping the toys) after the shoot. This is an extremely labour-intensive photographic practice, starting from the design of the set and its construction, followed by the self-portrait being taken in the right pose and then printed to the right scale. Once the artist's figure has been cut out, it is inserted in the sculptural scenario from which the negative is taken and finally printed in black and white. While *Bimbeloterie* (1989–), on which I will focus in this chapter, is usually printed in a 60x80 cm format, in recent years Rebufa has also used Lambda printing, Photoshop and other digital technologies, as in *Les Avatars de Mam* (2007) and *Mes Ancêtres* (2007).

9 See Monique Yaari, "Who/What Is the Subject? Representations of Self in Late Twentieth-Century French Art", *Word & Image*, vol. 16, no. 4 (2000), 364.

10 Rebufa's take on the miniature can also be distanced, as we shall see, from Raynaud's harsh caricature impulse, from Casabere's oneiric sublimity and from the overt ideological critique implied in Laurie Simmons's feminist-inflected work of the period.

11 See, for example, Federica Muzzarelli, *Le Origini Contemporanee della Fotografia: Esperienze e Prospettive delle Pratiche Ottocentesche* (Bologna: Quinlan, 2008), 99–100.

12 Lord, *Forever*, 28.

13 On the flatness of early cinema, see Antonia Lant, "Haptical Cinema", *October*, vol. 74 (Autumn, 1995), 45–73. *Balade* can also be seen in reference to the classical use of rear projection in Hollywood cinema's driving scenes, and to its citation in 1970s and 1980s feminist-oriented works, such as Cindy Sherman's *Film Stills* and Laurie Simmons's *Color Coordinated Interiors*.

14 Rebufa, email correspondence with the author, 2.4.2017.

15 Jameson, *Postmodernism*, 18.

16 See Philippe Ariès, "A Modest Contribution to the History of Games and Pastimes", in *id., Centuries of Childhood* (London: Jonathan Cape, 1962). On miniature see also Susan Stewart, *On Longing* (Durham and London: Duke University Press, 1993).

17 Ariès, "A Modest Contribution", 69.

18 Walter Benjamin, "Surrealismo: L'ultima Istantanea sugli Intellettuali Europei" [1929] in *id., Opere Complete*, vol. 3, 210.

19 Giorgio Agamben, "Il Paese dei Balocchi: Riflessioni sulla Storia e sul Gioco", in M. Niola (ed.), *Lévi-Strauss: Fuori di Sé* (Macerata: Quodlibet, 2008), 243–244, italics in the original, my translation. Similarly, Caillois sees games as rites "without myth", rituals which, unbound from their sacred origins, have been reduced to a profane dimension. See Caillois, *Man*, 57–58. See also Ariès, *Centuries of Childhood*, 68–69.

20 Jameson, *Postmodernism*, 53.

21 Roland Barthes, *Mythologies* (New York: Noonday Press, 1991). For Barthes, "French toys *always mean something*, and this something is always entirely socialized, constituted by the myths or the techniques of modern adult life" (53, emphasis in the original). Barthes's view leaves little space for creativity, with play conceived as the mere repetition of discursive codes: "The fact that French toys *literally* prefigure the world of adult functions obviously cannot but prepare the child to accept them all, by constituting for him, even before he can think about it, the alibi of a Nature which has at all times created soldiers, postmen and Vespas" (*Ibid.*).

22 See Brian Sutton Smith, *The Ambiguity of Play* (Cambridge, MA: Harvard University Press, 2001).

23 Much has been written on the cultural valences of Barbie. See, for example, Mary F. Rogers, *Barbie Culture* (London: Sage, 1999); Marlys Pearson and Paul R. Mullins, "Domesticating Barbie: An Archaeology of Barbie Material Culture and Domestic Ideology", *International Journal of Historical Archaeology*, vol. 3, no. 4 (December, 1999), 225–259; Erica Rand, *Barbie's Queer Accessories* (Durham, NC: Duke University Press, 1995).

24 Manson distinguishes the *poupée-model* from the *poupée-jouet*. As a fashion doll, Barbie finds an old lineage in the Renaissance doll models that would travel between courts as models of luxury and national garment, often part of negotiations and diplomatic exchanges. See Juliette Peers, *The Fashion Doll: From Bebé Jumeau to Barbie* (Oxford and New York: BERG, 2004).

25 Danos, *La Poupée*, 82.

26 *Ibid.*

27 Ariès, "A Modest Contribution", 68.

28 This translates in practice with the structural need for accessories as a way to develop Barbie's personality, which is at the basis of Mattel's astounding commercial success, as well as an expression of child play's commercialisation. See Dan Fleming, *Powerplay: Toys as Popular Culture* (Manchester and New York: Manchester University Press, 1996).

29 Rand, *Barbie's Queer*, 65.

30 Slavoj Žižek, *The Supreme Object of Ideology* (London and New York: Verso, 2008 [1989]), 186.

31 Paul Ardenne, *Olivier Rebufa* (Paris: Baudoin-Lebon, 2006), 56. Similarly, Nathalie Viot in *Olivier Rebufa: Le sens du modèle* (1995) describes Rebufa's tableaux as "tiny dreamed sequences" (12), my translation.

32 See S. Freud, "Psychopathic Characters on the Stage", in *id.*, *The Standard Edition of the Complete Psychological Works of Sigmund Freud: Volume VII (1901–1905): A Case of Hysteria, Three Essays on Sexuality and Other Works*, trans. James Strachey (London: Vintage, 2001 [1953]), 305–310.

33 Paul Verhaeghe, "From Impossibility to Inability: Lacan's Theory on the Four Discourses", *The Letter: Lacanian Perspectives on Psychoanalysis*, no. 3 (Spring, 1995), 96.

34 I use the term "pasticcio" here not to mean "pastiche" in the way Richard Dyer employs it, although the latter derives etymologically from the former. In Italian, pasticcio is a dish which combines different ingredients, often roughly. The term thus might help here to indicate the way Rebufa's combination maintains the character of its original component parts. See Richard Dyer, *Pastiche* (London and New York: Routledge, 2006), 9–21.

35 Anatomy and portrait as a historical art genre are strictly interconnected. Renaissance painters such as Leonardo da Vinci, Raffaello and Michelangelo had *compositio*,

anatomical study, regularly performed on cadavers. On the other hand, in anatomy treatises such as Andreas Vesalius's *De Humani Corporis Fabrica* (1543), one can find an attempt to aestheticise anatomic investigation, through a theatricalisation of the *écorché*, for instance, often represented in the poses of a living body, among natural backgrounds or historic settings. See Sara Ugolini, *Nel Segno del Corpo: Origini e Forme del Ritratto Ferito* (Napoli: Liguori Edizioni, 2009).

36 Stefano Ferrari has written of self-portrait as "psychic acrobatics", seen to emerge as a reverse move from the dynamics of identification with the image described by Lacan in the mirror stage. See Stefano Ferrari, *Lo Specchio dell'Io: Autoritratto e Psicologia* (Bari and Roma: Laterza, 2002), 177.

37 Sigmund Freud, *The Interpretation of Dreams* [1900], eds. James Strachey and Angela Richards (Harmondsworth: Penguin, 1991), 224. In the dream, dating to around 1899, he is in a lab working on the dissection of his own lower body, being both dissector and dissected, an operation which he takes to signify his own self-analysis as a "psychic dissection". Freud, moreover, often describes the decoding of dreams as "dissection" of their manifest content into smaller constituents, according to a backwards movement along the chain of associations through which the latent content had been condensed and displaced.

38 See Jonathan Sawday, *The Body Emblazoned: Dissection and the Human Body in Renaissance Culture* (London: Routledge, 1995), 117.

39 Barthes, *Camera Lucida*, 85.

40 Lacan, *The Four Fundamental*, 88. Commenting on Hans Holbein the Younger's *The Ambassadors* (1533), Lacan has described the anamorphic skeleton's head in the painting as the stain with the power "to catch in its trap the observer", literally called into the picture, and "represented here as caught" (*ivi*, 92).

41 Jameson, *Postmodernism*, 18.

42 *ivi*, 21.

43 *Ibid.*

44 *ivi*, 26–28. Jameson develops his analysis of the simulacrum hand in hand with a Lacanian account of schizophrenia. I return to this in Chapter 4.

45 On the conflictive narratives surrounding Man Ray's rayographs in the 1920s and 1930s and their relations with Dadaism and Surrealism, see Susan Laxton, "Flou: Rayographs and the Dada Automatic", *October* (Winter, 2009), 25–48.

46 Exhibited for the first time within the *First International Hygiene Exhibition* in Dresden in 1911 and in 1930, the *Gläserne Mensch* was accompanied by the *Gläserne Frau* (Transparent Woman). They were transparent life-size models of a male and female body that allowed an inspection of internal organs. See Jeffrey. T. Schnapp, "Crystalline Bodies: Fragments of a Cultural History of Glass", *West 86th: A Journal of Decorative Arts, Design History, and Material Culture*, vol. 20, no. 2 (2013), 173–194.

47 *ivi*, 184.

48 Barbie's disproportioned body has regularly been at the centre of a controversy in relation to adolescent eating disorders. See Lord, *Forever Barbie*, 226.

49 Barthes, *Camera Lucida*, 13–14; Benjamin, "Parigi Capitale del XIX secolo: I 'passages' di Parigi", in *Opere Complete di Walter Benjamin* (Torino: Einaudi, 1986), 124.

50 As is well known, the *panopticon* is a system of control, proposed by English philosopher Jeremy Bentham in 1791, which presents a space conceived as a circular array of inward-pointing cells at the centre of which would stand an observation tower with special shutters to prevent the prisoners from seeing the guards.

51 Michel Foucault, *Discipline & Punish: The Birth of the Prison* (New York: Vintage Books, 1995[1977]), 198.

52 Jacques Lacan, "Intervention sur l'Exposé de M. de Certeau: 'Ce que Freud Fait de l'Histoire: Note à Propos de 'Une Névrose Démoniaque au XVIIe Siècle: Congrès de Strasbourg (12 Octobre 1968)'", *Lettres de L'école Freudienne*, no. 7 (1969), 84.

53 Lacan, *Discours à l'Université de Milan*, 10.

54 In the *capitalist's discourse* we find a movement from (a) to $ [$a \rightarrow $$] instead of the *master's discourse*'s formula [$ <> a], where the double lozenge would indicate attraction and

repulsion, therefore the subject's relation to *jouissance* as a search for a "right" distance. See Lacan, *Discours à l'Université de Milan*, 36. See also Frédéric Declercq, "Lacan on the Capitalist Discourse", *Psychoanalysis, Culture & Society*, no. 11 (2006), 74–83; Todd McGowan, *The End of Dissatisfaction? Jacques Lacan and the Emerging Society of Enjoyment* (New York: SUNY, 2004); Colette Soler, "L'Angoisse du Prolétaire Généralisé", *Link*, no. 9 (mars, 2001), 35–41.

55 Lacan, *The Other Side*, 96.

56 *Objet a* is better described as a non-object, in so far as it is a cause-object, a pure function aimed at setting desire in motion through the supplementation of ordinary empirical objects with some unfathomable x to be staged in fantasy.

57 Slavoj Žižek, "'Pathological Narcissus' as a Socially Mandatory Form of Subjectivity", in *Manifesta 3: Borderline Syndrome: Energies of Sefence*, exhib. cat. (Ljubljana: Cankarjev Dom, 2000), 252.

58 See Massimo Recalcati, *L'Uomo Senza Inconscio: Figure della Nuova Clinica Psicanalitica* (Milano: Raffaello Cortina, 2010), 180. As a practicing psychoanalyst, Recalcati special-ises in "new symptoms", particularly anorexia, bulimia and toxicomania.

59 These are the titles of Massimo Recalcati and Charles Melman's books. See Recalcati, *L'Uomo* and Charles Melman, *L'Homme Sans Gravité: Jouir à Tout Prix* (Paris: Denoël, 2002).

60 Recalcati, *L'Uomo*, x.

61 *ivi*, 22, 182.

62 Recalcati, *L'Uomo*, 179.

63 Žižek, "Pathological Narcissus", 252.

64 Helene Deutsch, "Some Forms of Emotional Disturbance and Their Relationship to Schizophrenia", *Psychoanalytic Quarterly*, vol. 76 (2007[1942]), 133. Similar constructs can be found in Donald W. Winnicott's *false self* and Christopher Bollas's *normotic illness*. See Winnicott, "Ego Distortion in Terms of True and False Self", in *id.*, *The Matura-tional Process and the Facilitating Environment: Studies in the Theory of Emotional Development* (London: Karnac Books, 1990), 147; Christopher Bollas, *The Shadow of the Object: Psy-choanalysis of the Unthought Known* (London: Free Association Books, 1987), 146.

65 N. Wülfing, "Editorial", in *Psychoanalytical Notebooks 19*, 5.

66 See Lacan, *The Sinthome*; Miller, *La Convention d'Antibes*; and Wülfing, *Psychoanalytical Notebooks 19*. I return to the *sinthome* in *Chapter 5*.

67 Žižek, "Pathological Narcissus", 240.

68 *Ibid.*

69 Bollas, *The Shadow*, 146. See also Winnicott, "Ego Distortion", 66–67.

70 Žižek, "Pathological Narcissus", 251.

71 Thomas Elsaesser, "Primary Identification and the Historical Subject: Fassbinder and Germany", *Ciné-Tracts: A Journal of Film and Cultural Studies*, vol. 3, no. 3 (Autumn, 1980), 49.

72 See, for example, Fleming, *Powerplay*, and Alice Miller, *The Drama of Being a Child: The Search For the True Self* (London: Virago, 1995).

73 Miller, *The Drama*, 42; Fleming, *Powerplay*, 73.

74 Other formulations include "the decline of symbolic authority", "superego enjoyment" and the more colourful "phallophany of the anal father". See Žižek, *Enjoy Your Symptom: Jacques Lacan in Hollywood and Out* (New York: Routledge, 2001), 124. The "maternal superego" is too often read literally – for Robert Samuels, for instance, it means "women are being blamed for the chaotic nature of modern life", which ultimately disregards how maternal and paternal in Lacanian psychoanalysis indicate functional rather than biological positions. However, it is true that psychoanalysis has in the past played on the binary between mother and father as one between pre-symbolic and symbolic agencies. See Samuels, *New Media, Cultural Studies, and Critical Theory after Postmodernism* (New York: Palgrave Macmillan, 2010), 96.

75 Caroline Busta, "Body Doubles", in Graw, *The Return*, 45.

76 Lacan, *The Other Side*, 207. See Franco 'Bifo' Berardi, *The Soul at Work: From Alienation to Autonomy* (Los Angeles: Semiotext(e), 2009), and Alenka Zupančič, "When Surplus

Enjoyment Meets Surplus Value", in Justin Clemens and Russell Grigg (eds.), *Jacques Lacan*, 171.

77 Brian Massumi, "Navigating Movements", in Mary Zournazi (ed.), *Hope* (New York: Routledge, 2003), 224.

78 I am referring here to hypermodernity as a modification of modernity, as its consummation in a "hyperbolic spiral", as Lipovetsky put it. See Lipovetsky's chapter "Supplanting the Postmodern" in *Hypermodern Times*, 158.

79 Lacan, *Discours à l'Université de Milan*, 42.

80 Zupanĉiĉ, "When Surplus Enjoyment", 176.

81 Joanna Drucker speaks of "complicity" as a general aesthetic category in relation to post-1990s art. See Johanna Drucker, *Sweet Dreams: Contemporary Art and Complicity* (Chicago and London: University of Chicago Press, 2006).

82 Jameson, *Postmodernism*, 51.

83 *ivi*, 50, 54.

84 "Magic circle" is a metaphor used in play theory for a definition of play as a framed event. Play is generally viewed as a bounded experience, although definitions and degrees of boundedness (separateness from non-play) vary: "magic circle" (Huizinga, 1938), "frame" (Bateson, 1955), "membrane" (Goffman, 1961), "psychological bubble" (Apter, "A structural-phenomenology of play", 1991) are among the most notable definitions of such a boundary. See Johan Huizinga, *Homo Ludens: A Study of the Play Element in Culture* (London: Paladin, 1970); Gregory Bateson, "A Theory of Play and Fantasy" [1955], in Henry Bial (ed.), *The Performance Studies Reader* (London: Routledge, 2016); Erving Goffman, *Encounters: Two Studies in the Sociology of Interaction* (London: Allen Lane and Penguin, 1972); John H. Kerr and Michael J. Apter (eds.), *Adult Play: A Reversal Theory Approach* (Amsterdam: Swets & Zeitlinger, 1991).

85 Bateson discusses play as characterised by a frame introduced by "metacommunicative", intrinsic "signals". See Bateson, "A Theory of Play", 142.

86 See Claude Lévi-Strauss, *The Savage Mind* (Chicago: University of Chicago Press, 1967).

87 See, Sutton-Smith, "The Playful Modes of Knowing" [1970], in *Play: The Child Strived for Self-Realization* (Washington, DC: National Association for the Education of Young Children, 1971). Role play is also considered an "exercise of decentration" from the fixity of inherited social roles, caught between ideological interpellation and a singular re-construction of the world (see Danos, *La Poupée*, 25).

88 Barthes, *Mythologies*, 222.

89 Jameson, *Postmodernism*, 18.

90 Slavoj Žižek, *For They Know Not What They Do: Enjoyment As a Political Factor* (London: Verso, 2008[1991]), XLV.

91 Žižek, "Pathological Narcissus", 252; Colette Soler, "The Subject and the Other", in Richard Feldstein, Bruce Fink, and Maire Jaanus (eds.), *Reading Seminar XI: Lacan's Four Fundamental Concepts of Psychoanalysis* (New York: State University of New York Press, 1994), 48.

92 I am taking issue with Hervé Castanet's reading of *Bimbeloterie* here. He has argued that "the risk" correlative to Rebufa's "narcissistic love chasing its own tail might end up being a body of work that, likewise driven solely by the motor of the beloved mirrored image, would be running on empty". See Hervé Castanet, "Olivier Rebufa: Du Stéréotype Comme Style", *Art Presse*, no. 257 (2000), 39.

93 McGowan, *The End*, 28.

3

SILICONE LOVE

Photography as *de-Realisation*

After seeing how Rebufa has imbued the age-old appeal of a cultural icon such as Barbie with fresh aesthetic and critical dynamism, in this chapter we encounter a new paradigmatic figure which has emerged within the twenty-first century as a valuable device for artists to explore conventions and issues surrounding photography and subjectivity: the hyper-realistic *love doll*. This is a highly sophisticated, human-scale life-like doll principally designed for sex, a wonder of technological advancement featuring *cyber-skin* – high-quality artificial skin used in transplant surgery – an anatomically-correct body and a fully articulated posable skeleton.[1] With prices ranging from $3,000 to $30,000, love dolls have interchangeable faces and offer countless options for customisation, ranging from breast measurements and skin tone to eyeliner colour and pubic hair style. They are popular not only with *iDollators* – people, mostly men, who own love dolls for sex and companionship – but also with artists, filmmakers, amateur and professional photographers who use them as models, as in the case of Laurie Simmons's 2009 *Love Doll* series (Chapter 4), or as non-human actors, as in *Lars and the Real Girl* (Gillespie, 2007, Chapter 5).[2]

The love doll can be seen as the new avant-garde of mimetic representation thanks to the technological advancements in silicone materials and artificial intelligence (AI) that have allowed an unprecedented degree of realism in the representation of the human figure.[3] To the touch, silicone is the closest material to the effect of human skin, allowing the meticulous reproduction of every tiny detail of a human body, from the marks on the palm of hands to the consistency of female breasts. Besides physical likeness, it is also emotional verisimilitude that defines the new frontier of simulation. State-of-the-art love dolls are enhanced through robotics and humanoid software technologies, not only to give movement to the body but also to animate the face and offer more human-like emotional interaction.[4] As we shall see, emotional reciprocity is a central narrative surrounding love dolls and

their owners. At a basic level, emotional engagement is dependent on the dolls' material structure, since their heavy silicone-and-steel skeletons make these figures a decidedly persistent presence in the living space of their owners, refractory to disappearing under a bed or being enclosed in a small box like their old vinyl inflatable antecedents. The work of projection these dolls invite gives body to complex emotional environments and diverse, often conflicting, narratives. Broadly speaking, love dolls seem to offer a simplified version of human interaction, guaranteeing on one side 24/7 sexual availability and, on the other, a domestic sense of belonging. On the one hand, they seem to cater to a need to evade the emotional, social and financial commitment and obligations ascribed to committed relationships, a motive also often found in commercial sex; on the other, they are frequently associated with the emotional security customarily referred to marriage – as one iDollator put it, owning a doll is the reassuring fantasy of "coming home to someone".[5]

This chapter is concerned with a visual analysis of how this phenomenon of the life-size doll has been represented in European and American visual culture, with a focus on the photographic documentary work of French photojournalist Stéphan Gladieu, *Silicone Love* (2009, *Figures 3.1–3.2*).[6] In Gladieu's reportage, circulated widely in different forms in Europe and the United States, photographic preoccupations, sociological sensibility and psychological subtlety acquire a compelling and complex cypher which is exceptional among similar material.[7] In the course of my analysis I will refer to other media sources and particularly to another significant photographic documentary work on the theme by American photographer Elena Dorfman, *Still Lovers* (2005), which is another early, in-depth visual enquiry into the doll lovers' phenomenon after the first Real Doll was launched by Abyss in 1997.[8] Through close formal analyses of these images of men and dolls, this chapter will explore the interconnections of subjectivity and doubling there emerging and try to distil their actuality through a consideration of the historicity of *jouissance* and its organisation in the *capitalist's discourse*.

In current debates, love dolls are usually considered a transgressive fetish, an object of perversion or a misogynistic choice. In Lacanian terms, this means they are considered actors within a dynamic of transgression against the prohibition of the "paternal Law". However, once we start to consider the historicity of the formations of *jouissance*, we may find that the love doll might be better understood as an object inhabiting a situation beyond the problem of the split of subjectivity and symbolic substitution. The lens of the *capitalist's discourse* invites us to problematise and historicise the structure of the return of the repressed and the notion of fetishism, traditionally associated with loss, which in psychoanalysis is the original loss of *jouissance* that the subject is called to forgo in order to enter the social bond. As we saw in Chapter 2, the fetish, like the return of the repressed, presupposes an original moment in which the law of prohibition initiates – or attempts to initiate – lack. If the uncanny is an anxiety effect related to the emergence of *jouissance* within a (successful) neurotic alienation, the fetish is a reassuring illusion of wholeness in the face of an Other attempting to castrate the subject, to alienate her symbolically through a deprivation of *jouissance*. What becomes of the fetish once

there is not an Other "to do" the prohibition, substituted by an Other who instead demands enjoyment, as in the *discourse of the capitalist*? What becomes of dolls and doubles once fetishism has lost its transgressive value?

With its complex visual and thematic world, *Silicone Love* exposes the complications related to these notions in relation to popular assumptions surrounding the figure of the erotic doll and the men who live with them. One particularly persistent perception sees the doll as a woman-substitute – *Guys and Dolls* (Holt, 2006), for instance, opens with the consideration that "there are now three thousand Real Dolls in the world providing love and companionship that real women *cannot*".[9] Often such a direct equivalence between dolls and women is followed by the implication that iDollators are women haters, as suggested by French psychologist Elisabeth Alexandre, who produced one of the first documentaries on the phenomenon in 2002, *Eves de Silicon*, in collaboration with Elena Dorfman. Alexandre sees doll owners as a "direct line of a fundamental mythological group . . . interested in woman creation", that is to say Pygmalion-like misogynists only able to deal with an "artificial woman" who is "'perfect' and agrees to whatever her man desires".[10] A reference to the old tale of Pygmalion and its misogynistic implications is still vigorous and popular in the media, explaining the opposition the phenomenon receives in public opinion, particularly from women.[11] The love doll appears, in this view, as an ameliorated woman embodying a reassuring and submissive feminine subject, a beautiful and docile instrument without self-determination, as an alternative to sexually active and liberal contemporary "real women".[12]

If the various editorial texts accompanying Gladieu's photo-reportage seem to play on similar lines, a formal visual analysis of this documentary suggests that the doll might in fact be something different than a woman-substitute. With its sophisticated formal devices and rich network of cultural citations, *Silicone Love* puts a frame around a subculture as much as around the act of producing its image, avoiding exploitation while revealing a personal voice about the world observed. As we shall see, there is in Gladieu's documentary a reflective focus on the role of images in constructing versions of reality and a play between the attempt to reveal a portion of the world and the exposure of a personal lens on that world that challenges traditional conventions of documentary photography and its orthodox pretences to offer a faithful representation of an unmediated reality.

Documentary as "purposeful" pictorialism

Silicone Love is a pictorial photo-reportage, but its pictorialism is not only a formal issue, reflecting broader trends and changing practices in documentary photography. The reportage's appearance in various combinations of image and text across different media platforms in this sense is also the effect of the contemporary dominance of stock agencies, such as *Getty Images*, which collect and distribute archive images, selling image rights worldwide to news organisations through monthly subscriptions. While until the 1970s printed magazines such as *Time*, *Life* and *Paris Match* had the financial capacity to pay various photographers to work on

the ground, in recent decades, with the disappearance of those traditional printed forums and the rise of social media as an alternative source for information and news images – so-called citizen journalism – documentary photography has struggled to find suitable avenues for publication. At the same time, it has found new audiences in art galleries and museums and, through this hybridisation with the field of art photography, formal and aesthetic qualities have come to define more recent documentary work, with the idea of photographers being not just people who break the news but also storytellers. Gladieu's own trajectory as a photojournalist, which began in the 1980s documenting the lives of people in areas of conflict and has only recently gravitated towards the production of sociological stories, is paradigmatic of such mutated conditions in the field.[13] Riveting in its offering of non-mainstream content, *Silicone Love* at the same time appears distinctly sophisticated in form, paradigmatically emerging in this sense as a documentary photographic practice that seems to strive for a balance between marketability and social critique, pictorial aestheticisation and factual representation, artistic appeal and documentary value.

We can observe how in Gladieu's documentary there is an attempt to expose complexity in the choice of articulating the love doll's spaces of consumption with those of production and, in terms of style, the coupling of varied representational strategies. As we shall see in some detail, a seemingly unmediated documentary representational mode, typically associated with the foregrounding of the dolls' ordinariness as mere objects, is interweaved with a more aestheticised style of representation used to suggest the dimension of fantasy, fundamental to understand a world gravitating around the possibility to animate dolls in imaginary scenarios. Around the issue of animation, the question of fetishism becomes relevant. The field of production is exposed in a group of images depicting a world of men and de-fetishised commodities. In the series' images of the factory – the Californian company Abyss – the doll emerges as a mere object within a network of material relationships.[14] Male workers are depicted at work, never directly looking at the camera, absorbed in manufacturing silicone female bodies: a man is painting one doll's nipple areola, another is trimming excess material from a doll's hand, others are carefully checking on ankles of half-formed dolls hanging from chains. Emphasis is put on the men's careful, concentrated attitude and the sheer multitude of headless, big-busted female forms which surround them, often visually intruding in the foreground. Through a conventional, seemingly un-posed documentary style, Gladieu offers visibility to material production and ordinary working conditions, counteracting what Buchloh described as a general condition of Western "self-declared post-industrial and post-working class society", namely the "(im) possibility of an iconography of labour" in contemporary visual culture.[15] If commodity fetishism is traditionally defined as the displacement of social relations into relations between objects, here dolls appear as objects languishing rather than "abounding in metaphysical subtleties", with their insertion in a precise system of production pre-empting them of any possibility of fetishisation.[16] This is significant when we compare the depiction of the factory in *Silicone Love* with that of other documentaries, such as Elena Dorfman's *Still Lovers*, where the same subject

of female forms hanging from chains is abstracted from the action of production, with the effect of turning the factory into a desolate scene of female objectification, spectralised through the absence of human life.[17] By contrast, Gladieu's choice to display human labour, when articulated with other images in the series, exposes the dolls as uncomplicated mere artifacts, deprived of "a life of their own".[18] However, if labour is shown, the dolls' sexual apparatus is emphatically on display for the viewer, suggesting that such a gained visibility of labour is in need of its own tricks – would these workers be equally visible were they operating on engine parts or transistors? Here, then, we find not only an affirmation on the lack of fetishistic autonomy for the doll but a question relative to authorial intentionality within a realistic depiction of facts: the information does not pre-exist the act of looking, with photography thus exposed as an act of "purposeful discrimination", as Joel Snyder put it.[19]

When engaging with the arena of consumption of the dolls, the visual field of *Silicone Love* becomes even more contradictory. We can discern three main categories of images: un-posed images of men in action with their dolls; pictorial, posed domestic *tableaux* of men with dolls; portraits of dolls, alone within the frame. Taken together, these different typologies suggest awkwardness and simulacral perfection, opening onto a rather ambiguous existential dimension, not readable through the classical construct of the Freudian uncanny and its binary opposition between neurosis and psychosis, as I shall establish. The photographs of men in action with their dolls appear candid, and as such they are an exception in a series in which the majority of the images are staged. The image of a man carrying a doll and of another undressing a doll lying on a bed, for instance, manage to capture body movement in action and expose something of the (un-orchestrated) lived moment of the subjects, with the body escaping the intentional grid of imaginary self-presentation and releasing some of its Real, affective and existential dimension.[20] Awkwardness transpires from the way these men handle the dead weight of the dolls. In the first case, clumsiness is registered as the man's neck bends unnaturally backwards and the relative inability to see in front of him due to the obtrusive physicality of the doll, with artificial light at his back reinforcing this sense of a truncated directionality. In the second, the effort of the man is again evident in the way all his body is engaged in the action of undressing the doll, which, in contrast, is lying heavily on the bed. Light concurs to create an ambience, with its flat, uniform quality generating an almost dull visual field through which the dolls are exposed in their mere factuality.

In other instances, in contrast, photography becomes a tool to elevate reality beyond its ordinariness and to construct imaginary narratives. The image of a man dancing with his doll, for example, emerges as a fantasy *tableau*, whose constructedness however is exposed. That we might find ourselves in a different dimension of reality is signalled by the blaring acidity of the orange wall, artificial as candy and saccharine as the indulgence in the fantasy that the beloved character embodied in the doll might be able to dance standing on her own feet. On the one hand, it is as if we are allowed into the man's fantasy space, while, on the other, the white cord

reminds us of the machinery needed to lift a 40-plus-kilogram dead weight, which is largely left out of frame. In this sense, the cord holds the doll on a de-fetishised factual plane, while signalling an emergence of subjectivity, for in it one can sense the photographer's authorial intervention, as interpreter of what is seen. There Gladieu is clearly indicating his presence – a pointing finger, as it were – to the constructedness of the fantasy: the doll is "alive" and a mere thing at the same time.

A similar strategy can be found in a third group of images, where the doll is isolated and "animated" in a vignette, as in the portrayal of a doll in a black nightgown holding a glass of wine while sitting on a chair. The photograph gives body to a fantasy space in which the viewer is invited to invent a personality for this character or to speculate about the story the owner has invented for her – is she a Bond girl, a killer in disguise, or maybe a bored alcoholic housewife? Light and colours, albeit enhanced, are aridly cold despite the natural light source – one of the few instances in the series, usually shot during night hours under flat, artificial light. At the same time, here too we are reminded of the fabricated nature of the *ensemble*, with the doll's portrait on the table working as an additional simulacral *mise en abyme*. The doll is the copy of a copy, whose lips may replicate those of a certain actress, the eyes of another – those actresses in turn might themselves be surgically remodelled, as is often the case, to abide by old and new standards of beauty to be found in glossy fashion magazines and social media and so on and so forth *ad infinitum*. *Silicone Love* thus seems to suggest contradictory thematic and narrative possibilities through the coordination of different and opposed formal strategies, those of a dry documentary image and a more pictorial, crafted one. In terms of style, Gladieu's fluctuation between different photographic conventions suggests that to document this reality of men and dolls might mean working through – and with – the commingling of fantasy and ordinary reality that the constant presence of these dolls in the men's everyday lives implies.

Furthermore, in this alternation between different conventions and levels of reality, we can read not only the double binary between indexical and iconic values that has traditionally defined photography but also current formal and technological preoccupations in the context of post-internet photojournalism. *Silicone Love* exposes the attempt to strike a balance between a tendency towards an aestheticising formalism and the traditional critical vocation of documentary, also as a response to an over-competitive and difficult media market. There is hence the exposure of a contradiction: one between the documentary and artistic values of the image, between the photographic document as testimony to an exact situation that leads to an exact interpretation and the artwork as a text able to allow for different interpretations. Within photojournalism in particular, this dynamic is also between openness, in the commitment towards a presentation of facts open to different interpretations, and closure, in which we sense the authorial presence of the photographer as someone who offers a possible key for the interpretation of a complex, often chaotic and meaningless, reality. Here, we touch on the fundamental metadiscursive character of the image of the doll, as a reflexive tool able to expose the problem of the ethics of information, and on the possible role of authoriality to

sustain it, with photographers thus recognised for their role in interpreting what is seen through the camera lens. As with the doll, the question of fantasy as a screen in the image is central here, with the eye of the photographer becoming a mediatory screen through which the viewer can attend to the incongruences and horrors of reality in a meaningful way, outside of visual pornography. Photography is exposed as language and the photographic image as an interpretation of reality. Through an appeal to form, dolls and photography are doubles that can either veil or cover over ordinary reality. In this tension around the role of fantasy, *Silicone Love* thus prompts interesting questions on the value of doubling in the contemporary moment, both in relation to the role of these dolls in the lives of their owners and to photography as a documentary practice.

Although pictorial, *Silicone Love* seems to avoid the trap of an over-the-top aestheticisation which would exhaust its subject matter and commodify it through the transfiguration of a document of social reality into pure image, a sheer formal aesthetic object. There is aestheticisation at work in the series but one that emerges as a means to an end rather than as an end in itself or as a mere tool for marketability and curb appeal. There is style but not "mannerism", authoriality but not "auteurism".[21] The pictorialism at work here appears not fetishistically independent from its subject matter but instrumental in revealing something of the socio-historical complexity at hand. I shall argue that it is precisely with Gladieu's use of pictorial means that we can touch on the core of the photographer's "purposeful looking" and his interpretation of the observed social reality.

A paradigm of Gladieu's purposeful pictorialism is the remarkable image of a naked, perlaceous doll lying on a bed under a print of Alexandre Cabanel's *Birth of Venus (Figure 3.1)*. The composition constructs a self-contained simulacral world whose horizon is redoubled along the line of the two female reclining figures, the doll and the Venus. Symmetry and perspective are maximally emphasised to guide the viewer's eye in the image and lose it to its hyper-formalised order. This is an image constructed to the maximum degree for the triumph it accords to the play between different visual pyramids, doubled between the image and the image within the image, which is the Cabanel. The vanishing point of the former is prolonged in that of the latter so that the eye finds itself imbricated in a simulacral *ad infinitum* movement. The idealised virginal purity of the lethargic, remissive posture of the nineteenth-century Venus is doubled, as if turned awry, in the extreme hygienism of the bloodless allure of its twenty-first-century counterpart, pointing to a cultural-historical continuity of the "problem" of female beauty, its relationship to *jouissance* and representation.

The art of Cabanel is considered the apex of academism, of Western art's preoccupation with a mimetic representation of reality, at a stage where Romanticism, naturalism and the new medium of photography advanced different versions of reality. In the period's debate, the representation of the female body appears as a mirror for the preoccupations regarding the status of the image itself, as the discussions around the various Venus figures presented at the *Salon* testify. Cabanel's Venus was on display at the 1865 *Salon*, where at centre stage was Manet's *Olympia*,

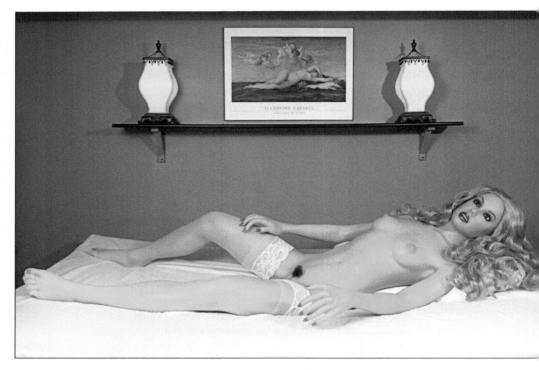

FIGURE 3.1 Stéphan Gladieu, [A naked doll lying on a bed], *Silicone Love*, 2009. Photograph. © Stéphan Gladieu. Courtesy of Getty Images.

firing debate on verisimilitude, taste and the role of myth in veiling the *unrepresentable*. *Olympia* prompted public scandal because it reconfigured the genre of the recumbent female figure through a debunking of the traditional mythologisation, still at work in the academism of Cabanel. Instead of a goddess, Manet represented a woman, a *cocotte*, looking aloof and impertinent at the same time, for her direct look confronted the (male bourgeois) viewer as if inhabiting the same space.[22] While for Cabanel's Venus image the viewer can be said to be *non-existent*, with the artwork maintaining its autonomy, Manet's Olympia image is facing its viewers, acknowledging their presence in the gallery. Crucially, in the debate of the time, the woman-as-prostitute parallels the image-as-prostitute, as an image that gives itself away too overtly to the viewer, to be enjoyed without the screen of allegory, still (although barely) keeping a veil of decency in Cabanel's *Venus*. On the other hand, from a different point of view, Cabanel's mimetic realism was also seen to give away, deemed "cloying" by *connoisseurs*, a judgement that Gombrich explained as an intellectualistic, bourgeois defence against the obviousness of the image, too despicably close to the exact likeness of photographic representation.[23] Therefore, although not "true" in the sense that Manet's naturalism purported to be – close to the real social condition of what is represented – Cabanel's *Venus* was judged too "real", too exact, therefore dull as an aesthetic experience, appealing to a "childish gratification" since the image would not stimulate an adequate effort of integration on the part of the viewer.[24] At the same time, Cabanel's Venus, while widely acclaimed, was also criticised for not being "real enough", expression of a form of beauty too abstracted from the "attraction of reality" (of real women): too "real" or too abstract, the (male painter's) image never manages to find a way to represent the *quid* of reality, of which the female body is the measure.[25]

From the point of view of psychoanalytic aesthetics, these debates point to the way in which the female body has traditionally signified the discrepancy that exists between the level of fantasy and its Real enigma, between the surfaces of representation and the depths of unrepresentability. From the perspective of my argument here, the interesting point is not much relative to the debate on the socially determined modalities of the construction of woman, but to the relationship between a phantasmatic construction and its Real core. At the centre of the epistemological congruence between the (image of) woman, the doll and the photograph is the problem of fantasy and its relationship with the unfathomability of the Real. Inherent to this entanglement is the place of the codes of beauty and their role in enabling the (impossible) visibility of the Real. This is a concern doubly relevant here for, as I have suggested earlier, it relates both to the role of the love doll in the lives of iDollators and to the photographic image. On one side there is a question on the connection between the doll and *jouissance* and, on the other, an interrogation on the relationship between the image and its beyond, the raw material of the social reality it purports to show.

From the point of view of the photographic, Gladieu's image emerges as iconically coherent in its hyperbolic symmetries, maximally constructed, and at the same time indexical, in line with Peirce's description of the index as a sign which

requires the beholder's observation to be interpreted.[26] Gladieu introduces a net-work of references that require an effort of interpretation, exposing photography's iconic coherence and indexicality. In *Silicone Love* thus we find a decisive authorial intentionality together with – rather than in opposition to – a sense of openness to the viewer, which contrasts recent considerations on digital photography as an ontologically fully intentional practice, closed to the viewer's intervention.[27] Nevertheless, we can see closure as a central aspect of *Silicone Love*. Citing the con-ventions of the traditional pictorial canon through a paroxystic internal formalism, Gladieu's image reconnects to a visual tradition focused on surface values for which the image is an expression of self-contained perfection. Symmetry and perspectival geometry are rhetorical choices that are particularly emphasised in this series and employed within a conceptual framework able to deliver thematic suggestions on what role the dolls may play in these men's lives. In one image, a man is on a sofa, reading a newspaper with two big-busted dolls beside him (*Figure 3.2*). A news-paper covers the man's face, a precaution which, if related to the photographer's will to protect anonymity, nonetheless reveals a need for protection. Even without this gesture of hiding, the issue of protection would transpire from this image all the same, since the man appears to be flanked by these robust dolls as if they were bodyguards. The fully closed blinds give the impression of a house-bunker where the closest semblance of outdoor life is a stuffed pigeon hanging on the wall, a double of the birds represented in the landscape painting, but also another instance of symmetry, with the man sitting underneath on a perfectly aligned vertical axis. The same closure to the external world can be read in another image of the same man, again flanked by doll-bodyguards, shot from the back while sitting before a computer screen. The glass window contradicts its promise of visibility by being thickly dark, doubling the black screen of the computer which, together with the usual insistence on perspective – with the vanishing point this time converging in the corner, coinciding on the axis uniting the screen and the man – suggests the self-containment of a firmly sealed world.

In all these images we can find a short-circuit between an ideal of form, exposed through a heightened use of classical composition, and the dimension of sex to which the dolls refer with their explicit offer and sexualised forms. Gladieu chooses to highlight symmetry and perspective, with its associated dream of a "fully rational – infinite, unchanging and homogenous – space" to tell a story about dolls, traditionally associated through play to the instance of a liberation of *jouissance*. Rather than in relation to Eros as subversion and revolt, as in the Freudian-Surre-alist tradition, these dolls appear in fact more concerned with a containment and rationalisation of it.[28] Perspective and composition, in this sense, convey an aspira-tion to stillness. Gladieu's paroxystic use of central perspective may be seen to point to the contradiction intrinsic in perspective itself: on one side a device of opening, with the concept of the framed painting as a window on the world; on the other a means of closure, expressing the need to encase the world into a grid, a cage, in the effort to dominate it. Writing on Paolo Uccello's exaggerated use of perspec-tive between the *Trecento* and *Quattrocento*, still far from the mature humanism of

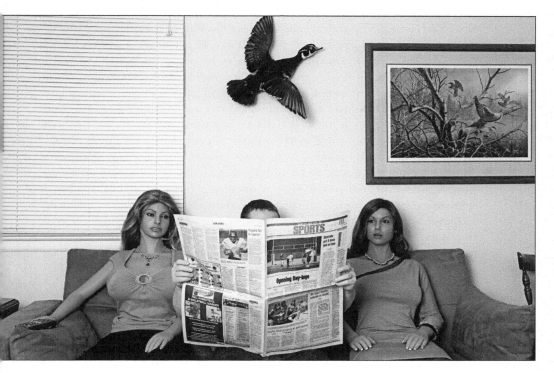

FIGURE 3.2 Stéphan Gladieu, [A man sitting on a sofa with two dolls], *Silicone Love*, 2009. Photograph. © Stéphan Gladieu. Courtesy of Getty Images.

High Renaissance, art historian Federico Zeri described it as a style that, twisting on its own mathematical rationality, has "produced images of abstract, even de-humanising, unreality".[29] Commenting on the same issue, Giorgio Vasari had already underlined how perspective, in excess, becomes a determination to "grind things too meticulously", to reduce them to a formula, with the consequence of "strain[ing] nature" and making things "sterile and difficult".[30] But Zeri also sees in such a use of mathematical composition a cypher of a broader cultural-historical moment, of the liminality of a period characterised by the demise of the mediaeval faith in a divine law as something able to provide the ultimate sense of the world, while the humanist confidence and ability to create a new order of meaning was yet to come.[31] This melancholic supra-signification of geometry suggested by Zeri may be resumed here to read *Silicone Love*, which similarly associates formal constructedness with a sense of closure. Images are usually taken indoors, under artificial light, with the level of the frame either very low, which instigates a sense of tightness, or opening onto a simulacral space, such as a wall with a stuffed bird or a TV screen. There is a compression of the visual field that creates an association between the space of the doll and a *too-full*, a sense of *horror vacui*. Artificial perfection – of the doll as well as of the image – is entwined with a sense of subjective vulnerability. By associating an insisted use of classical composition with self-enclosed internal spaces, acidity of colours and dull artificial light, *Silicone Love* suggests a sense of seclusion, as well as revealing a certain existential rigidity, a subjective intent to detach from an external, threatening reality. In the following section, I turn to the late Lacan to see how this visual proposition might be read in relation to contemporary structures of subjectivity. I will compare Gladieu's formal devices with those of Elena Dorfman's *Still Lovers* and attempt to read them through a contemporary account of narcissism, contextualised within the post-Oedipal terms of the *capitalist's discourse*.

Diet Pink Lemonade: the illusion of an *other without Other*

Gladieu's dolls are often phallic, assertive presences. They are portrayed sitting at the table while men wash the dishes or taking hold of the TV controller, one of the traditional insignia of the old patriarchal householder. In one image, a brunette doll is sitting on a sofa with the TV controller in her right hand while a man gives her a shoulder massage and watches Pamela Anderson fill the TV screen. Literally beheaded by the frame and with Mickey Mouse looming large on his jumper, the man is infantilised by the all-pervasive presence of monumental, hyper-sexualised female effigies. In *Silicone Love*, dolls appear to stand for gallant and charming female figures in opposition to the men's sense of closure and vulnerability. At the same time, dolls also embody vulnerability since their very structure – their sheer passive presence and dead weight – before any particular content, epitomises a demand for care. Literally, dolls function as helpless takers that are dependent on a competent caretaker – as one of the men said, "living with a doll is a lot like taking care of an invalid, you have to do everything for her".[32]

Questions of dependency, caretaking and vulnerability also acquire a rather compelling form in Elena Dorfman's *Still Lovers*, another in-depth analysis of the world of love dolls that utilises, however, very different visual strategies and thematic accents. Dorfman uses the conventions of classic portraiture to "animate" the dolls and subjectivise them, while the issue of vulnerability is narrativised through a traditional, clear-cut gender divide whereby the dolls emerge as helpless female victims and the men as dominant masters. Dorfman's dolls are either rescued by, or submissive to, dominant men. Commenting on her image of a big man carrying a voluptuous half-naked doll (*Figure 3.3*), Dorfman has adopted a rescue fantasy to frame the doll's inertia:

> to me he looks like this big bear of a guy rescuing a helpless woman, and you don't quite know what's going on. . . . You think he shouldn't be with this woman. It doesn't make sense, yet there he is, in his bedroom, and she's totally giving herself over to him.[33]

Compared to a similar image by Gladieu – the image of a man carrying a doll that I read in terms of visual dullness and existential awkwardness – the man here, in slightly low angle, is shown in control, monumental in his size and relatively at ease sustaining the weight of the doll. There is here a whole new dimension of added drama due to the contrast of natural light and shade in the room, with light converging on the white body of the doll, pointing to a fundamental aspect of Dorfman's series, that is, a focus on the dolls and their aliveness in terms of victimisation.

As if trying to replicate an iDollator's mindset, for some of whom dolls may be both alive and an instrument of sexual pleasure, Dorfman's camera oscillates between subjectivising portraits and objectifying, fragmented extreme close-ups.[34] While the first strategy creates a familiar, intimate closeness between the *doll-as-subject* and the beholder, the second can be seen to fragment the doll, offering it as a sexual object through a fixation on erotic details or through erotically charged scenes voyeuristically enjoyed, fragmented as if caught through a peephole. In medium and close-up, the *doll-as-subject* is portrayed as if returning the look of the viewer, a strategy which points to the dynamics of intersubjectivity and desire: "what does the doll want?" Through the fragmented extreme close-ups, instead, the doll appears as an object of sexual enjoyment, with the viewer absorbed in the frame, as it were, either towards a direct erotic interaction with the doll, or as a spectator-voyeur within an erotic scene.

With so many instances suggesting dominance and submission, it is impossible to miss *Still Lovers*' eroticisation. One photograph shows a doll in the foreground while the blurred figure of a man in the background is tinkering with her wrist, possibly tying her to the bed, causing the doll's arm to brusquely twist backward, in a somewhat unnatural manner.[35] The focus on the doll conveys a subjective investment in her, while her look falling downwards expresses passivity, which, added to the detail of the twisted arm, suggests a narrative of abuse. In another

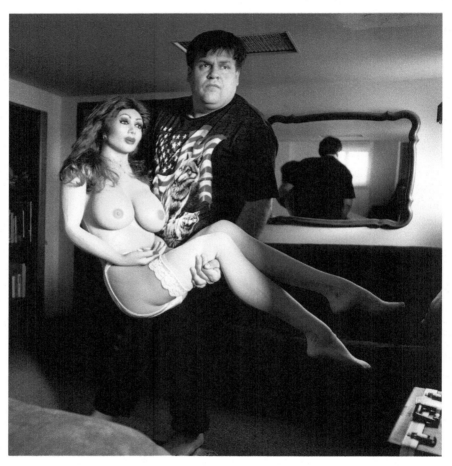

FIGURE 3.3 Elena Dorfman, *Slade*, *Still Lovers* series, 2005. Photograph. © Elena Dorfman. Courtesy of the artist.

image, a young-looking doll is portrayed in a chaste bridal dress before showing her, in the subsequent image, submissively sat on the bed with a man holding her, contained by the man's gesture.[36] These images read as fantasies of abuse within a traditional heterosexual male-to-female domination dynamic, all the more remarkable for their publication in the self-declared feminist-oriented magazine *Marie Claire*. If the essay accompanying the images pathologises doll owners as perverse "misogynists" who want to be in control of women, these images can be seen to offer the same sexual fantasy of dominance and submission to readers who, through a deferral of enjoyment to the other – it is the iDollator who animates the doll and objectifies women – can freely indulge in it.[37] The viewer is left to manage this fantasy of helplessness and dominance in her own terms, either sharing in the sexual fantasy by assuming one of the two positions in the scene, or rejecting it through a pathologisation of the men's "obvious deviancy".[38] Overall, Dorfman's visual strategies appear to work towards the construction of a fundamentally masochistic identificatory point of entry for the viewer, with the focus firmly kept on the doll as a subject acted upon by men, in turn essentialised as dominant masters. The paradigmatic case for such an identification dynamic is the image of a doll lying on a bed with the image's point of view constructed to coincide with that of the doll: the viewer-doll obliquely contemplates the disintegration of her own body in fragments in an apotheosis of self-abandonment (*Figure 3.4*). Here the severed arm and leg disturbingly appear as if belonging to the viewer, while further apprehension is suggested by the heavy artificial light and the darkness lurking beyond the two doors.

An investment in the aliveness of the dolls through the means of photography, conceived as an enabler of fantasy, is a rather typical feature of the representation of the love doll phenomenon in recent photography. Benita Marcussen is another photographer who humanises dolls in her photo-reportage *Men and Dolls* (2011–2015). Here, however, in distinct contrast to Dorfman's dramatic and rather sinister tone, the use of pastel colours, natural light and frequent outdoor staging point to the codes of the fairy tale, where men appear as naïve boys innocently playing with dolls.[39] In contrast to these works, Gladieu's approach is more ambiguous, as we have seen, offering the doll through the lens of fantasy as if alive, and at the same time disabling that fantasy potential through an exposure of the constructedness of the illusion or a focus on its simulacral qualities. Gladieu's formal choices create a contradiction between the animation of the doll in fantasy and its objective inertness, whereas Marcussen and Dorfman's use of the medium offers viewers a more consistent platform for a projection of aliveness onto the dolls.

As for vulnerability, if Dorfman focuses on the depicted men's will to mastery, Gladieu proposes a more paradoxical dynamic between men and dolls, as we have started to see: the doll is both the vulnerable other, requiring the men's mastery as caretakers, and a figure lending its body to carry ideal self-images of wholeness, as a gallant, assertive presence. *Silicone Love* advances the idea that the doll *is* and at the same time *is not* the vulnerable party, offering both a screen of projection for the subject's perceived vulnerability and a protective bulwark against external

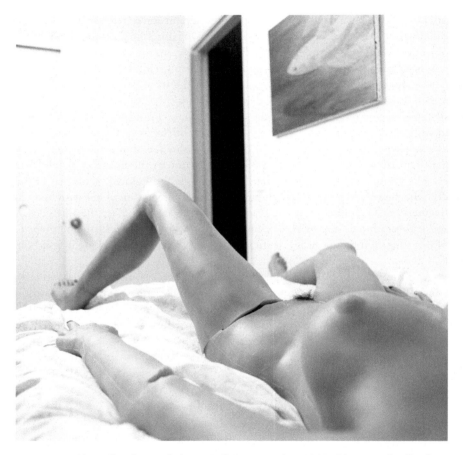

FIGURE 3.4 Elena Dorfman, *Galatea, Still Lovers* series, 2005. Photograph. © Elena Dorfman. Courtesy of the artist.

threats as an idealised personification of perfection, autonomy and assertiveness. We have seen how the photographer uses his *studium*, particularly through acidity of colours, artificial light and a heightened use of composition, to suggest how the world of the love doll might pertain to an edulcorated realm of artificiality, interdependent with the men's suggested sense of self-enclosure and vulnerability. From a psychoanalytic point of view, the love doll here seems to offer a platform for the projection of a narcissistic combination of vulnerability *and* reassurance in which the subject's actual Ego, and his ideal (good, satisfactory, unthreatening) other appear to blend. It seems that what is excluded from this composite *mélange* are the symbolic and real dimension of the other, its critical and threatening character omitted from the frame.

We shall point out that a narcissistic structure is consubstantial to the game of the doll, with projection and identification dynamics central to it, as we saw in Chapter 1. If the doll as projection of vulnerability offers to the player the possibility of self-care through the care of the other, on an ideal level the doll always embodies a self-image of success, as well as an idealised other.[40] The doll is a "domesticated other", the other as nice, kind, unassuming, always approving, easily bullied or pushed around, in the reassurance that no hurt or retaliation will be suffered as a consequence.[41] The doll-as-other embodies, as psychologist Jeanne Danos underlined, the perfect fantasy of "power for oneself and docility and receptiveness for the other", an ideal imaginary relationship which is not only fully reciprocal but also one "of sovereign to vassal", of master to slave.[42] However, when transposed onto the adult level of the love doll, the play analogy becomes somehow insufficient, since it is not an infantile narcissistic dimension that is at stake here. Gladieu's pairing of perfection and self-enclosure with vulnerability could be read instead through the construct of a reactive narcissistic subjective dimension. While men appear in these images as subjects preoccupied with protecting themselves, the doll as bodyguard might be seen as an ideal object set against a threatening, uncontrollable environment, left out of frame.

On one side, as enabler of a structure of caretaking, the love doll can be seen as the commodification of a maternal structure of love and care, one where "(what traditional ethics regarded as) the highest expression of your humanity – the compassionate need to take care of another living being – is treated as a dirty idiosyncratic pathology which should be satisfied in private, without bothering your actual fellow beings."[43] Seen this way, the love doll recuperates the ultimate of all comforting experiences, that of mothering, as a value to be circulated in the market. Cuteness is a valuable commodity, as Lori Merish underlined, one that entails the commodification of "the ritualized performance of maternal feeling".[44] Mothering and being mothered – which define an existential space of absolute love and care, indeed the apotheosis of authenticity, traditionally thought as the means to subvert capitalism's instrumentalisation – are here offered as the ultimate commodity.

From another point of view, the issue of formal control, and its exposure of a need to defend, points to the role of the doll as a device of idealised otherness set

against the intrusion of an Other of desire and *jouissance*. *Silicone Love* suggests that the doll might assist the subject in the mission to avoid the enjoyment of the Other, the (symbolic and Real) intrusion of an Other of sex and love. Far from the avant-garde doll as a figure of the emergence of *jouissance*, as a "harbinger of death", and of doubling as death of the Ego, the doll here appears as a shield against *jouissance*, a device able to maintain the Ego in a dimension of ideal purity. As opposed to doubling as "attending to one's own absence" as a way to "worship one's own dis-solution", consorting with the doll is here a version of consorting with an object devoid of otherness.[45] Instead of the ambivalence of the Freudian uncanny and its foundation in lack, we could recover Recalcati's notion of the "inhuman partner" to understand the doll's ability to cement the subject in a compact, undivided monad able to exclude the *other* as *Other*, as lack.[46] We could say that Gladieu's love doll works according to a *logic of subtraction*, with sharp geometrical coherence and aseptic beauty finding a resonance with the "style" of paranoia, which, as Recalcati put it,

> is to split the Same from the Other, by making the Other the place of a malevolent enjoyment from which the Same is required to protect itself. The defence [*difesa*] of the Same takes place thus through a hardening of its boundary, while ambivalence reveals that the boundaries (between friend and enemy) are necessarily intricate. In paranoia there is not ambivalence, in fact, but obliteration [*risoluzione*] of the ambivalence without symbolisation; an obliteration of ambivalence through unilateral denial.[47]

We may relate this passage to the formal issue of boundaries that we encountered in Chapter 1 in relation to the uncanny and photography. As we have seen, Rosalind Krauss's classical argument on the uncanny structural conditions of photography – with its discursive knot linking Bataille's *informe*, Caillois's *mimicry*, Lacan's *gaze* and Barthes's *punctum* – revolves around the concept of an obliteration of boundaries, as a strategy able to create a disturbance of the symbolic order. Instead of the lique-faction of boundaries typical of the style of the uncanny double of modernity, the hypermodern double appears with Gladieu in relation to a hardening of bound-aries, which can be considered as a non-Oedipal solution to the contemporary problem of treating the Real. *Silicone Love*'s mathematical rationality seems to work along this axis, *squeezing* the life out of the picture, with the doll shown as the enabler of an idealised dimension of pure beauty, as a defence against any possible contamination with the Real, left outside. *Silicone Love* can be seen to expose the love doll as a form of *beauty without abyss*, an exorcism of the Real, as opposed to a classical concept of beauty as an encircling of the Real, as its possible declination in form.[48] The visual and existential field of the love doll emerges here as that of the Same, as opposed to that of the Other which, from being the place of libidi-nal renunciation, becomes the place of a malignant enjoyment, "out there", from which the subject is compelled to defend.

Shielding from the Other *qua* malignant *jouissance*, left outside the frame, the doll can be seen as an object purged from ambivalence. It then becomes a haven

of safety, as an object of love (impossibly) unconcerned with enjoyment. A cypher of this movement towards *de-Realisation* – subtraction from the Real – may be the Gladieu's image of a doll associated to a sugar-free *Diet Pink Lemonade*, where what conjoins the two might be their shared mission as hypermodern commodities to administer pleasure without the destructive potential of *jouissance*. The love doll, in this sense, can be seen as a commodity delivering the promise of a "hedonist-utilitarian 'permissive' society" in which "enjoyment is tolerated, solicited even", as Žižek put it, "but on condition that it is healthy, that it doesn't threaten our psychic or biological stability".[49] Between enjoyment and pleasure, the love doll is certainly more attuned to the calculated, safe pleasures of the "enlightened hedonist" consumer, rather than to the mortiferous excess that is instead the jurisdiction of the "*jouisseur* propre", "bent on self-destruction".[50] In opposition to the standard view of iDollators as men who objectify women as objects for sex, sex might thus be the least pertinent argument to understand the phenomenon – as Gladieu has pointed out, "sex is fairly infrequent".[51] Against the messiness of *jouissance*, the doll seems to emerge as an instrument to sustain and endure the exclusion of sexed human beings through an affirmation of imaginary narcissistic wholeness, of that very privileged relationship which is the one with oneself.

The double as Ego supplement

We may consider the love doll in terms of inter-passivity, as a *pre-recorded* fantasy of sexual rapport. The doll would allow in this sense the realisation of a life unhindered by the sexual relationship with the Other, while at the same time affording these men to pass as chauvinist gritty individuals who only care about sex. The doll in this case seems to emerge not as a substitute for a woman, as it is often said, but for the (impossibility of the) sexual relationship as such.[52] We may in fact consider the love doll as the best possible realisation of the romantic fantasy of complementarity, which in the sexual relationship always *covers over* the insuperable incongruence between masculine and feminine modes of *jouissance*.[53] If Lacan has described the relationship between the sexes as *non-existent* – "*il n'y a pas de rapport sexuel*" being one of his most famous aphorisms – then the relationship with the love doll would be one which *exists*. Human intersubjectivity can be considered an effect of an ongoing failure – as Verhaeghe put it, "communication is always a failure . . . and that's the reason why we keep on talking".[54] The silence of the love doll is an indication that the problem of communication is past, that total knowledge and total understanding is achieved in the form of a *non-speaking anthropomorphous being*. In this sense, the love doll can be seen as the realisation of what Verhaeghe has called "*le dimanche de la vie*", the "Sunday of life", "where the dreamt-of perfect communication and sexual relationship would be possible".[55] In that case, "the truth would find a complete expression in the desire of the agent for the other, thus realizing the perfect relationship between those two with, as a product, the definite satisfaction which embraces the truth".[56] Here Verhaeghe is picturing the resolution of the impossibilities that characterise discourse in the Lacanian definition that we saw

in Chapter 1 – discourse as a structure of the social bond in which the agent never realises her (unconscious) truth in the place of the other, as a structure inhabited by lack. Silent and reciprocal, the "love" of the doll can be seen as the ultimate commodity, whereby the impossibility at the foundation of discourse, which is the impossibility for the subject to communicate her desire and to realise it, is side-stepped. The closure and lack of space that Gladieu suggests through heightened symmetry and composition in this sense seems to hint to – but not realise phantas-matically – such a mirage of perfect symbiosis with the other.

Conversely, on the same issue, Dorfman's documentary can be seen to ultimately transfigure the inhuman quality of the doll into a phallic dimension of desire, with photography fully realising a romantic scenario. The construction of the doll as an utterly humanised "she", who "gives herself" to the other's desire, in fact turns the narrative of domination-submission into the very ordinary play of semblances of *courtly love*, which makes up for the *non-existence* of the rapport between the sexes. Subjectivising the doll through the photographic strategies that we have seen, Dorfman makes a *Thing* out of the doll's objectual idiocy, turning its inhuman essential character into a loving subject. Instead of a repudiation of human love, dolls there appear as objects and subjects of love, instantiating the reversal from loved object to loving subject that can be seen at the basis of the event of love, where the other-as-object answers the call of the desiring subject – *consents* to the Other – thus finally subjectivising her position. Becoming a phallic object, Dorfman's dolls appear to hide an unfathomable kernel of desire beyond their silicone surface-veil. Through this change, the figure of the iDollator, which from a psychoanalytical point of view could be considered a "bachelor", someone whose libidinal position implies an asexual object, is transformed into a conventional heterosexual man: someone who makes a woman into his symptom, his object-cause of desire.[57] Through the transfiguration of the doll into a woman, Dorfman's reportage might be seen as an attempt to normalise these practices, whereby the man–doll relationship demands to be seen as analogous to a heterosexual couple, as a very ordinary imaginary comedy of the sexes.[58]

When considered jointly, Gladieu's and Dorfman's contrasting views on the figure of the doll and its lovers become instructive since, on one side, there is the depiction of the doll as an *inhuman partner* and on the other, a fantasy of ordinary heterosexual coupledom. Focusing formally on devices of control, as well as the-matically on fantasies of vulnerability and wholeness, Gladieu's reportage points to the fetishistic problem of avoiding the desire of the Other (lack), as well as to a psychotic avoidance of a threatening Real Other, and to a narcissistic functioning of the object as a supplement for a labile sense of identity. Although nothing can be said on the sociological and existential realities of doll lovers *per se*, Gladieu's photographic representation has the merit of suggesting complexity as opposed to a self-evident clear-cut definition of the phenomenon. Gladieu's aesthetics of the doll, as an object inhabiting a space of self-enclosed de-sexualised perfection, can be seen to point to a post-neurotic libidinal economy, a landscape that we can read through the terms of *the discourse of the capitalist*. In Chapter 2 we saw how

this discourse offers a framework to analyse the central place that the enjoyment object has come to assume in our contemporary civilisation, the place of "the compass", as Miller put it, in complete reversal from the modern prohibition of enjoyment as consubstantial to the Law.[59] The capitalist discourse is a discourse that sidesteps lack, promising wholeness rather than threatening separation, in line with a fetishistic strategy of negating symbolic alienation in favour of imaginary belief. However, we should ask what the meaning of fetishism in this situation is and if it can still be considered a productive notion to understand the hypermodern doll. Is the love doll a "modern fetish", as Marquard Smith suggested in his monograph on the theme, a mere contemporary version of a classical fetishist strategy?[60]

Through a reference to Pietz's anthropological notion of the fetish as a "material embodiment" rather than a "signifier referring beyond itself", Smith underlines how the contemporary erotic doll might be a thing enjoyed in its own material-ity and therefore something different to a (second-rate) substitute for a woman, a conclusion with which my own argument converges.[61] However, Smith seems to identify a subversive core in the love doll as an erotic thing that is at odds with the issues of vulnerability that we have seen conveyed in both Gladieu's and Dorfman's reportages. Smith frames the doll within a classical account of male auto-eroticism, attributing the doll to the "perversion of masturbation", seeing in it a "danger-ous supplement" able to supplant the "reproductive imperatives of nature".[62] The doll, for Smith, is an aid for "solitary pleasure" that might be "dangerous because as a perversion it replaces heterogenital coitus with a plethora of non-procreative practices and behaviours".[63] This conception of auto-eroticism as subversive is still a modernist one, Bataillan even (notwithstanding Smith's declared aversion to Surrealism), and it seems to miss the fundamental point of the historicity of the paradigms of *jouissance*.[64] Within Smith's account, the doll would be associated with a figure of the "pervert" that seems to be a lost specimen of past eras: the "pervert" as an almost mythical character in Western culture, a cypher of sublime damnation, of someone who radically contests the bourgeois social order and the Oedipal family model.[65] What we have seen so far instead points to the love doll as a figure more implicated with conformism than with subversion, with the desire to be normal rather than to be exceptional, with closure and safety rather than open-ing and danger. Both Gladieu's and Dorfman's very different accounts converge on the ascription of the love doll to a rather conformist scenario. May this point to the fact that fetishism has become something *ordinary* in the *capitalist's discourse*? What is the situational value of the doll-fetish once it is the dominant discourse itself to sustain the illusion that the object is not lost, that the plenitude of satisfaction is possible? These are the terms of the *discourse of the capitalist*, the discourse of "the end of dissatisfaction" that the contemporary figure of the doll helps to address in order to understand how the role of the fetish object has mutated from modernity to hypermodernity.[66]

If "projection of affective values, fantasmatic inversion between subjects and objects, symbolic substitution, fantasmagoria, permanent hallucination of a senti-mental nature, spectralisation" are the classical features ascribed to the fetish, where

does its creative potential lie once these elements become basic features of the dominant capitalist discourse?[67] With the subject manoeuvring her own signifiers, the symbiotic attachment between the object and the subject, the object's substitution of the authority of the old paternal metaphor and a generalised imaginarisation of experience as an effect of the dismantling of the Symbolic – what Žižek evocatively called "the plague of fantasies" – there is enough dematerialisation and imaginarisation of belief in our everyday experience to suggest that the fetish might in fact have exhausted its classical subversive role in this sense.[68] The *discourse of the capitalist* can be seen to give body to "the fetishist's magic and artful universe" described not so long ago by Janine Chasseguet-Smirgel as a dimension "giving us, for a while, the feeling that a world not ruled by our common laws does exist".[69] The Oedipal rules of the *master's discourse* setting the subject as lack of being, in turn an effect of the renunciation of full satisfaction, are precisely sidestepped in the *capitalist's discourse*, where the superego injunction points towards the more, the "want-to-enjoy", which is in fact a curse against the actual possibility to enjoy.[70] In this sense, the fate of the doll, of the fetish and the uncanny are inextricably linked, marked by a historical demise of the creative, subversive signification they held in modernity.

Gladieu's formal choices point to a movement of closure and protection against *jouissance*, which can be seen as the attempt to find a solution to the impasse of *the capitalist's discourse* and its anxiety-provoking inability to regulate *jouissance*. The love doll as protective screen can be seen as an answer to the problem of treating the Real in the context of the decline of symbolic efficiency. As Éric Laurent underlined, soon "the word 'psychosis' will be so out of sync with the spirit of the times that instead we will be speaking in terms of ordinary delusions".[71] This is because the "psychotic effort" has today become generalised in the attempt of each singular subject to treat *jouissance* through the construction of a symptom able to localise it.[72] If in neurosis the *Name of the Father* is such a symptom, limiting *jouissance* and mobilising it through *petit a* in the dynamics of desire, in the *post-neurotic* structure that is dominant in the contemporary clinic, *jouissance* is to be managed by a symptom working as a "formal envelope".[73] The closure and protection suggested by Gladieu for this world of men and dolls may be read as a subjective movement of enveloping the unbearable, an act of exclusion of the Real by a radicalisation of the boundary which creates a reassuring, framed reality. If the love doll is a fetish, it has emerged here as a purely protective function, not against an implacable castration but against a threatening *jouissance*, therefore embodying a substitute of castration in its function to sustain a minimal sense of liveable reality. In this chapter, protection has surfaced as a fundamental signifier in relation to doubling and dolls. If with Rebufa the doll appeared as a figure of capitalist *jouissance*, steeped in the superegoic pressures of enjoyment-as-Law, Gladieu's dolls have emerged within a narrative of safety, self-enclosure and protection against a Real chirurgically suppressed, left out of frame. Gladieu's foregrounding of the theme of vulnerability through a formal focus on order and control might be seen to expose subjectivity as an intent to protect through an act of will, as in an anorexic gesture. If the law of the anorexic

is total divestment as the apotheosis of a "domination of the will", to separate, to be independent from the Other, Gladieu's dolls appear similarly as an instrument enabling one to shield oneself from the intrusion of an Other who enjoys (sex and love).[74] In a complete reversal from its modernist declination as a figure of liberated *jouissance* and cultural-political antagonism against the prohibitions and limitations of symbolic law, the doll here emerges as a device of separation from the enjoyment of the Other, which affords a microcosm of security and control through an anorexic-like logic of subtraction. In command of a very manageable private world, thoroughly devoid of any hint of undecidability, Gladieu's doll lover might be seen as someone in charge of all outcomes. The aesthetic of *Silicone Love* has exposed a reassuring valence of the love doll as animating a dimension of experience whereby the subject seems able to sterilise ordinary reality and de-activate the threatening potential implied in its (Real) contingency.[75]

This is in part understandable through the frame of play, where one is always "encapsulated in a kind of psychological bubble", as play theorist Michael Apter suggested, feeling "secure and unthreatened" and overall "ultimately in charge of things" which are "freely chosen rather than an obligation or duty".[76] However, play is also generally considered an arena of unlimited possibility. If in play there is always a dialogue with the contingency of ordinary life, albeit within the safe boundaries of a protective frame, in *Silicone Love* we find the love doll as a phenomenon that seems to make of the avoidance of risk and contingency one of its main features, thus complicating a clear-cut definition.

If the *capitalist's discourse* offers enjoyment as an oppressive duty to fulfil, the love doll may be seen as an apotropaic object able to screen the subject from the anxiety this injunction produces. In this sense, the love doll could be seen as a commodity object of enjoyment which functions as a possible remedy to anxiety, in clear reversal of the traditional Freudian account of the doll as a cause of anxiety *qua* figure of the return of the repressed. Gladieu's reportage ultimately seems to expose the doll as a *heimlich* double, a crutch of the Ego, a device set as a bastion against the Real of sex, thus emerging as a highly compensative and protective, rather than subversive, figure. Far from its modernist role as a tool of deconstruction of the "privileges of the consciousness" through its connection to unconscious desire and political subversion, the doll is here a double that enhances the Ego. Gladieu's association of the doll with composition and artificial perfection suggests how the value of this figure may lay in the construction of narcissistic imaginary wholeness, as a reassuring *doppelgänger*, a narcissistic prosthesis, beyond the dynamics of the Oedipal norm.

From what has emerged so far in this book, dolls and their plays of doubling seem to have found a new place within contemporary culture, one of construction rather than deconstruction. Doubling has emerged as an imaginary protective screen enabling the subject to find a modicum of psychic consistency in a world where symbolic efficiency has ceased to afford it. In this sense, Gladieu's image of the iDollator might, in a paradigmatic form, expose a general condition of subjectivity within hypermodernity, that is to say the generalisation of the effort that is required by all in order to construct a modicum of reality. A sense of reality is

something that needs fabrication, an act of individual creation, which is a notion that Gladieu has imbued in photographic form, whereby the effort of offering information on a social reality has taken the form of contrivance, citation and artificiality. Documentary value is disentangled from the conventions of authenticity, and from a conception of unmediated photographic truth as some mythical unequivocal essence inherent in the medium. On the contrary, the photographic document has emerged as a fabricated vision, mediated by the purposeful looking of the photographer, as a route towards producing a meaningful insight into a social phenomenon. The dolls and photographs in *Silicone Love* speak of an image that before the chaos of the Real allows a space of existence, a possibility of inhabiting the inhabitable of the world.

Notes

1　Given the novelty of this phenomenon, there is limited academic research on the topic, with the internet providing the most significant and up-to-date information and commentary on it, especially in the form of online magazines and forums. On the history of fornicatory dolls, see Anthony Ferguson, *The Sex Doll: A History* (Jefferson, NC and London: McFarland & Co., 2010). On love dolls, see also Danielle Knafo and Rocco Lo Bosco, *The Age of Perversion: Desire and Technology in Psychoanalysis and Culture* (New York: Routledge, 2016); Marquard Smith, *The Erotic Doll: A Modern Fetish* (New Haven: Yale University Press, 2013).

2　A recent sociologic survey defined the identikit of the Western iDollator as predominantly white, male, middle-aged, single, heterosexual, employed and with a high school or higher degree. See Sarah Hatheway Valverde, "The Modern Sex Doll Owner: A Descriptive Analysis", MS thesis, California State Polytechnic University, 2012.

3　The doll-quality of the love doll (achieved through the attribution of larger, rounder eyes and more symmetrical faces, for instance) is still considered central among producers. They follow robot scientist Masahiro Mori's cybernetic theory of the "uncanny valley" (1970), which states that although empathy to robots increases with their human likeness, beyond a certain level of similitude, repulsion is activated, unless technological advancements can achieve a perfectly fully human appearance.

4　Abyss's Realbotix has led the industry in recent years. Launched in 2017, Realbotix presents animated head and facial features, with an Android app allowing users to create personalised avatars with customisable voices, moods and personalities.

5　Davecat (iDollator and synthetics' advocate), in "Tea Time with Davecat: Shouting to Hear the Echoes", *Womancipation*, online blog (25 June, 2013), available at <https://womancipation.wordpress.com/2013/06/25/tea-time-with-davecat-shouting-to-hear-the-echoes-part-one-2/>, last accessed 17.11.2019. Emotional reciprocity is not the only narrative surrounding love dolls. So-called *technosexuals*, gravitating within the *Alt. Sex.Fetish.Robots* community, for instance, sexually interested in machines and robots, seem to find in the love doll a robot-substitute or the promise of future technological possibilities to come. For an appraisal of the phenomenon within this context, see, for example, *The Mechanical Bride* (Allison de Fren, 2012) and David Levy, *Love and Sex with Robots* (New York: HarperCollins, 2007).

6　Appearing first as a photo-essay with text by journalist Anne Segnès as "Real Dolls and iDollators" in 2009, Gladieu's reportage has been widely published both in print and online in European and American newspapers and magazines. See the full reportage on the photographer's website, *Stephan Gladieu*, available at <www.stephangladieu.fr/article-10-fr/>, last accessed 4.1.2020. Other documentaries on the love doll include: *The Mechanical Bride* (Allison de Fren, 2012); *My Strange Addiction*, "Married to a Doll"

(TLC, 26.1.2011); *Taboo*, "Strange Love" (*National Geographic*, 2010), *Guys and Dolls* (Nick Holt, BBC, 2006), *Eves de Silicones* (Elisabeth Alexandre, France 3, 2002).

7 I must also admit a level of serendipity informing my choice to focus on Gladieu in this chapter, a sort of affective attachment of my own, for it was precisely my encounter with Gladieu's images on an Italian society and culture magazine in 2010 (in Andrea Scarano, "E L'Uomo Creò la Bambola" and Maddalena Oliva, "Povero Maschio", *IL Magazine: Il Sole 24 ore*, 21 June 2010, 63–72) that initially sparked my curiosity in the topic.

8 See Elena Dorfman, *Still Lovers* (New York: Channel Photographics, 2005). Initially commissioned by French women's magazine *Marie Claire*, *Still Lovers* has appeared in international publications such as *Artweek*, *The New York Times*, and the *International Herald Tribune*, besides being shown in museums and galleries and published as a monography with an introduction by French psychologist Elisabeth Alexandre, author of *Des Poupées et des Hommes: Dolls and Men: Investigation into Artificial Love* (La Paris: Musardine, 2005), which is illustrated with images from *Still Lovers*.

9 *Guys and Dolls* (Holt, 2006), my emphasis.

10 Alexandre, in Dorfman, *Still Lovers*, 9; Elisabeth Alexandre, "The Men who Have Sex with Dolls", *Marie Claire* (10.12.2007), available at <www.marieclaire.co.uk/news/ world/166117/the-men-who-have-sex-with-dolls.html>, last accessed 17.11.2017.

11 For a more nuanced, anthropological reading of the myth of Pygmalion as a tale engaging with a complex network of cultural traditions – the practice of *theogamy* and the figure of the *kolossós*, among others – see Michel Manson, "Y a-t-il un Mythe de la Poupée?", in *id.*, *Etats Généraux de la Poupée*.

12 Sometimes this reading is coupled with a feminist appraisal of the figure of the male demiurge, as in *The Mechanical Bride* (De Fren, 2012), where doll creation is seen as a cultural symptom of a historical and cultural passage from a "gynocentric" to a "patrocentric" civilisation.

13 *Silicone Love* certainly features among Gladieu's sociological works, a field of production which in recent years has included pieces on American polygamous communities, Afghan opium producers and brothel prostitutes in Nevada.

14 See these images on the photographer's website, *Stephan Gladieu*, available at <www. stephangladieu.fr/article-10-fr/>, last accessed 4.1.2020.

15 Benjamin H.D. Buchloh, "Allan Sekula: Photography Between Discourse and Document", in Allan Sekula, *Fish Story* (Dusseldorf: Richter Verlag), 191.

16 Karl Marx, *Capital: Volume 1*, trans. Ben Fowkes (Harmondsworth: Penguin, 1976), 163.

17 See this image in Dorfman, *Still Lovers*, 77.

18 Marx, *Capital*, 165.

19 Joel Snyder, "Picturing vision", *Critical Inquiry*, vol. 6, no. 3 (Spring, 1980), 509.

20 These images have not been selected to appear on Gladieu's website but are published in Oliva, "Povero Maschio", 70.

21 Allan Sekula, "Dismantling Modernism, Reinventing Documentary (Notes on the Politics of Representation)", *The Massachusetts Review*, vol. 19, no. 4 (Winter, 1978), 864. W.J.T. Mitchell has suggested that aestheticisation may work as an "ethical strategy" in documentary photography, as "a way of preventing easy access to the world [that the images] represent", which may be ultimately counterproductive in political terms. See William John Thomas Mitchell, "The Photographic Essay: Four Case studies", in *id.*, *Picture Theory: Essays on Verbal and Visual Representation* (Chicago and London: University of Chicago Press, 1995), 295.

22 For a detailed discussion on this debate, see Theodore Reff, *Manet: Olympia* (London: Allen Lane, 1976).

23 Ernst H. Gombrich, "Psychoanalysis and the History of Art", in *id.*, *Meditations on a Hobby Horse and Other Essays on the Theory of Art* (London: Phaidon, 1963), 59.

24 *Ibid.* Gombrich speaks of nineteenth-century academism, of Cabanel and the school of Bouguerau in particular, as exponents of a regressive aesthetic taste that encouraged "oral satisfaction", using the language of gastronomy to define it as a penchant for soft food as opposed to more "mature" crunchy pleasures (*ibid.*).

25 Théophile Thoré, "Le Salon de 1863", in *id.*, *Salons de W. Bürger: 1861 à 1868*, I, 373, cit. in Reff, *Manet*, 54.

26 Art historian Kris Paulsen underlined how Pierce's definition of the index is concerned with doubt rather than with epistemological certainty, with interpretation rather than with self-evidence, since it is a sign which points to something that has happened but which, for a lack of likeness to the referent, always needs interpretation. See Kris Paulsen, "The Index and the Interface", *Representations*, vol. 122, no. 1 (Spring, 2013). The anomaly of photography is to be an index that also presents a likeness to the referent, as an icon. Paulsen cites Peirce from *Philosophical Writings*: "Anything which startles us is an index, insofar as it marks the juncture of two portions of experience. Thus a tremendous thunderbolt indicates something considerable has happened, though we may not know precisely what the event was" (Charles Sanders Peirce, *Philosophical Writings of Charles Sanders Peirce*, ed. Justus Buchler (New York: Dover Publications, 1955), 108–109, cit. in Paulsen, "The Index", 95). Recent debates surrounding digital technology have sparked a rhetoric on the death of the index in photographic discourse for the assumed ability of digital images to eliminate the indexical connection between referent and sign. These interpretations are often based on a conflation between photography (which is an anomalous index, due to its iconic values) and the index, as well as a misleading interpretation of the immateriality of the digital photographic camera (the electronic light sensors of the CPD still function analogously, and electrons are indeed material entities). More fundamentally, Peirce's index is concerned with a principle of contextuality, "physical connection" rather than material causality (the index as physical trace), with the presentness of an "existential relationship" between the referent and the sign rather than historicity (a sense of pastness) and doubt rather than proof (epistemological certainty), as Paulsen underlined (Peirce, *Philosophical*, 106).

27 As in Fried, "Without a Trace" and *id.*, *Why Photography Matters*.

28 On Surrealism's "politics of Eros" as central in the poetics of the movement, see Mahon, *Surrealism*, 16.

29 Federico Zeri, "Rinascimento e Pseudo-Rinascimento", in *id.*, *Storia dell'Arte Italiana I: Dal Medievo al Quattrocento* (Torino: Einaudi, 1983), 555, my translation.

30 Giorgio Vasari, *Le Vite de' Più Eccellenti Architetti, Pittori, et Scultori Italiani, da Cimabue, Insino a' Tempi Nostri: Nell'Edizione per i Tipi di Lorenzo Torrentino Firenze 1550* (Milano: Einaudi, 1991), 257, my translation.

31 Zeri, "Rinascimento", 555.

32 Mahtek, a 45-year-old man from Michigan (USA), cited in Oliva, "Povero Maschio", 70, my translation.

33 Elena Dorfman, in Paulina Borsook, "Wired for Sex", *Paulina Borsook*, online blog, available at <www.paulinaborsook.com/wired4sex/dorfman.html>, last accessed 12.10.2017.

34 These images are available on the photographer's website, <http://elenadorfman.com/still-lovers/>, last accessed 4.1.2020. Dorfman has declared: "Sometimes I forget that the dolls are dolls. At first I was just playing along, out of respect for the owners, but ultimately it's become almost like the dolls are alive, and I apologize to them if I step on their feet. I think that's why this work is not about people having sex with their dolls. It's about their emotional lives" (Dorfman, quoted in Borsook, "Wired for Sex"). This is restated in *Still Lovers*: "I came to believe, as many owners do, that the silicon lovers can communicate, and even offer a sublime, sustained sort-of passion". See Dorfman, *Still Lovers*, 5.

35 See this image in Dorfman, *Still Lovers*, 92.

36 See these images in Dorfman, *Still Lovers*, 63–64.

37 Alexandre, "The Men". See also Dorfman, *Still Lovers*.

38 Dorfman, *Elena Dorfman*, website, available at <http://elenadorfman.com/bio/>, last accessed 3.7.2019.

39 See these images on the photographer's website, *Benita Marcussen*, available at <www.benitamarcussen.dk/projects>, last accessed 4.1.2020.

40 Danos has described dynamics of "protection" and "purification" in relation to the doll as a vulnerable self-other. See Danos, *La Poupée*, 230.

41 *ivi*, 85.

42 *Ibid.*

43 Žižek, "Risk Society and Its Discontents", *Historical Materialism*, vol. 2, no. 1 (1998), 144.

44 Lori Merish, "Cuteness and Commodity Aesthetics", in R. G. Thomson (ed.), *Freakery: Cultural Spectacles of the Extraordinary Body* (New York: New York University Press, 1996), 186. On empathy in relation to the commodity object, see also Mary Ann Doane, "The Economy of Desire: The Commodity Form in/of the Cinema", in J. Belton (ed.), *Movies and Mass Culture* (London: The Athlone Press, 1996), 131.

45 Alberto Castoldi, *Clerambault: Stoffe e Manichini* (Bergamo: Moretti & Vitali, 1994), 16.

46 See Recalcati, "Le Nuove Forme del Sintomo", in *id.*, *L'Uomo*, 141–160, my translation. I consider the issue of the inhuman partner from a different perspective in Chapter 4.

47 Recalcati, *L'Uomo*, 245, my translation.

48 The Lacanian notion of beauty as what veils the Real draws on a well-established tradition, which goes back to Nietzsche's definition of beauty as a dialectic with the "horror of the abysses" (Friedrich Nietzsche, *Opere Complete: Frammenti Postumi 1869–1874* (Milano: Adelphi, 1989), 161).

49 Slavoj Žižek, "The Impasses of Consumerism", in *Prix Pictet 05: Consumption* (Kempen: teNueues, 2014), 4.

50 *Ibid.*

51 Gladieu, *Stephan Gladieu*, website, available at <www.stephangladieu.fr/article-10-fr/>, last accessed 17.11.2019.

52 For the notion of interpassivity as "enacting substitute actions", see Robert Pfaller, *On the Pleasure Principle in Culture* (London and New York: Verso, 2014), 26. See also Slavoj Žižek, "The Interpassive Subject: Lacan Turns a Prayer's Wheel", in *id.*, *How to Read Lacan* (London: Granta Books, 2006), 22–39.

53 If masculine *jouissance* is phallic *jouissance*, to be achieved through the other's body, and always a solitary *jouissance*, feminine *jouissance* is, for Lacan, to be found beyond a phallic dynamic. While phallic *jouissance* substantiates subjective identity, feminine *jouissance* is seen as destabilising of identity. Phallic *jouissance* is not to be intended as an exclusive male requisite since it defines the reign of a logic of having, of a *jouissance* which can be accumulated, capitalised, and which is not precluded to – and today seemingly expected, even required from – women. On the absence of sexual relationship, see Jacques Lacan, "L'étourdit" [1972], *The Letter*, no. 41 (2009), 31–80; Colette Soler, *What Lacan Said About Women: A Psychoanalytic Study* (New York and London: Eurospan Distributor, 2006), 39–42, 242–243.

54 Verhaeghe, "From Possibility", 94.

55 *ivi*, 96.

56 *Ibid.*

57 For the figure of the bachelor, see Soler, *What Lacan Said*, 231–244. It is not that woman *is* the phallus but that she must resemble it if she wants to be loved (*ivi*, 31–34). Dorfman's analogy between dolls and women, however, might have the advantage of highlighting a (psychoanalytical) fundamental truth: that in order to be loved, woman, like the subject as such, can enter the other's fantasy frame only as an object – in love I am an object for the other and the other is an object for me. To enter the heterosexual *game*, woman, like the doll in Dorfman's account, elevated to the rank of the *Thing*, must take a phallic semblance, masquerading as that which can fill the lack in the other.

58 For Dorfman, these are "love affairs" of "intimate and playful" couples, in which "only one of [the participants] is human". See Dorfman, *Still Lovers*, 5.

59 Miller, "A Fantasy", 6.

60 See Marquard Smith, *The Erotic Doll: A Modern Fetish* (New Haven: Yale University Press, 2013).

61 William Pietz, "The Problem of the Fetish, I", *RES: Anthropology and Aesthetics*, no. 9 (Spring, 1985), 15, cit. in Smith, *The Erotic Doll*, 89.

62 *ivi*, 104.

63 *ivi*, 246.

64 *ivi*, 137, 346, note 5.

65 For an engaging historical account of the category of perversion within psychoanalytical institutions, see Elisabeth Roudinesco, "An Interview with François Pommier: Other Sexualities I: Psychoanalysis and Homosexuality: Reflections on the Perverse Desire, Insult and the Paternal function", *JEP: European Journal of Psychoanalysis*, no. 15 (Autumn/Winter, 2002), available at <www.psychomedia.it/jep/pages/number15.htm>, last accessed 17.11.2019.

66 "The End of Dissatisfaction" is the title of a 2004 book by Todd McGowan.

67 Massimo Fusillo, *Feticci: Letteratura, Cinema, Arti Visive* (Bologna: Il Mulino, 2012), 30, my translation.

68 'Plague of Fantasies' is the title of a 1997 book by Slavoj Žižek. See *id.*, *The Plague of Fantasies* (London: Verso, 2008[1997]).

69 Janine Chasseguet-Smirgel, *Creativity and Perversion* (London: Free Association Books, 1984), 88.

70 Jacques-Alain Miller, "A Reading of Some Details in Television in Dialogue with the Audience (Barnard College, New York April 1990)", *Newsletter of the Freudian Field*, vol. 4 (1990), 8.

71 Laurent, "Psychosis, or a Radical Belief", n.p.

72 *Ibid.*

73 *Ibid.*

74 Massimo Recalcati, "Hunger, Repletion, and Anxiety", *Angelaki*, vol. 16, no. 3 (2011), 34.

75 Valverde's sociological study has underlined the "adaptive features" of sex-doll ownership through evidence of dolls bringing "relief, security, and happiness to their owners." See Valverde, "The Modern Sex Doll", 35.

76 Kerr and Apter, *Adult Play*, 14. Recent debates on play and games, especially as a consequence of changes brought about by virtual reality, have overcome the twentieth-century conceptualisation of play, at the core of previous major contributions by Huizinga and Caillois, as "free", "pleasurable" and "safe" activity, separated from ordinary life. Play remains, however, a relatively separate sphere of activity. For Thomas Malaby, for instance, games are "socially legitimate arenas for contingency", semi-bounded cultural practices which replicate the contingency of ordinary life, from which the compelling nature of play derives. See Thomas Malaby, "Beyond Play: A New Approach to Games", *Games and Culture*, vol. 2, no. 2 (2007), 107.

4

LAURIE SIMMONS

Pictures beyond the *gaze*

We have encountered so far photographic practices that in their multiplicity of themes and codes present a decidedly hybrid character. After Rebufa's sculptural photographic performances and Gladieu's pictorial documentary, in this chapter Laurie Simmons will present us with yet another version of contemporary photography as a post-conceptualist, sculptural and pictorial practice, in this case highly concerned with the codes of the fashion and commercial image. Simmons emerged in the 1970s within the Pictures Generation presenting conceptualist, black-and-white images that attempted to defy a formal, modernist definition of photography, alongside artists such as Sherrie Levine, Richard Prince and Cindy Sherman.[1] This was a post-conceptualist generation of artists variously engaging with – and appropriating – images from media culture as a way to analyse and deconstruct the political and cultural strategies that make of any picture a construction. As we shall see in the first section of this chapter, through her career Laurie Simmons has cultivated a long-standing engagement with fashion photography, both working on commercial assignments in the industry and adopting its codes, themes and atmospheres to her own work.[2] Following the artist's engagement with dolls – from the early 4 by 5 inch *Black and White* (1976–78) and *Early Color Interiors* (1978–79) to the most recent, larger-scale images of *Underneath* (1998), *Color Pictures* (2007–09), *The Love Doll* (2009–11) and *How We See* (2015) – it is evident how the new technological possibilities of image-making developed since the 1990s have opened novel aesthetic directions both conceptually and formally in the artist's practice.[3] This development reflects a trend towards pictorialism that is observable on a broader scale in the field of contemporary art photography. Simmons's most recent large scale, digital and lavishly coloured images foreground high-production values in the past associated with the culture industry, thus not only showing new relationships between different fields of image production but also exposing a demise of the rhetorical oppositional strategies that so strongly

characterised modernist and postmodernist aesthetics and their cultural politics. One notices a visual chasm – from low to high definition images, from dark to light and coloured spaces, from gloomy and sinister atmospheres to a more luminous, albeit always complex, ambience – but also a conceptual one, which the artist herself has underlined in relation to the mid-1990s, defining it as a moment of "closing the door to thirty years of work", as the conclusion of an era in her career.[4]

The central interest of this chapter is to trace the change of this era in its formal and conceptual terms through an analysis of how the association of photography, dolls and doubling, a combination that has been largely at the centre of Simmons's career, emerges in her most recent work. The central case study will be *The Love Doll* series (2009–11), which can be considered a prominent example of a visual-philosophical reflection on an aesthetic and psychic shift occurred in the way we relate to photographic images, doubles of the human figure and simulation. The series presents sumptuous large-scale colour images of a Japanese life-size doll, set in the elegant interiors of the artist's own house in Connecticut (US). The chapter will briefly trace the artist's deployment of the figure of the doll and the structure of doubling in the miniature, black-and-white works of the 1970s and early 1980s before exploring the narrative implications and formal qualities of this recent series, where a highly constructed visual field is coupled with a focus on visual pleasure. It will demonstrate how the workings of doubling instanced in Simmons's recent image-dolls exceed a classical psychoanalytic aesthetics based on the Freudian *uncanny* and the Lacanian *gaze*, with their foundation in the Oedipal norm. If, for psychoanalysis, it is the notion of lack that inaugurates the subject and informs "how we see", I am to argue that Simmons's photography suggests how the contemporary simulacrum is to be found beyond lack, beyond the Oedipus, in a new territory where traditional psychoanalytic categories blur. By connecting visual considerations with new Lacanian theory developed in the past two decades from the clinic of the *sinthome* and the so-called *new symptoms*, I will read Simmons's image-doll as an *image-substance*, where the subject of the look is implied in a post-Oedipal relationship. By challenging a traditional consideration of visuality as field of the *gaze*, this photography invites us onto the uncharted ground of a post-Oedipal psychoanalytic aesthetics.

From "picture envy" to "the magic of the Hollywood style at its best"

When Simmons emerged in the 1970s, the boundaries between art, advertising and fashion photography had started to become more permeable. In this period, we find on the one hand the new relevance of hybrid figures of artist-photographers, such as Robert Mapplethorpe and Helmut Newton, and, on the other, fashion photographers, such as Guy Bourdin, who were beginning to borrow styles and codes from art, documentary and portrait photography for their commercial campaigns. Even so, the distance between the artistic and commercial practices of photography were still felt, with artists looking at commercial work through a sort

of "picture envy", as Simmons put it, since the level of artifice and skill attainable by the industry's financial and technological resources were still unavailable to artists working with photography.[5] This would eventually change in the 1990s, with the popularisation – and lower costs – of digital image-processing technology and the possibilities of creating and modifying images through digital camera systems and computer-based post-production tools like Photoshop, on the one side, and new visibility and market space for art photography on the other.[6]

Manoeuvring dolls in a dollhouse-space, Simmons's work has always engaged with the pleasures of composition. Colour emerged as early as 1978 in her *Early Color Interiors* and later in *Color Coordinated Interiors* (1982–83), which, with their miniature figures inhabiting dramatically lit spaces and set against bold patterned surfaces, are in strikingly clear visual conversation both with the period's more experimental fashion photography and feminist concerns on subjectivity and the representation of women in mass media. In these early series the high production values of the fashion industry are mimicked in *low-fi*, using cardboard sets, wallpaper fragments and rear projection – instead of the cut-and-paste technologies available to ad agencies – in order to create ambiences. Fashion's visual codes are put to work with a clear deconstructionist approach, particularly in relation to the use of the female figure as an element in a composition aimed at creating an atmosphere. Fashion editorials, such as Deborah Turbeville's *Bathhouse* for Vogue in 1975 and Guy Bourdin's 1976 advertising campaign *Sighs and Whispers*, can be seen to have played an active role – with their Surrealist-influenced, theatrical and dark moods, intense colour saturation and cropped compositions – in shaping Simmons's early style.[7] We may see quite punctual references between Turbeville's elegant ambiences and *Blue Tile Reception Area* (1983), for instance, with its grandiose architectural features and decorative tiles; or between Bourdin's fetishistic use of patterns and voyeuristic implant and *Purple Woman* (1978), among others, where the female figure is similarly set against flowery wallpaper and ostensively *seen*, as the aerial view suggests.

There is a strong feminist theoretical edge in the way Simmons engages with dolls in these early series. Like fashion mannequins, these female figurines are exposed as just another element of a scenography within a play of coordinated palettes, but the result *does not match*. In works such as *Blue Tile Reception Area* or *Yellow and Green Teen Room* (1983), the figures, over-imposed on a rear screen projected slide of a glamorous interior, of the kind found in home design magazines, appear at once subsumed by the space and cut off from it. Contributing to this effect is a dramatic use of light, whose sources are multiple and disconnected, which at once makes the figures stand out and veils the composition with a somewhat disquieting atmosphere. These images can be said to be post-Surrealist, for they convey a concept of simulation whereby "blending" is conceived as "an ultimately desirable state", in accordance with the terms of the death drive that we explored in Chapter 1: imitation is a function of the *gaze* and its disaggregating force on the Ego.[8] These images play on ambivalence, with the figure mobilised between appearance and disappearance. The *domestic hearth*, itself reduced to an interior design image

of artificial perfection, is exposed as a cage where the female figure is trapped in a play of semblances from which, however, it has started to disjoin, as a *corpus alienum* in the process of being expelled. As Simmons pointed out, the "feeling of artifice" in these early series served to "point out the darker subtext lurking beneath the whiteshed presentation of [that] time period", as a counterpart to media images of post-war America as young, affluent and happy.[9]

From these early *tableaux*, photography emerges as a conceptual tool for a critical scrutiny of the politics of visuality through a deconstruction of mass-media imagery, in which Simmons's generation had been raised and educated. Like many artists of the period, Simmons did not study photography but identified as an "artist using photography", in a phase wherein the medium was largely associated with Land, Body and Performance Art, as a supplement for recording art forms involving process and ephemeral events. Ephemerality is certainly conveyed in the sculptural forms of Simmons's early photography, where the *magic* of the medium was to create a credible ambience, a tangible atmosphere out of cardboard backgrounds and little dolls kept together by tape and extemporaneous props.[10]

By appropriating toys from the 1950s, Simmons's early images convey ambivalent affects. If, from the point of view of the counterculture to which Simmons belonged, these "girl toys" were seen as tools for indoctrination into the discourse of the authoritarian nuclear family, they represented at the same time affective remnants of childhood, of a personal cherished space of imagination and make-believe play, a dimension not typically found in the work of the Pictures Generation. The psychological effects of these images arise precisely in the gap between these two levels, between alienation and desire. For a post-conceptual generation of artists who grew up consuming cartoons, movies, comics and commercials, subjectivity was not the unmediated locus of selfhood that it had been for the previous generation. In line with the deconstructionist approaches of Baudrillard, Barthes, Foucault and Kristeva that were starting to disseminate in the United States at the time, the subject was considered at this point as an artificial, inauthentic aggregate of socio-political and cultural signifiers. Simmons's use of miniature dolls is in line with a reflection on the self as stereotype that colleagues such as Cindy Sherman and Richard Prince would take on, similarly, by recurring to television drama, cinema and advertising imagery to expose what in the subject is simulacrum, that is to say the subject as an infinite regress into representation.

Simmons's female toy figures in dollhouses from this period are typically read as stand-ins for feminine subjectivity. An image such as *Purple Woman/Gray Chair/ Green Rug/Painting* (1978) appears as much a statement about photography as about Woman, with the title itself suggesting this equivalence between doll and woman. This is a kind of photography which is highly conceptual, foregrounding low definition and a seemingly amateurish *mise-en-scène*. Through the exposure of technical flaws, such as inconsistencies of light and focus, this image takes distance both from the sophisticated image-making of modernist photography and its commercial counterpart. Although carrying references to painting – to the flatness of Matisse or the Nabis, for instance, in the way that different printed surfaces are associated

to flatten the visual field – the photography here is all but pictorial. The flaws and inconsistencies of scale between different patterns and objects in the image can also be seen to work in a Surrealist tradition, where the space acquires the aura of fantasy and dream, with incongruent elements condensed together. With its visual incompleteness, a strong sense of narrative is also suggested, and the viewer is invited to project motives and storylines, in an elusive search for meaning.

Shot directly from above and injected with a flat, dusky light, *Purple Woman* suggests ultimately a rather claustrophobic, sinister mood with a not-so-elusive political spin: the female figure is an icon among other icons, pinned down by the camera lens to a place of stillness and aloneness. The observer would not miss the richness of cultural references, particularly to Laura Mulvey's coeval concept of the "male gaze" to describe the way Hollywood cinema constructed visual pleasure on the exploitation of the image of the woman as spectacle – the woman as passive "image to be looked at" by a male "bearer of the look".[11] In this context, the foregrounding of the photographic image's constructedness acquired a subversive reverberation while simultaneously maintaining a critical ironic distance, both towards the texts of popular culture that were appropriated and towards the more rigorous political verve of a previous generation of women artists.

Regardless of how lightened it may be through the *naiveté* of children's toys, the subversive anti-patriarchal verve of Simmons's early work is evident, sometimes more overtly amusingly, as in *Untitled (Woman Standing on Head)* from 1976. Here the woman-doll, standing phallically upside down in a messed-up kitchen, is in dialogue with the phallic tumescence of Bellmer's dolls, as well as with the political anti-patriarchal force of Martha Rosler's *Semiotics of the Kitchen*, now a classic of conceptualist feminist work from the previous year. Like in Bellmer, the adoption of a black-and-white format and a dramatic use of light, with space characterised by extensive dark and out-of-focus areas, suggests the ambivalent visual quality of dream, with the doll here too becoming an "erectile doll", hinting to the menace of castration as a phallic proxy.[12] Like in Rosler's video piece, where an automaton-like housewife-figure going through the motions of her subjugation to kitchen work seems to suggest an alternative, castrating potential for the most ordinary kitchen utensils, here too the grimly-lit kitchen space becomes the stage for the woman-doll's random act of insurrection.

Clearly in these early series there is the attempt to foreground simplicity of means and an anti-pictorial visual field at a stage where visual pleasure was associated with female reification and patriarchal domination and, as such, to be "attacked", "left behind".[13] Here photography, in this sense, is certainly accepting the challenge launched by Mulvey in "daring to break with normal pleasurable expectations in order to conceive a new language of desire".[14] A look of 1968 revolution is superimposed on toys belonging to the previous 1950s generation, that of women who, like Simmons, came of age in the *Summer of Love*. Simmons's image at this point seems to attempt at the conceptualisation of a "female gaze", as it were, one conceived as insurrectional in its enjoyment of disruption: the "feminine" as a bone in the throat of patriarchal discourse, one that questions the interpellation

of the Other. The image creates a libidinal contradiction, suggesting the presence of the otherness of desire lurking *beyond* the veil of simulacral fabrications. There is the thematisation of the availability of the woman-image as a text to be filled with the meaning of the onlooker and the proposition of a space for transgression. The image is ambiguous, palpably incomplete with its low definition and abundance of dark spots and blurred shapes, calling for interpretation, almost as a riddle to be worked through: "what does the image mean?" as a correlative to "what does the woman want?"

The 2009–11 *Love Doll* series is certainly a continuation of the artist's life-long interest in engaging with the trope of the figure in interior, now grown full scale and inhabiting airy real-space interiors, as much as the photograph has become larger than life – all images are printed in a format of 52.5 by 70 inches, making the figure slightly bigger than the viewer in the gallery space. However, what we find here is not a mere life-size, digital re-adaptation of the early *tableaux* with dolls, since with different stylistic treatments come completely altered aesthetic effects and political import. What immediately strikes the viewer is the visual exquisiteness of this new exercise of *colour-coordinated interiors*. Consider, for instance, *The Love Doll/Day 11 (Yellow)*, displaying a beautiful Japanese-looking doll lying on the floor, featuring colour-coded clothes and accessories, or *The Love Doll/Day 9 (Shiso Soda)*, where the same doll, in an all-green outfit, is shown sunbathing in front of a window. Here we find in fact what Mulvey would have called in 1975 "the magic of the Hollywood style at its best", that is, a "skilled and satisfying manipulation of visual pleasure": the picture is a fine accord of hues, volumes and light before anything else.[15] Natural light can be seen to serve a central role in this series, with plays of light and shadows animating the space and the figure in a dramatically different way than in the past. In *Shiso Soda* we find the same trope of neatly defined shadows projected on female forms that we could have found in a Surrealist photograph at its best – we may think of Raoul Ubac's *Mannequin* (1937) or Man Ray's *Retour à la raison* (1923), for instance, where a nude female torso is similarly caught before a window – traditionally read as an instance of an uncanny "possession by space", of a subject dispossessed of its (Ego) boundaries by the emergence of *jouissance*.[16] Similarly, *Yellow* can be seen to dialogue with Cindy Sherman's 1981 *Centerfolds*, an image such as *Untitled#96*, for example, in which the horizontality of the figure and the image's format has been associated with the desublimatory effects of *base materialism*, of the *bassesse* of "carnal instincts", that is, the Real.[17] However, the shadows and horizontality found in Simmons's images could not be further removed from an impression of threat and dissolution in an all-encompassing *jouissance* for, on the contrary, they manage to catch that stillness of some sunny early afternoons in a domestic space, in which everything is calm and reassuring. It seems that the tropes are present but not their traditional psychological and political effects.

In terms of political scope, *The Love Doll* is clearly a long way removed from the anti-patriarchal mood of the work of the 1970s and the 1980s. A striking example of this situation is *The Love Doll/Day 4 (Red Dog)*, where one notices many of the

signifiers already present in 1978's *Purple Woman* – a doll on a chair and a picture on the wall. What emerges from the juxtaposition of these works is *Red Dog*'s pictorial amplification and hyper-definition insisting in the absence of the political gravity and oppositional strategies that characterise the earlier work. The golden-brown colour of the table and floor is seductively combined with the complementary purple of the chair's upholstery, in turn revived by the adjacent analogous red of the dog. The light is atmospheric, textured, while the oblique cut across the table creates a sense of motion in the scene, which gently animates the doll.[18] What is left of the old oppositional discourse has become text, a signifier to be pastiched in the internal references of the image. Here the dog, a classical signifier of the fidelity of the woman–Lady in many Renaissance paintings of bourgeois interiors, is a distant remnant of patriarchal power, reduced to cute fluffiness in its toy version. Speaking of miniature toys set around female forms, we might see here a dialogue with the phallic inflection of the many dinosaur toys that typically surround the young geishas of Nobuyoshi Araki's photography, renowned for its erotic and provocative edge and exquisite pictorialism. In the series *Kaori* (1990–2004), dinosaur toys present excrescences of male libido launched in an attack to the perlaceous splendour of a young woman, often enshrined in bloody hues of red and immobilised by the camera-phallus (as much as by the recurrent *bondage*) at the centre of tightly perspectival spaces. While Simmons's beautiful dolls seem decidedly unconcerned with the often hard-core erotic charge of Araki's flesh-and-blood geishas and with the use of the lens as an intensifier of sexual libido, it is evident that *The Love Doll* images are enthralling too, in their own way. The distance from Araki is even more evident considering Simmons's own version of the geisha motif, which, nevertheless, is no less hypnotic (*Figures 4.1–4.2*).

Organised chronologically in the form of a diary, with the progression of the days in which the relationship between artist and doll has developed, the series closes with the doll adorned with the most exquisite Japanese attire in the traditional geisha style. These final images can be seen to expose – retroactively – a general condition of the whole series: its sheer appeal to visual pleasure combined with a guilt-free exploitation of a classical trope of (alleged) female objectification, voyeuristically exposed. In contrast to Araki's flesh-and-blood geishas, often pointing their inflammatory look towards the viewer, here there is the idea of quietly entering this creature's world, usually coy in expression and incognisant of the viewer, who can see her from a very close distance without being acknowledged.[19] Simmons pointed out how she wanted to organise the series like "'the secret life of a lonely doll', a character wandering around an empty house, trying out a human existence".[20] Building on this suggestion that these images engage with categories of human/non-human and animate/inanimate will also require an exploration of how they do so in a very different way than through the typical ambiences and structures of the Freudian uncanny. Before moving on to discuss these ideas more fully, I will conclude this section by remarking how these images emerge with a certain haptic quality, seemingly instigating a *fascinum* for something placed beyond a purely visual level. If voyeurism presupposes a distance, a sense of separation from

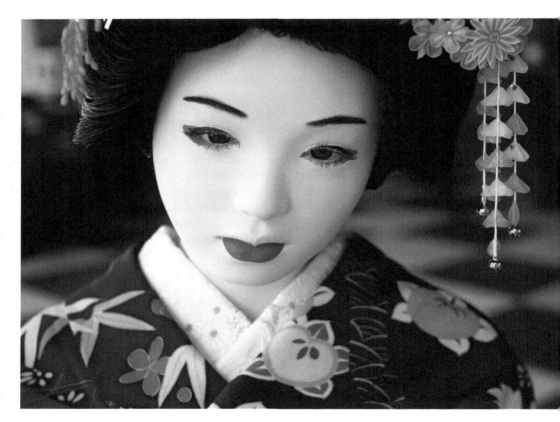

FIGURE 4.1 Laurie Simmons, *The Love Doll/Day 32* (*Blue Geisha, Close-up*), from *The Love Doll* series, 2011. Fuji matte print, 119.4 × 177.8 cm. © Laurie Simmons. Courtesy of the artist and *Salon 94*, New York.

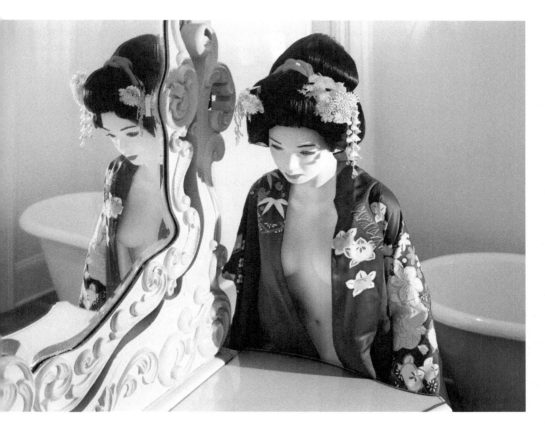

FIGURE 4.2 Laurie Simmons, *The Love Doll/Day 34* (*Blue Geisha, Dressing Room*), from *The Love Doll* series, 2011. Fuji matte print, 119.4 × 177.8 cm. © Laurie Simmons. Courtesy of the artist and *Salon 94*, New York.

what is observed – looking without being seen as a version of controlling the other reduced to an object, out of a symbolic exchange – the pleasure of looking is here, instead, built on the proximity with the object observed, a device which seems to expose a lack of separation. At the same time, the alien quality of this Japanese doll appears to frustrate the viewer's narcissistic identification as well as a sexualised look, which are the two poles found in Mulvey's argument on visual pleasure. If there is pleasure here, it does not seem to be the same pleasure Mulvey recounted in her classical reading of Hollywood cinema, where the woman-image is seen as an object of scopophilic sexual satisfaction, as an alternative to the ego-reinforcing effects implied in narrative and identification processes.[21] What kind of pleasure is then offered here? How can this ostensive lack of uncanny quality be read? How are we to understand an image that points beyond a purely visual level? In the next two sections I propose a theoretical reading of these aspects, which appear to be rather eccentric to modern and postmodern aesthetics, starting with a consideration of the series' thematic suggestions before adventuring on the structural level of a possible definition of this image.

Kawaii: the cuteness of the commodity

It would be quite difficult to read Simmons's love doll as a signifier of female subjectivity. The valorisation of surface values and visual pleasure that we find in this series can hardly be seen as a critique of the problem of femininity as *masquerade*. In the past, the *topos* of the cosmetic surface would have read as a *façade* concealing another *façade*, which psychoanalytically could point to the resistance implied in the act of feigning a *nothing* as a secret.[22] In this reading, simulation would be deception, in turn a defence of freedom, an act of female resistance against an oppressive male other. As part of such a discourse, the doll-geisha could be seen as a figure of the feminine subject as a subject of desire, beyond the accoutrements of a male-oriented performative mask. This conflation of doll and woman still maintains its currency, as we saw with Dorfman's *Still Lovers* in Chapter 3, one that is also keyed into Lynn Hershman Leeson's use of a love doll for her installation *Olympia: Fictive Projections and the Myth of the Real Woman* and its twin photographic work *Found Objects* (2007–08). In the installation, Hershman Leeson projects an image of Edouard Manet's *Olympia* on the naked body of a love doll designed to replicate the former's posture and physiognomic features, as a way to suggest "society's ongoing objectification of women".[23] Hershman Leeson's photographic series, focusing on the uncovering of the doll from its shipping crate, similarly capitalises on the doll's emotional humanness and her feminine vulnerability. The doll, photographed according to the codes of portraiture, with her look interrogated by the camera lens, for the artist appears "terrified, frightened and vulnerable".[24] Accordingly, the doll's hand is posed as if urging an intervention on the part of the viewer and the light is dramatic, animating the figure with human emotional quality.

In contrast, Simmons's formal choices signal an attempt to go beyond the classical theme of the doll as a representation of woman, as a screen onto which (male)

fantasies and desires are projected. It is precisely the *secret* behind the mask – the secret of the *nothing* of desire – which would make of the doll an object-cause of desire, that seems to be absent here. This is particularly evident in the images of the geisha, whose grace offered in hyper-definition incites, but also, paradoxically, soothes, the look. On one side, the doll is so realistic, available and consumable through the image's hyper-resolution that its visual enjoyment seems to become the main concern. It is difficult to linger here on the question "what does this mean?" since this image is so blatantly magnificent that one is rather compelled to revel in a fetishistic passion for its beauty. The image offers such a sensuous abandonment to its lavish visuality that the viewer is rather invited to become oblivious to any other type of considerations. The use of light, rendering these interiors as radiant and open as they could possibly be, clearly detaches this atmosphere from the claustrophobic space of the earlier 1980s' *Interiors*. When considering *Blue Geisha*, with its close-up of the geisha-doll, shoulders-up, filling the frame, or *Mirror*, with its instigation of nipple voyeurism, it is clear that these are images that want to seduce, to instigate pleasure through a self-conscious foregrounding of artifice (*Figures 4.1–4.2*). In contrast to Gladieu's choice of acidity of colour and monotony of light, among other means utilised to exercise an authorial reserve on the pretences of the simulacrum, Simmons's airy interiors and sapiently coordinated colours result in a resolute hymn to the seduction of beauty and the pleasures of illusion. There is clearly an appreciation for this marvel of contemporary material culture, exceptionally crafted in every minute detail, that Simmons imbues with a sense of aliveness, although not of human, let alone feminine, life.

If this doll is erotic, it is certainly an instance of a delicate, rather unthreatening eroticism. This is different to what we saw in Chapter 3, where the love doll emerged as an idealised self-other ultimately unconcerned with Eros and love through Gladieu's focus on central perspective and symmetry. The theme of purity, which in Gladieu's hyper-hygienic, cold artificiality emerged as an exclusion of *jouissance*, can be seen here in Simmons, on the contrary, as an attribute of the erotic charge of the doll, exposed through a sensuous treatment that glorifies the material sophistication of this exquisite Japanese doll. It is interesting to note how Simmons has declared her disinterest in engaging with the "creepy sexual side" of the love doll, a statement we read as a diary entry in relation to *Shiso Pepsi Green*, in which, as noticed earlier, one can see an interrupted formal reference to the Surrealist use of shadow as *invasion by space*, that is to say the *informe* of *jouissance*.[25] However, we could suspect that there is more to Simmons's declaration than (what would be a hypocritical) denial of the *actual* sexual function of the doll, displaced by a "maternal gaze", which would simply turn the doll from a sexual object into a "chaste", "adolescent", "virginal" and "innocent" subject, as some commentators have suggested.[26]

From a theoretical point of view, it is quite difficult to place this image within the terms of a traditional psychoanalytic aesthetic. Is this doll-image a version of what Lacan calls in *Seminar XI* the "Apollonian", an image that appeals to the eye and pacifies the *gaze*?[27] We saw in Chapter 1 how the scopic dimension for Lacan

relates to the *gaze*, as the emergence of *objet a* as a "hole" in the picture, as opposed to the *eye*, a "form of vision that is satisfied with itself in imagining itself as consciousness".[28] Playing in this opposition between the eye and the *gaze*, that is to say between geometral vision and *anamorphosis*, the field of the Ego and of unconscious desire, art is, for Lacan, the arena where either "something is given" to the *gaze* or not, where either a satisfaction to the *gaze* is offered or not.[29] This is the traditional way psychoanalysis has defined art as a sphere in an essential relation to the empty space of unconscious desire and its foundation in lack. Is this doll-image simply on the side of the plenitude of contemplation, as opposed to the function of the *gaze*? My short answer is no, but we will need a few more theoretical twists and turns to explore why this might be the case.

A fruitful point of entry in this analysis is to consider the Easternness of Simmons's doll, since in *The Love Doll* the code of purity emerges in a dialogue between Western and Eastern cultural tropes. Japanese culture is particularly relevant for this photographic series, something suggested retroactively by Simmons's most recent engagement with *cosplay* culture, starting with the 2014 series *Kigurumi, Dollers and How We See*.[30] If the geisha is a classic Western stereotype for a sophisticated, exotic and sensual eroticism, in *The Love Doll* series Simmons combines it with another Japanese *topos*, that of the *shoujo*, the Japanese teenage girl in school uniform typically signified by white, loose socks, the same worn by the doll in *Red Dog*. However, unlike the *shoujo* that haunted Japanese culture in the 1920s and 1930s, with her threatening instability making her a figure on the edge between infantile and adult sexuality, Simmons's adolescent-looking doll is suffused with the domestication more proper to *kawaii*, a taste for infantilised, naïve prepubescent figures that can be seen as the contemporary version of the *shoujo*.[31] Smallness, naïvety, youth and dependency are some of the qualities that contemporary Japanese love dolls share with *kawaii* and that Simmons has chosen as a way to differentiate her figure from the more overtly sexualised Western counterparts, like the Abyss-branded *Real Dolls* portrayed by Gladieu. However, *kawaii* ultimately suggests a figure of "unthreatening vulnerability" – the verb *kawaigaru* meaning "providing loving care" – able to elicit a response of care in the beholder, an affective dimension that we have seen similarly recurring in Gladieu's depiction of the love doll.[32]

However, here innocence and naïvety are not only eroticised by Simmons's treatment but also coded as exotic and unfamiliar, in dialectical opposition with signs of Westernness. The signifiers of the foreignness and innocence of the Japanese doll are coupled with the American middle-class standards of living materialised in the artist's house, sometimes with an accent on commodification, implied by the presence of amasses of *stuff*: whether fashion accessories, as in *20 Pounds of Jewelry* and *Shoes*, or food, as in *Candies*, everything is rigorously *faux*, plastic or plastic-looking. If the doll, often physically burdened or encircled by commodities, can be seen to "enac[t] and indulg[e] fantasies of unnecessary excess in Western culture", as Simmons put it, it also appears to act like a child who plays at being an adult, dressing up with mommy's fashion accessories.[33] The naïvety that Simmons has chosen for the design of her doll's facial expression is intensified by the

particular architecture of the images, with the doll presented at a very close distance from the objects it is shown to carefully observe, as if these were things never seen before. The doll's childish, almost alien, characterisation creates an antithesis with the specimens of Western consumer culture it faces, where everything, from shoes to food, is ostentatiously eye-catching, colourful and sumptuous as well as artificial. The doll's ethereal Far Eastern characterisation seems to frame this encounter as the ballast of Western commodity versus the Zen quality of Asian abstraction, something almost literalised in *20 Pounds of Jewelry* by the half-lotus position of the doll sitting on the sofa.

This coding of the doll as antithetical to Western capitalist culture in part resonates with the Japanese cultural history of dolls and their association, during Japan's modernisation through Western models in the late nineteenth century, with a fascination for "objects which represented quiet and innocence, or sometimes 'immaturity'".[34] Japanese scholar Akiyoshi Suzuki argued that the naïvety characteristic of traditional Japanese dolls testifies to a national symbolic struggle against "the modern Western subject", seen as "ugly and unclean because it seemed to have staunch desire and will".[35] Against this model of subjectivity, the object emerged as what is "clean because it seemed to have no desire of gain and never to cause conflict".[36] In the same vein, the innocence of the object can be seen as a cultural trope to signify an "anti-western kind of agency", an instrument to "eradicate uncleanness".[37] This perspective historically enriches a cultural codification that can be seen at work in Simmons's doll, whose rather ethereal appearance seems to emerge as a version of Zen-like distance from worldly things – from Western consumerism in particular. Since these things, at the same time, are eye-catching and conspicuous, there seems to be a play here between attachment and distance, attraction and repulsion.[38] We can find in Simmons's love doll the paradox of a *thing* presented as a way to create a distance from another *thing*. On the one hand, this is a similar strategy to what we observed in Gladieu's *Silicone Love*, where the doll emerged as an object of *ersatz enjoyment* as a defence from a more threatening enjoyment, that of sex and the relationship with the Other. In *Shoes* (2010) – and similarly in *Candies* and *20 Pounds of Jewelry* – the amorphous amass of female footwear, itself a textbook item of male fetishism, when coupled with the doll's horizontal, *animalesque* posture, can be seen to pastiche the Bataillan conceptualisation of the *informe* as a desublimatory force able to disaggregate the symbolic verticality of the subject of language and its categories.[39] Where a Bataillan notion of a four-legged human, with its re-established mouth-anus axis, would be a way to re-affirm the force of a *jouissance* transgressive of language and the Law, the formless here appears in the amass of shoes as a capitalist imitation – not *jouissance* but *imitation jouissance*, not excess as waste but an accountable value.[40] The purity of the doll, itself an object of capitalist *imitation jouissance*, can be seen to be raised here like a shield against the ersatz formlessness of *imitation jouissance*. This dialectic between a form of enjoyment as a protective barrier against another form of enjoyment, when read on a more structural level, can open interesting questions about the way this image-geisha works in relationship with the viewer. What could it mean to speak of an

image that, like this doll, protects against a threat perceived in the Other? Here we enter the field of what could tentatively be called the *image-substance*.

Beyond the Lacanian *gaze*: the *image-substance*

Interviewed on her 1980s work, Simmons underlined the importance of her early choice of low-production values as a strategy aimed at the creation of a maximally "dumb-looking" image, as a way to foreground the viewer's ability to project her own world onto the doll and the image.[41] We have seen how previous photographic series such as *Early Black and White* and *Color Coordinated Interiors* create absences in the visual field, pointing to a lack to be filled by the viewer. On the contrary, in *The Love Doll* series the choice of hyper-definition, both in the use of a hyper-realistic, human-scale doll and of high production values, seems to work in the exact opposite direction, creating a strong scopophilic regime where the image's *fullness* satiates the viewer, apparently giving an answer rather than suggesting a question. This image-doll, in the hyper-definition and proximity of its seductiveness, fills the frame and the look with such an immediate satisfaction that any other consideration becomes redundant. The series is constructed in a diaristic form over 33 days as an account of the artist's relationship with the doll, positioned in different scenarios with details suggesting a narrative. However, the inhuman beauty of the doll, with its gigantic presence on the wall, and the polished pictorial quality of the image, can be seen to absorb all the attention: it is a compelling invitation to *Enjoy!*, before any other consideration. The image sidesteps its relationship with an external conceptual frame as well as irony, typical of postmodernism and its attempt to deconstruct dominant discursive structures.

In recent interviews, the artist has emphasised the importance of freezing life through her set-up photography, whereby artifice is seen as the possibility, for the artist as well as for the viewer, to enter a place where "time stands still".[42] Reality in this dimension is something "pristine and still and quiet and beautiful", and since it is also a dimension "devoid of people", where people are synonymous with chaos, conceptually we are not far from the existential dimension of the iDollator that we came to see in Chapter 3.[43] For Simmons, this aspiration is connected to the picture perfectness of the family photographic practice of her childhood, in the 1950s and 1960s, when "everybody was dressed up and ready to go out, or when the house was particularly clean" and she would have a "Kodak moment", framing the ordinary at its ideal and aestheticised best.[44]

Elsewhere, Simmons has also spoken of her artistic preference for photographing dolls over human beings, since with the latter she can never "arrest the kind of emotion that [she] can from a doll", as from humans she would always "get too much emotion, too much response".[45] What Simmons seems to be interested in, on the contrary, is artificiality as "a kind of repose, a kind of permanence", as a formal construction of the figure within a controllable set of light and colour.[46] In this sense, we might see this search for artificiality as the very *trait d'union* between the set-up photography of the early series and the more recent work engaging life-size

figures. The issues of *kawaii* innocence and unthreatening eroticism on which I reflected earlier resonate with this notion of repose, but then we are faced with the theoretical problem of finding a way to speak of these images as delivering repose *and* an immediate satisfaction, a form of enjoyment, at the same time. If the visual field, as psychoanalysis maintains, is always in relation to the *gaze* as *objet a*, either as a way to "trap" it or to abandon it, these images can be seen to challenge this framework with the association of beauty, measure and repose, traditionally allied to contemplation, with the field of enjoyment.[47]

To explore this question, it might be beneficial to leave psychoanalysis aside, just for a while, and turn to philology, where some of the concerns considered here have recently been addressed through the notion of "beauty-as-closure". This is an aesthetic concept introduced by Raoul Eshelman to characterise "performatism" as an epochal shift from postmodernism in terms of a new cultural paradigm marked by an aesthetics of belief.[48] Beauty-as-closure is for Eshelman an aesthetic manoeuvre actualised in the work of a generation of artists come to prominence in the mid-1990s, such as Vanessa Beecroft, Andreas Gursky and Thomas Demand. As Eshelman observed, in the work of these artists one can identify strategies of closure, devices that limit the conceptual slippage typical of postmodernism, in which the meaning of the artwork is forever deferred in a signifying regress, ultimately leading to theoretical undecidability. Eshelman recapitulates a well-established diagnosis of contemporary visuality, speaking of the diffusion of digital manipulation as the source of a new type of undecidability, one between what is "real" and what is artificially manipulated. He has suggested that through the offering of hyperbolic, artificially-created beauty, in some contemporary works a new relationship between the artist-author and the viewer is negotiated, one which enthrals the viewer within the bounds of a "constructed, closed, and categorically organized artificial field".[49] For Eshelman, the viewer is "manipulated" into a riveting visual experience, into an alluring invitation to believe, fully knowing the artificiality of what is offered. A new type of accord would then seem to emerge between author and viewer, based on a deliberate act of will to overwhelm through – and to be overwhelmed by – the work's beauty.

We can see some tangencies between this argument and current debates within photographic theory, particularly with Michael Fried's recent characterisation of contemporary photography as strong in intentionality, with artists such as Thomas Demand and Jeff Wall seen to foreground a "completeness" of the image, a "structural indifference" to the presence of the viewer.[50] These features coincide with strategies that Fried previously associated with what he called the "absorption" and "autonomy" of modernist painting, as opposed to the "theatrical" approach of Minimalism, from which contemporary photography emerges as a contemporary version of the project of high modernism. However, Eshelman's concept of beauty-as-closure emphasises a "coercive" aspect of the work, as well as a focus on the beholder's self-awareness, in a way that seems at odds with the proclaimed self-sufficiency of the modernist object. I want to pause on Eshelman's notion of coercion not only to challenge Fried's connection between modernist painting

and contemporary photography, but also to test it in relation to the mesmerising beauty of Simmons's image-dolls. Eshelman's notion of beauty is seen as a function of closure because it is found in artworks that have the power to "cut us [viewers] off, at least temporarily, from the context around . . . and force us back into the work", as the philologist has put it:

> [o]n the one hand, you're practically forced to identify with something implausible or unbelievable within the frame – to *believe* in spite of yourself – but on the other, you still *feel* the coercive force causing this identification to take place, and intellectually you remain aware of the particularity of the argument at hand.[51]

Here Eshelman seems to synthesise a modernist conception of the artwork as complete in itself – closed in its beauty – and a post-conceptual one, whereby the art form is imbued with the phenomenological ability to make the beholder conscious of her own existence. The artwork appears in its ability, on the one hand, to absorb the viewer in its internal relations and, on the other, to maintain a separation, thanks to an intellectual distance. There are three aspects emerging from this argument that I would like to engage in my own analysis of Simmons's work, namely, the issues of *coercion*, *belief* and *intellectual awareness*.

I find the argument on coercion stimulating since it brings to mind the compulsion of addictive behaviours, which has been used to describe the contemporary subject's relation to the capitalist object. In the previous chapter we encountered Recalcati's notion of the *inhuman partner* in relation to those objects of enjoyment whose consumption has bypassed symbolic elaboration, compelling the subject into an autistic subjective space in which she is indeed cut off from a relationship to the Other.[52] Interestingly, the association between image and addiction is a central motif within a classical reading of the postmodern simulacrum – for Jameson, addiction is the simulacrum's proper form of "passion", where one can recognise "consumers' appetite for a world transformed into sheer images of itself and for pseudo-events and 'spectacles'".[53] Instead of a sense of history, Jameson argued, the simulacrum randomly cannibalises the styles of the past in order to overstimulate and fascinate the viewer, indeed to "intoxicate" her with "hallucinogenic intensity".[54] In his influential essay, Jameson individuated in capitalist visuality an *all-full* situation, in line with what we found implied in the Lacanian *matheme* of the *capitalist's discourse*, where the abolition of the distance between object and subject can certainly be read in the terms of an addictive position. In Chapter 2 we saw how the capitalist subject–object relationship can be described as one of blockage of the constitutive lack of subjectivity, as an effect of what Žižek has called the "saturated field" of the continuous offer of novel consumer items.[55] Similarly, for Recalcati, addictive subjectivity is "a social product of the capitalist's discourse" which, by "dissolving the belief in the orientative function of the Ideal", imposes never-ending consumption as the only possible pathway for satisfaction: where once was the belief in the Other we find the belief in the object.[56] It is precisely by bypassing

the Other that satisfaction in the *capitalist's discourse* is not *surplus jouissance*, an effect of the metonymy of desire, but a direct shortcut between subject and object, symbiotically curled on themselves as it were, in an autistic movement of closure.

Trying to bring this dynamic on the aesthetic level, we could draw an analogy between this saturation of lack characteristic of the capitalist discourse and the aesthetic level of the totalising closure of the viewer–artwork–artist relationship suggested by Eshelman. An aesthetics of closure then can be seen to formalise a capitalist transformation of the subject from a non-autonomous (lack of) being – traversed by a lack which would open her to the Other – into a self-sufficient "monad of enjoyment", cut off from context and forced back into a direct relationship with the object.[57] Eshelman did address the link between beauty-as-closure and capitalism, affirming how this aesthetic strategy emerges as one able to "captur[e] globalization pictorially in its own terms, as a total phenomenon".[58] Commenting on Gursky's digitally manipulated pictorial photography, he described its devices of closure – seen as an imposition of internal, totalising order on a complex architecture of details, sharply defined through digital manipulation – as a means to "experience the totalizing, dynamic, overwhelming effect peculiar to globalization itself".[59] We can (again) trace this argument about the totalising character of capitalist experience – what Eshelman calls "sublime totalization" – back to Jameson and his concept of the "postmodern sublime", as the sense of the "impossible totality of the contemporary world system", "enormous and threatening, yet only dimly perceivable".[60] Eshelman can be seen to expand on Jameson's (overall less neutral) consideration of capitalism as a dialectics of "catastrophe and progress", for which culture would be called to "do the impossible", to achieve "a type of thinking that would be capable of grasping the demonstrably baleful features of capitalism along with its extraordinary and liberating dynamics simultaneously within a single thought".[61] It is difficult to disagree with this judgement, which points to the fact that any contemporary cultural project, attempting to understand the present historical moment, cannot escape an engagement with what is compelling and alluring about the capitalist subjective experience, which is precisely what is foregrounded in Simmons's *Love Doll*.

Broadly speaking, what I have observed so far in relation to *The Love Doll* series can be seen to transcend the horizon of postmodernism and resonate with Eshelman's notion of beauty-as-closure. The foregrounding of beauty and pictorial values, the affirmation of authoriality, a lack of manifest irony and a certain closure towards external arguments are all features that recur here and that I have so far addressed in terms of a demise of the traditional feminist discourse, replaced by an appeal for the viewer to enjoy in the immediacy of the image. Hyper-definition, large format, textured print and an exquisite play of colours and light can be seen to attempt to win over the viewer, through an offer of immediate satisfaction. Simmons's pictorial treatment of the love doll's tantalising beauty can be seen as a consideration of contemporary visuality as a *saturated space* into which the viewer is enticed to plunge without questions. We could read Simmons's image-geisha as an offer of *presence without demand*, which is also one possible definition of virtual

reality. People, products, information and communication are virtual because they are "constantly at our disposal", as Mario Perniola put it, thus pointing to virtuality as a form of constant availability, as an excess of presence, rather than absence.[62] Similarly, Žižek suggested that virtual reality is best described in terms of "fullness", not merely as information overload but as textual realisation of the phantasmatic under-text which has traditionally characterised the "virtuality" of a fully functioning symbolic order, based on a gap between what is said – the "textual surface", at the level of the signifying chain – and what is implied at the level of the unconscious – the underlying fantasy.[63]

Analogously, Simmons's image may be seen to point to a lack of secret, of repressed under-text, that is to say a lack of phantasm. The visual fullness of Simmons's gigantic doll-image can be seen to convey a contraction of distance, the same posited by Žižek as the essence of virtual reality and by Lacan as the foundation of the *capitalist's discourse*. Like the virtual and capitalist objects, which reign over the hypermodern subject, cut off from the Other in a mirage of self-sufficiency, this image-doll is so satisfying and beautiful that one does not desire anything else. Simmons's doll-image thus can be read as a visual experience beyond desire, indeed as antagonist to desire: visuality not as an empty space on which a phantasmatic content may be projected, as in the Surrealist tradition and in Simmons's early series, but as an available presence, overwhelming in its *all-full present-ness*. The hyperbole of visual satisfaction in this series exposes a condition of visuality where the image almost becomes a substance, whose enjoyment is not an effect of the Other and the unconscious phantasm but proceeds directly from the Real. This is an image that offers a Real experience for the viewer, instead of being a metaphor for something else, as in the early *Interiors*. We can see how Simmons manages to suggest how an image can become an *inhuman partner*, working more on the level of enjoyment than on the level of the Symbolic, like in many contemporary process addictions.[64] This *image-substance* is thus eccentric to the realm of the *Thing*, to "what in the real suffers from the signifier", that is to say lost *jouissance*, another name of the object-cause of desire, on which psychoanalysis's traditional understanding of the artwork has been based.[65] This image seems to foreground a different way to relate to the Real, beyond the neurotic dynamic of repression, pointing instead to the realm of the *sinthome*, of a symptom become form, which implies a *management* of *jouissance*, rather than its limitation. Simmons's *Love Doll* in this sense gives body to an aesthetics of the *sinthome*.

On the level of the Imaginary, *The Love Doll* foregrounds the power of the image to link the viewer in a structure of belief. In fact, amending the generic use of the term "belief" adopted by Eshelman to define the aesthetics of beauty-as-closure, we should specify that the only belief that can be implied here is *imaginary* belief. This is not the belief that has traditionally linked subjectivity to the *virtuality* of the Other, an illusionary agency, *non-existent* but effective, a fiction with performative efficiency, that is to say operative on a symbolic level, as the means to grounding the subject's socio-symbolic position in the world. The historical tendency of the last few decades has been one of loss of efficacy of this fiction, that is a

loss of the subject's will to believe the fiction of the Other in a non-reflexive act of faith.[66] The trending term of "post-truth" in recent media is just another designation of this phenomenon, described as a fundamental lack of influence of objective facts in shaping contemporary public opinion in favour of "appeals to emotion and personal belief".[67] Therefore, simply put, one should be clear about the difference between symbolic belief – or faith, the dimension proper of the traditional big Other – and imaginary belief, the former rooted in the efficiency of a shared symbolic fiction, the latter based on the imaginary fascination for the simulacrum.[68] The compelling image of *The Love Doll* series can be seen, in this sense, to engage with the contemporary Western cynic unavailability to believe the Other's word – be it the Nation, the Party or God – substituted by an unprecedented fascination with the direct reality of what one can see, out of the old philosophical question of the truth or untruth of what is seen. Simmons's image-doll may be thus considered a visual meditation on the contemporary passion for (imaginary) presence, unconcerned with (symbolic) absence.

However, Simmons's offer of enjoyment in simulacral *present-ness* is also connected with an effect of repose and a suggestion of protection, as I observed earlier. We found the issue of protection in the visual world of Stéphan Gladieu, in Chapter 3, where it appeared in terms of an *anorexic* logic of subtraction – the doll as a device to exclude the Real in a paranoiac movement of distillation, and the image regimented through the rationalisation of geometry. Here, instead, protection is attuned to what I have described in terms of addiction and formalised through a logic of *addition*, where something is added rather than subtracted on the visual level. Whereas Gladieu links the image-doll to a will to de-eroticise and master – the Other, its desire, its enjoyment, ultimately what in the Other is uncontrollable – Simmons presents an *image-substance* that one is compelled to crave, to be dependent on, without any of the formal devices of control and restraint seen in Gladieu's authorial choices to counteract the doll-image's simulacral fascination. The rationale of addiction thus may have the advantage to describe what I see in Simmons's work as a visual paradox of *enjoyment as repose*.

Psychoanalytically, within an addictive logic, an object of enjoyment becomes a measure adopted by the subject to separate and defend from the Other – either from the desire of the Other (neurosis) or the enjoyment of the Other (psychosis).[69] In this context, dependence from *inhuman partners* is considered a new organisation of *jouissance*, which compensates for the current inefficacy of the Symbolic in regulating *jouissance* – and the state of generalised anxiety this provokes. This is where the *hyper-affective* dimension of the contemporary simulacrum, presented in the Introduction, comes to the fore. Simmons's *image-substance* is certainly not Jameson's simulacrum, the expression of a waning of affect. As seen in Chapter 1, Jameson conceives affect in terms of anxiety and links it to "alienation", the experience of "hysterics and neurotics", and the "bourgeois monad or ego", that is to anxiety as an effect of lack and castration.[70] He famously described the postmodern subject as defined by "a liberation from anxiety [and] from every other kind of feeling as well, since there is not a self present to do the feeling".[71] On the

contrary, the aesthetic dimension I am trying to describe here seems to be one in which anxiety is central. The anxiety at stake here, however, has more to do with the overwhelming presence of the object, of its proximity, than its absence, that is the anxiety arising "when there is no possibility of lack", as Lacan put it in his 1962 seminar.[72] If Freud defined anxiety as an effect of a traumatic loss or danger of loss, Lacan underlined how anxiety can arise from an excess of presence, linked to the emergence of *objet a* in the visual field.[73] Recent psychoanalytic discussions on anxiety have focused on its connection with the object's overproximity, typical of the *capitalist's discourse*. This overproximity is seen to favour a type of anxiety which is not in symbolic mediation with the problem of unconscious desire (as for the neurotic subject), but rather is related to the presence of the Real, from which the subject is compelled to defend in order not to decompensate in psychosis. Contemporary addictions can be seen, in this sense, as a response to this situation, a (dysfunctional) treatment of the anxiety provoked by the failure of distance from the object in the capitalist discourse.[74] This excessive enjoyment is not related with *objet a qua* object-cause of desire, with desire as lack, but rather with a *too-full* whereby "the distance separating *a* from reality gets lost", as Žižek put it, and "*a* falls into reality".[75] The Real here does not describe a repressed trauma in Freudian terms but the external "ontological condition of reality as such".[76] This means that in order to confront the contemporary structural inability of the Symbolic to limit the threatening excess of the Real, the subject must develop new strategies to make up for this symbolic inefficiency, which more and more often emerges as a recourse to the addictive logic of the *inhuman partners*.

In this sense Simmons's offering of visual satisfaction can be seen to expose the contemporary image as a form of enjoyment with analgesic effects, a solution propped up against the offenses of ordinary life in which *a* has "fallen into reality". This doll-image seems to advance the experience of an *all-full* as a way to obtain a separation from *jouissance*, equivalent to an anesthetisation, a paradoxical obliteration of affect via an affective hyper-stimulation. On the visual level, we would thus find the paradox of an enjoyment forming a barrier against another enjoyment, which parallels the dynamics that we saw at work on the narrative level, with the doll functioning as a Zen-like bastion against capitalist *imitation jouissance*. It would be the experience of an enjoyment not in the form of a return to a *mythical* pre-Oedipal *jouissance*, played on a fantasy of fusion, as for the modern doll, but as a form of separation from the Real, without the aid of the Symbolic.

Craving and addiction, in relationship to visuality and virtual reality, are issues that Simmons has addressed explicitly in her 2013 *Two Boys* series, produced right after *The Love Doll* project. *Two Boys* was born as a response to Nico Muhly's opera of the same title, presented at the New York Metropolitan Opera House in 2013, which explored issues of identity in the world of the internet, taking its inspiration from a real-life event.[77] Like in the opera, the mood in the pictures is dark, with life-size male medical dummies depicted as if transfixed on a laptop's screen, their faces showing eyes closed and an open mouth, rendered even more disquieting by the brilliant, cold light emanating from the laptop screen. In *Boy I, Corner*, we

find the same accord of hues between golden-browns, purples and reds found in *The Love Doll/Day 4 (Red Dog)*, albeit in an evidently mortiferous re-edition. In an interview, Simmons explained how the story of the two boys for her "involves the vastness, seduction and perils of the online world – something I think about often".[78] The artist specified that she wanted the images to "describe visually both the isolation and the focus a young boy might feel when completely immersed in the mental space of the web".[79] Virtuality becomes a "buzz", as the real boy of the story put it, something like "satisfying a craving – you had to be on there, you had to be doing it".[80] While *Two Boys* works visually in a more conventional way, with mannequins *standing for* (representing) young boys in the throes of the contradictory aspects of virtual reality, what I have tried to describe in *The Love Doll* series may suggest the isolation and focus of the contemporary simulacrum on a more complex structural level.

Simmons's latest work *How We See* (2015) also deals with the problem of a visual excess. In this series the artist engages with the human figure, an exception within a career predominantly preoccupied with inanimate human forms, finding the realisation of the fantasy of a human-doll in the contemporary *dollers'* subculture. *How We See* presents pictorial, big-scale photographic portraits of female models who reproduce a particular anime-related Japanese practice, that of painting eyes on closed eyelids. In these contexts, this is often found in conjunction with other strategies of *dollification*, such as the surgery modifications enacted by so-called *living dolls*.[81] Compared to *The Love Doll*'s focus on naturally-lit immersive spaces, here the figure is set against an artificial background of acid colours, whose tone is registered in the title, together with the name of the models. The image is vibrant, thanks to hallucinogenic hues, the extraordinary beauty of the models and the use of a lateral light source, which, creating zones of shade on the models' bodies, works haptically, almost guiding the viewer's sense of touch over them. *How We See* can be read as the literalisation of a lack of *gaze* in the image. Like in *The Love Doll* series, the polished photographic effects of high-end advertising are put at work within a recovery of a concept of beauty that seems to bypass the sublime, the uncanny and the abject, with their confrontational presence as puncture, as *gaze*. The models become Greek statues, lacking the "light of the eye", for the eye here is reduced to a surface, not opening into the "abyss of the soul", on the *other scene* of the unconscious.[82] This is beauty beyond classic beauty, as what represses the disgusting formlessness of the Real, and beyond modern beauty, as what veils it with the sublime or the uncanny. Retrospectively, *How We See* might suggest that *The Love Doll* series' hyperbolic beauty is similarly concerned with an image which attempts to bypass the level of unconscious desire, of something lurking under the skin of the *semblant*, to be instead what attempts to substitute for it. I previously said that Simmons's *image-substance* may be understood as an image that does not repress *jouissance* but knots it in a different way. The image does not *prick* the viewer, does not offer the *gaze* as what can annihilate or reduce her Ego, but can be seen instead as what reinforces the Ego, cementing it.[83] The scopophilic pleasure of this image does not instance a loss of Ego, as an alternative to the ego-reinforcing effects of

narrative, as it was for Mulvey in "Visual Pleasure" but, on the contrary, emerges as a strengthening of the Ego.[84] This is doubling *minus* the uncanny, mimicry beyond the Oedipus. Through the doll, Simmons here gives body to our hypermodern fascination with an image that, like a substance, solidifies identity, where identity has become otherwise unstable for a loss of symbolic efficacy. Delivering an immediate enjoyment unconcerned with the Other – with meaning – the *image-substance* seems to function, at the same time, as a screen against an excess found in ordinary reality. Rather than a symptom, a figure of the unconscious, as it was for the Surrealists, the doll embodies here the paradox of a non-signifying sign.

If we return to the Lacanian diagram of the visual field, discussed in Chapter 1, this condition problematically seems to escape the triangular systems included therein, both that of *representation* and that of the *picture*. If we say that this image is unconcerned with lack and desire, then it cannot be considered a *picture* in the Lacanian sense, since there is no secret that "reflects our own nothingness".[85] With a foregrounding of immediate satisfaction, I have pointed to the fact that we might be a long way from the function of the veil, from that which "incites [the viewer] to ask what is behind it", from an image indicating "something other than what it is", that is *objet a* as lack.[86] However, since this image is *not unconcerned* with enjoyment, it cannot be considered only *representation*, as in the geometral field described in the first Lacanian triangular figure. Saying that this image may be *Apollonian*, that it gives "not so much to the gaze as to the eye", as "something that involves the abandonment, that *laying down*, of the gaze", risks missing the intrinsic level of the *appetite* here, a craving for an image which does offer a certain satisfaction on the level of *jouissance*.[87] There seems to be here a "trap", a "capture", a loss of "mastery", to use the terms that Lacan associates to the *gaze*, but seemingly not in relationship with unconscious desire. This image may describe a new situation in which the subject is captured by the image in a way that is not "opaque" nor "ambiguous" so much as functional to achieve a certain mastery, not *against* but *through jouissance*.[88] We would then find the paradox of a loss of mastery (the addictive level implied in the *image-substance*) functional to mastery and, as such, quite at odds with the Lacanian classical paradigm of the visual field as the field of the *gaze*. The section on the *gaze* in *Seminar XI* concludes with a consideration of the *gaze* as an "evil eye", in its being a "fascinum", "that which has the effect of arresting movement and literally, of killing life", that is to say the effect of separating the subject emerging there as lack of being.[89] Lacan there underlined how, in culture, "there is no trace anywhere of a good eye, of an eye that blesses", "beneficent" instead of "maleficent".[90] In Simmons's topos of beautiful eyes with no gaze we might indeed find an instance of the image as "good eye", one which does not separate the subject who sees. The *fascinum* offered by *The Love Doll* can be seen not as one that provokes castration but one that in fact attempts to substitute castration, as a remedy to the disruption of the knot between the Real, the Imaginary and the Symbolic characteristic of the contemporary capitalist experience.

In his renowned argument on postmodernism, Jameson attempts to describe the logic of the simulacrum as something different from the problem of castration,

and he recurs to a traditional (early Lacanian) account of schizophrenia. Arguing about the simulacrum as "waning of historicity", Jameson interprets meaning, in a Lacanian sense described as an effect of the slippage between signifiers in the signifying chain, as a "temporary unification of past and future with one's present".[91] In this sense, the simulacrum for Jameson is analogous to schizophrenia: a "breakdown of temporality [which] suddenly releases the present of time from all the activities and intentionalities that might focus it and make it a space of praxis".[92] With this, he attempts to underline a material dimension of the present – we could say its Real dimension – as isolated from context and history, that is to say from the Symbolic. The fundamental excessive character of what Jameson calls "schizophrenic aesthetics" could be referred to what I have tried to describe in this chapter in terms of immediate satisfaction: "vastness, brilliant light, and the gloss and smoothness of material things".[93] This, which for him describes a "materiality of perception properly overwhelming", might also relate to the astounding character of the big-scale, shiny surfaces foregrounded by Simmons's *Love Doll*.[94] However, the dimension that I have described in this chapter exceeds a classical account of psychosis and its traditionally exceptional connotation, as well as a traditional neurosis-psychosis binary. On a semiotic level, Jameson described the effect of "heightened intensity" as the workings of a "signifier in isolation", of a series of signifiers unrelated between them, whose effect on subjective experience is one of (psychotic) "fragmentation".[95] Conversely, the heightened formalism and harmonious whole of the image *without a secret* that I have described in Simmons's work may be better defined as a vacillation of signification effected by an enunciation disconnected from a signified, by a series of signifiers without a signified.[96] The effect of this would be rather one of reintegration and closure, instead of fragmentation, with the closing effects of the *image-substance* in fact acting as a treatment of the disintegration of the signifying chain that would lead to a full-blown psychosis (Jameson's "schizophrenia"). The closed beauty foregrounded in Simmons's simulacrum, as opposed to Jameson's "schizophrenic aesthetics", is what in fact may protect the hypermodern subject from psychotic decompensation. In other words, the hypermodern simulacrum emerges, at once, as effect and (dysfunctional) cure of the disintegrating effects of the *capitalist's discourse*.

Another fundamental aspect differentiates *The Love Doll* from the realm of Jameson's postmodern simulacrum. Whereas Jameson describes the affect proper to the simulacrum as intolerable "euphoria", as opposed to (Oedipal) anxiety, here we might be more concerned with the visual experience of an excess at once pacificatory and closely aligned with anxiety, namely, as a defence against anxiety.[97] This is not the anxiety connected to alienation, that is to say to lack, to which Jameson refers, but the anxiety effected by a lack of distance from the object of *jouissance*, from a presence of *petit a* in ordinary reality that is characteristic of the contemporary capitalist discourse. With Simmons's *Love Doll*, then, we may find the problem of an image at once alternative to the apotropaic function of beauty as amulet that we found in Gladieu, then alternative to the beauty as *tyche* veiling the Real of lack that is expressive of an aesthetic of *anamorphosis*, and also alternative to a

"schizophrenic aesthetic", which would let the horror of the Real emerge without veil (if this could ever be possible). Between the two traditionally opposed poles of form and formless, Apollonian and Dionysian, Simmons's image might suggest a different organisation of the visual field, in which the Real is entangled through a different knot. The image has emerged not as conflict, internal contradiction between the Ideal and the Real, but as an attempt at repose, in which it is a certain form of *jouissance* itself that seems to work as a limit to the unbearability of an unscreened Real, *fallen* into ordinary reality.

Dolls and photography have a long history of interconnection, thanks to their common structure of doubling, with one typically used to say something about the other. If modernism affirmed the subversive potential of the doll-image as an uncanny double against the de-subjectivising machinations of industrial capitalism, Simmons's doll-image can be seen to self-consciously acknowledge its alignment with mass culture values, rather than signalling opposition, through the hyper-polished *virtuoso* means of high-end advertising. There seems to be the affirmation of the ability of art to compete with the high-production values of fashion and commercial images, while overcoming a postmodernist, intellectually distanced critical position from mainstream culture. With this we open to the problem of a contemporary definition of cultural "resistance" and the issue of intellectual awareness, raised by Eshelman in relation to *performativism*. What kind of subject are we implying by talking about a viewer able to be "critical", to experience "ambivalence" and to "develop an intuitive resistance" to the simulated beauty of global capitalism as a response to a work of art?[98] Is this not implying that such a subject could still function Oedipally, therefore restoring the old modern subject that analyses like Eshelman's would like to dispose of? Instead of trying to critique new discursive organisations with the aid of traditional constructs – whose loss of operative force is today more than noticeable – we ought to sharpen our intellectual creativity and develop new critical tools and approaches.

The Love Doll offers a self-reflective experience of "how we see" in the contemporary moment. It does not offer the interruption of the simulacrum, which is something we encountered instead with Olivier Rebufa and Stéphan Gladieu, in their different formal strategies. Simmons confronts us with the truly mesmerising fascination of the contemporary simulacrum, into which we are allowed to go all the way. *The Love Doll* suggests that art cannot conceive itself outside of the capitalist game or speak from a place of externality to what it purports to resist or subvert. This approach confirms a general decline of the modernist model of cultural critique based on opposition and negativity, with artists for the most part working, since the 1990s, "in recognition of their relations of compromise and contradiction, their more self-consciously positive – or nuanced and complex – engagements with the culture industry".[99] Strategies of imitation have instead emerged as central rhetorical tools in recent contemporary art, which presents yet another facet of the philosophical significance of mimicry, and the relevance of dolls and other figures of the double, in contemporary culture. Mimicry is a device capable of creating new knowledge, as Rebufa showed with his exercise of world-building, a function

connected to play as a form of synthetic knowledge. As Hal Foster recently put it, "mimetic exacerbation" emerges as the principal mode of the contemporary avant-garde, whereby a "heightened, even exacerbated" form of "mimesis of the given" is mobilised as a way to achieve distance, albeit one attained not "through withdrawal but through excess".[100] This logic of an excess as distance resonates with this chapter's overall argument, but we should understand distance as something different than the effect of a symbolic act of sublimation. The *enjoyment-as-repose* of Simmons's *image-substance* may in fact point to the fact that another type of distance can be achieved, one which implies going through an excess to achieve a modicum of stability. As both art and subjectivity are historically determined and reciprocally interconnected, it is always problematic to extend the concepts of one period to another. While Foster sees a general substantial continuity between contemporary art's use of mimicry and the historical avant-gardes, particularly the parodic imitations of Dada, it should be clear by now that I am in fact less inclined to believe so. This is because, particularly in the case of Simmons – but one could extend this thought to many other artists, like Jeff Wall or Vanessa Beecroft – one would struggle to find traces of negativity, so central in the poetics of Dada and the historical avant-gardes. Neither would I speak of "capitalist nihilism", of exultation in degradation, as the only alternative position, for someone like Simmons who rose to prominence within a generation of art-makers with a stringent conceptualist approach to the problem of representation.[101] Neither critical nor celebratory of capitalist conditions, *The Love Doll* can be seen as a reflective-critical operation able to put a frame around a present condition of visuality with the view of understanding it, before anything else. It presents an image that aims to overwhelm the viewer, exposing the peculiar character of capitalist experience in its most fascinating and mesmerising aspects. The artwork always installs a frame around what it presents and represents. It is always reflexive on a fundamental level. Even when it replicates the codes of mainstream visuality, it is a bracketing operation. In an era of mindless consumption and autistic enjoyment, taking the time to interrogate an image and to observe the very impossibility of creating the space for a question is already an ethical-aesthetic act.

Notes

1 The term "Pictures Generation" derives from the 1977 exhibition *Pictures*, curated by Douglas Crimp at *Artists Space* (New York), which featured some of the artists that would become associated with the term – Troy Brauntuch, Jack Goldstein, Sherrie Levine, Robert Longo and Philip Smith. See Douglas Crimp, "Pictures", *October*, vol. 8 (Spring, 1979), 75–88 and *id.*, "The Photographic Activity of Postmodernism", *October*, vol. 15 (Winter, 1980), 91–101. See also Douglas Eklund, *The Pictures Generation 1974–1984* (London: Yale University Press, 2009).

2 Like many of her peers at the time, Simmons developed first-hand experience of the codes and conventions of commercial photography by working in the media industry. See Marvin Heiferman, "Conversation with Laurie Simmons", *Art in America* (April, 2009), 112.

3 A complete catalogue of Simmons's work is available on the artist's website, *Laurie Simmons*, available at <www.lauriesimmons.net/photographs>, last accessed 11.1.2020.

4 Simmons, in Nels P. Heighberg, "Laurie Simmons's Role Plays: Love, Sex, Desire", *Spot Magazine* (Autumn, 2012), 12. The reference is to *The music of regret* (1994), featuring black-and-white images of the artist's own replica in the form of a ventriloquist dummy, as the *ad quem* term.

5 Heiferman, "Conversation", 118.

6 The value of one of the images of Cindy Sherman's *Film Stills*, for instance, was worth $1,500 in 1987 in contrast to the $25,000 in 1997, with MoMa paying $1 million for the complete set in 1996. See Carol Squiers, "Market Report", *American Photo* (April, 1997), 73.

7 Simmons has recently spoken of Turbeville's *Bathhouse* pictures as what "changed her world" in David Sims, "The New Look: Art and Fashion Photography", *Artforum International*, vol. 54, no. 9 (2016), 272.

8 Simmons, in James Welling, *Laurie Simmons: Color Coordinated Interiors* (New York: Skarstedt Fine Art, 2007).

9 Simmons, in Jan Seewald, "The Camera Lies; or, Why I Always Wanted to Make a Film", in *Imagination Becomes Reality*, exhib. cat. (München: Kunstverl. Ingvild Goetz, 2007), 150.

10 From this point of view, Simmons's sculptural photography resonates with the work of James Casabere, who was working in the same period with miniature architectural spaces animated by intricate lighting effects and equally evocative of memory, both on an individual and collective level. However, Casabere would later move towards more decidedly three-dimensional model constructions and a consideration of identity in relation to public spaces, while Simmons developed a more intimate dimension of analysis, in part as an effect of the lasting presence of the human forms.

11 Laura Mulvey, "Visual Pleasure and Narrative Cinema" [1975], in *id.*, *Visual and Other Pleasures* (Bloomington and Indianapolis: Indiana University Press, 1989), 19. Sherman, in her 1975 black-and-white video *Doll clothes*, played on a similar vein, with the bi-dimensional photographic cut-out doll of her figure shot as it tries to gain independence by choosing her outfit, before being put back in the sleeve of the book by a large human hand entering the frame from above.

12 Krauss, "Corpus Delicti", 62.

13 Mulvey, "Visual Pleasure", 16.

14 *Ibid.*

15 *Ibid.* Interestingly, *against interpretation*, the artist underlined how the book in *Yellow* is "only" a yellow book, and the fact that it is a monograph on Minimalist Donald Judd should not be taken for "more of what it really is", a colour component. See Laurie Simmons, *The Love Doll* (New York: Salon 94, 2012) 31.

16 Krauss, "Corpus Delicti", 50. See Chapter 1 for an analysis of this theoretical knot between the *informe*, mimicry and the emergence of *jouissance*.

17 See Krauss, "Cindy Sherman", 130.

18 The atmospheric effect is heightened in the print version of the images through the use of matte paper, whose textured surface decreases the dynamic range of colours, particularly of the darkest areas, with the effect of visually diluting the contrast of the image, whose amplification is conversely one of the means by which the dramatic effect of the earlier series was achieved. To heighten this effect, *The Love Doll* photographic book is printed on textured paper, according to the rationale given by the artist "to evoke the touch of a love doll's skin". See Simmons, *The Love Doll*, back cover.

19 The exception in the series is *The Love Doll/Day 30/Day 2 (Meeting)*, the only instance where two dolls are present in the frame, with both set to look into the camera.

20 Simmons, *The Love Doll*, 82.

21 Mulvey, "Visual Pleasure", 21.

22 This would be a Lacanian reading of the notion of *masquerade*, whereby the *nothing* behind the mask can be seen as a way to depict the inexistence of a feminine (or masculine) pre-discursive being. Following Lacan, Žižek underlined that the feminine masquerade proves that woman is "more subject than man", for it implies woman's awareness of the

empty space of desire concealed behind the (imaginary) mask, the "'nothing' of her freedom, [that the mask keeps] out of reach of man's possessive love". See Slavoj Žižek, "Woman Is One of the Names-of-the-Father, or How to Misread Lacan's Formulas of Sexuation", *Lacanian ink*, no. 10 (1995), available at <www.lacan.com/zizwoman.htm>. On femininity as masquerade, the classical reading is Jean Rivière, "Womanliness as a Masquerade" [1929], in Athol Hughes (ed.), *The Inner World of Jean Rivière: Collected Papers 1920–1958* (London: Karnac Books, 1991), 90–101.

23 Lynn Hershman Leeson, in Stephanie Buhmann, "Art of the Artificial", *The Villager*, no. 51 (May, 2008), available at <http://thevillager.com/villager_264/artoftheartificial. html>, last accessed 30.7.19.

24 *Ibid.*

25 Simmons, *The Love Doll*, 29. See Chapter 1 of this book for a detailed discussion of the aesthetics of the *informe* of *jouissance*.

26 Calvin Tomkins, "A Doll's House", *The New Yorker* (10 December 2012), 41; Jeffrey Kastner, "Laurie Simmons", *Artforum* (May, 2011); Linda Yablonsky, "Laurie Simmons", *Wallpaper★* (May, 2012), 245. See also Matthew Weinstein, "Two Boys", in Laurie Simmons (ed.), *Big Camera Little Camera*, ex. cat. (Munich: DelMonico Books, 2018), 49.

27 Lacan, *The Four Fundamental*, 101.

28 *ivi*, 108, 74. See also *Chapter 1*.

29 *ivi*, 101. I return to this question later in this chapter. See also Chapter 1 for an introduction on the theory.

30 Cosplay is the abbreviation of "costume play", a popular cultural practice where participants wear costumes, often portraying anime characters. *Kigurumi* is a subset practice of cosplay that implies the use of masks and bodysuits that cover the whole of the body, hands and feet included. "Dollers" is the name often given to *kigurumi* participants. I return to *How We See* later in this chapter.

31 On *kawaii*, see Jennifer Robertson, *Takarazuka: Sexual Politics and Popular Culture in Modern Japan* (Berkeley: University of California Press, 1998), 156–157.

32 Christine R. Yano, "Kitty Litter: Japanese Cute at Home and Abroad", in Gilles Brougère, David Buckingham, and Jeffrey Goldstein (eds.), *Toys, Games and Media* (Mahwah: L. Erlbaum Associates, 2004), 53.

33 Laurie Simmons in *Prix Pictet 05*, 122.

34 Akiyoshi Suzuki, "Cross-Cultural Reading of Doll-Love Novels in Japan and the West", *Journal of East-West Thought* (Autumn, 2013), 108.

35 *ivi*, 117.

36 *Ibid.*

37 *ivi*, 119, 117.

38 One struggles to avoid here a Žižekian digression when reminded of the philosopher's sourly sharp designation of Western Buddhism as "the paradigmatic ideology of late capitalism", a "pop-cultural phenomenon preaching inner distance and indifference toward the frantic pace of market competition" and, as such, "arguably the most efficient way for us to fully participate in capitalist dynamics while retaining the appearance of mental sanity". What Žižek is describing here is the typical split between knowledge and belief characteristic of fetishism. See Slavoj Žižek, *The Puppet and the Dwarf: The Perverse Core of Christianity* (Cambridge, MA: MIT Press, 2003), 26.

39 I speak about the *informe* in relation to photographic theory in Chapter 1.

40 In Chapter 2, we saw how the *capitalist's discourse* can be seen to mobilise *jouissance* as a value "to be inscribed in or deducted from the totality of whatever it is that is accumulating" (Lacan, *The Other Side*, 96). Capitalist *imitation jouissance* is deprived of the condition proper to *jouissance*, its being an uncountable hindrance to language, as an instance of the death drive, in this sense obstructing the singularity of *jouissance* proper through a standardised, deceptive form of *jouissance*.

41 Simmons, in Linda Yablonsky and Laurie Simmons, *BOMB*, no. 57 (Autumn, 1996), 21.

42 Laurie Simmons, "Photography, Perfection and Reality", *art21* [online], available at <https://art21.org/read/laurie-simmons-photography-perfection-and-reality/>, last accessed 10.4.19.
43 *Ibid.*
44 *Ibid.*
45 Simmons, in Andrea Blanch "Laurie Simmons: A Real Doll", *Museé Magazine* (April, 2010), available at <http://museemagazine.com/culture/art-2/features/interview-with-laurie-simmons-a-real-doll>, last accessed 10.3.17.
46 *Ibid.*
47 Lacan, *The Ethics*, 89.
48 Raoul Eshelman, "Performatism in Art", *Anthropoetics*, vol. 13, no. 3 (2007/2008), no pagination. See also *id., Performatism: or the End of Postmodernism* (Aurora, CO: Davies Group, 2008).
49 *Ibid.*
50 Fried, "Without a Trace", 101, 102. For an alternative reading of Demand's art as an open form of storytelling, see Margaret Iversen, "Invisible Traces: Postscript on Thomas Demand", in *id., Photography, Trace*, 100–109. For a detailed engagement with Fried's position, see the essays collected in Diarmund Costello and Margaret Iversen (eds.), *Photography after Conceptual Art* (Chichester: Wiley-Blackwell, 2010).
51 Eshelman, "Performatism", 2, emphasis in the original.
52 See Recalcati, "Le Nuove Forme". See also Yael Goldman Baldwin, Kareen Malone, and Thomas Svolos (eds.), *Lacan and Addiction: An Anthology* (London: Karnak Books, 2011), esp. Rik Loose, "Modern Symptoms and Their Effects as Form of Administration: A Challenge to the Concept of Dual Diagnosis and to Treatment" (1–38) and Thomas Svolos, "Introducing the New Symptoms" (75–88).
53 Jameson, *Postmodernism*, 18.
54 *ivi*, 28.
55 Žižek, "Pathological Narcissus", 252.
56 Recalcati, *L'Uomo*, 199, my translation.
57 *ivi*, 201.
58 Eshelman, "Performatism", n.p.
59 *Ibid.*
60 *Ibid.*; Jameson, *Postmodernism*, 28, 27.
61 Jameson, *Postmodernism*, 47.
62 Mario Perniola, *Il Sex Appeal dell'Inorganico* (Torino: Einaudi, 2004), 39, my translation.
63 Žižek, *The Plague*, 200.
64 This does not mean that this artwork *is* Real. Art is always a framed event. Nonetheless here we find the notion of an image less grounded in the symbolic function and more in a short-circuit between the Real and the Imaginary, which in turn demands the development of new critical and linguistic tools beyond those traditionally available in psychoanalytic aesthetics.
65 Lacan, *The Ethics*, 125.
66 See, for example, Žižek, *The Ticklish*, esp. "Whither Oedipus"; Jacques-Alain Miller, "The Other Without Other", *Hurly-Burly*, no. 10 (December, 2013), 15–29; Renata Salecl, "Cut in the Body", in Sara Ahmed and Jackie Stacey (eds.), *Thinking Through the Skin* (New York: Routledge, 2001).
67 The term entered the Oxford Dictionary in 2016, after a registered increase of its usage by 2,000% between 2015 and 2016, particularly in relation to Donald Trump's election to the American Presidency and the debates on Brexit in the UK.
68 This is a classic of Lacanian–Žižekian ideology critique. Žižek differentiates between symbolic *fiction* and imaginary *simulacrum*, pointing out how the same structure of fetishistic disavowal ("je sais bien . . . mais quand meme") is put at work with different effects. In the first case, I disavow what I see in favour of the belief in the symbolic fiction of the other as Other, while, in the second, I disavow what I know in order to believe what I see. See Žižek, *The Ticklish*, 324–325.
69 See Baldwin, Malone, and Svolos, *Lacan and Addiction.*

70 Jameson, *Postmodernism*, 14, 15.

71 *ivi*, 15.

72 Lacan, *Anxiety*, 36.

73 This distance from Freud is emphasised by Lacan himself. See *id.*, *Anxiety*, 35–36. See also Sigmund Freud, *Inhibitions, Symptoms, and Anxiety*, ed. James Strachey (New York and London: W.W. Norton, 1989 [1926]); and *id.*, *New Introductory Lectures on Psycho-Analysis* [1933], ed. James Strachey (Harmondsworth: Penguin, 1991). In the latter, Freud would affirm that there is a "twofold origin of anxiety", "one as a direct consequence of the traumatic moment and the other as a signal threatening a repetition of such a moment" (90).

74 Recalcati, *L'Uomo*, 210. This is a direction already present in Lacan's 1956 seminar (titled *The Object Relation*) where phobia, fetishism and subjective formations in general are seen as a remedy to anxiety. There Lacan speaks of Little Hans as developing a phobia (of horses) as a substitute for a failed symbolic alienation. Castration is here what can save the subject from anxiety, rather than what causes it, as for Freud. Later, castration – that is repression via the paternal metaphor – becomes only one among other ways the subject can manage *jouissance* (See Lacan, *The Sinthome*).

75 Slavoj Žižek, *The Metastases of Enjoyment: Six Essays On Women and Causality* (London: Verso, 2005[1994]), 76.

76 Žižek, *Enjoy*, 129–130.

77 The true story at the basis of the plot involved a 14-year-old boy from Manchester (UK) who engineered his own death through manoeuvring a 16-year-old boy, met in an MSN chat room, into killing him, by engineering an intricate narrative sustained by multiple characters impersonated online. The older boy was initially charged for stabbing the younger boy, who eventually was prosecuted for incitement to murder his own person. See Judy Bachrach, "U Want Me 2 Kill Him?", *Vanity Fair* (February 2005), available at <www.vanityfair.com/news/2005/02/bachrach200502>, last accessed 17.11.2019.

78 Laurie Simmons, "Gallery Met: Two Boys", *Metropolitan Opera*, website, available at <www.metopera.org/Visit/Exhibitions/Gallery-Met-Exhibitions/Gallery-Met-Two-Boys/>, last accessed 17.11.2017.

79 *Ibid.*

80 Bachrach, "U Want Me 2 Kill Him?".

81 One famous example is Valeria Lukyanova.

82 Hegel, *Aesthetics*, 520, in Slavoj Žižek, *Disparities* (London and New York: Bloomsbury Academic, 2016), 152.

83 Lacan, *The Four Fundamental*, 82.

84 Mulvey, "Visual Pleasure", 18.

85 Lacan, *The Four Fundamental*, 92.

86 *ivi*, 112.

87 *ivi*, 101.

88 This is what is implied in the Lacanian *sinthome*, to which I return in Chapter 5.

89 Lacan, *The Four Fundamental*, 118, 115.

90 *ivi*, 115, 119.

91 Jameson, *Postmodernism*, 26.

92 *ivi*, 27.

93 Marguerite Séchehaye, *Autobiography of a Schizophrenic Girl* (New York, 1968), 19, cit. in Jameson, *Postmodernism*, 27.

94 *Ibid.*

95 *ivi*, 27, 28.

96 This is also analogous to the formula of the *capitalist's discourse*, where the ongoing circularity between the four positions of the discourse and the inversion of the arrow between agent ($) and truth ($S_1$) translates a lack of repressed truth. In clinical practice, as previously noted, this brings the difficulty of treating symptoms refractory to symbolic formalisation. On this, see Oscar Ventura, "The Symbolic Order in the 21st Century. It's Not What It Used to Be. What Consequences for the Treatment?: Without Nostalgia", in *Psychoanalytical Notebooks, Issue 23: Our Orientation* (London: London Society of the Lacanian School, 2011), 85–96.

97 Jameson, *Postmodernism*, 28.
98 Eshelman, "Performatism", n.p.
99 Drucker, *Sweet Dreams*, 8.
100 Hal Foster, *Bad New Days: Art, Criticism, Emergency* (London: Verso, 2015), 95, 78, 92.
101 Foster, *Bad New*, 96.

5

LARS AND THE REAL GIRL

A tale of the *New Father*

The new relevance of the life-size doll is evidenced in recent films that have given this figure the relevance of a protagonist, such as *Monique* (2002, Valérie Guigna-bodet), *Love Object* (Robert Parigi, 2003), *Lars and the Real Girl* (Craig Gillespie, 2007) and *Air Doll* (Hirokazu Koreeda, 2009), among others. These recent films are in dialogue with a longstanding cinematic tradition in which inanimate life-size replicas, such as mannequins, statues and dolls, often embody a fetish that the protagonists, customarily male, are required to abandon to make space for a flesh-and-bone, less-domesticated female companion, or else they end up mad or dead.[1] In contrast with this cinematic tradition and its cultural associations, some of these recent films mobilise the figure of the inanimate double in new ways, calling for alternative cultural and psychoanalytical readings. Among these, *Lars and the Real Girl*, in focus in this chapter, presents an innovative approach to the old motif of men in love with dolls through the hybridisation of different generic registers.

The film, usually categorised as a romantic comedy-drama, tells the story of an emotionally withdrawn 27-year-old man, Lars Lindstrom (Ryan Gosling), who is diagnosed with a delusional disorder when he introduces a hyper-realistic sex doll that he calls Bianca to his family as his real girlfriend, treating her as a sentient living being.[2] Interestingly, the critical debate on the film appears polarised, with reviews either celebrating or despising it. It is seen either as an accurate psychological character study, "grounded in reality"[3] and delivering a heart-warming "life-affirming statement of hope"[4] or, inversely, considered a "smarmy little number . . ., trafficking shamelessly in heartland stereotypy",[5] lacking in credibility[6] and "emotionally deflated".[7] Academic readings have usually focused on the film's psychological implications, referring often to Donald Winnicott's notion of the *transitional object* – an object *in between* the subject's body and external reality – to underline the perceived healing role of the doll in the film.[8] The standard critical line on the characterisation of the doll in the film sees it as a maternal double that

needs to be abandoned, together with Lars's tics and seemingly asocial behaviours (he does not tolerate being touched by others), in order for Lars to entertain a "mature" social relationship with a "real girl".[9] In many of these readings, the film's particular visual style and subtle humour get lost, with the text thus becoming a more or less straightforward illustration of psychoanalytical concepts. This chapter aims instead to bring together the film's peculiar visual character, its quirky flair, with its wide-ranging cultural and psychoanalytical references, while attempting at the same time to leave room for semantic ambiguity. To appreciate the film's distinctive style, the chapter will introduce structural elements from the fairy-tale genre, whose presence in the film has past mainly undetected in critical readings. Through the mobilisation of the notion of the *sinthome* and a contextualisation of the film's themes through recent discussions on "responsible fatherhood", the chapter will highlight the innovative character of *Lars*'s adoption of the figure of the doll, beyond conventional associations with the maternal sphere. My reading will expose how the film plays skilfully not only with the complex cultural history of the figure of the doll and its structure of doubling but also with the romantic genre and conventional representations of gender, coupledom, fatherhood and mental health. Through an analysis of the film's rich network of references and narrative implications, this chapter will show how *Lars* exceeds the traditional Surrealist coding of the doll as a figure of the uncanny, thus suggesting new valences for doubling and make-believe in contemporary culture.

The hypermodern *kolossós*: from symptom to *sinthome*

The film's narrative is set within a fervently Christian community of a generic small town of the American Midwest. It opens with a depiction of Lars's lonely life: split between his work in an office cubicle, surrounded by colleagues preoccupied with action figures, online porn, and teddy bears; and his home, a converted garage on the side of the family house, where older brother Gus (Paul Schneider) and pregnant sister-in-law Karin (Emily Mortimer) have recently moved after the death of the brothers' elderly father. Preoccupied by Lars's avoidant behaviour, Karin tries to convince an unconcerned Gus that his younger brother needs help, while at the same time making efforts to involve recalcitrant Lars in their family life. Lars, however, regularly avoids her invitations as well as fleeing from Margo (Kelly Garner), a new office colleague who shows some romantic interest in him. When Lars announces that he has met a Danish-Brazilian girl on the internet, the couple rush to prepare the guest room in excitement, but they have a chilling surprise when they encounter Bianca, a custom-made, life-size sex doll that Lars treats as a living person. Following Karin's suggestion, the next morning they all visit the family doctor with the excuse to check that Bianca is well after a long trip from Brazil, and Dagmar (Patricia Clarkson), who is also a psychologist, diagnoses Lars with a delusional disorder. She advises the couple to go along with Lars's delusion and proposes to have weekly checks on Bianca, as a way to monitor Lars's mental wellbeing. The couple asks their local church's board members for help and these,

after some feeble opposition, accept Bianca into the community, which transforms the whole village into a collective make-believe set in the effort of sustaining Lars's conviction that Bianca is a living person. Thanks to Bianca being soon invited to engage in the community, volunteering with children and working part-time as a model in a department store, Lars finds himself interacting more with people. Through his weekly check-in with Doctor Dagmar, he starts recounting his personal history, marked by the death of his mother during labour, and he is helped to overcome his fear of being touched. After developing an attraction for Margo and going out with her, Lars finds Bianca "unconscious" one morning, and she is rushed to the hospital by ambulance. There Lars announces that she is very ill, and she is brought home, where she will "die" few days later during a walk to the nearby lake, after Lars had kissed her for the first time. Bianca is given a funeral, which all the townspeople attend, and is buried in the cemetery. At the burial site, Lars, finally alone with Margo, asks her to take a walk with him, an invitation that she happily accepts.

The improbable charitable engagement of the whole community in Lars's belief that Bianca is a living person is the central motive for why the film is often labelled a feel-good movie – an "idealistic view of small-town life", "a study in conviction and Christian love" – with the happy ending assumed to imply that Lars has managed to successfully get rid of the doll-hindrance and connect with a real girl.[10] The film, in effect, couples the improbability of its premises with a series of other formal aspects, often disparaged as lack of realism and credibility, such as the predictability of its narrative, the abstraction regarding time and location, the accentuated stylisation of the décor, and the psychological flatness of the characters. However, one can argue that it is precisely these elements, which can be referred to the genre of the fairy tale, that are central to the film's own aesthetic and the pleasures it offers. *Lars* clearly plays with the topos of male initiation stories, showing the vicissitudes of a young(ish) man's passage into adult life and his growth from naivety to maturity, from a lower to a higher level of existence, according to a developmental logics typical of fairy tales.

Many of the building blocks of the rather predictable plot can be seen to derive from the fairy-tale genre. The death of the mother and the hero's orphan condition, the rivalry among siblings, the motif of the magic doll and the presence of typified characters – the colleague-helper who introduces Lars to love dolls online, the girl-princess conquered at the end of the quest, the doctor–fairy godmother, ethereal and stately in her long blonde hair in the final scene, finally departing after the match is accomplished – are all elements characteristic of a fairy-tale plot. The polarisation of good and bad, often at the basis of fairy tale, is here detectable in Lars's opposition to his older brother Gus, who, like the two brothers of many tales, embody opposite characteristics: the former is a simpleton, single and afraid of women, the latter a successful business owner, tenant of the family house, doting husband and father-to-be. However, while Lars is hyper-sensitive, Gus is indifferent and rude, and the viewer's sympathies may likely converge, initially, on the immature and awkward Lars, rather than on his distant brother. While Lars

lacks virility and a romantic companion, Gus lacks empathy and compassion, and the obvious development of the story will solve this initial lack for both. Despite this polarity, we are not presented with a clear opposition between good and evil, like in a moral fable, which is often cautionary in its message. *Lars* is in fact closer to those fairy tales that give "the hope that even the meekest can succeed in life", the reassurance that, "however outcast and abandoned [one may feel] in the world, groping in the dark", they are ultimately capable of achieving "rewarding relations with the world around" them.[11] This is the consoling aspect of the story, but it should not be dismissed as plainly saccharine, since the narrative development and the ending can be seen to offer a humorous, thought-provoking twist, as we shall see.[12]

Besides combining familiar tropes and standard characters, the film achieves fairy-tale flatness and abstraction through a warping of its spatio-temporal dimension to the *far-away*. The film's leap into abstraction, sometimes recognised by commentators, has often been connected to a lack of accuracy, realism and seriousness – as one critic observed, *Lars* is "so removed from the larger world, from Iraq, Hillary, Rush and Britney, it might as well be in deep space".[13] Indeed, we can recognise a contemporary world – mobile phones and love dolls have recently appeared, signalling that we might be in the late 1990s – but this is certainly a *secondary* world, where husbands always cook for their wives, the Church welcomes a sex doll among its parishioners and everyone in the community does their best to make Lars feel accepted and loved, because this is "what Jesus would do", as Reverend Bock reminds. The *mise en scène*, a geeky version of Upper Midwestern Scandinavian style, to which the protagonist's Swedish surname Lindstrom alludes, is central to achieve distance from what is represented, to mark the film's world as not commanding serious allegiance to a factual plane. Like witches and charming princes of fairy tales, this devoted Christian community, albeit described realistically, can only exist in the story.

The set could be a visual adaptation of the agrarian Upper Midwest described by Garrison Keillor in his celebrated tales of Lake Wobegon, inhabited by people of hardy Scandinavian and German stock, who do their work, go to church, help each other and dress with high rise blue jeans, patterned jumpers and a whole array of knitted accessories.[14] It is this vision of the Upper Midwest that we will see as an important reference for *Lars* in other respects, that vision of people speaking in a Scandinavian-esque accent and being overly nice, polite, and always willing to help others, which was memorably exploited in *Fargo* (Cohen, 1996). Given the popularity of Keillor's mythical and gently satirical rendition of the Midwest, *Lars*'s audience, at least in the US, would not have failed to recognise, and enjoy, many of the elements connecting the two worlds. Keillor's affective satire of regional details, local manners, speech and folklore, as well as his description of Lake Wobegon as a place of timelessness and unchanging characters, scepticism towards progress and technology, are here mobilised to tell a story about change and progressive gender and sexual mores. The irony is that the lake of the film, clearly a homage to Lake Wobegon, "the symbol of permanence in a world of change", is here precisely

the locus of change, a gateway between the past (childhood and its games) and the personal development of the protagonist, a place of rebirth.[15] The lake is the set of Bianca's death in a scene which is a witty appropriation of the Christological iconography of water baptism, closing a series of doubling between Lars and Bianca: where the doll dies, the "new" Lars is reborn, like Jesus arising from the waters of the Jordan after being baptised by John. It has been observed how, in his tales of Lake Wobegon, Keillor "delights in walking that thin line between imagination and reality", with the blurring of imagined and real space "mak[ing] it difficult to distinguish fantasy from reality, subjective perception from objective truth and mythical place from actual place".[16] This can be seen as a striking characteristic of Gillespie's treatment as well, achieved by playing with various generic conventions but deserting all of them: *Lars* is almost a romantic comedy, almost a drama, almost a fairy tale.

What *Lars* clearly is, instead, is a *mise en abyme* of storytelling, a reflection on narrativity and meta-narrativity. If it is Lars who starts telling a story – Bianca is a missionary of Brazilian and Danish descent, reliant on a wheelchair, orphan and unable to give birth and so on – Bianca's life story, emerging and descending in the space of the film, will be created as a collective effort, thus taking life on the screen for the viewer. On this level, as a redoubling of storytelling and the ability to engage the audience into a second-grade make-believe play, the film resonates with illustrious literary and cinematic precedents. One reference should be made to Luigi Pirandello's *Enrico IV* (1922), in which a rich man in 1921 Italy believes himself to be a feudal king, and everyone around him sustains this delusion. Other intertextual links can be established with Cervantes's *Don Quixote* (1615) – cited in the film, with Lars at one point shown to read it out loud to Bianca – and *Harvey* (Henry Koster, 1950), where James Stewart plays the part of an amiable alcoholic who thinks he is ubiquitously accompanied by an invisible gigantic rabbit. For the way *Lars* attempts to walk the thin line between fantasy and ordinary reality, the style of Hal Ashby, seen in films such as *Harold and Maude* (1971) and *Being There* (1979), emerges as another relevant intertextual reference. There, too, we find a mix of dark satire and fairy-tale elements, with the message of the film being obscured by the act itself of telling the tale, while pop-psychology didacticism and symbolism are transcended in the pleasure of creating a film world in which childhood wonder obscures the cynicism of the adult world.

Rather than psychological realism, *Lars* offers fairy-tale tropes, the recognition of which is part of the pleasure offered to the audience, through the creation of "a gnawing familiarity – that comforting yet supernatural awareness of living inside a story" that Kate Bernheimer attributes to fairy tales.[17] Flatness, typically achieved in the fairy tale through conjoining matter-of-fact descriptions of events with a suspension of physical and psychological laws, is quite evident in *Lars*, where things happen and characters do things, but their deep psychological motives remain inexplicable, enigmatic, ultimately not credible – and indeed not showing any effort to be. We are informed that Lars has bought a love doll once this has already happened, for instance, while Karin and the community devote all their efforts to

help Lars, never telling us why. If all this makes little sense logically or psychologically, it follows a certain fairy-tale "nonsensical sense".[18] If the world of *Lars* bears resemblance to the ordinary world of human existence, it diverges from it, opening into another place, a magical world of possibilities where wonders are fulfilled.

In such a world, characters have a limited emotional range and psychological depth. Karin, true *deus-ex-machina* and double of the narrator-screenwriter Nancy Oliver in her role to feed the plot with continuous inventions, does not show signs of evolution during the story, apart from her growing pregnant belly. Equally, Doctor Dagmar's palpable existential intensity maintains the same beautiful pitch all along, like a cypher, in her role of enabler-godmother-doctor. Gus, Lars's double as the capable but insensitive brother, is the only character to show the signs of some psychological conflict, however predictable in its trajectory, as a mirror of Lars's own development towards social maturity. Margo is, among the co-protagonists, the flattest character, a proper animated version of a princess-doll, with almost non-existent psychological motivations, as has been widely noted by commentators, thus emerging as a barely alternative choice to the inanimate doll Bianca. With regard to Lars, if someone has called Gosling's approach a "character study", others criticise his mannerisms, such as Manohla Dargis who describes Lars as a character "more stunted than damaged, soft rather than hurt", and Gosling "never fill[ing] this conceit with life".[19] "Lars too is a doll", she adds, "as pliable as Bianca and just as phony".[20] Albeit within a negative critique, Dargis points to a fundamental flatness of Lars as a character, who, although on a path of personal development, effectively appears as an abstraction of the human capability for self-renewal rather than a character imbued with a complex psychic world. Lars's condition is one of loneliness and helplessness at the beginning, which, thanks to his self-starter act of creativity − the invention of the doll-girlfriend − turns into secure and self-possessed individuality at the end. A reference to Ashby seems topical here again since Lars shares this condition of allegorical simplicity with the similarly simple-minded Chance of *Being There*, with Gosling showing the same respect for the character there demonstrated by Peter Sellers, and with Lars, like Chance, made to be something more than a cheap joke.

Thanks to this simplicity, the characters on screen can be seen − like Bianca in the narrative, functioning as an empty vessel for others, who fill her with their various contents − as the audience's dolls, allowing a range of responses as an effect of an animating effort. In this sense, the film's use of colour reinforces this logic. The limited colour palette − the greys and browns of the first part's costumes and décor, accentuated by the winter landscape − may not only be an emotional and social coding conveying sorrow, boredom and middle-class respectability, but also a choice which creates abstraction and absence, similar to that found in fairy tales.[21] Likewise, the matter-of-fact quality of the story, working in derogation of logical sense and leaving unexplained holes in the narrative, may be seen to create what has been called a "lyrical disconnect" in relation to "a story that enters and haunts you deeply", precisely like *Lars*, often described this way, as a "strangely affecting love story".[22]

Alongside its fairy-tale flatness and absurdism, the film shows a great deal of knowledge of psychoanalytical theories, as well as managing to reflect contemporary mores and manners. It offers an amusing and subtle satire of current definitions of femininity, masculinity and family, dialoguing particularly with recent US debates on fatherhood, as we shall see in the second section of this chapter. Like the world of fairy tales, described by Marina Warner as "laboratories for experiments with thought, allegories of alternatives to the world we know", *Lars* introduces us to a topsy-turvy realm, in which women manage the world and men strive to be more like them – steady and empathetic, forward-thinking and firm – and human society as a whole is a place where everyone is accepted and valued for their unique, quirky idiosyncrasies.[23] *Lars* transports the audience beyond the limits of mere ordinary reality, engaging subtly with political and philosophical thinking, while delivering through its kind satire not only consolation and hope but poignant humour and social and sexual critique. If the merit of the film, often highlighted by enthusiasts and detractors alike, is its ability to walk "a delicate line through a minefield of potential bad taste", the fairy-tale register should be recognised as a central means for this achievement since it allows the handling of a problematic sexual theme, still generally deemed perverse and freaky, that might be difficult to address otherwise.[24] In its allegorical treatment of sexuality, mental illness and the figure of the doll, the film shows a sure awareness of the traditional associations, well established in Western culture, between psychosis, the double and the maternal. In what follows, I first trace the connections established between the character's illness and the maternal sphere, before analysing the way the doll enters this scenario. We will delve into the ways the film mobilises these classical associations and how it manages to function differently from other films engaging the figure of the doll while using the same tropes.

The references to psychoanalysis and its traditional associations between psychosis and the maternal are introduced in the first section of the film, which makes of Lars a cypher of psychotic-like helplessness against a threatening world. Lars's illness is initially established as fidelity to the maternal sphere, which the film translates in the most literal sense in the character's physical attachment to a baby blanket that the mother had crafted for him before dying in labour. This is a central object in the affective dynamics of the narrative, circulating exclusively between Lars, Bianca and sister-in-law Karin, as a token of the imaginary doubling and projections built along the axis of the mother–child relationship. Transitional object *par excellence*, listed by Winnicott among the first "not-me" objects of the child, midway between thumb sucking and the first toy, the blanket is presented in the first scene as a sign of a maternal thing which is coded as dead and deadly in its association with the sterility of Lars's dwelling.[25]

To the sound of a naïve melancholic melody, the film opens with the camera observing Lars behind the window of his garage apartment watching a family scene outside. He sports a bad haircut and an unfortunate 1970s moustache, halfway between the funny-looking Carl Showalter (Steve Buscemi) in *Fargo* and the fervent Christian devotee Ned Flanders from *The Simpsons*. In the window glass we

perceive the faint reflection of figures bustling around a car in a snowy landscape, with the noise of children chuckling in excitement. The portrait of Lars's face through the glass, itself a double of the cinema screen, with projected action on it, is almost a still in its ten-second duration, were it not for the feeble movements of the projected figures on the glass. Showing his face encased within Georgian bars, this shot conveys at the same time proximity and detachment from the protagonist. Proximity is offered through a close-up of Ryan Gosling, a popular icon of American independent cinema, whose attractiveness is clearly displayed here, despite the odd moustache. This could be seen as an attempt to facilitate the audience's emotional involvement with a character who will soon display rather uncomfortable behaviours. Despite the close-up, Lars appears distant, enigmatic. If the superimposition of the family scene on his portrait suggests a collapse of fantasy and ordinary reality, the absence of a shot reverse shot frustrates an identificatory spectatorial dynamic: we cannot see what Lars sees. The bars of the window framing Lars's face in this scene rework the motif of the cage, classically used to describe (psychic) entrapment and a disturbance of personality, a fixation to the mirror, reminiscent of Raoul Ubac's 1938 *Mannequin* and Caillois's theory of mimicry.[26] This motif suggests that Lars, like Caillois's psychotic insect, may be suffering from a "disturbance in the perception of space", "no longer know[ing] where to place itself".[27] In Lars's gesture of covering his mouth with his baby blanket, we can read an attachment to the maternal object, while the claustrophobic, cavern-like appearance of his murky garage apartment reads as a *non-living space*. All white as the outside snow-bound landscape, this is an aseptic and hollow ambience, with the dreariness of the décor and the almost complete absence of accessories and food marking it as a space bereft of human life.

The entire first section of the film aims to define Lars as outcast, in response to many others trying to convince him that he needs a significant other to be happy, someone to share his life with. Lars's exclusion from a symbolic shared space emerges as a comic motif in the early sequence of Sunday Mass, with his childish behaviour during the sermon and his even more childish reaction to Margo's approach. It is a dry humour emerging from context more than words, mainly from the contradiction between Lars's awkward behaviour and general expectations of what is an acceptable, adult and masculine demeanour. Lars is described as childish, albeit in an indulgent way – as Mrs Gruner (Nancy Beatty) puts it, he is a "good boy". Like a boy, he gets distracted easily during the Reverend's speech, who is preaching God's law of "love one another", but that becomes background noise while Lars's attention is evidently focused on the toys of a nearby child who is placidly sleeping on the mother's breast.

In our first sight of Lars in the church, his figure, rendered clumsy by the bulky winter coat and his mother's blanket used as a scarf, is set against the blurred silhouette of the minister of God, a visually inconsistent – in addition to being barely audible – presence, as an allegory of Lars's disconnect from the surrounding symbolic world. Here we meet Margo, who is singing in the choir but, like Lars, indulges in distractions, losing her tempo while giggling, amused at Lars's childlike

misbehaviour. In the world of *Lars*, where men are indifferent or invisible – Gus is unconcerned with Lars's withdrawal, and the Reverend is plainly undetectable – it is women who are the ones who see, who are either concerned about or interested in Lars. In this scene, through the means of subjective shots, the viewer assumes Margo's gaze, through which Lars's immature tics are read as amusing and lovable quirks. Later, observing him through mother-to-be Karin's point of view, the viewer is invited to ascribe meaning to what is not (yet) meaningful. Like a mother with an infant, Karin attributes a significance to gestures and behaviours that Lars's lack of expressive language renders enigmatic.

The dynamic of the look receive a decided emphasis in the film, with the device of the frame within the frame being repeated several times, particularly in relation to Karin, often replicated in point-of-view shots while she observes Lars through the windows of the family home. This stress reflexively doubles the centrality of women's views in the narrative, in a way that ironically reverses the classical reading of Hollywood cinema as a male viewing machine, controlling a passive woman's image and imposing male characters' points of view. In *Lars*, on the contrary, we have many instances of women gazing at the protagonist, and little is known about what Lars actually thinks and wants if not through the women's narratives and desires projected on him. In contrast to conventional protagonists who are given narrative agency and whose knowledge and desires are shared through constructions of identificatory spectatorship, Lars is a hero whose point of view remains enigmatic, and whose content we are mainly able to construct through what others around him see and say. Gosling's understated acting style adds to the affective flatness of his character, which is a style that, following Lauren Berlant, can be seen as one that "foregrounds the obstacles to immediate reading", while at the same time "intensifies the curiosity one must bring to its aesthetics".[28] This underperformed emotionality is not only functional to the depiction of an emotionally withdrawn character, but manages to expose a fundamental aspect of the film, related to its fairy-tale coding: the universalisation of the space of fantasy, whereby it is not only Lars's delusion that brings fantasy to contaminate the fabric of ordinary reality but the whole community projecting content on the doll, as well as on Lars. There is a varied phenomenology of fantasy in the film: fantasy that allows one to see others as lovable and that initiates sociality (Karin and Margo's projections on Lars), fantasy that covers over the Real (Lars's initial need for defence from others: through the invention of the doll-girlfriend), and fantasy which allows one to inhabit the Real (Lars's final opening to others: through the doll's life). From a psychoanalytical point of view, Lars may be seen as a human being lacking a fantasy screen that would allow him to relate to others and their *jouissance*. In this sense Lars is a "boy", unable to decipher women's demands from which he can only flee.

It is precisely Lars's failure to conform to others' – and the audience's – expectations in terms of adulthood and masculinity that produces comic effects. Freud has described laughter as the effect of a conflict between what is observed in the comic object and one's own ideal image.[29] He refers to an initial moment of identification and to a second of aggression, when the image of the other does not correspond to one's ideal Ego, with laughter emerging as a device able to

create distance from the inadequate image, which therefore exposes a moment of narcissistic defence. In the scene of the first encounter with Margo at the end of Mass, social conventions of heterosexual masculinity and generic expectations of romance are embodied on screen by Mrs Gruner, who, despite making an effort to show liberal views on alternative sexualities – she knows "everything about gays" since her nephew is gay – urges Lars to find someone and not "leave it too long", since "it's not good for you". We follow Mrs Gruner and Lars at their back left walking out of the church; he is clumsily obscured by a large arrangement of flowers that he has politely offered to carry before a cut shows us the old lady from the opposite side, handing a flower to Lars, suggesting he should give it to "somebody nice", "for a start". A reverse shot reveals Margo behind them, a materialisation of somebody nice, indeed *über-nice* with her pink knitted mittens and naively flirtatious tics. On hearing Margo's "hello", Lars reacts by throwing the flower away with the most theatrical gesture, before freezing from embarrassment and running away, like prey chased by a *she-hunter*. Lars's passive mode of action and awkwardness towards the other sex clearly contradicts the image of assertive, heterosexual masculinity as an active, sexually dominant position. At the same time, this scene sets the terms of the protagonist's mission, creating romantic expectations in the audience for a final "and they lived happily ever after".

Lars's passivity, however, is also a coding of mental illness, whose exact nature is more left to the imagination than specified, which is another way the film plays on the plane of myth rather than within the conventions of realism. Although Lars "appears to have a delusion", as Doctor Dagmar says, his condition does not seem to make sense diagnostically but rather suggest malaise on a more abstract, existential plane. The film plays on the affinity between Lars and Bianca on the level of objecthood to convey the nature of Lars's illness, and after the freezing episode at the church, we find Lars sitting still in a dark room, immobile like a doll.[30] By showing Lars in opposition to the diegetic world of the social and reduced to an object, freezing under the gaze of the other, the film translates two ways in which psychoanalysis describes psychosis. A classical psychoanalytical account of psychosis sees it as a condition in which the subject finds herself in a "symbolic opposition" to the Other, unable to mobilise a foreclosed master signifier, a *Name of the Father* that would allow her to find a position in discourse.[31] Psychosis is also defined as a situation whereby the subject find herself thrown in the field of the Other as an *object a*, at the mercy of a threatening *jouissance*. In a psychotic structure, the demand coming from the Other cannot be turned into desire – as in the neurotic's experience – taking on a persecutory feel, with the subject exiled from subjectivity and displaced into the status of object. We can read Lars's appeal to flight and his tendency to immobilise as an allegory for the cycle of restlessness and helplessness of a subject unable to defend from the unbearable anxiety caused by the demands of the Other that, out of symbolic frame, appear threatening and malignant. The film's use of the blanket and of pink flowery pyjamas, among the many layers of clothes that Lars's costume includes, are hints to the fact that, as in psychosis, it is some sort of excess that the protagonist is trying to manage to achieve a minimum of subjective stability.

After the first section of the film has established Lars's condition of suffering, the doll's arrival appears initially as a device for Lars to defend himself from the intrusion of others. As in a fairy tale, Bianca's arrival is a matter-of-fact event, introduced by an intertitle displaying the text "six weeks later" at the end of the first section. The viewer will never know in Lars's words the exact motives for his decision to buy a love doll, or how he practically did it, leaving the other characters, principally Karin and Dagmar, to come up with a rationale. Initially the doll is presented as a disturbance, with Bianca playing the role of the villain, of hindrance to the romantic hopes around the Lars–Margo couple. The first shot of Bianca, sitting on the family sofa with Lars, is a comic treat, playing on the contrast between the hyper-sexualised figure of the doll, wearing a black fishnet shirt and faux leather black boots, and the antiquated fashion of the parlour and its inhabitants. The juxtaposition of the cheap sexualised appeal of the doll with Lars on one side, sporting his best Christmas jumper and hair slicked back for the occasion, and Karin on the other side, in her chaste brown corduroy pinafore dress, is one of the most enjoyable moments in the film as a skilful construction of deadpan humour. Bianca's role as the outsider, coming to disturb the tranquil, devoted manners of the Christian community, sustains a good part of the film's comic effects, exploiting the same juxtaposition between Minnesotan nicety and the depravity of outsiders that *Fargo* had notably employed a decade earlier.[32] The Scandinavian over-nicety of the community is here contrasted not with horrifically violent crimes, as in *Fargo*, but with the doll's reference to non-conventional sexual mores. Gus's annoyance at others' willingness to play along with Lars's delusion offers a double of the sceptical audience, and comic situations are typically built on his uptight reactions, with appalled facial expressions and skittish gestures at hearing Lars's stories about Bianca – that she has likes and dislikes, that she wants to choose a magazine while waiting for the doctor, that she is a nurse and can help Gus who is feeling sick and so on. There is an opposition between a level of ordinary reality, sustained by uncompassionate Gus for whom the doll is a mere inanimate object, and a level of delusion, whereby the doll is a living being, with wants and desires that the whole community sustains, in an act of communal *as if* play.

The absurdism of the film does not lay so much in the doctor's proposed solution to "go along" with Lars's delusion, as much as in the fact that the community wilfully participates in the clinical intervention, effectively transforming the village into an open-air psychoanalytical couch. Contrary to criticism pointing to the motif of a doctor suggesting people to mirror Lars's delusion as unrealistic, there is a certain clinical validity in this instruction. Within a psychoanalytic account of classical psychosis, a delusional metaphor, that is the delusional construction of a world view, is one possible way for a subject not inserted in discourse to stabilise "the disaster of the imaginary" that results from the foreclosure – the exclusion from the symbolic order – of a key signifier.[33] Instead of building psychic stability around the paternal metaphor, a psychotic subject can use her delusion to find sense in the chaos of existence. While the psychoanalytical treatment with neurotic subjects aims to create conflict in the analysand, questioning her identifications through an

opening to the enigma of desire as lack, the intervention with subjects not inserted in discourse, on the contrary, is usually directed at the stabilisation of the Imaginary, as a way out from the pain caused by an overwhelming, unbridled *jouissance*. If in the first case the intervention moves from the Imaginary, the level of fantasy, to the Real, the level of the drive, in the second case, the direction is opposite, from the Real to the Imaginary, towards the construction of a fantasy scenario.

The doll, as in the Kleinian approach with children, works in the film's narrative as a platform onto which the interpretive work is displaced. Bringing the doll to the doctor for her weekly blood pressure checks, Lars recounts his story to Dagmar, exposing his fears of having caused his mother's death. In most readings of the film, Lars's evolution is usually seen as a working through of a traumatic experience, with the illness and death of the doll repeating – as a way to master – the traumatic loss of his mother. However, notwithstanding its play with traditional cultural associations between the doll and the maternal, the film can be seen to make space for a more adventurous reading. *Lars* initially plays with these traditional associations, with the arrival of the doll undoubtedly coded as funereal. Arriving in a coffin-like box within the frame of a gothic-inflected landscape, it seems that Mother herself has come back from the realm of the dead, with the doll appearing as a *kolossós*, a double of the dead. Through a long shot of the wide open space marked by the big white Lindstrom house, in the background of a landscape made spectral by a thick blanket of snow, we see the heavy crate-coffin containing the doll being unloaded from a van. Evoked by the branch-claws of a majestic, leafless tree, etched against a turbulent sky under the sound of cawing crows, the presence of the macabre could not be more evident and at the same time more parodic, contrasted with the ordinary character of the brown UPS courier van.

We encountered the notion of the *kolossós* in Chapter 1, mobilised by Maurizio Bettini to describe the uncanny valence of the doll as virginal double, a presence signifying an absence created by loss. What we find here is a rather eccentric and clever re-edition of this classical figure, described by Vernant as a double that facilitates the passage between the world of the living and that of the dead. He describes it as a double of the dead that "returns to the light of day and manifests his presence in the sight of the living".[34] Silence, coldness, rigidity, lack of sight and mobility are classical attributes of death symbolised in the *kolossós* – whereby death appears "as a petrification of living beings" – and are features that can certainly describe the doll Bianca, which is never animated on screen.[35] These attributes can be seen to characterise Lars too, initially shown as a quasi-silent, immobile object, an object of the gaze rather than a subject holding the look, *seen* rather than *seeing*. The attributes of life to which the *kolossós* is opposed – voice, light (as an instance of sight) and movement – then return in Lars's delusional construction of the doll as a living being. However, these are not generally assumed in the diegesis, if not for the subtle change of the doll's face from her initial heavy makeup to a more chaste, natural look, up to the final greenish skin tone that signifies her illness. Here, again, the film can be seen to play its generic positioning ambiguously. On the one hand, it keeps its distance from an overblown fantasy scenario in which the doll would be

fully animated, a trope ancient as cinema itself – from the already-mentioned works by Meliés, Lubitsch and Mattsson, to Michael Gottlieb's *Mannequin* (1987), which all play on the animation of a doll-mannequin into a real girl through the use of editing, switching on screen from object to real actress.[36] In *Lars*, Bianca's voice is only audible to Lars, and her lack of movement is circumvented by her disability – she is constrained to a wheelchair by her illness, as if contingently unable to walk. On the other hand, the progressive discoloration of Bianca's face, which gradually appears more ill, achieved through the use of several masks for her face, complicates a clear-cut generic definition, partially conceding to Lars's delusion and to the age-old magic of cinema animating the doll into a living character.

The early scene of the doll invited to the family dinner could be seen as a witty version of the rite of evocation of the dead described by Vernant, as one of the main functions of the *kolossós*, called into the sphere of the living through a rite of hospitality, before being re-established forever in the realm of the shadows.[37] The film's ambiguity allows for an initial reading of Bianca as the *psuché* of the dead mother, her ghost, which, haunting Lars with its "dangerous power", is first fixed on the double-*kolossós* and then forever relegated to its resting place.[38] Accordingly, most readings see the final Lars, meditating on the doll-mother's grave, as someone emerging to new life, transfigured into an assertive heterosexual man finally able to embrace the joys of coupledom. Seen this way, the film's use of the doll would appear to be in continuity with a cinematic tradition in which dolls, mannequins and the like are figures marking a (male) subject's deadly attachment to the maternal object, as to a pre-symbolic *jouissance* that, if not abandoned, drives the protagonist to madness and death. However, if *Lars* enters into dialogue with this post-Surrealist cinematic tradition, the characters' flatness and the central narrative development show how the doll in fact enables, rather than hinders, the protagonist's entrance into a discursive symbolic sphere.

It is then with another aspect of the *kolossós* that the doll's diegetic role can be seen to engage more strongly, that is to say, its being "a substitute for the absent corpse", rather than an "image of the dead" – not a *representation* of someone but a *place-holder*.[39] A reference to recent psychoanalytic theory becomes relevant at this point, since this formulation by Vernant is strikingly evocative of the Lacanian *sinthome* as a "supplementary device", a place-holder for the *Name of the Father*.[40] The *sinthome* is in opposition to the metaphorical functioning of the Freudian symptom, which is a signifying formation to be interpreted as a message addressed to a consistent, complete Other. Through this lens we can appreciate *Lars and the Real Girl* as a humorous mythical take on present times as the era of the decline of the Oedipus, in which every individual subject is required to find a way to treat *jouissance*, once the Other has lost its symbolic efficacy to localise it through the traditional means of metaphorisation. It is through this framework that we become better positioned to make sense of the enabling function of the doll in the film, which is not otherwise understood through the structure of the return of the repressed. The doll does not stand for a traumatic eruption of *jouissance*, as in the modernist tradition, but can be seen as an original creation able to manage *jouissance* in the absence of a traditional paternal function.

Before exploring this reading in more detail, it might be helpful to pause and clarify some aspects of this theoretical framework. As seen in previous chapters, in the past couple of decades psychoanalytic practice has registered a blurring of the boundary between traditional classifications of neurosis and psychosis. The notion of "ordinary psychosis" recently introduced in Lacanian theory aims to address this situation, which can be translated as the "end of the power of the Name-of-the-Father as the unique signifier for symbolic law".[41] Just as the Oedipus complex had been redefined by Lacan as one of Freud's myths, so has Miller called the *Name of the Father* "a Lacanian credo, unable to account for the existence of cases standing between categories".[42] In the 1970s, Lacan had set the foundations for this displacement, by theorising the pluralisation of the *Name of the Father* in his *RSI* seminar, making it a symptom among others.[43] In the 1950s, the Other was seen to possess a substantial quality, with the paternal metaphor conceived as the only means to localise *jouissance* in the body and stabilise the subject, with psychosis emerging as an exception to neurosis, and foreclosure as "the nonexistence of this thing [the *Name of the Father*] in that place".[44] In his 1975–76 seminar on Joyce, Lacan introduced the *sinthome* as a universal construction, referring to the fact that each subject is required to singularly knot her psychic structure and find a suitable form of social bond with the Other, with repression through the *Name of the Father* as only one form for achieving this. The famous formula "The Other does not exist" implies that every subject has to find a means to "avoid madness", where the choice is, as Žižek put it, between the symptom and nothing, [whereby] we "choose something (the symptom-formation) instead of nothing (radical psychotic autism, the destruction of the symbolic universe)".[45] As Miller underlined, Lacan's *sinthome* is an "effort to write both signifier and jouissance in one sole trait", that is to describe a symptomatic form which "is not a formation of the unconscious", to be deciphered, but a "detached piece" which has a function for the subject, who "makes an art" of it.[46] Thomas Svolos put it most succinctly: "the sinthome is nothing other than the social bond for the subject", that is a *semblant* of the Other that needs constructing for each and every subject.[47]

When we bring this framework in dialogue with *Lars*, the role of the doll in the narrative structure can be seen in a new light. The initial introduction of the doll Bianca in the story is a function of exclusion – as an *ersatz other* cleverly crafted by Lars to isolate himself from the pressures of an Other of sex and love – but in the film's later development, Bianca clearly emerges as an act of creation that marks a structural change in the way Lars is perceived, which has effects on the way laughter is produced. If at the beginning Lars is a comic object in his opposition to the discursive field created in the narrative, with the introduction of the doll he becomes the creator of a joke, this way starting to subjectify his position. In this sense, an analogy can be identified between Lars's new subjective position and the way the comic effect is produced for the audience, with a movement from a bipartite to a tripartite structure, in which the doll functions as a *trestle* supporting the protagonist, a subjective supplement giving him a voice and taking him out of his initial condition of objecthood. If the doll's initial intrusion into the Christian

community is comic in its role of hindrance to all that is deemed normal, the subsequent participation of the parishioners in the projection of the most varied narratives on the doll means that Lars acquires a life, too, by proxy. We see him making himself up at the mirror, eating voraciously, for him and the doll – playing on the "eating for two" motif that popular wisdom attributes to pregnant women – going to parties for the first time and so on. We may read this as a moment when a modicum of symbolic efficiency sets in, making *Lars* a philosophical tale on the essential role of fiction in the creation of the Social, as a fiction which "possesses performative power – is socially operative, structures the socio-symbolic reality".[48] Bianca may not be a real girl, but she has real effects, functioning on a symbolic level. Accordingly, the notion of the *sinthome* is a much more compelling critical tool for us to be able to account for this fundamental dynamic in the narrative structure of the film. Like the *sinthome*, the doll here works as a formal envelope of excessive *jouissance*, a tool able to knot the registers of experience into a stable psychic reality. Rather than signifying the eruption of *jouissance*, as in the Surrealist tradition and the Freudian return of the repressed, the doll here can be seen to work as a fundamentally reparative device allowing the formation of the social bond through a containment of *jouissance*. Far from acting as an *unheimlich* "harbinger of death", Bianca emerges as a double functioning as a narcissistic prosthesis, fundamentally enabling the invention of an Ego. Whereas the father figures of the story are unavailable or invisible, the doll can be seen to assume the role traditionally assigned to the paternal function, that of organising a consistent psychic experience through a fastening of *jouissance*.

The community's projection of content onto the doll can be seen to transform the doll into an *ersatz-point-de-capiton*, a signifier around which Lars can be seen to organise his life and through which he is able to produce knowledge – what it means to grow up, to be an adult man – which is what, at one point, he asks of his brother. In Lars's world, this knowledge is a definite list of (ideal) behaviours that the brother dictates to him in a scene that is a humorous re-contextualisation of a man-to-man talk, with Gus hustling between cooking and folding clothes in the laundry: 1) "you don't jerk people around", 2) you "don't cheat on your woman", 3) you "take care of your family" and 4) you "admit when you're wrong" – besides doing the chores, obviously. Ethics becomes a neat list, and Lars will diligently try to put it in action, repeating one of the precepts to Margo after their first night together at the bowling alley – "I'll never cheat on Bianca . . . 'cos a man doesn't cheat on a woman". The efficacy of this easy-to-follow inventory will mark the obsolescence of Bianca that will be soon afterwards put to rest by Lars, after honouring her with a funeral, since it has done what he needed. This list delivers a problem-solving approach to the enigma of the other's desire, and we may see Lars's social inclusion, rendered in the bowling scene, as a metaphor of the consumerist approach typical of the *capitalist's discourse*, as a possible means for a subject excluded from discourse to stabilise psychic reality.[49] Gus's list, like a database of possible solutions, can be seen to give Lars new signifiers that he can adopt, as a consumer, to navigate how people and life function, ignoring the question of unconscious

truth. If the doll's independent life gives Lars a prop to learn how to deal with women and other people's capricious demands, Gus's list provides instrumental knowledge that he can use to transform inexplicable behaviours into more predictable demands, as for a subject attempting to wrap up the other's *jouissance*.

The sequence of bowling with Margo can be seen to formalise this newly found subjective consistency. Here the same signals that caused Lars to run away at the beginning of the film – Margo's flirtatiousness – become alluring and inviting for him, who can now actively engage in the sensual play of looking and being looked at.[50] The bowling scene is entirely played on this dynamic of the look, and at this point, for the first time, there is a glowing quality to the image, which emphasises the protagonist's newly acquired communicative competence. We may know nothing of Lars's and Margo's thoughts and emotions, but colours and light, together with an elevating musical theme, translate excitement and the joy of seduction, albeit always within a naïve register, far from an overt sexualisation. Comparing visually Margo and Lars's first encounter with this moment, we can appreciate how the initial opaqueness, absence of music and limited palette of beiges, greys and browns, conveying awkwardness and dullness, have turned into a softly vibrant mood of romantic colours, in which pale pinks and blues are revived with hints of yellow – a fairly popular wedding palette, in fact. Even the old-fashioned Minnesotan attire of the two appears at its best here. Lost any trace of bulkiness, their flannel check shirts and side-parted hair have acquired a more *hipster* look, accompanied by a beaming fuchsia neon illumination from the counter, reverberating on bodies and things. The camera movements follow the two as they alternate on the bowling lane, with a dance of coming and going, their play of looks and baroque self-conscious gestures, choreographed to the uplifting musical score, acquiring a haptic quality, as if the look of one could touch the body of the other only through the viewer's intervention. This is romance in the world of Lars, naïve and sexless, touching without touch, with the audience forever filling in the gaps of interrupted and enigmatic emotions.

The doll has played the role of enabler of Lars's transformation from helplessness to active player in the theatre of his life, guiding Lars in his own private rite of passage towards manhood. An important element that supports a reading of the doll as an *ersatz paternal metaphor* is the doubling between Bianca and Gus in the narrative structure. It is the parable of Gus, himself engaged on a path of enlightenment towards responsible fatherhood, to further suggest that the doll in *Lars* is engaged in a narcissistic strengthening potential, rather than as an uncanny figure of annihilation, as in the modernist tradition.

Propped-up fathers and the Other of care

In parallel to the doll's production of a social bond for Lars, the film traces Gus's maturation of guilt and repentance, an event as central in its unlinking of Lars's personal development as totally predictable. The sequence of Gus confessing his guilt to Karin can be very enjoyable, if one reads it in relation to the film's

characterisation of the village as a fervent Christian community, as a parody of the sacrament of penance, in which the sinner takes steps towards conversion through confession. Gus discloses his "sins" of selfishness to the wife-priest, while the camera gets closer to him with a close-up, cutting to show Karin's face empathising with the penitent sinner. Before the husband's assumption of guilt for the brother's madness – "it's all my fault", which replaces his previous mantra "it's not my fault" – Karin relieves him with an unfinished sentence, she invites him onto the sofa and gives him a hug as a sign of granted absolution. Gus's development can be seen as one of penance, repenting of his previous selfishness towards his younger brother and declaring his humility, in this scene efficiently rendered in the assumption of the most awkward, floppy posture ever seen in the act of sitting on a sofa. Lars's car launched on a downhill road, in the following shot, signals the success of the sacrament of healing, informing us metaphorically that the story has taken the "right direction", easing towards a happy ending.

At this turning point in the narrative, we find a symbolic handover between Gus and Bianca, with the former becoming a loving compassionate father figure discarding his initial negative traits of intolerance and negativity, absorbed by the latter – a classic split between good father and bad father, worthy of a tale by E.T.A. Hoffmann. However, where in *The Sandman* it is the good father who dies, leaving poor Nathaniel in the clutches of bad father Coppelius-Coppola, who will guide him to his fatal end in madness, in the fairy-land of *Lars* the opposite is the case. Shuffling tropes from the gothic and the horror genre with the fairy tale, the scene of Lars's quarrel with Bianca at the lake informs us that Lars has developed an interest in Margo, and that Bianca has now become a dominant, capricious and jealous character, who reproaches and "yells" at him.[51]

The construction of the father appears as a double concern in *Lars*, first in the guise of Bianca as an *ersatz paternal metaphor*, and then in that of Gus as a mythical *New Father*, an updated (good) version of the old (dead and bad) *paterfamilias*. Before the arrival of the doll, the world of *Lars* appears to be a society characterised by the dominance of strong women and the failure of men who, nonetheless, occupy centre stage as the main protagonists: Lars is an incompetent man, indeed a 27-year-old "boy", and Gus is an incompetent father. Women "wear the trousers", with Karin as the supreme governess, always quick-witted and empathetic – the scene of her cooling the frenzied husband down with firmness and compassion while holding a ladle with the other hand is instructive on this point. At one point she lands on Lars's back, immobilising him on the car drive, in order to invite him over for "salmon and cherry pie", while Dagmar will later give him a relaxing back massage, with Lars curled in foetal position in her consultation room. The women's role as "governesses" is a central element conveying the film's story as an initiation journey for the two brothers, who, like fairy-tale heroes in their route to self-actualisation, "will be guided step by step, and given help when it is needed" by stable, strong, motherly female figures.[52] It is the strength and compassion of the women that guide the narrative and allow the development of their male counterparts towards manhood (Lars) and responsible fatherhood (Gus). Within this quest,

the doll can be seen to be an educational prop for both, allowing Lars to learn how to conduct himself in a romantic relationship, and dad-to-be Gus to rehearse basic parental skills, taking care of Bianca like a child – washing, carrying and dressing her – in the family home with Karin.

While *Lars*'s women, with their strength and wisdom, are unchanging pillars, the role of Gus in initiating Lars to the mysteries of manhood and his own development through guilt and penance make of him a substitute father, albeit one in the making, as a double of Bianca as *ersatz paternal metaphor*. Read in this way, the film opens an interesting dialogue with the debate on fatherhood that, particularly in the US, has been a major cultural and political concern in the last few decades. The discursive construction of responsible fatherhood has been advanced by organisations such as the Fatherhood Responsibility Movement, a network of associations active since the mid-1990s, which, although related to several cross-party federal initiatives promoting family and child wellbeing, has typically expressed a conservative agenda in terms of family values and gender roles, especially in its pro-marriage wing.[53] In common with a vast array of other interest groups, the Movement hold the notion that father absence is the main root of social pathology, with fatherlessness seen as "one of the greatest social evils of our generation", an "engine driving our worst social problems, from crime and teen pregnancy to child poverty and domestic violence".[54] Having lost their legal authority in the family, fathers have, on the other hand, gained a new central role in recent American legislation in relation to the emotional and psychological wellbeing of children, becoming the "producer[s] of normal, heterosexual children, the stabilizing anti-delinquency agent, and the bringer[s] of realistic values and the desire for achievement".[55] The Fatherhood Responsibility Movement can be seen to add a masculinist narrative to this framework, claiming that, since the family has become "feminised", the reestablishment of fathers ought to imply the masculinisation of fatherhood, in a double attempt to domesticate men and separate them from any "feminising" connotations of family involvement.[56] As social anthropologist Anna Gavanas pointed out, Christianity has emerged in the United States as "a common ground where different constituencies of men come together within the Fatherhood Responsibility Movement", with religious metaphors used to assert a notion of male leadership, as a part of their ideas of a gendered division of labour.[57] In relation to this dominant discourse, the fundamental joke of the film is to offer a fairy tale of the construction of responsible fatherhood not only as an Other of (motherly) care, in which the father has, in fact, to be "feminised" in order to succeed, but also as a figure finally unable to produce the hoped-for "normal, heterosexual children", since Lars is not exactly a classic picture of heterosexual masculinity by the end of the film.

In regard to Gus, it is clear that he begins his parabola in the skin of the old, uncompromising *paterfamilias*, and the comic gags based on his rigidity create a distance from such a figure, albeit through an affective lens. Gus's initial point of view, unsympathetically judgemental and emotionally distant, is opposed to Karin's point of view, whose look towards Lars is one of care. Although described as a "good

husband", always busy in the kitchen amongst pans and chopping boards, Gus can be seen, initially, to be identified to the old (dead) father, as an absent and resented figure towards Lars. The failure of "the old man" is first subsumed and then expiated through Gus's act of contrition, from which he will embrace Karin's view that Lars is, in fact, worthy of love, notwithstanding his attachment for a "fiancée in a box". Gus's self-perceived fault is to have been *absent*, coded in turn as a form of selfishness – "I left home as fast as I could", "I never thought about him". The father is thus restored in the film but as a *present*, all-loving figure as opposed to the absent old *paterfamilias*. Through the functional role of the doll, the story can accordingly be seen to allegorise the removal of an unforgiving (Freudian) paternal figure – an agent of prohibition, distant from the subject's ways of *jouissance* – in favour of an agency which is present and called to guarantee the enjoyment of the invidual.

It is exactly this hateable characterisation of the old father that the poor doll will end up absorbing and, as such, destined to be disposed of to make space for the compassionate manners of Gus the *New Father*. Seen this way, the doll's "dead" body emerges as the *paterfamilias's kólossos* rather than a maternal object, as in the classical cinematic and cultural tradition, namely, that which needs to be abandoned in order for Gus to fully embrace the new ideal of the caring, present father. After all, Bianca is the only one "yelling" at Lars at the end of the film, indeed the only bearer of prohibition in a world bathed in the benevolence of the right to enjoy. *Lars* can hence be read as an allegory of the post-Oedipal ideal of a familiarised society, where public institutions do not exist to discipline or regulate individuals' conduct but to narcissistically facilitate their emotional wellbeing and self-actualisation. The absurdist premise of an entire community playing make-believe with a sex doll for the sake of the wellbeing of one "good boy" could not be a better satire of the therapeutisation observed in Western societies, where public institutions have increasingly assumed the role of "ersatz families".[58]

The responsible father that *Lars's* world props up, in its fundamental absorption of Karin's maternal point of view, can be read in opposition to the conservative politics of groups, such as the Promise Keepers and the like, calling for the return of an authoritarian father of prohibition, able to restore discipline and the moral education of the young. With men called upon to recover their feminine-compassionate aspect, the film could not better mock such contemporary conservative attempts at the masculinisation of fathers and the reaffirmation of traditional, gendered divisions of labour in the family. In relation to this dynamic, the figure of the doll is appropriated from its original feminine roots, both to signpost the protagonist's path to manhood and the ideological passage between the old Father of the Freudian tradition to the hypermodern *New Father* of presence. *Lars* can be seen as an allegory of a cultural shift, a moment where a system "restructures its rules in order to accommodate itself to new conditions by incorporating the originally subversive moment": the compassionate maternal is not in opposition to the paternal, but the first is subsumed by the latter.[59] Historically a female initiation figure, the doll in this story becomes the enabler of the men's self-actualisation. We saw in Chapter 1

how the doll's role in the fairy tale is typically that of a magic object with a strong maternal connotation with the function to accompany the young woman to marriage, often creating the conditions for it. We also saw how the doll's role as magic helper in the folk tradition translates its historical place within classical antiquity's female initiatory rituals. In being offered by Greek and Roman young women to the temple on the eve of their wedding, the *pūpa* and the *kóre* were considered not only apotropaic objects, as a double of the living child, but also symbols of female virginity, a double of the (symbolically) dead child, in a rite of separation from childhood. The film engages ingeniously with this tradition, peppering it with more virile undertones of physical pain, displays of courage and the ability to control one's emotions, commonly associated to male rites of passage.[60]

However, in doing so, *Lars and the Real Girl* not only shows knowledge of a variety of cultural sources and the will to thus entertain a savvy viewer in the know, but it also applies a twist to the consoling causality of the fairy tale and the symbolic efficacy of initiation rituals, through a final undermining of the magic it has created. Although the film can be seen to reach a happy conclusion in the final formation of the couple, it does not deliver the satisfaction that its consoling premises had led viewers to expect. There is a doubt about the doll's efficacy to achieve the "mature sexuality" that its historical and cultural tradition would imply. In the final sequence of the film, which is set at the cemetery after the doll's funeral, Lars's fresher appearance on a sunny spring day, having scrapped the baby blanket, suggests that he has made his transition into manly adulthood, but there is no clear sign of a "maturation" into heterosexual sexuality. On one hand, *Lars* suggests a developmental cycle through the allegory of the passage from winter to spring and from doll to real girl, while on the other, what we are finally presented with is a self-conscious display of conventions at the level of genre and gender. The couple is formed, but the camera shows it with an odd lateral angle, with the two standing beside each other at the grave site. In a pause in the scarce irrelevant dialogue, Lars closes his eyes, as an actor in recollection before a performance, and, creasing his forehead with a frown, he finally pronounces his invitation to Margo – "do you want to go for a walk?" – with the kind of masculine erotic assertiveness that Gosling is known for, off screen, as a sexy icon. It seems that Lars can *do* heterosexual masculinity, and that is all the viewer is allowed to know about his transformation. This can be considered a subtle moment of subversive comedy, where the subjective movement towards the belief in the master signifier (heterosexual masculinity) comes to the fore, and identification with it shows as a moment of disidentification.[61] The final image of the film, with Lars and Margo smiling but looking in different directions, somewhere off screen, adds to this performative dimension, leaving the viewer with the impression of an unstable, unfinished business.

The romantic colour palette returns in this final scene, brightened up by the natural warm but pale light of springtime, with the two wearing the same combination of colours in romantic blue and pink. They are indeed a perfect match, but surely disappointing as a classic romantic couple. Real girl Margo has demonstrated to be no more three-dimensional than Real Doll Bianca, or less child-like

than Lars, in this sense a rather improbable object-cause of desire for his male counterpart. Flat as gingerbread dolls on a wedding cake, both have not easily lent themselves to identification, due to their psychological inconsistency and general affective vagueness. This is their charm, as a visual question mark attempting to posit the impossible scenario of romance beyond the Oedipal constellation, in a story whose utopian horizon affirms that to be good you are allowed to be ill, inefficient and with troubles. Through the reflexive adoption of the building blocks of the fairy-tale form, the film seems to suggest that a sense of self, masculinity and fatherhood are similarly realities to be constructed, while the a-historical fairy-tale temporality makes one dream of new possible myths to be written on the ashes of the inefficiency of the Oedipal norm. However, unlike fairy tales with their definite clear ending, Lars's *finale* is open, ambiguous, suggesting another beginning but without any promise that the newly formed couple will lead to a future, let alone a happy one.

The reading of *Lars* in this chapter has underlined how the figure of the doll, exposed in many of its cultural and historical nuances – with links to psychoanalysis, the anthropology of the *kolossós* and its literary magic role within the fairy tale – ultimately emerges as an object enabling the stabilisation of subjectivity and the formation of sociality, in opposition to the traditional Surrealist reading of it as a figure of the uncanny. While the modernist use of doubling is based on a concept of psychosis as a "loss of ego substance", a "decline in the feeling of personality and life", in *Lars* the double embodied by Bianca can be read as a device enabling psychic stability, carrying a subject initially excluded from discourse into a social bond.[62] In opposition to a maternal characterisation of the doll that would turn the film into a cheesy, fundamentally nostalgic piece, this chapter has proposed to read *Lars*'s doll as an *ersatz-paternal function*. This allows to account for the centrality that the issue of fatherhood plays in the film and contextualise it in relation to current debates on the decline of traditional forms of symbolic authority in Western culture. Reviving the doll's fairy-tale role of magic helper, *Lars* has foregrounded doubling and make-believe as essential dimensions for the creation of a world in which one can believe, offering an allegory for the new contemporary relevance of the *sinthome* as an invention that substitutes for an "Other that does not exist".

Notes

1 We find men losing their sanity, dying or both as a consequence of their fetishistic choice in Arne Mattsson's fantasy-drama *The Doll* (1962), Mario Bava's *Hatchet for the Honeymoon* (1964), Luis García Berlanga's *Life Size* (1974), among others. We also find inanimate human replicas – to be distinguished from science fiction's technologically animated replicas – playing central roles in *The Doll* (Ernst Lubitsch, 1919), *House of Wax* (André de Toth, 1953) and *The Green Room* (François Truffault, 1978), for example. In line with the modernist tradition, the dolls in these films can be seen as figures of deadly *jouissance* hindering the subject's access to the Symbolic and the sexual relationship, a situation often crystallised in the presence of a protagonist fixated on a maternal object. As in the Freudian paradigm, in this cinematic lineage, the doll is an impediment to coupledom, keeping the male protagonists out of a social bond with the Other. See Chapter 1 for a detailed account on the modernist nuances of the figure of the doll.

2 The film premiered at the Toronto Film Festival in 2007. Nancy Oliver's screenplay won an Original Screenplay Award from the National Board of Review in 2007 and was nominated for an Oscar and a BAFTA in the same year.

3 Alissa Simon, "Review: 'Lars and the Real Girl'", *Variety* (11 September 2007), available at <http://variety.com/2007/film/awards/lars-and-the-real-girl-4-1200556447/>, last accessed 17.11.2019.

4 Roger Ebert, "Lars and the Real Girl Movie Review", *Roger Ebert*, website, available at <www.rogerebert.com/reviews/lars-and-the-real-girl-2007>, last accessed 17.11.2019.

5 Ella Taylor, "Painful to Watch Ryan Gosling in this Smarmy Little Number", *The Village Voice* (2 October 2007), available at <www.villagevoice.com/2007/10/02/painful-to-watch-ryan-gosling-in-this-smarmy-little-number/>, last accessed 17.11.2019.

6 See Mahola Dargis, "A Lonely Guy Plays House With a Mail-Order Sex Doll", *New York Times* (12 October 2007), available at <www.nytimes.com/2007/10/12/movies/12lars.html>, last accessed 17.11.2019.

7 Geoff Pevere, "'Lars and the Real Girl': Emotionally Deflated", *Toronto Star* (2 November 2007), available at <www.thestar.com/entertainment/movies/2007/11/02/lars_and_the_real_girl_emotionally_deflated.html>, last accessed 17.11.2019.

8 See Winnicott, "Transitional Objects". Readings of the films based on this notion include Andrea Celenza, "Mutual Influence in Contemporary Film", *Contemporary Psychoanalysis*, vol. 46, no. 2 (2010); Joye Weisel-Barth, "Loneliness and the Creation of Realness in Lars and the Real Girl", *International Journal of Psychoanalytic Self Psychology*, vol. 4, no. 1 (2008); Christine C. Kieffer, "Guys, Dolls, and the Uses of Enchantment", *Psychoanalytic Dialogues: The International Journal of Relational Perspectives*, vol. 25 (2015).

9 The exception is Claire Sisco King and Isaac West, "This Could Be the Place: Queer Acceptance in Lars and the Real Girl", *QED: A Journal in GLBTQ Worldmaking*, vol. 1, no. 3 (2014). The authors underline how "little learning Lars does in this film – at least as it pertains to Bianca" (75). However, the essay ultimately maintains the orthodox interpretation of the doll as a maternal object: it is seen to signify "a backward gesture emanating from [Lars's] refusal to let go of his lost maternal bond" (70).

10 Philip French, "Lars and the Real Girl", *The Guardian* (23 March 2008), available at <www.theguardian.com/film/2008/mar/23/comedy.drama>, last accessed 17.11.2019; Ann Hornaday, "'Lars and the Real Girl': Break a Wooden Heart", *Washington Post* (19 October 2007), available at <www.washingtonpost.com/wp-dyn/content/article/2007/10/18/AR2007101802350.html?nav=emailpage>, last accessed 28.09.2019.

11 Bruno Bettelheim, *The Uses of Enchantment: The Meaning and Importance of Fairy Tales* (London: Vintage Books, 2010 [1975]), 10, 11.

12 The nicety is criticised, for instance, in Rob Mackie, "DVD Review: Lars and the Real Girl", *The Guardian* (5 September 2008), available at <www.theguardian.com/film/2008/sep/05/dvdreviews.drama>, last accessed 17.11.2019; and David Ansen, "Ansen on 'Lars and the Real Girl'", *Newsweek* (10 November 2007), available at <www.newsweek.com/ansen-lars-and-real-girl-103141>, last accessed 17.11.2019.

13 Dargis, "A Lonely Guy".

14 See, for example, Garrison Keillor, *Lake Wobegon Days* (New York: Viking Press, 1985).

15 Stephen Wilbers, "Lake Wobegon: Mythical Place and the American Imagination", *American Studies*, vol. 30, no. 1 (Spring, 1989), 14.

16 *ivi*, 12, 13.

17 Kate Bernheimer, "Fairy Tale Is Form, Form is Fairy Tale", in Dorothy Allison et al. (eds.), *The Writer's Notebook: Craft Essays from Tin House* (New York: Tin House Books, 2009), 65.

18 *ivi*, 67.

19 Dargis, "A Lonely Guy". For the film as a character study, see Hornaday, "Lars and the Real Girl".

20 *ivi*.

21 See Bernheimer, "Fairy Tale", 67.

22 *Ibid.*; *Lars and The Real Girl*, DVD cover.

23 Marina Warner, *Once Upon a Time: A Short History of Fairy Tale* (Oxford: Oxford University Press, 2014), 5. For a reading of *Lars* as a utopian version of queer acceptance, see King and West, "This Could Be the Place".

24 Ansen, "Ansen on Lars". In this sense, *Lars* is closer to the fantasy world of *Air Doll* than to the realistic style of *Monique*, more attuned to the former's poetic animation of the doll in a childlike surreal space than to the latter's slapstick comedy treatment of a man having "the time of his life" masturbating with a doll.

25 Winnicott, "Transitional Objects", 90.

26 See Chapter 1.

27 Caillois, "Mimicry", 27, 28.

28 Lauren Berlant, "Structures of Unfeeling: Mysterious Skin", *International Journal of Politics, Culture, and Society*, vol. 28, no. 3 (September, 2015), 193.

29 See Sigmund Freud "Jokes and Their Relation to the Unconscious" [1905], in *id.*, *The Penguin Freud Library*, vol. 6 (Harmondsworth: Penguin Books, 1976).

30 This same affinity in objecthood between Lars and the doll is later echoed by Bianca's biography, herself marked by maternal loss and physical vulnerability, translated into her paralysed condition.

31 Jacques Lacan, "On a Question Preliminary to Any Possible Treatment of Psychosis", in *id.*, *Écrits*, 465.

32 The couple Karin–Gus can be seen to double *Fargo*'s Marge (Frances McDormand) and Norm (John Carroll Lynch), similarly portrayed as overly nice, in old-fashioned attire, and defiant of traditional gender divisions of labour. Karin, like Marge, is the heavily pregnant woman who leads and finally solves problems, albeit on an obviously much lighter register than in *Fargo*'s pluri-homicidal crime case.

33 Lacan, "On a Question Preliminary", 465.

34 Vernant, *Myth and Thought*, 306–307.

35 *ivi*, 311.

36 Toys have been animated on screen since cinema's beginnings: from Arthur Melbourne Cooper's *Dreams of Toyland* (1908), where toys are animated with stop-motion, to *Ted* (Seth MacFarlane, 2012), whose teddy bear's animation is achieved with 3D technology and motion-capture effects. See also *Babes in Toyland* (1934), *Nutcracker* (1986), *Labyrinth* (1986), *The Christmas Toy* (1986), *The Indian In The Cupboard* (1995), *Small Soldiers* (1998), among others. Animated play dolls, puppets and ventriloquist dummies appear in numerous horror movies, such as *Dead of Night* (1945), *Magic* (1978), the *Chucky* series (*Child's Play*, Don Mancini, 1988–2013), *Dead Silence* (2007), up to the recent *Annabelle* (John R. Leonetti, 2014).

37 See Vernant, *Myth and Thought*, 314.

38 *ivi*, 306.

39 *Ibid.*

40 Miller, "Ordinary Psychosis Revisited", in *Psychoanalytical Notebooks 19*, 161.

41 Marie-Hélène Brousse, "Ordinary Psychosis in The Light of Lacan's Theory of Discourse", in *Psychoanalytical Notebooks 19*, 10.

42 Lacan, *The Family Complexes*, 39; Miller, "Ordinary Psychosis Revisited", 142.

43 See Jacques Lacan, "Seminar 7: Tuesday 11 March 1975", in *id.*, *RSI* [unpublished], trans. Cormac Gallagher, 8, available at <www.lacaninireland.com/web/wp-content/uploads/2010/06/RSI-Complete-With-Diagrams.pdf.>, last accessed 17.11.2019.

44 Thomas Svolos, "Ordinary Psychosis in the Era of the *Sinthome* and Semblant", *The Symptom* (October, 2009), available at <www.lacan.com/symptom10a/>, last accessed 17.11.2019.

45 Žižek, in Ellie Ragland-Sullivan and Mark Bracher (eds.), *Lacan and the Subject of Language* (New York and London: Routledge, 1991), 207.

46 Jacques-Alain Miller, "The Sinthome, a Mixture of Symptom and Fantasy", in Véronique Voruz and Bogdan Wolf (eds.), *The Later Lacan: An Introduction* (Albany: State University of New York Press, 2007), 60; *id.*, "Pièces Détachées", *Orientation Lacanienne, Cours 1 (17.11.2004)*, 7–8 [unpublished], available at <http://jonathanleroy.be/

wp-content/uploads/2016/01/2004-2005-Pi%C3%A8ces-d%C3%A9tach%C3%A9es-JA-Miller.pdf>, last accessed 17.11.2019, my translation from French.

47 Svolos, "Ordinary Psychosis".

48 Žižek, *The Ticklish*, 330.

49 As Vanheule suggested, "capitalist discourse opens a market with solutions for distress, thus avoiding a confrontation with the fundamental non-rapport and with basic questions of existence, like 'who am I' or 'what do I want?'. In case of psychosis such avoidance is functional since a signifier for addressing these issues is lacking, as Lacan's hypothesis of foreclosure makes clear". See Stijn Vanheule, "Capitalist Discourse, Subjectivity and Lacanian Psychoanalysis", *Frontiers in Psychology*, no. 7 (2016), 11.

50 This passage from object to subject of the gaze is introduced in a previous scene through a redoubling of the cinematic apparatus. Like a cinema goer himself, Lars is shown sitting and watching Margo while eating from a pack of crisps. The camera subjectivises Lars's position of onlooker, with Margo now transformed into the object of the look, in a direct reversal of the initial relationship in the church.

51 The very long shot in which we overhear Lars arguing with Bianca in the car can be seen as a humorous pastiche of Hitchcock's same trope in *Psycho*, when a still of the house from a long distance is the only visual concession to the reprimand that Mother makes to Norman. Far from *Psycho*, in the world of *Lars* the loneliness and mental illness of the protagonist is taken care of by (several) mother figures and propped-up fathers.

52 Bettelheim, *The Uses*, 11.

53 See Anna Gavanas, "Domesticating Masculinities and Masculinizing Domesticity in Contemporary U.S. Fatherhood Politics", *Social Politics*, vol. 11, no. 2 (2004), 247–266.

54 David Blankenhorn, in Wade F. Horn et al., *The Fatherhood Movement: A Call to Action* (Lanham, MD: Lexington Books, 1999), 170.

55 Carol Smart, "The Legal and Moral Ordering of Child Custody", *Journal of Law and Society*, no. 18 (1991), 485–486.

56 Gavanas, "Domesticating Masculinities", 248. See e.g., David Blankenhorn, *The Good Family Man: Fatherhood and the Pursuit of Happiness in America* (New York: Institute for American Values, 1991).

57 Gavanas, "Domesticating Masculinities", 260.

58 Žižek, *The Ticklish*, 343. Psychologist and philosopher Ole Jacob Madsen, writing on the "therapeutic turn" in Western culture, takes this issue one step further when he underlines how religion has emerged as a primary *arena of* therapeutisation, where the notion of God found in contemporary American and European Christian circles emerges as the ultimate guarantor of the individual's path to successful self-actualisation. As the One who is "always there to help", God does not impose constraints anymore but is closer to a "cosmic therapist" who "administrates rights" and imposes obligations only to a limited extent, "wholly keeping with the therapeutic ethos in which the Self is the foremost authority". See Ole Jacob Madsen, *The Therapeutic Turn: How Psychology Altered Western Culture* (London and New York: Routledge, 2014), 48.

59 Žižek, *The Ticklish*, 328.

60 The sequence of the doll's funeral can be also read in relation to ancient pagan ceremonies involving korai and pupae and to Japan's present-day Buddhist ceremony of the *ningyo kuyo*, a funeral for dolls held in temples.

61 Alenka Zupančič defines "true comedy" as a moment where "the very universal aspect of [the signifier] produces its own humanity, corporeality, subjectivity". See Alenka Zupančič, "The 'Concrete Universal', and What Comedy Can Tell Us About It", in Slavoj Žižek (ed.), *The Silent Partners* (London and New York: Verso, 2006), 183.

62 Hollier, "Mimesis", 11; Caillois, "Mimicry", 30.

CONCLUSIONS

Doubles beyond the uncanny

This book has explored an aesthetic and psychic shift in the way the human and photographic double is perceived in contemporary visual culture, in contraposition with a traditional interpretation of doubling as a motif of the uncanny and its connections with loss and castration. Through close formal analyses of photographic and cinematic works produced between 1989 and 2016, this book has found the double as an object of visual pleasure, an associate of a capitalist *jouissance*-turned-Law, a device of narcissistic reinforcement and an enabler of sociality, beyond the traditional dynamics of the Oedipus. Throughout a series of case studies, I have proposed conjoining the fields of art history and visual theory with a recent corpus of psychoanalytic concepts emerged in the Lacanian School, testing their potential as a new aesthetic model. The *discourse of the capitalist*, the *sinthome* and *ordinary psychosis* – the main theoretical tools mobilised throughout this project – deal with the "evaporation of the Father" and the crisis of (unconscious) desire in the contemporary discourse of civilisation.[1] If the *capitalist's discourse* has been adopted as the frame to account for the problematic denial of lack implied in the hypermodern proximity of the libidinal object, discussions about the *sinthome* and *ordinary psychosis* have offered a view of new ways to curb *jouissance* within the contemporary decline of traditional forms of symbolic authority. The *sinthome*, a symptom functioning as a "place-holder" for the *Name of the Father*, implies the possibility of managing *jouissance* through a formal envelope, rather than exclusively through repression by means of the paternal metaphor.[2]

As analysed in detail in Chapter 1, the notion of lack is central to an understanding of the Freudian concept of the uncanny and the figure of the double in modernity. As Freud underlined in his 1919 essay, it is repression that gives rise to the effect of the uncanny.[3] The lost object thus rises like a ghost before the subject, which is pierced with an image of death: the Ego is annihilated by the emergence of the lost object. The case studies presented in this book have explored what

becomes of the doll, and of the image, in the context of the capitalist discourse, at the core of which stands an object which engulfs the subject, rather than a lost object, in a fundamental denial of lack and disruption of the logic of desire. I have proposed to read the muted aesthetic qualities of the hypermodern double through the notions of the historicity of the unconscious and the discursivity of *jouissance*, thus understanding the contemporary discourse of civilisation as one that foregrounds *jouissance* as its "compass" instead of hampering or inhibiting it, as in the past.[4]

The exploration of this book has arisen from the realisation that recent photographic forms of the double possess none of the traditional distinctive qualities and effects of their avant-garde precedents. I have offered a synthesis of these aspects in Chapter 1, where I attended to the classical role of the double as an uncanny figure of disruption, between narcissistic presence and symbolic absence, due to its connection to a moment of loss. I have followed Rosalind Krauss's classic reading of Bellmer's dolls and Hal Foster's notion of *traumatic realism* in relation to postmodern human replicas as ways to trace the traditional links between the modern double and a concept of visuality held in the theories of the uncanny, *mimicry*, the *informe*, the *punctum* and the Lacanian *gaze*. Moving from the visual arts to classic texts by Charles Baudelaire, Rainer Maria Rilke and Victor Hugo, the chapter highlighted how dolls and other human replicas are defined in modernity by their ability to reveal, through doubling, the fundamental split of the subject of the unconscious.

From a formal point of view, the potential of the uncanny to blur boundaries – ultimately, for psychoanalysis, the boundary between the Ego and the unconscious, between Law and *jouissance* – has traditionally been translated in aesthetic devices aimed at the creation of ambivalence: between self and other, past and present, interior and exterior, rational and irrational, and so on. Photography and the doll, through their common structure of doubling, have traditionally emerged as devices of anamorphosis, as cultural associates in a mission to disrupt dominant forms of subjectivity and artistic conventions. Attacks on the contours of the body, distortion of perspective, rotation from verticality to horizontality, blurring, flashing and other technical means of image manipulation, together with the production of a sense of dread or oneiric atmosphere through the use of light and colour, have all typically been photographic means able to create the menacing effects of the uncanny.[5] The "beyond the uncanny" this book's title refers to is first and foremost an effect of the simple observation that the aesthetic qualities of the image-dolls analysed here cannot be captured through an aesthetics of anamorphosis. Foregrounding flatness, *present-ness* and visual pleasure, they do not lend themselves to a reading which would point to (unconscious) depth, absence and unsettling effects of ambivalence and threat.

As a device able to give primacy to the beholder's intervention in defining meaning, the uncanny saw a major comeback in the 1990s, with a central role in practices and theories that tried to counteract the post-structuralist model of the simulacral. In the introduction, I touched on Mike Kelley's *The Uncanny* and Hal Foster's notion of *traumatic realism* as two major examples of such a recent

deployment of the uncanny as a means to oppose a postmodern notion of the sim-
ulacrum, which implied a model of the image as devoid of depth and subjectivity
as well as devoid of affect and history.[6] Arguing against an a-historical mobilisation
of the notion of the uncanny, the chapter highlighted how, from a psychoanalytic
point of view, the Freudian notion refers to a precise structure: a subject pierced by
the uncanny is a subject as *lack-of-being*, a subject of the unconscious as desire. By
mobilising Lacan's theory of the discourses and the notion of the *capitalist's discourse*
as antagonistic to desire, this book has analysed the muted import of the contem-
porary double as an instance of a new aesthetic experience to be found beyond the
subject of desire, beyond the Oedipus.

The work of Olivier Rebufa analysed in Chapter 2 presented a focus on visual
and psychic flatness that I read as the oxymoron of a *historic simulacrum*, able to
create a subjectivising effect through play and the metonymy of the series. I read
Rebufa's use of flatness, the stereotype and the mirror as signifiers of the psychic
flatness of the narcissistic subject implied by the *discourse of the capitalist*, while the
evidence of montage was seen to reveal the image's own constructedness, thus cre-
ating the effect of deflating its simulacral power. As a sculptural and performative
form of photography, we have seen how Rebufa's image pre-empts the truth-effect
of the Barthian *punctum*, rooted in the unconscious, while simultaneously working
conceptually as a form of *divertissement* with the potential to distance the viewer.
Death is a miniature figurine literalised in an amusing *tableau*, but the intermina-
bility of the series can be seen as a device able to push a capitalist look requesting
enjoyment towards the hysteric gap of a question. I argued that it is the structure of
play of Rebufa's self-portraits with dolls that, ultimately, creates a fissure between
immersion in the illusion and distance, between enjoyment and self-awareness.
Reading this work as a *historical simulacrum*, I pointed to the paradoxical condition
of a play of surfaces as a means to achieve the "retrospective dimension" of a project
of reorientation within the confusion of the contemporary capitalist experience.[7]
This would be the paradox of a *poison* taken as treatment, which can be seen to
parallel the structure of the *sinthome* as a form of enjoyment which defends against
the Real, a dynamic that I subsequently mapped in the visual works of the follow-
ing chapters.

After introducing the notion of *superego enjoyment* in relation to Rebufa's capital-
ist fantasia, Chapter 3 looked at Stephan Gladieu's photo-reportage on men living
with life-size dolls, which I read as doubles mobilised to protect a subject against
a threatening *jouissance*, perceived in the Other. In *Silicone Love*, dolls appear ani-
mated and mere things at the same time, with a clear authorial intervention in the
documentary's emphasis on the dolls' simulacral auto-referentiality or objectual
inertia. I argued that this strategy, whereby the fantasy of the doll's aliveness is never
assumed in the image, in fact counteracted by an exposure of its constructedness,
creates an effect of *de-fetishisation*. The documentary's careful use of composition,
perspective, symmetry and acidic colour can be seen to expose a kernel of closure
and protection inherent in the phenomenon of the love doll. I read the use of arti-
ficial light, the setting in self-enclosed interiors and the lack of space, coupled with

an insistence on symmetrical composition, as a suggestion of a paranoid logic of exclusion. Drawing on this formal emphasis on control, I underlined how the doll emerges here as a device of defence, rather than ambivalence – the true dimension of the unconscious and the uncanny. Far from emerging as a "harbinger of death", *Silicone Love* can be seen to expose the double as a crutch of the Ego, a narcissistic prosthesis *de-Realised* from any contamination with *jouissance*.

After reading Gladieu's doll hygienistic formalism as the allegory of an *anorexic gesture*, as a device set against the intrusion of the Other through an act of will, I proposed to engage with Laurie Simmons's lavishly pictorial *Love Doll* series, in Chapter 4, through a bulimic logic of addition. In terms of *jouissance*, something is added rather than subtracted. I described the exquisiteness of Simmons's Japanese dolls, set within airy, elegant interiors and treated through pictorial means and hyper-definition, as an *image-substance*, instigating a passion for fullness in the beholder. The chapter identified an oxymoron in the series between the immediate enjoyment of the image's visual magnificence and an atmosphere of repose, emerging from the image's measured treatment of light and colour, as well as the emphasis on the dolls' innocence. This is an oxymoron that I called *enjoyment as repose*, explored through a Lacanian understanding of addiction to conceptualise how hyper-stimulation could result in a protective effect.

The Love Doll can be seen as a synthesis between the capitalist injunction to enjoy – encountered in Rebufa's figure of Barbie as an Other who enjoys – and the issue of protection, already emerged in relation to Gladieu's love dolls. However, whereas Gladieu's focus on protection can be seen to evoke a will to master an excess of *jouissance* through a paranoid move of distillation, whereby *jouissance* is left in the Other, I read Simmons's pictorial splendour in terms of an *image-substance* that instigates craving. Lacan's *discourse of the capitalist*, with its formulation of an unprecedented proximity between subject and object – whereby the subject is engulfed by the object as an effect of a denial of lack – was the theoretical background mobilised here to describe the image's imposition of visual satisfaction and its seeming indifference for a repressed *truth*, or phantasmatic under-text.

In their different nuances, all the case studies in this book foregrounded how the contemporary photographic forms of the double exceed an understanding of subjectivity as *lack of being* and of visuality as the field of the *gaze*, in which a repressed object would be revealed through a dynamic of concealment. It is particularly here in Chapter 4 where this situation finds a visual paradigmatic form, unhindered by the devices of restraint instead found in the other case studies analysed. Simmons's doll-image can be seen to offer a *jouissance* floating on a surface, knotted in form instead of being repressed, as in the classic structure of the work of art. The doll here acquires a distilled visual form as a device of doubling which affords psychic stability instead of posing a threat to it, as its modern counterpart. The doll-image is a double that does not divide, as in the classical Lacanian diagram of the *gaze*, but one that instead offers a modicum of stability through a formal envelope of *jouissance*, *managed* rather than reduced. This shift in the way the image is linked to the Real can be seen as the shift from the image as locus

of the (Freudian) *symptom* to the image as *sinthome* – *doing*, rather than meaning, something for the viewer.

The dynamic of the *sinthome* has subsequently offered a productive critical tool to analyse *Lars and the Real Girl* and its narrative structure in Chapter 5, and put into contrast the figure of the double with the issue of fatherhood, central in the film. Through the structure of the *sinthome*, the film's formal emphasis on flatness, abstraction and atemporality, often seen as handicaps, was read as a purposeful aesthetic choice, which, borrowing from the structure of the fairy-tale genre, introduces us to a post-Oedipal aesthetic. By recuperating the fairy-tale role of the doll as magic helper, *Lars* characterises the doll Bianca as a double which enables the social bond. Breaking with a longstanding cinematic tradition in which dolls signify a deadly maternal attachment, here the doll creates the social bond, instead of hindering it. By underlining the doubling between the doll and Gus, the paternal figure of the narrative, the chapter thus countered conventional readings of the film which have identified the doll as a maternal object. A lookalike of a maternal object, the doll is seen in the chapter to function, structurally, as an *ersatz-paternal metaphor*, becoming a *kolossós* of the "bad" absent father, finally dying to make space for the "good" present *New Father* (Gus) at the end of the film. Appropriating the cultural history of the doll as an object related to female initiatory rituals, *Lars* transforms this figure into an enabler of male self-actualisation. This can be seen to reflect on a contemporary ideological passage between the old father of absence, unconcerned with *jouissance*, and the new father of presence, whereby conventional binary divides between the maternal and the paternal, the realms of presence and of absence, the spheres of *jouissance* and the Law, lose significance. This mobilisation of the doll as an enabler of sociality, as an *ersatz Name of the Father*, can be seen to foreground doubling as a supplementary device that creates symbolic effects outside of the Symbolic, in striking contrast to the modern double as a figure of subjective separation and social disruption.

Testing new concepts from the last teaching of Lacan and the contemporary psychoanalytic clinic, this book has explored how the new formal strategies associated with the figure of the double resonate with a new, hypermodern aesthetic and subjective dimension. Rebufa can be seen to update narcissism for the 1990s, coupling a flat display of enjoyment with a suggestion of duty and apathy. The notion of narcissism as the "socially mandatory form of subjectivity" within the contemporary capitalist social bond has indeed been one of the main critical *leitmotif* running through this book.[8] Rebufa's work offered the opportunity to reflect on how the post-1968 cultural deployment of the notion of narcissism as a strategy aimed at subversion through a liberation of *jouissance* had already become in the 1990s anachronistic, if not counterproductive in political terms, ultimately aligned with the workings of the capitalist discourse, which in fact extracts *surplus enjoyment* for profit. The hope to create cultural shock through a flaunting of enjoyment, advanced in 1990s projects such as *The Uncanny* and *Abject Art*, can be seen, with hindsight, to have underestimated the convergence between the capitalist discourse and the invitation to get past one's inhibitions. The liberation of *jouissance*, the

mission that aligned Surrealism to Freudianism in the first half of the twentieth century, can be seen as a "sensational success".[9] As Miller has put it, "Freudian practice anticipated the rise of the object small *a* to the social zenith and this practice contributed to its installation".[10] An autistic *jouissance* without the Other rules within the contemporary social bond, with *jouissance* therefore hardly conceivable as a "bone in the throat" of the Law. Still thought in the 1990s as a disruption of dominant discourse, the revelation of the Real through *traumatic realism* can be seen, at best, as a reflection of the *Status quo*.

The fetish has emerged as another notion that might usefully be subjected to a revision in terms of its cultural and political potential in the contemporary moment. In Chapter 3, Gladieu's documentary *Silicone Love* offered the opportunity to explore the entanglement of fetishism with the contemporary capitalist discourse. If the object is lost in perversion, and belief has the function to deny it, as opposed to neurosis's acceptance of it, how are we to conceive the object of the *capitalist's discourse*, with its attachment to the subject? Is the love doll a fetish object, as suggested by Marquard Smith?[11] In the chapter, I examined how Gladieu's love doll appears as a device of protection from enjoyment, reading thematic and formal suggestions of closure and defence as the means of an adaptive strategy against the dominant capitalist compulsion to enjoy. In this sense, the doll does not appear as a substitute for a woman but as an *inhuman partner*, a partner beyond the human, not as a misogynistic choice but as an asexual choice.

All the photographic works analysed in this book suggest a coupling of simulacral flatness and affective intensity, in this sense pointing beyond the postmodern simulacrum as "waning of affect".[12] Flatness has emerged as a fundamental signifier. We encountered it in the depthless fantasia of Rebufa's cut-out figures within a sculptural photographic world; in Gladieu's authorial choice of disruption of the doll's aliveness; in Simmons's construction of enjoyment without *gaze*; and in *Lars*'s presentation of a protagonist lacking in psychological depth and conventional identificatory power. In these works' coupling of flatness with enjoyment, the traditional oppositional binary between affect and the simulacrum, central in the 1990s debates recalled earlier, loses its relevance. The book opened, in the introduction, with a challenge to the classical oxymoron between a concept of reality as repulsive *excess* and one as simulacral flatness emerging in the debate of the time. The notion of an image, as well as of a subject, at once *hyper-affective* and lacking in depth, has traversed this entire book, in relation to the new organisation of *jouissance* observed in the contemporary clinic of the "new symptoms", where *jouissance* takes centre stage, unknotted from the symbolic level of the Other as a regulating agency. In their different modalities, the case studies analysed can be seen to point to a new regime of visuality characterised by an *excess-with-flatness*, a Real intensity floating on a surface, beyond the traditional dynamics of the return of the repressed. The hypermodern double reveals a simulacrum which is in direct relationship with the Real, beyond the dynamics of symbolic alienation, not repressed but organised *through* form. The hypermodern image has become the substitute for a failing paternal Law.

The aesthetic qualities of the hypermodern double can be seen to expose a contemporary shift in the way a sense of reality is structurally created. The renewed relevance of the human double and its plays of simulations in contemporary visual culture in this sense reveals the current crisis of the Symbolic. However, rather than a disruption of the Imaginary – as in Foster's "crisis of the image-screen" – the demise of the Symbolic emerges today as a reinforcement of the Imaginary, which is an attempt to solve the contemporary problem of treating the Real and creating a modicum of psychic consistency.[13] In this context, the return of dolls, mannequins and other figures of the double in recent Western visual culture can be seen to expose a contemporary preoccupation with the role of the simulacrum in its new function of organising psychic consistency where the Symbolic has failed. Rather than concealing and revealing a repressed Real, the hypermodern simulacrum seems to envelop an un-symbolised Real, knotting it on the surface. The workings of doubling analysed in this book have relinquished the classical modernist connection to "legendary psychasthenia", to a psychotic loss of Ego boundaries, to relate instead to a reinforcement of the Ego, as a way for the contemporary subject to achieve a feeling of life.[14] Exceeding the modalities of the Freudian unconscious, the double has appeared in this book as a supplement of the Ego, a protection against the Real and a device preoccupied with creating a sense of reality by holding the different registers of psychic experience together.

Reading doubling through the lens of the *capitalist's discourse*, the *sinthome* and *ordinary psychosis*, the actuality of the yet so different photographic practices here analysed has come to the fore. It should be clear by now that the imaginary strengthening to which this book has connected the image-doll is not linked to a soothing restoration of a modernist ideal of subjectivity as idealised whole, or of the image as an autonomous entity. The photographic work analysed here appears beyond the classical contraposition identified between the pictorialism of modernist photography – whose "sharply focused image" would give the beholder the "illusion of mastery" – and an avant-garde photography that instead would blur categories in order to "[erect] the fetish, the informe, the uncanny".[15] Subjectivity and visuality have emerged here as hybrids. If the contemporary subject resides beyond the binary categorisations of neurosis and psychosis, the visual appears to overlap traditional boundaries between practices – photography, performance, sculpture, painting, documentary – and between genres – comedy, drama, fairy tale – contravening any notion of a pure medium. If there is any continuity between the modernist doll and its hypermodern counterpart is precisely in the intrinsic semiotic liminality that makes this human-like object a central device of aesthetic exploration. The doll's semiotic indecisiveness as both an image and an object at the limit of personhood has to be seen as the essential starting point for the ability of the works analysed to explore questions concerned with our current fascination with images and simulation. The challenge of this book has been to investigate the formal hybridity of the contemporary photographic image through the terms of the new hybridity of form and enjoyment,

symbol and *jouissance*, that contemporary psychoanalysis has identified as a cypher of hypermodern subjectivity.

In relation to the art-historical contextualisation of the return of the human double that I recalled in the Introduction, the case studies in this book can certainly be seen to play within the post-conceptual legacy of Minimalism and its theatricality. A disinterest towards medium specificity is associated in these works with strong authorial intentionality, with the proposition of a highly constructed image, as well as with a theatrical, conceptual force. This hybridity emerged in Olivier Rebufa's *Bimbeloterie* as a maximally constructed fantasia engaging the beholder through a sado-masochistic structure as well as through play; in Stephan Gladieu's pictorial documentary as a fiction *qua* document; in Laurie Simmons's large-scale pictorial photography as maximally theatrical, as an image that badly wants to create (Real) effects for the viewer; and in *Lars and the Real Girl* as a post-narrative cinematic experience, at once closed (to conventional identificatory dynamics) and open (to curiosity). Therefore, if this book subscribes to the general idea of linking the return of dolls and other human replicas in contemporary art within the art-historical trajectory of Minimalism, as suggested by Mike Kelley, Hal Foster and Isabelle Shaw, among others, I have proposed a substantial amendment. This book has understood these figures' condition as "quasi-subjects" – to use Shaw's definition – through the constructs of a hypermodern, post-Oedipal subjectivity, beyond the notion of the Real as what is excluded from the Symbolic.[16] Objects, images and persons have appeared to be coordinated in a logic that goes beyond the old binaries of interior-exterior, form-formless, conscious-unconscious, Law-*jouissance*.

Ultimately, the image-doll of this book can be seen to open to the problem of a definition of visuality beyond the traditional dynamics of lack and sublimation. As we saw in Chapter 1, the symbol has traditionally been considered by psychoanalysis as a horizon opened by absence (of the mother), by a renunciation to *jouissance*. The hypermodern image-doll seems instead to point to an aesthetic dimension eccentric to the realm of the "elevation of an object to the dignity of the Thing", beyond the empty space of lack.[17] Following the notion of the *sinthome* onto the aesthetic ground ultimately means exploring new ways to theorise our relationship with the aesthetic object, traditionally connected to lack, as a logics of emptying of *jouissance*, both in production and reception. The contemporary image-doll can be seen to foreground a different paradigm of visuality whereby the signifier is directly linked with *jouissance*, beyond the classical workings of symbolisation as evacuation of *jouissance*. This is not to suggest that the image *is* Real. Like a subject always in need of a way to operate on the Real in order to be human, art can only exist as a framed event. Nonetheless, the dimension we have explored in this book through the contemporary visual forms of the double presents an unprecedented encryption of the Real in the fabric of the image, which appears tightened in a knot without the means of symbolic alienation. Dolls, with their fundamental semiotic liminality and anthropological complexity, point us once again towards intellectual curiosity, asking for an effort to think newly about aesthetics in the era of the *evaporated Father*.

Notes

1 Lacan, "Intervention sur l'Exposé", 84.
2 Miller, "Ordinary Psychosis Revisited", 161.
3 Freud, "The Uncanny", 241.
4 Miller, "A Fantasy", 6.
5 See Krauss, "Corpus Delicti"; Foster, *The Return*.
6 Among recent examples of the mobilisation of the uncanny, see Tamara Trodd, "Thomas Demand, Jeff Wall and Sherrie Levine: Deforming 'Pictures'", in Costello and Iversen, *Photography After*, 130–152.
7 Jameson, *Postmodernism*, 18.
8 Žižek, "Pathological Narcissus", 234.
9 Miller, "A Fantasy", 11.
10 *Ibid.*
11 See Smith, *The Erotic Doll: A Modern Fetish.*
12 Jameson, *Postmodernism*, 11.
13 Foster, *The Return of the Real*, 156. See my *Chapter 1* for a discussion.
14 On legendary psychasthenia as loss of Ego, see Caillois, "Mimicry" and my Chapter 1 for a discussion.
15 Krauss, *Corpus Delicti*, 72.
16 Shaw, *Art and Subjecthood*, 14.
17 Lacan, *The Other Side*, 141, 165.

SELECTED BIBLIOGRAPHY

Adams, Parveen, *The Emptiness of the Image: Psychoanalysis and Sexual Differences* (London: Routledge, 1996).

Agamben, Giorgio, *Stanzas: Word and Phantasm in Western Culture* (Minneapolis: University of Minnesota Press, 1993).

Ahmed, Sara, "Multiculturalism and the Promise of Happiness", *New Formations*, no. 63 (Winter, 2007/2008), 121–137.

———— & Stacey Jackie (eds.), *Thinking Through the Skin* (New York: Routledge, 2001).

Air Doll, dir. by Hirokazu Koreeda (2009).

Alexandre, Elisabeth, *Des Poupées et des Hommes: Dolls and Men: Investigation Into Artificial Love* (La Paris: Musardine, 2005).

Apter, J. Michael & Kerr John H. (eds.), *Adult Play: A Reversal Theory Approach* (Amsterdam: Swets & Zeitlinger, 1991).

Ardenne, Paul, *Olivier Rebufa* (Paris: Baudoin-Lebon, 2006).

Ariès, Philippe, *Centuries of Childhood* (London: Jonathan Cape, 1962).

———— & Margolin Jean-Claude (eds.), *Les Jeux à la Renaissance: Actes du 23. Colloque International d'Etudes Humanistes* (Paris: Librairie Philosophique Vrin, 1982).

Badiou, Alain, *In Praise of Love* (London: Serpent's Tail, 2012).

Baldwin, Yael Goldman, Malone Kareen & Thomas Svolos (eds.), *Lacan and Addiction: An Anthology* (London: Karnak Books, 2011).

Barthes, Roland, *Image, Music, Text* (New York: Hill and Wang and Noonday Press, 1988).

————, *Mythologies* (New York: Noonday Press, 1991).

————, *The Responsibility of Forms: Critical Essays on Music, Art and Representation* (Berkeley and Los Angeles: University of California Press, 1991 [1982]).

————, *Camera Lucida* (London: Vintage, 2000 [1980]).

Bateson, Gregory, "A Theory of Play and Fantasy", in Henry Bial (ed.), *The Performance Studies Reader* (London: Routledge, 2016 [1955]).

Baudelaire, Charles, *Oeuvres Completes I* (Paris: Gallimard, 1975), 581–587.

Baudrillard, Jean, *Simulations* (New York: Semiotext, 1983).

Benjamin, Walter, *Opere complete di Walter Benjamin* (Torino: Einaudi, 1986).

Berardi, 'Bifo' Franco, *The Soul at Work: From Alienation to Autonomy* (Los Angeles: Semiotext(e), 2009).

Berlant, Lauren, *Cruel Optimism* (London: Duke Universtiy Press, 2011).

———, "Structures of Unfeeling: Mysterious Skin", *International Journal of Politics, Culture, and Society*, vol. 28, no. 3 (September, 2015), 191–213.

Bernau, Anke, *Virgins: A Cultural History* (London: Granta Books: 2007).

Bernheimer, Kate, "Fairy Tale Is Form, Form Is Fairy Tale", in Dorothy Allison et al. (eds.), *The Writer's Notebook: Craft Essays from Tin House* (New York: Tin House Books, 2009), 61–73.

Bettelheim, Bruno, *The Uses of Enchantment: The Meaning and Importance of Fairy Tales* (London: Vintage Books, 2010 [1975]).

Bettini, Maurizio, *Il Ritratto dell'Amante* (Torino: Einaudi, 1992).

Bodei, Remo, *La Vita delle Cose* (Roma: Laterza, 2011).

Bollas, Christopher, *The Shadow of the Object: Psychoanalysis of the Unthought Known* (London: Free Association Books, 1987).

Bonazzi, Matteo & Daniele Tonazzo, *Lacan e l'Estetica* (Milano: Mimesis, 2015).

Bonnefis, Philippe, "Child's Play: Baudelaire's Morale du joujou", in id., *Reconceptions: Reading Modern French Poetry* (Nottingham: University of Nottingham Press, 1996), 21–36.

Brougère, Gilles, Buckingham David & Jeffrey Goldstein (eds.), *Toys, Games and Media* (Mahwah: L. Erlbaum Associates, 2004).

Buchloh, Benjamin H.D., "Allan Sekula: Photography between Discourse and Document", in Allan Sekula (ed.), *Fish Story* (Dusseldorf: Richter Verlag), 189–201.

Caillois, Roger, "Mimicry and Legendary Psychasthenia", transl. John Shepley, *October*, vol. 31 (Winter, 1984 [1939]), 16–32.

———, *Man, Play and Games* (Urbana: University of Illinois Press, 2001 [1958]).

Castanet, Hervé, "Olivier Rebufa: Du Stéréotype Comme Style", *Art Presse*, no. 257 (2000), 34–39.

Castle, Terry, *The Female Thermometer: Eighteenth-Century Culture and the Invention of the Uncanny* (New York: Oxford University Press, 1995).

Castoldi, Alberto, *Clérambault: Stoffe e Manichini* (Bergamo: Moretti & Vitali, 1994).

Celenza, Andrea, "Mutual Influence in Contemporary Film", *Contemporary Psychoanalysis*, vol. 46, no. 2 (2010), 215–223.

Chasseguet-Smirgel, Janine, *Creativity and Perversion* (London: Free Association Books, 1984).

Cixous, Hélène, "Fictions and Its Phantoms: A Reading of Freud's Das Unheimliche (The 'Uncanny')", *New Literary History*, vol. 7, no. 3, *Thinking in the Arts, Sciences, and Literature* (Spring, 1976), 525–548.

Clemens, Justin & Grigg Russell (eds.), *Jacques Lacan and the Other Side of Psychoanalysis: Reflections on Seminar XVII* (Durham, NC: Duke University Press, 2nd Printing, 2007).

Costello, Diarmuid & Iversen Margaret (eds.), *Photography after Conceptual Art* (Chichester: Wiley-Blackwell, 2010).

Crimp, Douglas, "Pictures", *October*, vol. 8 (Spring, 1979), 75–88.

———, "The Photographic Activity of Postmodernism", *October*, vol. 15 (Winter, 1980), 91–101.

Danos, Jeanne, *La Poupée Mythe Vivant* (Paris: Editions Gonthier, 1966).

Declercq, Frédéric, "Lacan on the Capitalist Discourse: Its Consequences for Libidinal Enjoyment and Social Bonds", *Psychoanalysis, Culture & Society*, no. 11, 2006, 74–83.

Deitch, Jeffrey, *Post Human* [ex. cat.] (Pully and Lausanne: FAE Musée d'Art Contemporain, c1992).

Deutsch, Helene, "Some Forms of Emotional Disturbance and Their Relationship to Schizophrenia", *Psychoanalytic Quarterly*, 76 (2007 [1942]), 325–344.

Doane, Mary Ann, "The Economy of Desire: The Commodity Form in/of the Cinema", in J. Belton (ed.), *Movies and Mass Culture* (London: The Athlone Press, 1996), 119–134.

Dolar, Mladen, "'I Shall Be with You on Your Wedding-Night': Lacan and the Uncanny", *October*, vol. 58 (Autumn, 1991), 5–23.

——, *A Voice and Nothing More* (Cambridge, MA: MIT Press, 2006).

The Doll, dir. by Ernst Lubitsch (UFA, 1919).

The Doll, dir. by Arne Mattsson (1962).

Dorfman, Elena, *Still Lovers* (New York: Channel Photographics, 2005).

Drucker, Johanna, *Sweet Dreams: Contemporary Art and Complicity* (Chicago and London: University of Chicago Press, 2006).

Dufour, Dany-Robert, *The Art of Shrining Heads: On the New Servitude of the Liberated in the Age of Total Capitalism* (Cambridge: Polity Press, 2008).

Dyer, Richard, *Pastiche* (London and New York: Routledge, 2006).

Edelman, Lee, *No Future: Queer Theory and the Death Drive* (London: Due University Press, 2004).

Eklund, Douglas, *The Pictures Generation 1974–1984* (London: Yale University Press, 2009).

Elsaesser, Thomas, "Primary Identification and the Historical Subject: Fassbinder and Germany", in *Ciné-Tracts: A Journal of Film and Cultural Studies*, vol. 3, no. 3 (Autumn, 1980), 43–52.

Eshelman, Raoul, "Performatism in Art", *Anthropoetics*, vol. 13, no. 3 (2007/2008), n.p.

——, *Performatism: Or the End of Postmodernism* (Aurora, CO: Davies Group, 2008).

Eves de Silicones, dir. by Elisabeth Alexandre (France 3, 2002).

Feldstein, Richard, Bruce Fink & Maire Jaanus (eds.), *Reading Seminar XI: Lacan's Four Fundamental Concepts of Psychoanalysis* (New York: State University of New York Press, 1994).

Ferguson, Anthony, *The Sex Doll: A History* (Jefferson, NC and London: McFarland & Co., 2010).

Ferrari, Stefano (ed.), *Lineamenti di una Psicologia dell'Arte: A Partire da Freud* (Bologna: CLUEB, 1999).

——, *Lo Specchio dell'Io: Autoritratto e Psicologia* (Bari and Roma: Laterza, 2002).

—— (ed.), *Il Corpo Adolescente e le Sue Rappresentazioni: Percorsi Interdisciplinari tra Arte e Psicologia* (Bologna: CLUEB, 2007).

Fleming, Dan, *Powerplay: Toys as Popular Culture* (Manchester and New York: Manchester University Press, 1996).

Foster, Hal, *Compulsive Beauty* (Cambridge, MA: MIT Press, 1995).

——, *The Return of the Real: The Avant-Garde at the End of the Century* (Cambridge, MA: MIT Press, 1996).

——, *Bad New Days: Art, Criticism, Emergency* (London: Verso, 2015).

Foucault, Michel, *Discipline & Punish: The Birth of the Prison* (New York: Vintage Books, 1995 [1977]).

Franchi, Franca (ed.), *Locus Solus: L'Immaginario degli Oggetti* (Milano: Bruno Mondadori, 2007).

Freud, Sigmund, "The Uncanny", in James Strachey (ed.), *The Standard Edition of the Complete Psychological Works of Sigmund Freud*, vol. 17 [1917–19] (London: Hogarth Press and the Institute of Psycho-Analysis, 1959 [1919]).

——, *Three Essays on the Theory of Sexuality*, transl. James Strachey (New York: Basic Books, 1962 [1905]).

——, "Jokes and Their Relation to the Unconscious", in *The Penguin Freud Library*, vol. 6 (Harmondsworth: Penguin Books, 1976 [1905]).

——, *Inhibitions, Symptoms, and Anxiety*, ed. James Strachey (New York and London: W.W. Norton & Co., 1989 [1926]).

——, *The Interpretation of Dreams*, eds. James Strachey and Angela Richards (Harmondsworth: Penguin, 1991 [1900]).

————, "Psychopathic Characters on the Stage", in James Strachey (trans.), *The Standard Edition of the Complete Psychological Works of Sigmund Freud: Volume VII (1901–1905): A Case of Hysteria, Three Essays on Sexuality and Other Works* (London: Vintage, 2001 [1953]), 305–310.

————, *The Standard Edition of the Complete Psychological Works of Sigmund Freud: Volume IX (1906–1908): Jensen's 'Gradiva' and Other Works*, transl. James Strachey (London: Vintage, 2001).

————, *The Standard Edition of the Complete Psychological Works of Sigmund Freud: Vol. 22 (1932–1936): New Introductory Lectures on Psycho-Analysis and Other Works* (London: Vintage, 2001 [1933]).

Fried, Michael, "Art and Objecthood", in id., *Art and Objecthood: Essays and Reviews* (Chicago: University of Chicago Press, 1998 [1967]), 148–172.

————, "Without a Trace: The Art of Thomas Demand", *Artforum* (March, 2005), 200–201.

————, *Why Photography Matters as Art as Never before* (New Haven: Yale University Press, c2008).

Fusillo, Massimo, *Feticci: Letteratura, Cinema, Arti Visive* (Bologna: Il Mulino, 2012).

Garrison, Keillor, *Lake Wobegon Days* (New York: Viking Press, 1985).

Gavanas, Anna, "Domesticating Masculinities and Masculinizing Domesticity in Contemporary U.S. Fatherhood Politics", *Social Politics*, vol. 11, no. 2 (2004), 247–266.

Giani Gallino, Tilde, *La Ferita e il Re: gli Archetipi Femminili della Cultura Maschile* (Milano: Cortina, 1986).

Goffman, Erving, *Encounters: Two Studies in the Sociology of Interaction* (London: Allen Lane and Penguin, 1972).

Gombrich, Ernst H., *Meditations on a Hobby Horse and other Essays on the Theory of Art* (London: Phaidon, 1963).

Graw, Isabelle (ed.), *Art and Subjecthood: The Return of the Figure in Semiocapitalism* (Berlin: Sternberg Press, 2011).

The Green Room, dir. by François Truffault (Les Films du Carrosse, 1978).

Gross, Kenneth, *The Dream of the Moving Statue* (London: Cornell University, 1992).

———— (ed.), *On Dolls* (London: Notting Hill Editions, 2012).

Guys and Dolls, dir. by Nick Holt (BBC, 2006).

Heiferman, Marvin, "Conversation with Laurie Simmons", *Art in America* (April, 2009), 110–121.

Hemus, Ruth, *Dada's Women* (New Haven and London: Yale University Press, 2009).

Hollier, Denis, "Mimesis and Castration", transl. William Rodarmor, *October*, vol. 31 (Winter, 1984 [1937]), 3–15.

Horn, Wade F. et al., *The Fatherhood Movement: A Call to Action* (Lanham, MD: Lexington Books, 1999).

Hornaday, Ann, "*Lars and the Real Girl*: Break a Wooden Heart", *Washington Post* (October 19, 2007 [Online]).

House of Wax, dir. by André de Toth (1953).

Howard, Jan, *Laurie Simmons: The Music of Regret* [ex. cat.] (Baltimore: Baltimore Museum of Art, 1997).

Hugo, Victor, *Les Misérables* (London: Penguin Books, 1982).

Huizinga, Johan, *Homo Ludens: A Study of the Play Element in Culture* (London: Paladin, 1970).

Iversen, Margaret, *Beyond Pleasure: Freud, Lacan, Barthes* (University Park, PA: The Pennsylvania State University, 2007).

————, *Photography, Trace and Trauma* (Chicago: University of Chicago Press, 2017).

Jameson, Fredric, *Postmodernism: Or, the Cultural Logic of Late Capitalism* (Durham, NC: Duke University Press, 1992).

Jay, Martin, "The Uncanny Nineties", *Salmagundi*, no. 108 (Autumn, 1995), 20–29.

Kelley, Mike, *The Uncanny* (Arnhem and Los Angeles: Gemeentemuseum, 1993).

———, *The Uncanny* (Liverpool: Tate Liverpool, 2004).

Kieffer, Christine C., "Guys, Dolls, and the Uses of Enchantment", *Psychoanalytic Dialogues: The International Journal of Relational Perspectives*, vol. 25 (2015), 508–515.

Krauss, Rosalind, "Notes on the Index: Seventies Art in America", *October*, vol. 3 (Spring, 1977), 68–81.

———, "Corpus Delicti", *October*, vol. 33 (Summer, 1985), 31–72.

———, *Bachelors* (Cambridge, MA: MIT Press, 1999 [1993]).

Lacan, Jacques, "La Famille", in *Encyclopédie Française*, vol. 8 (Paris: A. de Monzie, 1938).

———, "Intervention sur l'Exposé de M. de Certeau: 'Ce que Freud Fait de l'Histoire: Note à Propos de 'Une Névrose Démoniaque au XVIIe Siècle: Congrès de Strasbourg (12 Octobre 1968)", *Lettres de L'école Freudienne*, no. 7 (1969).

———, "Discours à l'Université de Milan (12.05.1972)", in Giacomo G. Contri (ed.), *Lacan in Italia 1953–1978: En Italie Lacan* (Milano: La Salamandra, 1978), 32–55.

———, *The Seminar of Jacques Lacan: Book VII: The Ethics of Psychoanalysis*, ed. J.-A. Miller (London: Tavistock and Routledge, 1992 [1959–1960]).

———, *The Four Fundamental Concepts of Psychoanalysis [Seminar XI]* (London: Penguin Books, 1994 [1973]).

———, *Ecrits: The First Complete Edition in English*, transl. B. Fink (New York and London: W.W. Norton & Co., 2006).

———, *Le Séminaire: Livre XVI: D'un Autre à l'Autre* (Paris: Seuil, 2006).

———, *The Seminar of Jacques Lacan: Book XVII: The Other Side of Psychoanalysis* (New York; London: W.W. Norton & Co., c2007).

———, "L'Étourdit", *The Letter*, no. 41 (2009 [1972]), 31–80.

———, *The Sinthome: The Seminar of Jacques Lacan: Book XXIII*, transl. Richard Price (Cambridge, UK and Malden, MA: Polity Press, 2016).

———, *The Seminar of Jacques Lacan: Book X: Anxiety*, trans. Cormac Gallagher, from unedited French manuscripts [Printed].

———, *The Seminar of Jacques Lacan: Book XXII: RSI*, trans. Cormac Gallagher, from unedited French manuscripts [Online].

Lant, Antonia, "Haptical Cinema", *October*, vol. 74 (Autumn, 1995), 45–73.

Lars and the Real Girl (Craig Gillespie, 2007).

Laurent, Eric, "Psychosis, or a Radical Belief in the Symptom", *Hurly-Burly: The International Lacanian Journal of Psychoanalysis*, no. 8 (2012).

Laurie Simmons: Big Camera, Little Camera [ex. cat.] (Munich: DelMonico Books and Prestel, 2018).

Laxton, Susan, "Flou: Rayographs and the Dada Automatic", *October* (Winter, 2009), 25–48.

Lévi-strauss, Claude, *The Savage Mind* (Chicago: University of Chicago Press, 1967).

Levy, David, *Love and Sex with Robots* (New York: HarperCollins, c2007).

Lichtenstein, Therese, *Behind Closed Doors* (Berkeley, CA and New York: University of California Press, 2001).

Life Size, dir. by Luis García Berlanga (1974).

Lipovetsky, Gilles, *L'Ere du Vide: Essais sur l'Individualisme Contémporain* (Paris: Gallimard, 1983).

———, *Hypermodern Times*, trans. Andrew Brown (Cambridge: Polity Press, 2005).

Lomas, David, *The Haunted Self: Surrealism, Psychoanalysis, Subjectivity* (New Haven and London: Yale University Press, 1997).

———, *Narcissus Reflected* (Edinburgh: The Fruitmarket Gallery, 2011).

Lord, M.G., *Forever Barbie: The Unauthorized Biography of a Real Doll* (New York: Morrow and Co, c1994).

Lotman, Jurj, *Testo e contesto* (Roma-Bari: Laterza, 1980).

Love Object, dir. by Robert Parigi (2003).

Madsen, Ole Jacob, *The Therapeutic Turn: How Psychology Altered Western Culture* (London and New York: Routledge, 2014).

Mahon, Alice, *Surrealism and the Politics of Eros: 1938–1968* (New York: Thames & Hudson, 2005).

Malaby, Thomas, "Beyond Play: A New Approach to Games", *Games and Culture*, vol. 2, no. 2 (2007), 95–113.

Manson, Michel, "La Poupée, Objet de Recherche Pluridisciplinare", *Histoire de l'Education*, no. 18 (April, 1983).

——— (ed.), *Les Etats Généraux de la poupée* (Paris: C.E.R.P., 1985).

———, "La Poupée de Cosette, de la Littérature au Mythe", in Evelyne Poirel (ed.), *Lorsque l'Enfant Paraît . . . Victor Hugo et l'Enfance* (Paris: Somogy, 2002), 64–87.

Marra, Claudio, *L'Immagine Infedele: La Falsa Rivoluzione della Fotografia Digitale* (Milano: Mondadori, 2006).

"Married to a Doll", dir. by Pray (My Strange Addiction, the Learning Channel, 2011).

Marx, Karl, *Capital*, vol. 1, transl. Ben Fowkes (Harmondsworth: Penguin, 1976).

Masschelein, Anneleen, *The Unconcept: The Freudian Uncanny in Late-Twentieth-Century Theory* (Albany: SUNY Press, 2011).

Massumi, Brian, "Realer Than Real: The Simulacrum According to Deleuze and Guattari", *Copyright*, no. 1 (1987), 90–97.

———, "Navigating Movements", in Mary Zournazi (ed.), *Hope* (New York: Routledge, 2003), 210–243.

Mcgowan, Todd, *The End of Dissatisfaction? Jacques Lacan and the Emerging Society of Enjoyment* (New York: SUNY, 2004).

———, *Out of Time: Desire in Atemporal Cinema* (Minneapolis: University of Minnesota Press, 2011).

Mechanical Bride (The), dir. by Allison de Fren (2012).

Melman, Charles, *L'Homme Sans Gravité: Jouir à Tout Prix* (Paris: Denoël, c2002).

Merish, Lori, "Cuteness and Commodity Aesthetics", in R.G. Thomson (ed.), *Freakery: Cultural Spectacles of the Extraordinary Body* (New York: New York University Press, 1996), 185–2013.

Miller, Alice, *The Drama of Being a Child: The Search For the True Self* (London: Virago, 1995).

Miller, Jacques-Alain, "A Reading of Some Details in Television in Dialogue with the Audience (Barnard College, New York April 1990)", *Newsletter of the Freudian Field*, vol. 4 (1990), n.p.

———, "Les Six Paradigmes de la Jouissance", *La Cause Freudienne*, 43 (October, 1999), 7–29, available in English translation as "Paradigms of Jouissance", trans. Jorge Jauregui, *Lacanian Ink*, vol. 17 (2000), 10–47.

———, "Pièces Détachées", *Orientation Lacanienne: Le Cours de Jacques-Alain Miller*, Cours 1 (November 17, 2004).

———, "A Fantasy", *Lacanian Praxis: International Quarterly of Applied Psychoanalysis*, no. 1 (May, 2005 [2004]), 6–17.

———, "Extimity", *The Symptom*, no. 9 (Fall, 2008).

———, "The Other without Other", *Hurly-Burly*, no. 10 (December, 2013).

Mitchell, Juliet & Jacqueline Rose (eds.), *Feminine Sexuality: Jacques Lacan and the Ecole Freudienne* (London: The Macmillan Press, 1982).

Mitchell, William John Thomas, "The Photographic Essay: Four Case Studies", in id., *Picture Theory: Essays on Verbal and Visual Representation* (Chicago and London: University of Chicago Press, 1995), 281–321.

Monique (Valérie Guignabodet, 2002).

Mullins, Paul R. & Marlys Pearson, "Domesticating Barbie: An Archaeology of Barbie Material Culture and Domestic Ideology", *International Journal of Historical Archaeology*, vol. 3, no. 4 (December, 1999), 225–259.

Mulvey, Laura, *Visual and Other Pleasures* (Bloomington and Indianapolis: Indiana University Press, 1989).

———, "The Index and the Uncanny: Life and Death in the Photograph", in id., *Death 24x a Second: Stillness and the Moving Image* (London: Reaktion Books, 2006), 54–66.

Muzzarelli, Federica, *Le Origini Contemporanee della Fotografia: Esperienze e Prospettive delle Pratiche Ottocentesche* (Bologna: Quinlan, 2008).

My Strange Addiction, "Married to a Doll" (TLC, January 26, 2011).

Nowak, Magdalena, "The Complicated History of Einfühlung", *Argument*, vol. 1 (2011), 301–326.

Panofsky, Erwin, *Persepctive as Symbolic Form* (New York: Zone Books, 1991).

Paradoxa (Special number "The Return of the Uncanny"), vol. 3 (1998).

Paulsen, Jack, "The Index and the Interface", *Representations*, vol. 122, no. 1 (Spring, 2013), 83–109.

Pavón-Cuéllar, David, "Extimacy", in Thomas Teo (ed.), *Encyclopedia of Critical Psychology* (New York: Springer, 2014), 661–664.

Peers, Juliette, *The Fashion Doll: From Bebé Jumeau to Barbie* (Oxford and New York: BERG, 2004).

Peirce, Charles Sanders, *Philosophical Writings of Charles Sanders Peirce*, ed. Justus Buchler (New York: Dover Publications, 1955).

Perniola, Mario, *Il Sex Appeal dell'Inorganico* (Torino: Einaudi, 2004).

Pfaller, Robert, *On the Pleasure Principle in Culture* (London and New York: Verso, 2014).

Poupées et Tabous: Le Double Jeu de l'Artiste Contemporain [ex. cat.] (Paris: Somogy Editions, 2016).

Psychoanalytical Notebooks: London Society of the New Lacanian School: Issue 23, Our Orientation (London: London Society of the NLS, 2011).

Psychoanalytical Notebooks: A Review of the London Society of the New Lacanian School, London, March 2008: Issue 19, Ordinary Psychosis (London: London Society of the NLS, 2008).

Rand, Erica, *Barbie's Queer Accessories* (Durham, NC: Duke University Press, 1995).

Rank, Otto, *The Double: A Psychoanalytic Study*, ed. Harry Tucker Jr. (Chapel Hill: The University of North Carolina Press, c1971 [1914]).

Recalcati, Massimo (ed.), *Forme Contemporanee del Totalitarismo* (Torino: Bollati Boringhieri, 2007).

———, *Il Miracolo della Forma: Per un'Estetica Psicoanalitica* (Milano: Mondadori, 2007).

———, *L'Uomo Senza Inconscio: Figure della Nuova Clinica Psicanalitica* (Milano: Raffaello Cortina, 2010).

———, "Hunger, Repletion, and Anxiety", *Angelaki*, vol. 16, no. 3 (2011), 33–37.

———, *Le Mani della Madre* (Milano: Feltrinelli, 2015).

Reff, Theodore, *Manet: Olympia* (London: Allen Lane, 1976).

Rivière, Jean, "Womanliness as a Masquerade", in Athol Hughes (ed.), *The Inner World of Jean Rivière: Collected Papers 1920–1958* (London: Karnac Books, 1991 [1929]), 90–101.

Robertson, Jennifer, *Takarazuka: Sexual Politics and Popular Culture in Modern Japan* (Berkeley: University of California Press, 1998).

Rogers, Mary F., *Barbie Culture* (London: Sage, 1999).

Rogers, Robert, *The Double in Literature* (Detroit: Wayne State University Press, 1970).

Role Models: Feminine Identity in Contemporary American Photography [ex. cat., National Museum of Women in the Arts, Washington, DC, October 17, 2008–January 25, 2009] (London: Scala, 2008).

Ronen, Ruth, *Representing the Real* (Amsterdam and New York: Editions Rodopi B.V., 2002).

Rose, Jacqueline, *Sexuality in the Field of Vision* (London: Verso, 2005).

Roudinesco, Elisabeth, "An Interview with François Pommier: Other Sexualities I: Psycho-analysis and Homosexuality: Reflections on the Perverse Desire, Insult and the Paternal Function", *JEP: European Journal of Psychoanalysis*, no. 15 (Autumn/Winter, 2002).

Royle, Nicholas, *The Uncanny* (Manchester: Manchester University Press and Routledge, 2003).

Rugoff, Ralph (ed.), *The Human Factor: The Figure in Contemporary Sculpture* (London: Hayward Publishing, 2014).

Salecl, Renata (ed.), *Sexuation* (Durham, NC and London: Duke University Press, 2000).

Sawday, Jonathan, *The Body Emblazoned: Dissection and the Human Body in Renaissance Culture* (London: Routledge, 1995).

Scarano, Andrea, "E l'uomo creò la bambola", *IL Magazine: Il Sole 24 ore* (June 21, 2010), 63–72.

Schnapp, Jeffrey T., "Crystalline Bodies: Fragments of a Cultural History of Glass", *West 86th: A Journal of Decorative Arts, Design History, and Material Culture*, vol. 20, no. 2 (2013), 173–194.

Schwartz, Hillel, *The Culture of the Copy: Striking Likenesses, Unreasonable Facsimiles* (New York: Zone Books, 1996).

Sekula, Allan, "Dismantling Modernism, Reinventing Documentary (Notes on the Politics of Representation)", *The Massachusetts Review*, vol. 19, no. 4 (Winter, 1978), 859–883.

Silvestrini, Elisabetta & Elisabetta Simeoni (eds.), "La Cultura della bambola", in *La Ricerca Folklorica: Contributi allo Studio della Cultura delle Classi Popolari*, no. 16 (Brescia: Grafo, 1987).

Simmons, Laurie, *In and Around the House: Photographs, 1976–79* (Buffalo: CEPA, 1983).

———, *Laurie Simmons: Interviewed by Sarah Charlesworth* (New York: A.R.T. Press, 1994).

———, *Laurie Simmons: Walking, Talking, Lying* (New York: Aperture, c2005).

———, *The Love Doll* (New York: Salon 94, 2012).

———, *Big Camera Little Camera* [ex. cat.] (Munich: DelMonico Books, 2018).

Simms, Eva-Maria, "Uncanny Dolls: Images of Death in Rilke and Freud", *New Literary History*, vol. 27, no. 4, *Literature, Media, and the Law* (Autumn, 1996), 663–677.

Sisco King, Claire & Isaac West, "This Could Be the Place: Queer Acceptance in *Lars and the Real Girl*", *QED: A Journal in GLBTQ Worldmaking*, vol. 1, no. 3 (2014), 59–84.

Smart, Carol, "The Legal and Moral Ordering of Child Custody", *Journal of Law and Society*, no. 18 (1991), 485–500.

Smith, Marquard, *The Erotic Doll: A Modern Fetish* (New Haven: Yale University Press, 2013).

Smith, Valerie, "Something I've Wanted to Do But Nobody Would Let Me: Mike Kelley's 'The Uncanny'", *Afterall*, no. 34 (Autumn/Winter, 2013), 16–27.

Snyder, Joel, "Picturing Vision", *Critical Inquiry*, vol. 6, no. 3 (Spring, 1980), 499–526.

Soler, Colette, "L'Angoisse du Prolétaire Généralisé", *Link*, no. 9 (March, 2001), 35–41.

———, *What Lacan Said about Women: A Psychoanalytic Study* (New York and London: Eurospan Distributor, 2006).

Stacey, Jackie & Lucy Suchman, "Masculinity, Masquerade, and Genetic Impersonation: Gattaca's Queer Visions", *Signs: Journal of Women in Culture and Society*, vol. 30, no. 3 (2005), 1851–1877.

———, *The Cinematic Life of the Gene* (Durham, NC: Duke University Press, 2010).

———, "Animation and Automation: The Liveliness and Labours of Bodies and Machines", *Body & Society*, vol. 18, no. 1 (2012), 1–46.

Stewart, Susan, *On Longing* (Durham, NC and London: Duke University Press, 1993).

Stoichita, Victor, *A Short History of the Shadow: Essays in Art and Culture* (London: Reaktion Books, 1997).

Suleiman, Susan Robin, *Subversive Intent: Gender, Politics, and the Avant-Garde* (Cambridge, MA: Harvard University Press, 1990).

Sutton-Smith, Brian, "The Playful Modes of Knowing", in *Play: The Child Strived for Self-Realization* (Washington, DC: National Association for the Education of Young Children, 1971 [1970]).

———, *The Ambiguity of Play* (Cambridge, MA: Harvard University Press, 2001).

Suzuki, Akiyoshi, "Cross-Cultural Reading of Doll-Love Novels in Japan and the West", *Journal of East-West Thought* (Autumn, 2013), 107–126.

Ugolini, Sara, *Nel Segno del Corpo: Origini e Forme del Ritratto Ferito* (Napoli: Liguori Edizioni, 2009).

Uther, Hans-Jörg, *The Types of International Folktales* (Helsinki: Academia Scientiarum Fennica, 2004).

Valverde, Hatheway Sarah, *The Modern Sex Doll Owner: A Descriptive Analysis* (San Luis Obispo: California State Polytechnic University, 2012).

Vanheule, Stijn, "Lacan's Construction and Deconstruction of the Double-Mirror Device", *Frontiers of Psychology*, no. 2 (2011).

———, "Capitalist Discourse, Subjectivity and Lacanian Psychoanalysis", *Frontiers in Psychology*, no. 7 (2016).

Vanier, Alain, "Winnicott and Lacan: A Missed Encounter?", *The Psychoanalytic Quarterly*, vol. 81, no. 2 (2012), 279–303.

Vasari, Giorgio, *Le Vite de' Più Eccellenti Architetti, Pittori, et Scultori Italiani, da Cimabue, Insino a' Tempi Nostri: Nell'Edizione per i Tipi di Lorenzo Torrentino Firenze 1550* (Milano: Einaudi, 1991).

Verhaeghe, Paul, "From Impossibility to Inability: Lacan's Theory on the Four Discourses", *The Letter: Lacanian Perspectives on Psychoanalysis*, no. 3 (Spring, 1995), 91–108.

Vernant, Jean Pierre, *Myth and Thought among the Greeks* (London: Routledge, 1983).

Vidler, Anthony, *The Architectural Uncanny: Essays in the Modern Unhomely* (Cambridge, MA: MIT Press, 1996).

Violi, Alessandra (ed.), *Locus Solus: Giocattoli* (Milano: Mondadori, 2010).

Von Boehn, Max, *Dolls and Puppets* (New York: Cooper Square Publishers, 1966).

Voruz, Véronique & Bogdan Wolf (eds.), *The Later Lacan: An Introduction* (Albany: State University of New York Press, 2007).

Warner, Marina, *Once Upon a Time: A Short History of Fairy Tale* (Oxford: Oxford University Press, 2014).

Webb, Peter, *Hans Bellmer* (London and New York: Quartet Books, 1985).

Weisel-Barth, Joye, "Loneliness and the Creation of Realness in *Lars and the Real Girl*", *International Journal of Psychoanalytic Self Psychology*, vol. 4, no. 1 (2008), 111–118.

Weller, Dennis P., *Is Seeing Believing?: The Real, the Surreal, the Unreal in Contemporary Photography* [ex. cat., North Carolina Museum of Art, Raleigh, NC, January 14–April 1, 2000; the Cummer Museum of Art and Gardens, Jacksonville, Fla., April 22–July 8, 2001] (Raleigh, NC: North Carolina Museum of Art, 2000).

Welling, James, *Laurie Simmons: Color Coordinated Interiors* (New York: Skarstedt Fine Art, 2007).

Wilbers, Stephen, "Lake Wobegon: Mythical Place and the American Imagination", *American Studies*, vol. 30, no. 1 (spring, 1989), 5–20.

Winnicott, W. Donald, "Transitional Objects and Transitional Phenomena: A Study of the First Not-Me Possession", *International Journal of Psychoanalysis*, no. 34 (1953), 89–97.

————, *The Maturational Process and the Facilitating Environment: Studies in the Theory of Emotional Development* (London: Karnac Books, 1990).

Yaari, Monique, "Who/What Is the Subject? Representations of Self in Late Twentieth-Century French Art", *Word & Image*, vol. 16, no. 4 (2000), 363–377.

Yablonsky, Linda, "Laurie Simmons", *Wallpaper* (2012), 245–246.

———— & Laurie Simmons, *BOMB*, no. 57 (Autumn, 1996), 18–23.

Zeri, Federico, *Storia dell'arte italiana I: Dal Medievo al Quattrocento* (Torino: Einaudi, 1983).

Žižek, Slavoj, *The Supreme Object of Ideology* (London and New York: Verso, 2008 [1989]).

————, "Risk Society and Its Discontents", *Historical Materialism*, vol. 2, no. 1 (1998), 143–164.

————, "'Pathological Narcissus' as a Socially Mandatory Form of Subjectivity", in *Manifesta 3: Borderline Syndrome: Energies of Defence* [ex. cat.] (Ljubljana: Cankarjev Dom, 2000), 234–255.

————, *The Ticklish Subject: The Absent Centre of Political Ontology* (London: Verso, 2000).

————, *Enjoy Your Symptom: Jacques Lacan in Hollywood and Out* (New York: Routledge, 2001).

————, *The Puppet and the Dwarf: The Perverse Core of Christianity* (Cambridge, MA: MIT Press, 2003).

————, *The Metastases of Enjoyment: Six Essays on Women and Causality* (London: Verso, 2005 [1994]).

————, *For They Know Not What They Do: Enjoyment as a Political Factor* (London: Verso, 2008 [1991]).

————, *The Plague of Fantasies* (London: Verso, 2008 [1997]).

————, "The Impasses of Consumerism", in *Prix Pictet 05: Consumption* (Kempen: teNueues, 2014), 4–9.

————, *Disparities* (London and New York: Bloomsbury Academic, 2016).

Zupančič, Alenka, "The 'Concrete Universal', and What Comedy Can Tell Us about It", in Slavoj Žižek (ed.), *The Silent Partners* (London and New York: Verso, 2006), 171–197.

INDEX